Champaign
Spring 1989

THE A. W. MELLON LECTURES IN THE FINE ARTS

Delivered at the National Gallery of Art

Washington, D.C.

BOLLINGEN SERIES XXXV · 3

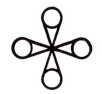

THE ART
OF
SCULPTURE

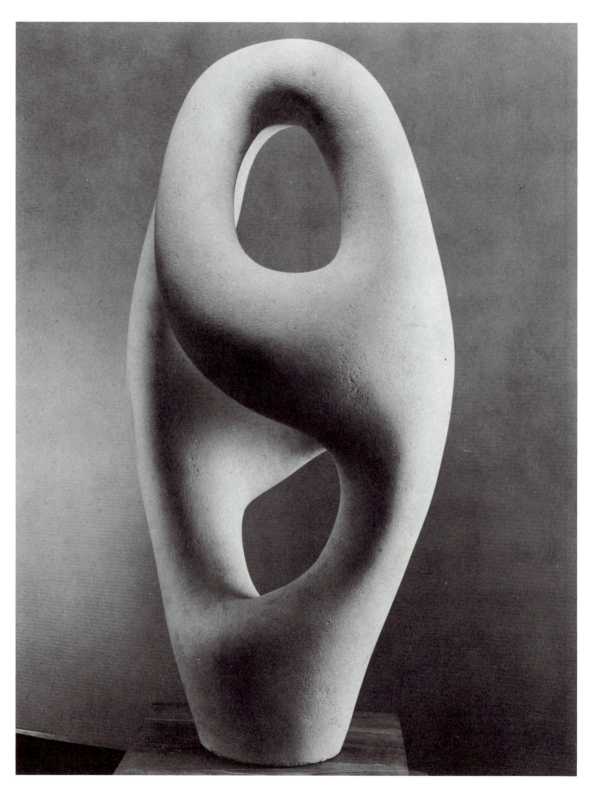

JEAN ARP. Ptolemy. 1953. Stone. H. 40 in.

HERBERT READ

THE
ART OF SCULPTURE

THE A. W. MELLON LECTURES
IN THE FINE ARTS
1954
NATIONAL GALLERY OF ART
WASHINGTON

BOLLINGEN SERIES XXXV · 3

PRINCETON UNIVERSITY PRESS

THIS IS THE THIRD VOLUME
OF THE A. W. MELLON LECTURES IN THE FINE ARTS,
WHICH ARE DELIVERED ANNUALLY
AT THE NATIONAL GALLERY OF ART, WASHINGTON.
THE VOLUMES OF LECTURES CONSTITUTE NUMBER XXXV
IN BOLLINGEN SERIES

Second Edition, 1961
Second Printing, 1964
Third Printing, 1969
First Princeton/Bollingen Paperback Printing, 1977

ISBN 0-691-01811-1 (paperback edn.)
ISBN 0-691-09786-0 (hardcover edn.)
Library of Congress Catalogue Card No. 53-5537
Printed in the United States of America
by Princeton University Press, Princeton, New Jersey

TO

NAUM GABO

BARBARA HEPWORTH

HENRY MOORE

SCULPTORS AND FRIENDS

IN GRATITUDE

Preface

The purpose of this book is to give, with appropriate illustrations, an aesthetic of the art of sculpture. Sculpture, as I relate in the course of my argument, has always had difficulty in establishing its independence as an art, and this has been in some measure due to the lack of any clear formulation of the requisite autonomous laws.

Some of the greatest artists, such as Leonardo, have been the greatest detractors of sculpture, and until comparatively recently sculptors themselves have all too readily submitted to the rule of the architect or the painter. There have been repeated attempts to establish a free sculpture, notably those of Donatello and Michelangelo; but the full consciousness of the need for such a liberation came only with Rodin. Since Rodin's time there has arisen what is virtually a new art— a concept of a piece of sculpture as a three-dimensional mass occupying space and only to be apprehended by senses that are alive to its volume and ponderability, as well as to its visual appearance.

"This is what the sculptor must do," writes one of the greatest of contemporary sculptors. "He must strive continually to think of, and use, form in its full spatial completeness. He gets the solid shape, as it

were, inside his head—he thinks of it, whatever its size, as if he were holding it completely enclosed in the hollow of his hand. He mentally visualizes a complex form *from all round itself;* he knows while he looks at one side what the other side is like; he identifies himself with its center of gravity, its mass, its weight; he realizes its volume, as the space that the shape displaces in the air." [1]

Such an awareness of the essential nature of the art of sculpture has never until our own time been so clearly held and so clearly expressed. I shall be content if in this book I give historical support and theoretical extension to such a practical vision.[2] I see the sculpture of the past as often approaching and even attaining this independent character, this ideal that only the sculptors of our own time have fully realized. I do not claim that the sculpture of Rodin or Moore is on this account "greater" than the sculpture of Donatello or Michelangelo: greatness is another question, and not wholly an aesthetic one. I claim only that the sculptor now has a much clearer conception of the scope and methods of his art and is free to develop that art with a purity and power that can only make more evident whatever greatness or nobility he may possess.

That the independence of each of the arts is a good thing in itself may not be evident, but it is an inevitable condition of the arts within our civilization. In the past the arts have only occasionally been united, and then as great architecture. We have no "operatic" architecture unifying all the plastic arts, such as the Greeks or the people of the Middle Ages possessed, and it is doubtful whether the technical processes of

1. Henry Moore, "Notes on Sculpture," in Herbert Read, *Henry Moore: Sculpture and Drawings* (2nd edn., New York, 1946), p. xl.

2. I do not wish to imply that I am the first to make such an attempt—I have at least three predecessors: C[arola]. Giedion-Welcker, *Modern Plastic Art*, tr. P. Morton Shand (Zurich, 1937; rev. and enl. edn. titled *Contemporary Sculpture*, New York, 1955); László Moholy-Nagy, *The New Vision* (Documents of Modern Art; 3rd rev. edn., New York, 1946); W. R. Valentiner, *Origins of Modern Sculpture* (New York, 1946). Andrew Carnuff Ritchie, in *Sculpture of the Twentieth Century* (Museum of Modern Art, New York, 1952), gives an extensive survey of the "diverse directions sculpture has taken in our century."

modern building, conditioned as they are by machine production, can ever produce an architecture capable of accommodating the personal arts of painting and sculpture. The classical temples and the Gothic cathedrals were the creation of individuals, of humanists who could naturally co-operate with the sculptor and painter on the same level of aesthetic sensibility. The typical modern building is conceived in a spirit and with technical methods that call for quite a different human component—for an impersonal team of constructive engineers and scientists. The separation of the arts in our modern industrial civilization is inevitable, and consequently such arts as sculpture and painting must evolve their own aesthetic, as music in its independence has done in the past.

A first outline of this book was delivered as the Ferens Fine Art Lectures at the University of Hull in the 1951–52 session. I was restricted to four lectures and felt that I had not adequately covered the subject. When I was invited to give the A. W. Mellon Lectures in the Fine Arts, at the National Gallery of Art, in Washington, I recast this original material, expanding it to six lectures, and these form the basis of the text of the present volume.

I wish to express my thanks to the Senate and Council of the University of Hull, as well as to the A. W. Mellon Lectureship Committee, for without their patronage the book could never have been written or published. My debt to Mr. Huntington Cairns, the secretary of the National Gallery, extends far beyond official limits: his encouragement and enlightenment have been precious to me for many years. To the director of the National Gallery, Mr. David E. Finley, to the assistant director, Mr. Macgill James, and to Mr. Raymond S. Stites, the curator in charge of education, I am indebted for much practical help and advice.

Finally, I should like to thank those who made my stay in Washington such a pleasant experience, above all Mr. and Mrs. Robert Richman, who extended to me all the material comforts and social delights of their home.

HERBERT READ

Lexington, Massachusetts
 Spring, 1954

Preface to the Second Edition

In this new edition several typographical errors have been corrected and a new ascription noted (page 61), but otherwise the text is substantially the same as in the first edition.

H. R.

Stonegrave House, York,
 January 1961

Note

For the third printing I have made no changes other than a new reference to Gabo's Manifesto, on pages 98–99.

H. R.

Stonegrave House, York,
 February 1968

NOTE OF ACKNOWLEDGMENT

Grateful acknowledgment is made to the following publishers for permission to quote as indicated: to George Allen and Unwin, London, for quotations from John Ruskin's works (ed. E. T. Cook and Alexander Wedderburn); to Basic Books, New York, for a passage from Jean Piaget, *The Construction of Reality in the Child;* to G. Bell and Sons, London, for a passage from Hegel's *The Philosophy of Fine Art;* to the Cresset Press, London, for a passage from John Summerson, *Heavenly Mansions;* to Dover Publications, New York, for passages from Cennino Cennini's *The Craftsman's Handbook* (tr. D. V. Thompson) and Heinrich Wölfflin, *Principles of Art History;* to Gerald Duckworth and Co., London, for a passage from Margaret Alice Murray, *Egyptian Sculpture;* to Harcourt Brace and Co., New York, for ten lines of poetry from T. S. Eliot, *The Complete Poems and Plays,* and for a passage from *The Notebooks of Leonardo da Vinci* (ed. Edward MacCurdy); to International Universities Press, New York, for passages from Wilhelm Worringer, *Abstraction and Empathy,* and Paul Schilder, *The Image and Appearance of the Human Body;* to Oxford University Press, London and New York, for a passage from *The Literary Works of Leonardo da Vinci;* to Phaidon Press, London, for quotations from Heinrich Wölfflin, *Classic Art,* and Bernard Berenson, *The Italian Painters of the Renaissance;* to G. P. Putnam's Sons, New York, for quotations from

NOTE OF ACKNOWLEDGMENT

Wilhelm Worringer, *Egyptian Art* (copyright 1928); to Routledge and Kegan Paul, London, for passages from Frederick Antal, *Florentine Painting and Its Social Background*, Jean Piaget, *The Child's Construction of Reality*, Wilhelm Worringer, *Abstraction and Empathy*, and Simone Weil, *Gravity and Grace;* to the University of Chicago Press for a passage from C. F. von Weizsäcker, *The History of Nature* (tr. Fred D. Wieck and copyright 1949, University of Chicago); and to Yale University Press, for quotations from Gisela M. A. Richter, *The Sculpture and Sculptors of the Greeks.*

Acknowledgment for permission to reproduce photographs of works of art is made in the List of Plates.

Contents

List of Plates

The plates are arranged approximately in the order that they are referred to in the text, but this order has been varied both to confront various pieces for comparison and to bring together pieces that are related in material or technique. Not every illustration is referred to specifically in the text. Where there is no indication of photograph source, the photograph either is an official one, supplied by the museum or gallery in question, or is by the artist, or is from an unknown source.

30. Statuettes. Cyclades, end of 3rd millennium B.C. Carved marble. *a.* From Skyros. *b.* From Paros. *c.* From Amorgos. H. 19¼ in.
a, b. National Museum, Athens. c. British Museum, London. P: *Crown copyright.*

31. Amulets (fertility charms?). Cyclades, end of 3rd millennium B.C. Carved marble. *a.* From Amorgos. H. 4⅜ in. *b.* From Kimolos. *c.* From Paros. H. 6 in.
a, c. British Museum, London. P: *Crown copyright. b. National Museum, Athens.*

32. Statuette. Greece (Tanagra), IV–III centuries B.C. Terra cotta. H. 10 in.
British Museum, London. P: *Crown copyright.*

33. Musicians. China (T'ang Dynasty), A.D. 618–906. Statuettes of terra cotta. H. about 10¾ in.
Rietberg Museum, Zurich. P: *Ernst Hahn.*

34. Statuettes of the Bodhisattva Avalokiteshvara. China (T'ang Dynasty), A.D. 618–906. Carved ivory. H. 3¾ in.
Freer Gallery of Art, Washington. P: *Courtesy of the Gallery.*

35. FRANZ ANTON BUSTELLI (1723–63). Lady with flask. Bavaria (Nymphenburg), about 1760. Porcelain. H. 7¾ in.
Museum für Kunst und Gewerbe, Hamburg.

36a. Figure. Belgian Congo (Waregga tribe). Wood. H. 9¼ in.
John P. Anderson Collection, Red Wing, Minnesota. P: *Walker Evans.*

36b. Youth Imploring. By a congenitally blind youth of 17. XX century. Modeled in clay.
P: *Viktor Lowenfeld.*

37a. Mask. Ivory Coast (Dan tribe?). Wood. H. 10⅝ in.
Paul Guillaume Collection, Paris. P: *Walker Evans.*

37b. Pain. By a congenitally blind youth of 18. XX century. Modeled in clay.
P: *Viktor Lowenfeld*

38a. GIACOMO BALLA. Abstract Study of Velocity. 1913. Gouache. 17 x 20 in.
Rose Fried Gallery, New York. P: *John D. Schiff.*

38b. Impression from cylinder seal. Mesopotamia (Susa), before 3000 B.C. Steatite. H. 0.67 in.
P: *Éditions "Tel."*

38c. Impression from cylinder seal. Mesopotamia (Tello), before 3000 B.C. Marble. H. 0.86 in.
Louvre, Paris. P: *Éditions "Tel."*

39. MARCEL DUCHAMP. Sad Young Man in a Train. 1911. Oil on cardboard. 28.6 x 39.4 in.
Peggy Guggenheim Collection, Venice.

40. Ax-shaped tablet. China, before 220 B.C. Jade. H. 7¾ in.
Fogg Museum of Art, Harvard University (Winthrop Bequest).

41. Carved skull, probably representing the Death God. Aztec, about 1324–1521. Rock crystal. H. 8⅓ in.
British Museum, London. P: *Crown copyright.*

42. Perseus beheading Medusa, from a metope of Temple C at Selinus. Sicily, 550–530 B.C. Marble.
Museo Nazionale, Palermo. P: *Anderson.*

43. Lapith and Centaur, from a metope of the Parthenon. Athens, about 447–443 B.C. Marble. 47 × 50 in.
British Museum, London. P: *Crown copyright.*

44. Elephant. Ritual vessel (*huo*). China (early Chou Dynasty, or earlier), about 1122–249 B.C. Bronze. H. 8¼ in.
Freer Gallery of Art, Washington. P: *Courtesy of the Gallery.*

45. Monster. Ritual vessel (*huo*). China (Shang Dynasty), about 1766–1122 B.C. Bronze. H. 7⅕ in.
Freer Gallery of Art, Washington. P: *Courtesy of the Gallery.*

46. Head of a horse belonging to the chariot of Selene, goddess of the moon, from the Parthenon frieze, east pediment. Athens, 442–38 B.C. Marble. H. 41 in.
British Museum, London. P: *F. L. Kenett.*

47. Head of a cat, from a group of cat and kittens. Egypt (Saïte or Ptolemaic period), VII–I centuries B.C. Bronze. L. of group, 21²⁵⁄₃₂ in.
National Gallery of Art, Washington (Gulbenkian Collection). P: *Courtesy of the Gallery.*

48. Bisons modeled in clay. Grotto of the Tuc d'Audoubert (Ariège), France. Paleolithic period (Magdalenian style). L. about 24 in.
P: *Max Begouen.*

49. The She-Wolf nourishing Romulus and Remus. Siena, XV century. Bronze. H. 14⁵⁄₁₆ in. L. 25¼ in.
National Gallery of Art, Washington. P: *Courtesy of the Gallery.*

50. Quadruped. China (late Chou Dynasty), VI–III centuries B.C. Bronze. H. 4½ in.
Freer Gallery of Art, Washington. P: *Courtesy of the Gallery.*

51. Dog. Mexico (so-called Western Civilization), from Colima, 500 B.C. –A.D. 1521. Ocherous clay, covered with a polished red slip. L. 16½ in.
Museo Nacional de Antropología, Mexico City. P: *F. L. Kenett.*

52. Fabulous bird. Mosan, early XIII century. Ewer of gilt bronze, cast and chased, enriched with niello and silver. H. 7⅜ in.
Victoria and Albert Museum, London. P: *F. L. Kenett.*

53. PABLO PICASSO. Cock. About 1932. Bronze. H. 26½ in.
Tate Gallery, London. P: *F. L. Kenett.*

70. DESIDERIO DA SETTIGNANO (1428–64). The Young Christ with St. John the Baptist. Florence, mid-XV century. Marble. H. 15¾ in.
National Gallery of Art, Washington (Mellon Collection). P: *Courtesy of the Gallery.*

71. FRANCESCO DI GIORGIO MARTINI (?) (1439–1502). An Allegory of Discord. Siena, about 1450–1500. Stucco. W. 26½ in.
Victoria and Albert Museum, London. P: *Crown copyright.*

72. GIOVANNI PISANO (1240?–?1320). The Annunciation. Detail from a panel of the pulpit in Sant' Andrea, Pistoia. Commissioned 1298, completed 1301. Marble. Panel: 33 × 40¼ in.
P: *F. L. Kenett.*

73. GIOVANNI PISANO. The Virgin Mary. Group from the Crucifixion Panel (see plate 72).
P: *F. L. Kenett.*

74. GIOVANNI PISANO. The Nativity. Detail from a panel (see plate 72).
P: *F. L. Kenett.*

75. TINO DI CAMAINO (1285?–1337). Votive relief of Queen Sancia, with donor, Virgin and Child, Sts. Clara and Francis, and angels. Italian, about 1300–1337. Marble. H. 20¼ in.
National Gallery of Art, Washington (Kress Collection). P: *Courtesy of the Gallery.*

76. GIOVANNI PISANO. Virgin and Child, in the Cathedral at Prato. About 1317. Marble. H. 27½ in.
P: *Alinari.*

77. Virgin and Child. French (School of Paris), XIV century. Ivory. H. 14 in.
Victoria and Albert Museum, London. P: *F. L. Kenett.*

78. TINO DI CAMAINO. Virgin of the Annunciation, in the Church of Santa Croce, Florence. About 1319. Marble. H. 28¾ in.
P: *Heursa.*

79. TINO DI CAMAINO. Charity. Florence, about 1321–24. Marble. H. 49¼ in.
Museo Bardini, Florence. P: *Alinari.*

80–81. Probably by NINO PISANO (1313?–?1368). Virgin and Child ("Madonna del Latte"), Pisa, about 1365–68. Marble. H. 35⅝ in.
Museo Civico, Pisa. P: *F. L. Kenett.*

82–83. JACOPO DELLA QUERCIA (1371–1438). The Madonna of Humility. Italian, about 1428–35. Marble. H. 23 in.
National Gallery of Art, Washington (Kress Collection). P: *Courtesy of the Gallery.*

84–85. DONATELLO (about 1386–1466). The David of the Casa Martelli. Italian, 1434–38. Marble. H. 64 in. (Plate 85: head of Goliath.)
National Gallery of Art, Washington (Widener Collection). P: *Courtesy of the Gallery.*

197. CONSTANTIN BRANCUSI. Bird in Space. 1940. Bronze. H. 52 in.
Peggy Guggenheim Collection, Venice. P: *Charles Piccardy.*

198. JACQUES LIPCHITZ. Man with a Guitar. 1915(?). Cast stone. H. 38¼ in.
The Museum of Modern Art, New York. P: *Eliot Elisofon.*

199. JACQUES LIPCHITZ. Mother and Child II. 1941–45. Bronze. H. 50 in.
The Museum of Modern Art, New York. P: *Eliot Elisofon.*

200–201. HENRY MOORE. Madonna and Child. 1943–44. Hornton stone. H. 59 in.
Church of St. Matthew, Northampton, England.

202. JEAN ARP. Outrance d'une outre mythique ("Extremity of a mythical wineskin"). 1952. Stone. H. 17 in.
P: *Curt Valentin Gallery, New York.*

203. HENRY MOORE. Family group. 1947. Bronze. H. 16 in.
The British Council, London.

204. Chac Mool, the Rain Spirit. Mayan (New Empire), from Chichén Itzá, A.D. 948–1697. Limestone. L. 58½ in.
Museo Nacional de Antropología, Mexico. P: *F. L. Kenett.*

205. HENRY MOORE. Reclining figure. 1929. Brown Hornton stone. L. 32 in.
Leeds City Art Gallery.

206. HENRY MOORE. Reclining figure. 1945. Bronze. L. 17½ in.
Private collection.

207. ALBERTO GIACOMETTI. A city square. 1948. Bronze. H. 8½ in.
Museum of Modern Art, New York. P: *Soichi Sunami.*

208. ALBERTO GIACOMETTI. Figure of a man. 1947. Bronze. H. 70½ in.
Tate Gallery, London. P: *F. L. Kenett.*

209. HENRY MOORE. Double standing figure. 1950. Bronze. H. 7 ft. 3 in.
The British Council, London.

210. REG BUTLER. Woman standing. 1952. Bronze wire and sheet metal. H. 18½ in.

211. ALEXANDER CALDER. Bougainvillea. 1947. Mobile of wire and sheet metal. H. 76 in.
Collection of Mr. and Mrs. Burton Tremaine, Meriden, Conn. P: *Herbert Matter.*

212. REG BUTLER. Project for a monument to the Unknown Political Prisoner. 1952. Bronze wire with stone base. Projected minimum H. 150 ft., with 3 figures 8 ft. high.
Collection of Mr. and Mrs. A. J. T. Kloman, New York. P: *F. L. Kenett.*

213. BARBARA HEPWORTH. Head ("Elegy"). 1952. Mahogany and strings. H. 17 in.
University of Nebraska Art Gallery. P: *Studio St. Ives Ltd.*

THE ART

OF

SCULPTURE

CHAPTER ONE

The Monument and the Amulet

It has been the custom in the past—notably, in the sixteenth century—to discuss the relative merits of the various arts; in particular, the arts of architecture, painting, and sculpture have been compared and placed in an order of nobility that has varied from age to age and from person to person. Leonardo thought that painting was the superior art, whereas Michelangelo called sculpture the lantern of painting and between the two arts saw as much difference as that between the sun and the moon. Michelangelo changed his opinion when Benedetto Varchi pointed out to him that things which have the same end are themselves the same, and that as both arts may be presumed to be striving after the identical ideal of nobility, they should be judged worthy of equal esteem.[1]

Such a discussion would seem very sophisticated and unreal today. The arts do not now compete to express a common ideal; and even if they did, nobility would not be its name. Instead, the arts seek to distinguish themselves one from another, to preserve boundaries, to rely on distinct sensations, to appeal to specialized sensibilities. It is claimed that each art has its proper virtues, determined by the nature of its

1. Leonardo's and Michelangelo's state- *Art History,* ed. Elizabeth Gilmore Holt
ments are accessible in *Literary Sources of* (Princeton, 1947), pp. 178, 193.

3

tools and materials, and that the faculties engaged by these tools and materials are so distinct that the products cannot be usefully compared.

We may suspect such separatism to be a reflection of our disunited society. We may share certain sentiments of liberty or equality, but we do not seek to embody them in living forms. We may hold ideals in common, but they remain bloodless abstractions. Yet when Michelangelo and his contemporaries strove to express ideals of nobility, they were dealing not in abstractions but in concrete realities. Nobility to them was a characteristic of the human body, and the artist of the Renaissance, following the example of the classical artist, had no other aim than to crystallize, as it were, the sense of glory in the image of man. Classical sculpture, as Hegel said, had conceived "the astounding project of making Spirit imagine itself in an exclusively material medium." [2]

We now live in a romantic age, for which only poetry, in Hegel's opinion, is an appropriate art. But the history of art since Hegel's time has not borne out such a view. Rather we may say that painting and sculpture have escaped from the idealistic bonds in which Hegel would have confined them and have established themselves, equally with poetry, as media for the expression of states of sensibility.

Hegel tried to exclude subjectivity from the art of sculpture. He could do so only by excluding all types of sculpture other than the one that expressed the classical ideal. A scientific or aesthetic approach such as we insist on now cannot accept such a restriction. Instead we should begin from our most rudimentary experiences of form—from the merely sensational reaction of the human organism to shape as such. The solidity of a form, as it is clearly distinguished in perception, is already a sculptural sensation. As the art develops, in history or in the sensuous experience of the individual, we may begin to associate with each shape

2. G. W. F. Hegel, *The Philosophy of Fine Art,* tr. F. P. B. Osmaston (London, 1920), III, p. 121. For an illuminating analysis of Michelangelo's ideal in relation to the image of the human body, see Adrian Stokes, *Michelangelo, a Study in the Nature of Art* (London, 1955).

4

an idea; we inhabit the shape with our spirit; and finally, if we are artists, we try to realize ideas as specific shapes, to create symbols for our indeterminate feelings—to become conscious, in the forms of art, of the dimensions of reality.

The theoretical aspects of our inquiry will, I hope, become clear as we proceed on our empirical path. I shall begin by showing with what difficulty the art of sculpture established its independence—its physical independence as an art separate from its architectural setting, and its aesthetic independence as an art with its own creative principles, its own standards of appreciation. I shall be concerned in this first chapter with a process that may well be described by the biological term "fission," for in the beginning there was neither architecture nor sculpture, as a distinct art, but an integral form that we should rather call the *monument.* Both architecture and sculpture may be conceived as evolving from an original unity, and it is by no means possible to describe this original entity as essentially architectural or essentially sculptural.

Independent of the monument, there was from the beginning another form of art that was gradually to merge with sculpture, but that had a separate origin and usage and was never confused with the monument. This was the *amulet*—the small, portable charm, worn on the [28, 31, 34] person as a protection against evil, or as an insurance of fertility. We may decide, after reviewing all the evidence, that there is still a case for keeping the monument and the amulet in separate aesthetic categories, but that the specific art of sculpture, an art with its distinct aesthetics, comes into existence somewhere between these two extremes —as a method of creating an object with the independence of the amulet and the effect of the monument.

If we look at this original unity from the architectural point of view, we must make a further distinction. What we generally conceive as constituting architecture—buildings that can be lived in or worked

in or worshiped in, buildings with an inner space—is not essentially monumental and probably had a different origin from the monument. Four bamboo posts and a thatch of palm leaves—or, alternatively, the [1] more plastic adobe hut, molded by hand from mud and baked in the sun—such was the protype of the human dwelling, of the machine-to-live-in. But the temple and the cathedral—buildings that in the minds of most people usually objectify the art of architecture—had a development independent of the dwelling. They evolved from the monument, which was originally a solid sculptured object.

Such a statement is perhaps too positive. The origins of art are lost in prehistory, and we must proceed imaginatively, not scientifically, to reconstruct them. Some of Hegel's theories are worthy of Herodotus, and in this spirit he suggested that the first monuments were phallic. "It was in India especially," he wrote, "that the worship of the energy of generation assumed the exterior shape and significance of the organs of sex. Enormous columnar images were in this respect raised of stone as massive as towers and broadening out at the base. Originally they were themselves independently the aim and objects of such worship; only at a later time it became customary to make openings and hollow chambers within them and deposit in these divine images, a custom which was maintained in the Hermes figures of the Greeks, little temple shrines that could be carried. The point of departure, however, in India was the phallus pillars, which had no such hollows, and which only at a later date were divided into a shell and kernel, growing thus into pagodas. For the genuine Indian pagodas, which should be distinguished essentially from later Mohammedan or other imitations, do not originate in the form of the dwelling, but are narrow and lofty, and receive their fundamental type from these columnar constructions."[3]

A glance at some of the architectural monuments of the Far East will confirm this theory. In its whole conception, the Chinese pagoda

3. Ibid., III, 39–40.

6

is sculptural—not only in its details, but as an isolated mass. The Indian temples, whether single blocks or complex groups of buildings, are even more strikingly sculptural in conception and execution—for example, the Rajrani Temple at Bhuvaneshvara. The sculptural significance of this architecture is, of course, still more obvious in those remarkable temples and monasteries which are carved out of solid rock, such as the cave temples of Ajanta or the Kailasanatha at Ellora, elaborate constructions that are sculptured mountains.[4] [2] [3]

As we turn westward, the monument gives way to the sarcophagus, the "flesh-consuming" stone. Already in Paleolithic times the disposal of the dead had assumed far greater importance than the shelter of the living, and the origins of architecture, in Egypt, Mesopotamia, and Greece, are to be sought in the tombs, catacombs, and labyrinths associated with various burial cults. The first tombs were natural caves or the space at the entrance of these caves. Later, tombs were excavated out of the solid rock; and, where suitable cliffs did not exist, what were in effect artificial masses of rock were made, with tomb chambers within. Thus the pyramid was evolved. The desire to record events in the life of the deceased led to the decoration of such tombs, by carved reliefs or mural paintings. At Giza the reliefs on one of the earliest rock-cut tombs include a reproduction of the actual dwelling of the deceased, a simple hut of palm tree trunks and turfed roof. [4]

The temple in our Western sense of the term has a different origin. It was the god house. In the early animistic religions, a god might be housed in some prominent natural object, such as an outstanding rock,

4. The Indian monument was often a development of the grave mound or stupa, especially in the early Buddhist period. Cf. Heinrich Zimmer, *The Art of Indian Asia* (Bollingen Series XXXIX; New York, 1955), I, 6: "By Asoka's time it [the stupa] had become transformed into a shrine, either containing ashes or relics, or else simply standing as a memorial. In the course of the subsequent centuries the stupa developed variously, particularly following the spread of Buddhism throughout Asia, but in its earliest known examples, at Bharhut and Sanchi, the form was that of a moundlike central structure surrounded by a railing with sumptuously carved gates."

and the first altars were stones. The next stage in the evolution of the
temple is illustrated vividly in the twenty-eighth chapter of Genesis,
where it is related that Jacob "went out from Beer-sheba, and went to-
ward Haran. And he lighted upon a certain place, and tarried there all
night, because the sun was set; and he took of the stones of that place,
and put them for his pillows, and lay down in that place to sleep."
While he slept, he had his dream of a ladder set up in that place where
he lay, with its top reaching to heaven, and "the angels of God ascend-
ing and descending on it." The rest of his vision does not concern us
now, but we note that when Jacob awaked out of his sleep, he was
afraid and said: "How dreadful is this place! This is none other but the
house of God, and this is the gate of heaven. And Jacob rose up early
in the morning, and took the stone that he had put for his pillows, and
set it up for a pillar, and poured oil upon the top of it." After naming
the place and making his vows, he declared: "And this stone, which I
have set for a pillar, shall be God's house." Such was the origin of the
sacred pillar at Beth-el, the prototype of the Jewish temple.

[6, 29] When, at a later stage in his religious development, man began to
make graven images of his God, he hollowed out the massebah or stone
pillar and placed an image inside. The whole notion of the temple, as
it originates in the Near East, is of a monolithic structure enclosing an
image of the deity, like a shell enclosing a kernel. The shell was grad-
ually enlarged to accommodate a rock altar for the sacrifices to the god
and an image of the god himself, but the interior of such a temple
was always conceived as arcane and inaccessible and the structure it-
self as monolithic.

 The Greek temple had the same kind of origin: the Doric temple
is a stone shelter for an image of a god, with just space enough for that
[7] image and for an altar. The Parthenon itself was no more, though the
image had grown gigantic and there was more space for the altar and
the ceremonial sacrifices. Architecturally the controlling impulse was

still toward the monolithic block, and we may suppose that this impulse is responsible for that harmonization of parts to the whole, that integration of multiplicity to unity, which is the fundamental characteristic of classical Greek architecture. [8]

Like the Indian temple, the Greek temple is essentially a plastic [9] conception, constructed *as if* carved out of rock. Paestum and Segesta— what are these monuments but sublime pieces of abstract sculpture? But naturalistic sculpture was also present, tucked away in the metopes and gables. What function has such sculpture in the otherwise monolithic structure of the Doric temple?

In genetic terms, it can be regarded as a vestige of the mural decoration of earlier tombs. At some point in the history of architecture the concept of the tomb and the concept of the temple were merged, and the temple took over some of the features of the tomb. The pillar was combined with the cave; if the pillars already carried a graven image (as we know from the Bible they did), then once the pillars had assumed the burden of the temple roof, it would be natural to transfer the graven image to the gable or metope. These sculptures may origi- [42, 43] nally have had a very precise function, of a protective or perhaps of a minatory character; later, they became merely ornamental.[5]

For our present discussion it is not important to elaborate on this evolutionary process, which begins with the consummated union of sculpture and architecture. We seek to know under what conditions that marriage can be a happy one; what compromises have to be made by each party to the union; and under what circumstances a separation is to be recommended.

If we conceive the original integral monument as being gradually

5. Cf. G. Rachel Levy, *The Gate of Horn* (Chicago and London, 1948), Ch. III. Max Raphael, *Der Dorische Tempel* (Augsburg, 1930), suggests (pp. 56–57) that the frequent representation of conflicts in the sculptured metopes of Doric temples is a symbolic reflection of the imprisonment, by the weight of the buildings, of the chthonic forces in the earth below.

blown up or stretched out to make room inside for the image of the god and for ritual ceremonies, we can see that a spatial problem would arise on the *outside* of the monument. Either this extra space must be covered with more and more figures, more or less unified in conception—as in Indian architecture—or the sculpture must shrink into niches and panels, leaving the walls as blank, undecorated surfaces. A bifurcation in the history of architecture then takes place, one direction determined by the predominance of the constructive intellect and leading to the classical tradition, the other direction determined by the predominance of plastic sensibility and leading to the oriental and Gothic traditions. We refer, in each case, to a predominant effect: there is no architecture without some degree of calculation, and no architecture is an art unless it engages our sensibility, as plastic expression. Still, the stress is always there—the conflict, in simplest terms, between form and decoration, between function and aesthetic effect. It is always possible, however, to suggest that fundamentally two types of sensibility are involved—a sensibility on the one hand that prefers geometric and inorganic forms, and a sensibility on the other hand that prefers naturalistic and organic forms. We have here Worringer's well-known distinction between abstraction and empathy.[6]

Even so we must be careful to make a distinction, which Worringer himself is careful to make, between a vital and a dead type of abstraction. One cannot too often affirm that forms purely intellectual in their conception or origin are capable of affecting the aesthetic sensibilities. We must always be prepared to acknowledge the truth of Hölderlin's great affirmation, that he who has most deeply thought has also most vitally felt.[7] Thought in its intuitive aspects is an animating principle; and "the tectonic of the Greeks," as Worringer has pointed out, "con-

6. Cf. *Abstraktion und Einfühlung*, tr. Michael Bullock as *Abstraction and Empathy* (London and New York, 1953), p. 114.
7. "*Wer das tiefste gedacht, liebt das Lebendigste*," in "Sokrates und Alkibiades."

Cf. Michael Hamburger, tr., *Hölderlin: His Poems Translated* (London and New York, 1952), pp. 101–2: "Who most deeply has thought, loves what is most alive."

sists in the animation of stone, i.e. an organic life is substituted for stone. That which is conditioned by the construction is subordinated to a higher organic idea, which takes possession of the whole from within outward and imparts to the laws of matter an organic illumination." This movement, Worringer goes on to say, "was already foreshadowed in the construction of the Doric temple, whose inner constitution is otherwise still purely abstract. In the Ionic temple and the architectural development ensuing upon it, the purely constructional skeleton, which is based solely upon the laws of matter, that is to say, upon the relationship between load and carrying power, etc., was guided over into the more friendly and agreeable life of the organic, and purely mechanical functions became organic in their effect. The criterion of the organic is always the harmonious, the balanced, the inwardly calm, into whose movement and rhythm we can without difficulty flow with the vital sensation of our own organisms." In absolute antithesis to the Greek idea of architecture we have the Egyptian pyramid, which "calls a halt to our empathy impulse and presents itself to us as a purely crystalline, abstract construct."

Sculpture, therefore, is not strictly necessary to the humanization or animation of architecture; vital sensations need not necessarily be embodied in illustrative figures, in models drawn from nature—a principle we have had to reaffirm in our own times in defense of abstract painting and sculpture as well as modern architecture. In spite of the possible vitality of geometrical constructions, however, there exist powerful psychological tendencies the final effect of which is to destroy the crystalline integrity of geometrical constructions. The most powerful impulse in the disintegration of the classical ideal of construction was, as Riegl was the first to demonstrate, the subjective need for expressive space: for space itself as a significant symbol.[8] The outer structure of

8. In *Stilfragen* (Vienna, 1893) and also in *Spätrömische Kunstindustrie* (Vienna, 1901). I have dealt at greater length with space symbolism in *Icon and Idea: The Function of Art in the Development of Human Consciousness* (Charles Eliot Norton Lectures, 1953–54; Cambridge, Mass., 1955), Ch. III.

buildings had to conform to this inner need—had to support and reflect those essentially interior concepts of the dome and the vault that had first given rise to a consciousness of space as such. This distention of the interior destroyed the simple rectangular structure of column and architrave, elements that had lent themselves to great refinements of harmony and proportion in Greek architecture: the Doric and Ionic melodies, as subtle and as abstract as music. This orchestration, in which sculpture might play a part—might come in with the right effect at the right moment, like the human voice in Beethoven's *Ninth Symphony*—included every external aspect of the temple. But once the creative spirit had moved inside the building, all this music, this orchestration, moved in too. The very columns, the purpose of which had been to give aesthetic vitality to the exterior walls, moved in and became the pillars

[10] of the nave in the Christian basilica. The exterior of the basilica might be, and often was, a shell, an unadorned stone box, as angular as the pyramids, but at first far less impressive, because it was not consciously conceived as a sculptural mass.

Sculpture was then reunited to architecture as an alleviation of this external severity. There is an excellent description of this transitional process—as of much else that is relevant to our theme—in Ruskin's *Stones of Venice*. He is discussing some of the details of the Ducal Palace and observes that, as the building was very nearly square on the ground plan, "a peculiar prominence and importance were given to its angles, which rendered it necessary that they should be enriched and softened by sculpture. I do not suppose that the fitness of this arrangement will be questioned; but if the reader will take the pains to glance

[12a] over any series of engravings of church towers or other foursquare buildings in which great refinement of form has been attained, he will at once observe how their effect depends on some modification of the sharpness of the angle, either by groups of buttresses, or by turrets and

niches rich in sculpture. It is to be noted also that this principle of breaking the angle is peculiarly Gothic, arising partly out of the necessity of strengthening the flanks of enormous buildings, where composed of imperfect materials, by buttresses or pinnacles; partly out of the conditions of Gothic warfare, which generally required a tower at the angle; partly out of the natural dislike of the meagreness of effect in buildings which admitted large surfaces of wall, if the angle were entirely unrelieved. The Ducal Palace, in its acknowledgment of this principle, makes a more definite concession to the Gothic spirit than any of the previous architecture of Venice. No angle, up to the time of its erection, had been otherwise decorated than by a narrow fluted pilaster of red marble, and the sculpture was reserved always, as in Greek and Roman work, for the plane surfaces of the building." [9]

[12b]

Ruskin asserts *as a principle* that, if architecture requires large surfaces of undecorated walls, then the angles of the building must be "softened" by sculpture. The aesthetic purpose of this softening process is, according to Ruskin, to avoid a "meagerness of effect" produced by severely rectangular wall surfaces, and the Ducal Palace is given as an example of a building that "throws the main decoration upon its angles."

Our contemporary sensibility is so different in this respect that we may question the argument, corresponding as it does to what we now regard as a quaint preference for the deckle edge in books and writing paper. In a Gothic building of a more elaborate nature—the typical cathedral with its fretted towers and pinnacles—not only are the angles or edges of the rectangular surfaces softened by sculpture, but every suggestion of the foursquare block disappears until the spectator is left with the plastic monument once more, with architecture conceived as integral sculpture.

9. John Ruskin, *The Stones of Venice,* II (*The Sea-Stories*), viii, 31. See *Works,* ed. E. T. Cook and Alexander Wedder- burn (London and New York, 1904), X, 356–57; all refs. to Ruskin are from this edn.

Nevertheless the more the building itself, as a unity, becomes sculptural, the less the detail of it is sculpture. Ruskin, in another part of *The Stones of Venice,* recognized this paradox. "If, to produce a good or beautiful ornament, it were only necessary to produce a perfect piece of sculpture, and if a well-cut group of flowers or animals were indeed an ornament wherever it might be placed, the work of the architect would be comparatively easy. Sculpture and architecture would become separate arts: and the architect would order so many pieces of such subject and size as he needed, without troubling himself with any questions but those of disposition and proportion. But this is not so. *No perfect piece either of painting or sculpture is an architectural ornament at all,* except in that vague sense in which any beautiful thing is said to ornament the place it is in. . . . And so far from the perfection of the work conducing to its ornamental purpose, we may say, with entire security, that its perfection, in some degree, unfits it for its purpose, and that no absolutely complete sculpture can be decoratively right." [10] Ruskin spends the rest of a very interesting chapter in showing how sculpture is fitted for its architectural purpose by what would be faults and deficiencies if it had no special duty.

We might regard the matter as settled by these magisterial sentences but for a suspicion that some at least of the imperfections which Ruskin admitted into sculpture as admirable for the purpose of architectural ornament have by now become qualities we admire in sculpture itself. One of the puzzles of architectural sculpture has always been to know from what distance the sculpture should be viewed. It is foolish, as Ruskin says, "to carve what is to be seen forty feet off with the delicacy which the eye demands within two yards; not merely because such delicacy is lost in the distance, but because it is a great deal worse than lost—the delicate work has actually worse effect in the dis-

10. *The Stones of Venice,* I (*The Foundations*), xxi, 3 (*Works,* IX, 284).

14

tance than rough work." [11] We know, from surviving documents no less than from an examination of the work itself, how carefully medieval and Renaissance sculpture adapted their style to an ideal distance and a line of vision from that distance. Apart from rough cutting, which gives a stony texture to the distant eye, there are two principles at work, which Ruskin called Simplification and Emphasis. Simplification involves "the rejection of all the delicate passages as worse than useless, and the fixing the thought upon the arrangement of the features which will remain visible far away . . . by choice of different subjects for different places, choosing the broadest forms for the farthest distance, it is possible to give the impression, not only of perfection, but of an exquisite delicacy, to the most distant ornament." Similarly, Emphasis —or energy, as Ruskin also calls it, "the unnatural insisting upon explanatory lines"—will make the subject intelligible at a distance from which accuracy would give the effect of confusion.[12]

These principles are theoretically very convincing, and the sculptors' practical adaptations, which Ruskin regarded as faults and deficiencies imposed on the art of sculpture, did accommodate sculpture to the architectural complex; they unified the details with the mass. It is, therefore, disconcerting to find that many of these architectural sculptures, detached from their setting and placed in some museum at eye level, immediately strike us as among the noblest works ever conceived in this medium. One may cite as examples the magnificent figures by Giovanni Pisano, now in the Museo San Matteo in Pisa, which formerly were part of the external decoration of the Baptistery; or in York, the still more impressive figures of the prophets and evangelists [24, 25] from St. Mary's Abbey, now in the Yorkshire Museum. There are thousands of such pieces of sculpture, which owe their immediate aesthetic appeal to those qualities of simplicity and significant emphasis that

11. Ibid., I, xxi, 21 (*Works*, IX, 297–98). 12. Ibid., I, xxi, 15 (IX, 292).

were dictated by architectural considerations. Any typical piece of contemporary sculpture, not conceived for a distant location or even for a contemporary architectural setting, will proudly display these same qualities of simplicity and significant emphasis; Henry Moore's

[200, 201] *Madonna and Child* at Northampton, England, is an example.[13]

A real dilemma is thus presented to us, which we can resolve in two ways. We can say that a specific aesthetic quality arises from the external necessities imposed by an architectural setting on the sculptor: a discipline of limitations that communicates an aesthetic thrill, the thrill of formal difficulties triumphantly overcome. Or we can say that the qualities of simplicity and emphasis appropriate to architectural sculpture are in themselves of positive aesthetic value, irrespective of their architectural function, and that sculpture is all the better, other things being equal, for having these qualities imposed on it. Ruskin might have admitted the former argument. At any rate, he admitted that physical limitation is one of the first necessities of good ornament. This does not consist, he says, "in the mere shutting of the ornament into a certain space, but in the acknowledgment *by* the ornament of the fitness of the limitation;—of its own perfect willingness to submit to it; nay, of a predisposition in itself to fall into the ordained form, without any direct expression of the command to do so; an anticipation of the authority, and an instant and willing submission to it, in every fibre and spray; not merely *willing*, but *happy* submission, as being pleased rather than vexed to have so beautiful a law suggested to it and one which to follow is so justly in accordance with its own nature." Ruskin proceeds with an illustration that I must quote, because it so perfectly explains the significance of form in art: "You must not cut out a branch of hawthorn as it grows, and rule a triangle round it, and suppose that

13. Illustrated in Herbert Read, *Henry Moore: Sculptures and Drawings* (2nd edn., New York, 1946), pls. 107–112. Cf. the 3rd British edn. (London, 1949), pls. 56j, 56k.

it is then submitted to law. Not a bit of it. It is only put in a cage, and will look as if it must get out, for its life, or wither in the confinement. But the spirit of triangle must be put into the hawthorn. It must suck in isoscelesism with its sap. Thorn and blossom, leaf and spray, must grow with an awful sense of triangular necessity upon them, for the guidance [13] of which they are to be thankful, and to grow all the stronger and more gloriously." [14]

Such a quality of formal "necessity," although it would seem to arise from the subordination of sculptural detail to architectural unity, may nevertheless have a value independent of its architectural setting. If we transfer this quality, along with the virtues of simplicity and emphasis that have been dictated by another external consideration or limitation, that of distance, to sculpture conceived in the round—like an amulet, but an amulet enlarged to some convenient yet still portable size—we have a work of art with many distinct aesthetic virtues. What then is left that Ruskin or any other philosopher of art might consider necessary for the perfect piece of sculpture?

Obviously, if Ruskin is to be held to a logical argument, he must be answered by one based on some antithesis to simplicity and emphasis—one based on elaboration, therefore, and delicacy. When in his *Lectures on Art* Ruskin directly enunciates the "main principles of good sculpture," he gives two: "first, that its masters think before all other matters of the right placing of masses; secondly, that they give life by flexure of surface, not by quantity of detail." Neither of these principles conflicts with the virtues of simplicity and emphasis, but in explaining the second one, Ruskin becomes more specific and explains that "From the Elgin Marbles down to the lightest tendril that curls round a capital in the thirteenth century, every piece of stone that has been touched by the hand of a master becomes soft with under-life, not resembling

14. *The Stones of Venice,* I, xxi, 32 (*Works,* IX, 305–6).

17

nature merely in skin-texture, nor in fibres of leaf, or veins of flesh; but in the broad, tender, unspeakably subtle undulation of its organic form." [15]

I am not trying to find an inner contradiction in Ruskin's argument. Even here, however, when he is giving us the specific qualities that distinguish sculpture from the other arts, he takes his examples from architectural sculpture—examples illustrating the ineffable subtlety of its flexure. Elaboration of detail he dismisses as unworthy of the art. As for smoothness of finish, which remains as one possible quality inappropriate to architectural sculpture but perhaps desirable in independent sculpture, a footnote on Canova is decisive: "The admiration of Canova I hold to be one of the most deadly symptoms in the civilization of the upper classes in the present century." [16]

We seem driven to the conclusion, therefore, that there is no separate species of sculpture which is specifically architectural. When Ruskin says that "no perfect piece . . . of . . . sculpture is an architectural ornament at all," he is making use of two ambiguous words. When he qualifies sculpture as "perfect," he does not mean aesthetically perfect, but rather "conceived in complete isolation"; and when he uses the word "ornament," he is not seeing the sculpture as such but as a part of an architectural unity undifferentiated and unfocused. Often enough, sculpture is scamped in its architectural uses, conceived as mere space filling or surface fretting, botched by masons without any force or feeling. Then it is one weakness in the building and probably not the only one. Limitation and subordination promote aesthetic compensations, however, and there are details of form and composition that we may study with great profit, as Ruskin studied them, in the carved capitals of Romanesque and Gothic architecture.

The Romanesque basilica is of particular interest because it may be said to represent the perfect marriage of architecture and sculpture.

15. *Lectures on Art*, vi, 166 (*Works*, XX, 160–61).

16. *The Stones of Venice*, I, xx, 11 (*Works*, IX, 260).

Here architecture is no longer a sculptural complex, as in Chinese or Indian or Gothic architecture; sculpture is no longer a subordinate ornament, as in Greek or modern architecture. How this perfect accord came about, to last only about a century and a half, is hard to explain: it was a happy miracle. The Church had taken over the classical temple with its perfunctory ornament, and in their structure and external appearance, its new buildings were sometimes little more than barns. Eastward from Rome, at Ravenna and in Syria and Greece, developed the specifically Byzantine style, in which sculpture remained strictly subordinate to architecture and merely ornamental in function. Northward from Rome, in Lombardy, France, Spain, and England, developed the style that we call Romanesque. In this style, when it had fully developed, sculpture was no longer a subordinate ornament but a separate art admitted into equal association with the architecture. This development was no doubt due to the imperious need felt by a missionary church for pictorial or figurative illustration of its doctrines. The sculpture of the period thus has its parallels in illuminated manuscripts and metalwork and in the glass painting that was an original creation of this time. For the decorative the Romanesque church-builders substituted the didactic, and the results include some of the supreme masterpieces of the art of sculpture.

Two architectural features lent themselves to this didactic purpose: over the doorway to the church, the lintel to which all newcomers lifted their eyes as they entered the building; and, inserted at points where the superimposed weight of the roof met the upthrust of walls and columns, the capitals of the columns, which also marked the points where visual perception automatically came to rest. When the doorway became arched, the lintel panel was included within the semicircle of the arch and became the carved tympanum, of which fine examples remain at Malmesbury and Ely. The elaboration of the porch, by the [15a, 18] carving of the keystone and jambs, followed as a natural development

19

and led eventually to the elaborate sculptural porches of the early Gothic period. By then the architecture was beginning to absorb the sculpture into its integrated sculptural mass, and the sculpture gradually lost its separate entity.

[14, 15b] The Romanesque capital still retains its architectonic function, as transitional member between the column and the architrave; but essentially it has become a field for relief sculpture—four contiguous panels that can be rounded into one continuous truncated inverted cone. Some very pretty problems of composition ensue in the carving of both capital and tympanum. The problem set by the tympanum is relatively simple, because a single isolated plane is involved: it is a problem of

[16, 19] adapting the elements of the composition to a semicircular space. One subject was peculiarly fitted for such a shape—Christ in glory—and one finds this subject in the cathedrals of Rochester, Barfreston, and Ely in England and in many Romanesque churches in France—at Vézelay,

[17] Moissac, and, of course, Chartres. The Romanesque sculpture exercised considerable ingenuity in fitting other and most inconvenient subjects to this pre-ordained space—for example, the six Apostles enthroned at

[18] Malmesbury are, with difficulty and by the help of the angel above them, made to fit into the semicircular space of the tympanum. To take another example, the subject of the Last Supper, which is easily fitted into a rectangular lintel, may be ingeniously distorted to fit into the semicircular space of the tympanum, as above the west entrance to the church at Charlieu in the Loire.

We need not refer to the compositional niceties imposed on the sculptor of the capital. In general, his problems are those of the sculptor of a relief, although his field is fan-shaped rather than rectangular. Also its plane is often convex, as in the Doric capital, or concave, as in the Corinthian capital, but it may be flat. Ruskin has discussed the principles of decoration in relation to the form of the capital with a detail

that leaves nothing to be said.[17] One point that he does not make is important from the sculptor's point of view: the surface of the capital is so inclined, as a consequence of its transitional function, that the plane it presents to the spectator is roughly at right angles to the line of vision. It follows that those distortions that have to be introduced into sculpture that is placed at a height and is parallel to the perpendicular wall of the building in order to adapt it to an acute angle of vision are no longer necessary. Generally the spectator looks at and into the carved capital at a correct angle of vision, though naturally there is still a fixed point at which the angle of vision is geometrically exact.

The relief on these Romanesque capitals is usually deep; sometimes the figures are almost detached from their ground. Dictated no doubt by the dimness of the interior of the Romanesque church, this feature is an example of the adaptation of sculpture to the impact of light that will be a subject for separate consideration in Chapter VI.

[14]

For a relatively brief period—perhaps for no more than the twelfth century—sculpture asserted itself as an independent art in close association with architecture. In all these twelfth-century Romanesque basilicas, the unadorned wall-surfaces also have their independent aesthetic function. The uniqueness of the Romanesque church lies in the perfect balance established and maintained between a figurative sculpture and a geometrical harmony of plain surfaces: an interplay of illustration and abstraction. Now that in our own time we once more delight in an architecture of plain surfaces and abstract harmonies, we may speculate whether we should not turn to this Romanesque prototype to help us to solve the problem of the relation of modern sculpture to modern architecture.

We no longer have tympanums above our functional doorways,

17. *The Stones of Venice,* I, xxvii (*Works,* IX, 359–87).

and our columns, if they exist at all, are usually of steel and usually embedded in the walls or partitions. The typical modern building offers to the sculptor nothing but plain surfaces, and the building that usually serves as the ideal prototype of modern architecture offers nothing but a harmony of plain surfaces that the sculptor may imperil with his incrustations. This factor makes the modern problem more difficult than the Romanesque problem, but it so happens that the leading sculptor in England, Henry Moore, was recently asked to solve it. It was proposed

[11] for him to add sculptural decorations to the severely functional building that housed the *Time-Life* offices in Bond Street, London. He worked in close association with the architect, and it was agreed that the main structure, an uncompromisingly geometrical expression of its administrative functions, offered no foothold for sculpture of any kind. On its Bond Street elevation, however, the façade of the building has two levels, and behind the lower level is a terrace with access to a mezzanine floor in the higher part of the building. A screen or free-standing wall designed to enclose the terrace offered the necessary scope for the sculptor. A blank wall, in this particular situation, and in relation to the building as a whole, would have been empty of interest.

Could this wall be so treated by the sculptor that it asserted itself as sculpture and yet remained in harmony with the architecture? When submitting his maquettes to the architect, the sculptor sent an accompanying letter in which he stated his case: "I have tried to use the fact that it is only a screen with space behind it, therefore a sculpture that can be pierced and so be of interest from both sides and also give an interesting penetration of light. I had your perspective sketch by the side of me as I did each of them, and my aim was to give a rhythm to the spacing and sizes of the sculptural motives which should be in harmoney with your architecture, so that the sculpture could really have some proper relationship to the building, for it seems to me that a portrayal of some pictorial scene in that position would have no con-

nection with your building and would only seem like hanging up a stone picture there, like using the position as a hoarding for sticking up a stone poster. . . ."

This letter illustrates the peculiar difficulties that face the modern sculptor when he is asked to co-operate with a modern architect. To hang a stone picture on the building was exactly what the Romanesque sculptor did, and the pictorial scene he wrought was relevant to the function of the building. His problem was to hang a picture in the right place without detracting from the monumental effect of the flat surfaces of the structure. He achieved this effect by carving *into* the walls rather than by hanging a carving *onto* the walls, and this is what Henry Moore has done. His carvings do not interfere with the architect's systematic use of flat surfaces. By actually piercing the screen so that light shows through it, he even has avoided the effect of a second plane. The sculpture is suspended in the prime, architectural plane and thus is completely integrated.

That Moore, whose recent work has been predominantly figurative, should have had recourse to abstraction for these particular motives is again evidence of his perfect understanding of the problem involved. There is no possible accord between a functional architecture and a naturalistic ornament—one may just as well imagine that the pyramids will be improved by the addition of a few gargoyles. The modern architect loves the foursquaredness of his foursquare buildings, and will by no means tolerate his angles' being "softened by sculpture," even by abstract sculpture. Modern functional architecture and modern sculpture, we must conclude, can be married only by geometrical law, and even then the union must not contravene the integral monumentality of the building.

The question remains: do the adaptations and sacrifices made by the sculptor for the sake of architectural unity destroy the sculptural integrity of his work? Must we end by reaffirming the truth of Ruskin's

assertion that "no perfect piece either of painting or sculpture is an architectural ornament at all," because "the especial condition of true ornament is, that it be beautiful in its place, and nowhere else"? The implication is that perfection of form in one art is incompatible with perfection of form in another art. Logically this conclusion would seem to be true, for the premises of every art are distinct, determined by separate materials, separate processes, separate senses. At best, therefore, we have a synthesis of two arts that, while it destroys the integrity of each, creates a new unity greater than either. The Greek temple, the Romansque basilica, the Gothic cathedral, the modern functional building: these are rather to be considered as complex monuments, opera that combine the elements of two or more distinct arts into a synoptic structure for which we must seek separate laws of conception and comprehension. In their perfected development these arts meet in a common element, one to enclose space, the other to occupy it. Such an opposition can be fully resolved only in a unity that abolishes the distinction.

That unity we call the monument, an ambiguous word that may sometimes mean architecture, at other times sculpture. Its very ambiguity indicates that a distinction has been abolished, that in the dialectics of art thesis and antithesis have been reconciled in a new synthesis. We found such a synthesis in the origin of these arts, and I believe that we are working toward another synthesis at the present time. No synthesis is stable, however, unless it is based on a clear understanding of the terms involved. It will be my endeavor, in the succeeding chapters of this volume, to establish the limitations and essential qualities of one of these terms, the art of sculpture. I am going next to suggest that these limitations and qualities are determined by the manageable dimensions and direct tactility of the amulet. Only as it engages a distinct and special range of sensibility does the art of sculpture reveal its full splendor.

CHAPTER TWO

The Image of Man

If we look through an illustrated book devoted to the history of sculpture, or if we walk through the galleries of sculpture in some great museum, we are immediately struck by the surprising fact that at least nine-tenths of all the sculpture ever carved is devoted to one subject— the human body. I call this fact surprising, but what is perhaps more surprising is that the average visitor is not surprised. He has established a conventional association between sculpture and the human body, and he reserves his surprise, if he experiences any in an art gallery, for sculpture that *ignores* the human body. It is true that we also accept the sculpture of animals as a conventional category of secondary inter- [44–55] est; but though they have been occasionally attempted, we do not expect to see sculptural representations of landscape and still life, which are normal subjects for the art of painting. Only in comparatively recent times has sculpture been conceived as an art capable of creating three-dimensional forms irrespective of subject.

To make a first approach to the aesthetics of sculpture with a consideration of the *subject matter* of the art is perhaps an arbitrary proceeding. I think we shall find, however, that the development of the sculptural representation of the human body, considered purely as the

25

representation of that particular subject, plunges us directly into aesthetic problems peculiar to the art of sculpture. Initially we may speculate on the probable reasons for the sculptor's almost exclusive concern for the representation of his own species.

As is well known, art began, in prehistoric times, with a different prejudice—with an almost exclusive concern for the depiction of animals—and it is generally assumed that this prejudice was connected with prehistoric man's dependence on animals as his food. The drawings in the caves almost certainly had a function in magical rites designed to assure successful hunting or, in certain cases, connected with fertility. The rare examples of human representation in Paleolithic art are of males participating in hunting scenes or of females who, because they are represented as pregnant, may reasonably be associated with fertility rites.[1] The male representations are, with one or two exceptions, all drawings; the female representations all sculptures. The fact that some of the surviving sculptures are detached, transportable amulets, of small size and often of perishable materials such as wood, ivory, bone, steatite, and chalk, may partly account for the apparent predominance of animal representations in prehistoric art. The human sculptures may largely have disappeared; at any rate, the animals drawings remain in undisputed possession of the prehistoric caves.

It used to be assumed that sculpture was the original art of prehistoric man and that drawing and painting were much later acquisitions.[2] This view was based on the erroneous idea that sculpture involved a much simpler process of reproduction than drawing—the idea

1. An engraved slab from Laussel represents a man apparently throwing a javelin; in H. Breuil, *Four Hundred Centuries of Cave Art*, tr. Mary E. Boyle (Montignac, France, 1952), fig. 318. Females are sometimes depicted in the Paleolithic rock paintings in Spain—e.g., the so-called *Dancing Women* at Cogul; see Hans-Georg Bandi, "The Art of the Spanish Levant," in Johannes Maringer and Hans-Georg Bandi, *Art in the Ice Age* (New York, 1953), fig. 145.

2. The view goes back to a French archaeologist called Piette, and was effectively demolished by G. H. Luquet, *L'Art et la religion des hommes fossiles* (Paris, 1926), pp. 15 ff.

that modeling or carving in the round was a process of direct imitation, whereas drawing or painting required the translation of three-dimensional experience into two-dimensional abstraction. Nothing could be farther from the psychological facts. Volume, the notion of a three-dimensional mass, is not given by direct visual perception. We see objects from several points of view and retain one particular and significant aspect as a memory image. "The aspect which is selected by the memory is that which shows the form with the property that differentiates it from other forms, makes it thereby most easily distinguishable, and presents it in the greatest possible clearness and completeness of its constituent parts: this aspect will certainly be found in almost every case to be coincident with the form's greatest expansion." [3] It therefore requires an imaginative or at least a mental effort to pass beyond the memory image and construct a three-dimensional image. We are aided in this task by other sensations or by the memory of such sensations— sensations of touch and weight—but this fact only serves to emphasize the complicated mental procedure involved in the conception and representation of the solidity of a solid object.

I shall deal with the psychological problems involved in the perception of space and volume in the next chapter. Here I merely want to emphasize the fact that the notion of the size and shape of things and of their position in space had to be learned and that this process of learning, which we can observe in the early years of civilized children, has also a phylogenetic history—that is to say, the human race was not divinely gifted with the ability to perceive the three-dimensional character of objects: only gradually did it acquire that ability.

It is possible that this ability arose through a self-awareness of the tridimensionality of the human body and that the first sculptures were representations of the body image present in the individual mind. The

3. Emanuel Loewy, *The Rendering of Nature in Early Greek Art,*
tr. John Fothergill (London, 1907), p. 12.

earliest of these figures—they are usually between four and eight inches long—are attributed by archaeologists to the Aurignacian period, the earliest period in which works of art have been found. Presumably they were used as portable fertility charms—amulets as we have called them in the first chapter—and the earliest types are realistic. The small lime-

[27] stone statuette found at Willendorf, in Austria, shows a female figure that, by our standard of beauty, may seem grotesque. Still, as human figures of similar proportions occur among the pygmies and other African tribes today, we may assume that this representation of the human body was as realistic as the contemporary drawings and sculptures that represent animals. A larger example, seventeen inches high, is a re-

[26] lief cut into the surface of the rock; it was found on the wall at Laussel, in the Dordogne, and shows a woman holding a bison's horn in her right hand.

Quite different in style, though not in intention, is the ivory statuette of a woman from Lespugue, in the Haute-Garonne. Though usually ascribed to the Aurignacian period, this highly stylized figure antici- pates the schematic character of the later Magdalenian figures. There are numerous small amulets of the same stylistic character, found at prehistoric sites as far apart as southern France and the Ukraine. Usually they too are carved of ivory. Such conventional or schematic forms must belong to a different phase of cultural development from that of the Willendorf *Venus,* and most of these figures do indeed come from Mag- dalenian sites. They foreshadow the geometrical art of the Neolithic period, during which the realistic image of the human body was at first gradually, and finally completely, suppressed.

Let us return, however, to the earlier evidence of what was un- doubtedly a fundamental problem in the development of human con- sciousness: man's need and his ability to represent the human figure in sculptured form, and the persistence of this need in various guises through many centuries of human history.

Fertility rites and other magical uses apart, man originally needed sculpture as a means of establishing a sense of real existence. Some trace of this primitive impulse can be found in Greek mythology. In the story of Narcissus a youth falls in love with his own image as reflected in a clear spring, and being unable to endow that image with corporeality, pines away and dies. The story of Pygmalion has a happier ending, for having made a marble statue of a girl, Pygmalion fell in love with it and asked Aphrodite to give it life. His wish was granted, and Pygmalion married this beautiful creature and named her Galatea. In some versions of the legend Galatea is identified with Aphrodite herself, goddess of love and procreation. It is perhaps significant that both these legends have retained a powerful hold on the human imagination, even into our own time. They illustrate the deep-seated longing that man has to project an icon, a material counterpart of his mental image of himself.

It is important to remember that the image we possess of ourselves is not necessarily definite; it is certainly not present at birth but is something that we have to construct as part of our growing consciousness of the external world.[4] Only by conceiving an *image* of the body can we situate the *idea* of ourselves in the external world. That image is not built up solely by sight. Sight gives us the image of other people but only a partial image of ourselves, for even in multiple mirrors we can look in only one direction at a time. To arrive at a satisfactory image of ourselves, we also must touch our bodies and must take account of all our internal bodily sensations, particularly those of muscular tensions, of movement and lassitude, and of gravity and weight. We assemble and compare all these different impressions and sensations, and from that total evidence we construct the body image.

4. Cf. Herbert Read, *Art and the Evolution of Man* (Conway Memorial Lecture 1951; London, 1951); and *Icon and Idea: The Function of Art in the Development of Human Consciousness* (Charles Eliot Norton Lectures 1953–54; Cambridge, Mass., 1955).

That image is not necessarily a visual image. Apart from psychological factors that distort the image and that we shall consider presently, there are physiological or somatic factors that considerably influence our image of our own body. Some interesting evidence in this direction is provided by the sculpture of blind children, which has been studied by Münz and Löwenfeld.[5] It may be thought that congenitally blind children are incapable of any coherent representation of the human figure, but this is far from the truth. They can mold the human figure with a high degree of realism but with certain exaggerations or emphases that are of the greatest significance for our inquiry. The general form of the sculpture is built up from a multitude of tactile impressions; the features that seem to our normal vision to be exaggerated or distorted proceed from inner bodily sensations, an awareness of muscular tensions and reflexive movements. This kind of sensibility has been called *haptic,* a relatively new but necessary word derived from the Greek *haptikos* meaning "able to lay hold of." In the clay

[36b] model of a *Youth Imploring,* by a congenitally blind boy of seventeen, we see how the whole plastic emphasis is on an upward-stretching tension of the body, the arms and hands being grossly exaggerated while the legs and feet have no significance at all.[6] The sculpture of primitive races evinces exactly the same kind of exaggeration. A wood carving

[36a] from the Belgian Congo shows a human figure in the same attitude and with the same exaggerated emphasis of the uplifted arms.[7] It is not likely that the Negro sculptor was blind: he was giving expression to his haptic sensations.

One of the most distinct haptic sensations is that produced inside the neck by the act of swallowing, and we find that an elongation of

5. L. Münz and V. Löwenfeld, *Plastische Arbeiten Blinder* (Brünn, 1934); and Viktor Löwenfeld, *The Nature of Creative Activity,* tr. O. A. Oeser (London and New York, 1939).

6. From Löwenfeld, pl. 35.

7. *African Negro Art,* ed. J. J. Sweeney (Museum of Modern Art, New York, 1935), no. 446. *African Folktales and Sculpture,* ed. J. J. Sweeney and Paul Radin (Bollingen Series XXXII; New York, 1952), pl. 98.

the neck is characteristic not only of the art of children in general and of blind children in particular but also of most archaic sculpture. The Cycladic figures, carved in marble, with which Greek sculpture begins [30, 31] its history, all exhibit this tendency, and the same feature is carried over into the bronzes of the Geometric Epoch and persists to the end of the sixth century B.C.

Another haptic sensation, very obvious to blind children but also persisting in primitive and archaic art, is that produced by the wrinkling of the face. Congenitally blind children will emphasize these wrinkles, [37b, 37a] and the same emphasis may be found in a Greek mask of terra cotta or a mask of carved wood from the Ivory Coast. Many other types of sculpture, especially from medieval art and from Oriental art, can be shown to have characteristics caused by inner, haptic sensation.

Man begins, therefore, with two conflicting types of the body image. One is due to the immediate experience of his own body, both what he can see of it and what he can feel of it. The other is due to his observations of the bodies of his fellow men and is based primarily on vision but also, perhaps, to some extent on tactile sensations—we are all doubting Thomases who seek to confirm by touch what is given by sight. I repeat, these two kinds of image are antithetical. We do not normally fix, as part of our visual impression of another person's body, the expressive wrinkles that he produces under the stress of emotion, and we certainly do not visualize such sensations as swallowing and stretching. We tend to see the other person's body in repose, but the human eye is not a passive lens, at least it does not reflect onto a perfect mirror. Vision is *colored*, as we say. It is distorted by memories, associations, and above all by desires, and to a considerable extent we see what we want to see. Especially is this so when we look at the human body, for we look at other bodies with the desire to find ourselves, to find out what we look like. The desire expressed by Burns—

O wad some Power the giftie gie us
To see oursels as ithers see us!

—is relatively sophisticated. The first desire is to see ourselves as we see others—to relate our own body image, the notion we have of our own shape and appearance, to the visual impression we have of other people. But of course we do not wish to think of ourselves as misshapen or ugly, so we tend to be selective in our vision. We idealize the human body; that is to say, we identify the body image with the prevailing ideal of bodily perfection. "A body image," as Dr. Paul Schilder writes in *The Image and Appearance of the Human Body*, "is in some ways always the sum of the body images of the community according to the various relations in the community. Relations to the body images of others are determined by the factor of nearness and farness and by the factor of emotional nearness and farness." [8] The sexual instincts are thus involved. Not only do we tend to idealize the object we love and desire, but also we can transfer to an ideal representation of the human body those desires that we cannot satisfy in reality. Here is the first stage in the Pygmalion myth. Also, beauty is a social phenomenon, and, as Schilder puts it, "The beautiful object provokes sexual tendencies without satisfying them, but at the same time allows everybody to enjoy it. Beauty thus becomes suspended action, and it is understandable that the classicist ideal does not desire the expression of strong emotion and violent movement." [9]

Whether or not it has a sexual basis, this process of idealization is fundamental to the development of the art of sculpture. Without stressing the underlying erotic motive, we may conclude that in a very obvious sense there has been a tendency in art to idealize the human body in order to make it more attractive as an object of desire.

[63]

8. (New York, 1950), p. 302.
9. Ibid., p. 303. I would like to refer once more to Adrian Stokes's book on Michelangelo (see p. 4, n. 2). It treats this whole theme, particularly in reference to Michelangelo, with the advantage of a deep knowledge of Freudian psychoanalysis.

The process of idealization leads, however, in two opposed directions. In one, tending to the kind of idealization that we term *classicism*, the desire is sublimated, the action suspended. In another direction, tending to what we term *realism*, the desire is if not incited at least held in tension. There is a further tendency, not so openly recognized, that is opposed to idealization. It is really a form of *sadism* or *nihilism*, and it seeks to destroy the body image as an object of desire. I shall have something to say in the last chapter about the appearance of this tendency in the art of sculpture.

Here and always when we consider the evolution of one of the plastic arts, we are involved in two distinct processes, which sometimes run together and sometimes pull against each other. One, which will be the theme of the next three chapters, is physical and technical; it is the evolution of human skill in the manipulation of a material. We must suppose that man's need for expression exists: his aim, then, is to make the expression effective for a particular purpose either personal or social. One may, if he likes, consider such technical processes while ignoring the underlying intention of the artist, and the history of art then becomes the history of a particular human ability. Skill is always related to an *intention*, however, and skill, in art, is usually subordinate to the artist's intention. I say *usually*, because there is an exceptional type of artist whose only purpose is to display his technical skill; with him the means becomes the end. We call him a *virtuoso*, and he is apt to be a very inferior kind of artist.

Generally speaking, the intention in art is to create a symbol representing a particular feeling or intuition present in the consciousness of the artist, a symbol acceptable to other people because it materializes a feeling or intuition vaguely present in their consciousness. The artist is the unique individual who is first prompted to create such a symbol. The intention of the artist is *emotive*. He is burdened with some feeling that he wants to share, proud of some perception that he wishes to

33

publish. He therefore embodies his state of mind in a material pattern of some kind, which pattern becomes the objective symbol of his inner state.

There is, moreover, an intention of a more social or pragmatic kind. [88, 89] The artist uses his artistic skill to record some common experience, to represent some particular scene. His controlling intention is no longer primarily personal but social, and he must take care to employ the visual conventions of his time. Such art is not necessarily naturalistic or mimetic; visual conventions vary considerably from age to age. Still, it is essential that the symbols created by the artist be acceptable to the society for the use of which they are intended.

This enumeration does not exhaust the functions of art, but whatever the intention of the artist, it is liable to be furthered or frustrated by the skill at his disposal. In the case of the sculptor there is not so much the problem of projecting a visual image as there is the much more complicated problem of first realizing a three-dimensional image before it can be projected. We begin to see, therefore, with what difficulties, in contrast to those of painters, the first sculptors set about their task.

Most archaeologists agree that the great majority of carved objects that have survived from prehistoric times are cult objects: we call them idols. There can be little doubt that the so-called *Venus* of [26] Laussel, attributed by the Abbé Breuil to the Périgordian period, is such a cult object: she holds a horn, perhaps already a symbol of plenty, and her projecting hips, large breasts, and hand over the womb are all features that were to become throughout early history characteristic of the goddess of fertility. Nevertheless, as I have already pointed [27] out, such figures are realistic. Like the *Venus* of Willendorf, the *Venus* of Laussel is quite a·fair representation of a savage or aboriginal woman of today—only the head is conventionalized.

The degree to which the conventionalization of this subject can
be carried is illustrated by those Cycladic idols of the Bronze Age
(2500 B.C.) carved in forms that resemble a violin. Virtually only the
breasts and the womb are left to symbolize human fertility. There is a
great variety of these idols, and they reach a degree of stylization which
is far from the realism of the *Venus* of Laussel. There was established
a geometric convention that served as a symbol in the cult of fertility
but that at the same time attained independent status as a work of art.

Let us consider more closely the formal characteristics of a typical
Cycladic idol. The cult requirements are adequately satisfied by the
emphasis on the breasts and sex and by the protective position of the
arms. But elements not required by the cult have been introduced by
the sculptor—elements that were not present in the *Venus* of Laussel,
a figure no doubt equally effective as a symbol of fertility. The object
is separated from the realistic image by certain formal conventions: it is
stylized. Note, for example, the repetition of the triangular motif. The
whole torso is an elongated triangle, and subordinate to this main form,
but as echoing correspondences, we have the pubic triangle, the tri-
angle of the head, and the projecting triangle of the nose. The angular
shoulders and elbows further emphasize the dominant formal motif.

Here is a point that we shall consider in greater detail at a later
stage: the superimposition, on an object with a pragmatic intention, of
formal characteristics that have a separate function. This is an aesthetic
function. The form is made to please: there is a free play with the
form that is independent of function. This simultaneous symboliza-
tion of two distinct mental processes represents an extraordinary devel-
opment of human consciousness. For the moment let us note that the
cult object of a naked goddess of fertility had very wide distribution
throughout the ancient East and underwent many stylistic transforma-
tions. It appears, for example, frequently in Babylonian and Egyptian

[30, 31]

[28, 31]

art, nearly aways in this same attitude but generally more naturalistic in style.[10]

The influence of intention on the representation of the human body is best studied in Egyptian sculpture. When the intention is religious, or in a more general sense hieratic (and in ancient Egypt there was no clear distinction between the divine and the hieratic), the form is frozen, as it were, into a rigid convention; all vitalistic impulses are subordinated to symbolic values, to the metaphysical idea. Aesthetic values are not thereby excluded. On the contrary, for the first time in the history of art there emerges a clear and contemporaneous distinction between the geometric and the naturalistic in art. It is not a question of a particular stage of artistic or historical development; neither is it a question of skill or style. Rather, two distinct intentions have produced, side by side, two types of art, one exhibiting a tendency to abstract harmony, the other a tendency to naturalistic vitality.

Let me first illustrate this contrast in two typical works of the Old Kingdom, dating from the third millennium B.C.[11] The first is an [154] example of the hieratic style in sculpture. It represents a king, Men-kau-Ra, between two goddesses, and displays all the formality and rigidity of this type of sculpture. True, the king does advance one foot, as if to assert his freedom or superiority, but such is the conventional attitude of a male figure. Otherwise he shares the attributes of the two flanking figures, and even his features are almost identical with theirs, beard and wigs apart. The group has an immense concentration of power, with many qualities, plastic and rhythmic, that would justify

10. Cf. G. Contenau, *Manuel d'arché-ologie orientale* (Paris, 1927), II, 839–46. An illustration in Vol. I of this *Manuel* (fig. 128) shows a Babylonian tablet with a representation of the goddess of fecundity in exactly the same attitude as the Cycladic idol discussed here.

11. The contrast has been studied both generally and with particular reference to Egyptian art by Wilhelm Worringer, *Egyptian Art*, tr. and ed. Bernard Rackham (London, 1928), and in his *Abstraction and Empathy*, tr. Michael Bullock (London and New York, 1953). Cf. also Margaret Alice Murray, *Egyptian Sculpture* (London, 1930), where the group of Men-kau-Ra between two goddesses is discussed and illustrated (pp. 59–61, pl. x).

our claiming it as a great work of art. I contrast it to the famous group of an Egyptian official and his wife from the Louvre, admittedly a [155] little later in date but representing a contrast in style not explained by any process of evolution. There is, of course, an important difference in material. The hieratic group is carved out of a hard stone, schist, whereas this second group is carved out of wood; different materials encourage different treatment. That is not the real explanation of the difference between these two works of art, however, for a general survey of Egyptian art of this period shows that "a polarity permeated Egyptian existence." This is Wilhelm Worringer's expression, and he goes on to say that "Egyptian culture is massive only in its official utterances; in its more intimate forms of expression it is of an absolutely Japanese lightness . . . in Egypt there are only two kinds of sculpture, sculpture on the grand scale and miniature sculpture, excessive heaviness and the most trivial delicacy. The mean of a culture balanced in itself is always wanting." [12]

This difference used to be explained as a difference between the art of the court and the art of the people, and Worringer admits that "It is indeed of the very essence of artificially constructed cultures that an organic transition from the sphere of the home to that of public life is lacking. . . . [As a consequence] under the pressure of the contrast in which it stands with public life, the life of the home takes on a certain hot-house character and advances even some degrees further in delicacy. In short, the lyric element in life puts forth blooms of a trivial delicacy because every means of intercourse with public life is wanting." [13] No culture has lavished such exquisite sensibility on small utensils, jewelry, and cosmetic articles. One can speak also of an oasis culture, of a civilization isolated from normal contacts with flora and fauna and therefore indulging in a sentimental preference for floral ornamentation. Any prevailing art-style always has a materialistic basis, but we

12. Worringer, *Egyptian Art*, p. 57. 13. Ibid., p. 58.

must not confuse the river with the bed in which it runs. The materials of art are fused into a style by what the Germans call a "will-to-form." The difference between the hieratic and the intimate or domestic sculpture of Egypt is a difference of will or intention. In one case the intention is metaphysical, in the other case it is pragmatic. To the dead the Egyptian erects the pyramid, which Worringer has called a "rationalized labyrinth," an artificial mountain of enduring stone; for himself he builds a temporary structure of bamboo poles and palm leaves. He carves a god or a king as a grim and impassive monolith; when he rep-

[58] resents a young girl, she is as delicate and as appealing as a lotus bloom.

I shall deal later with the influence of these diverse intentions on the technique of sculpture—with the possibility, for example, that the sculptor's handling of spatial problems may be influenced by a metaphysical fear of space. For the moment I want to emphasize only the fact that sculptural form is not merely a question of artistic capability but that to a large extent it may be determined by conceptual considerations, whether these are religious or social in origin. I have used what is perhaps the most obvious illustration of conceptually determined styles; I should now like to return to the subtler problems involved in the representation of the human figure, with particular reference to the evolution of Greek sculpture.

The form of the Cycladic figure that I have discussed was determined, I suggested, primarily by cultic purposes: it spelt fertility, which is a magical concept. But this cultural intention was combined with a will-to-form that is purely aesthetic. The idol had in no sense lost its pragmatic uses nor even whatever supernatural qualities can be attributed to a relatively trivial ritual object.

Between a cult object like the Cycladic figure and a figure in the

[128, 129] fully developed style of the fourth century such as the famous *Aphrodite* from Cyrene lies an absolute difference of style that we can explain

38

only by interposing a considerable number of evolutionary stages. The period involved may be twelve centuries; nevertheless we are still concerned with the same cult object, as Aphrodite is, after all, the goddess of fertility. A metaphysical intention is still to be expressed in such a work, but it is subordinate to other values, the values we now call humanistic. The question I raise is whether the metaphysical changes induced stylistic changes or whether forms evolved independently of the evolution of beliefs and intentions.

I am again bypassing the Marxist argument that would reduce all changes, metaphysical as well as stylistic, to a basis in the changing economic structure of society. I do not dismiss this materialistic hypothesis as invalid: it is merely, from my point of view, devoid of any aesthetic interest. The philosophy of art is concerned not with the economic factors that account for a particular range of products but with the psychological factors that account for the aesthetic quality of those products. It is concerned with the interplay of matter and spirit, of form and intention. Whatever the origin of life may have been, it is the *quality* of the process of living that now interests us.

By the time we reach the historical beginnings of Greek sculpture in the seventh century B.C., about eight centuries have elapsed, and no continuity of race or civilization is discernible. Greek sculpture of the Archaic period is hieratic, and in this stylistic respect has obvious affinities with Egyptian sculpture. The figure of a woman in the Louvre, [56] discovered in Auxerre but certainly of the Dorian school and perhaps carved in Crete in the late seventh century, has all the formal rigidity of the Egyptian figures we have considered, and the attitude is ritualistic. The features are conventionalized, without any specifically human expressiveness. But within a century an extraordinary change has taken place. A series of "archaic *Apollo*"s that have survived from the sixth [61] century, with a fairly wide distribution throughout the Hellenic world, shows us a body already anatomically realistic and facial features often

39

wreathed in an expressive smile. Thenceforward the way was open to all the refinements of realism, and it is a matter of taste where we fix the peak—in the still slightly conventionalized anatomy of the Louvre pugilist, of the second quarter of the fifth century, or in the ideal perfection of the *Venus de Milo* or in the Parthenon frieze. It is to be observed, however, that anything in the nature of realism or expressionism, in the modern sense of such words, came only in the late Hellenistic period, the period of decadence.

What triumphed in the classic period of Greek sculpture was primarily a *metaphysical* intention. The body image had been fully realized as an anatomical structure, had been detached in space from the welter of other sense impressions, and had become a symbol of human self-sufficiency, of human self-satisfaction. It is possible that the prototypes of these sculptures never existed in the flesh and that in the sculptor's representation they are products of certain selective conventions, like modern film stars, who may have to submit even to surgical operations in order to conform to type. That consideration is irrelevant, however, for the selection of a beautiful type from the realistic mass is already a process of idealization. The question to decide is whether this gradual process of idealization or humanization, which was the motive power for an enormous advance in the technique of sculpture, has anything to do with the aesthetics of sculpture.[14]

Let us for a moment try to evade the distracting presence of the body image—a difficult thing to do in the case of Greek sculpture. [182] There exists a fragment of the Parthenon frieze where the folds of the drapery immediately engage our interest and where, although it is pul-

14. Loewy, pp. 57–58, in discussing the *Apollo* of Tenea, which he gives us as an example of the development of the figure in the round from the two–dimensional image by adding other views or facets to the original one, admits that the choice of the four aspects in question might be explained by the fact that these aspects (front, back, left, and right) are those of which we are most aware in our own bodies—an explanation which "implies the artist to have started, not from the observation of nature, but from his own consciousness."

satingly present, we may discount the body beneath the drapery. The aesthetic force of this fragment, isolated as it is from the composition as a whole, is constituted by a rhythmic sequence of vertical folds subtly varied in width and direction and interrupted by loops and tucks that counterpoint the rhythm and agitate an otherwise too static parallelism. I shall not pursue such formal analysis into every detail, especially as I shall return to this subject in the fifth chapter. The only point I make is that an abstract and geometrical harmony, quite comparable to the play of triangular motifs in the Cycladic figure, survives the decapitation and general dilapidation to which these maidens have been submitted. They might have survived this punishment even had they been naked, for many a fragmentary torso still lives as a work of art. It does not live, however, as a body image, as an ideal of humanity. As an ideal it has been shattered, defaced. A work of art, on the other hand, and particularly a piece of sculpture, is not destroyed so long as a recognizable fragment of it survives. The fragment bears the artist's signature, the impression of his sensibility, and that quality we must isolate if in the end we would stand in the immediate presence of the work of art.

Indeed, the artist's signature survives not merely the physical dismemberment of the statue but even the spiritual destruction of the body image. The motives that underlie the grotesque distortions of tribal art have their origin in magic or religion and are therefore not essentially different in kind from the cult objects of Greek religion. An African idol is also a human figure, a body image, and, reduced to [166] formal terms, its aesthetic appeal is not essentially different from that of the Parthenon maidens. We observe in both the same contrast between the physique of the body and the geometry of its clothing, the same repetitive rhythms and linear counterpoint.

If we turn to contemporary sculpture, we find an even more extreme contrast. In Henry Moore's bronze standing figure, for example, [209]

41

all the elements of the human form are present but completely dislocated, as it were, and recomposed into a formal structure only remotely suggested by or suggestive of the original motif. Formally and aesthetically this figure is not far removed from the Cycladic figures with which we began our consideration of the body image in sculpture. Compare for a still nearer parallel, a Greek bronze of the Geometric period. There is a difference, because the modern sculptor has asserted a will-to-form that, while not arbitrary, is far removed from the phenomenal or retinal appearance of the original object. In his own way, however, the sculptor of the *Venus de Milo* or any exponent of the classical ideal has ignored or suppressed much that is given in direct sensation—not only the slight irregularities or disproportions that any actual human model is likely to possess but also any sensations, such as his own haptic sensations, that seem to conflict with his intellectual ideal. In other words, the classical sculptor no less than the modern sculptor has his will-to-form, but although in both cases it is an imperious will, it functions within a world of organic forms. To be completely independent, the sculptor would have to desert the organic world, would have to invent a new reality that owes nothing to the human form or to any other vitalistic structure. Certain modern sculptors, the constructivists, have not hesitated to take this step, but Moore would maintain that their forms thereby lose emotional appeal to become purely intellectual. I shall not discuss that point now; the borderline between the intellect and the sensibility is very difficult to draw.

Art, however, and certainly the sculptural representation of the human body, has not ventured hitherto to forego the quality that, to borrow a term from the anthropologist, we may call *mana*. I know that it is dangerous to introduce a term that has complex significance in one sphere of knowledge and to make it serve a different purpose in another sphere of knowledge, but I believe that in this case there is some justification. Mana, in anthropology, is the name given to that

power immanent in all things, not merely men and animals but even inanimate objects like rocks and sticks. It is an elemental force manifested universally—the causal explanation of all natural and supernatural occurrences. It is the power celebrated in all myths and religions, energizing all magic and ritual. The cult objects made by primitive people—idols, fetishes, and totems—are automatically endowed with this dynamism, and a close relationship is thus established between the form and the power of the work of art. That is to say, an object is created in the belief that it will be immediately endowed with mana. The primitive sculptor works with the knowledge that he is creating, not a lifeless object, but a living form. Emotion determines form, as it does in all expressionistic art, and once the form has been determined it *contains* the emotion. The same emotion is automatically induced in anyone who contemplates the fetish or idol, for contemplation is identification.

I think there can be no doubt that this animistic procedure has persisted throughout the history of art, though it becomes attenuated and feeble to the degree that art becomes idealistic or intellectualized. There is no mana in a construction by Naum Gabo, and very little in [219] the anthropological sense in Michelangelo's *Slaves*. When the repre- [94, 95] sentation of the human body becomes completely naturalistic, we have reached the stage of *narcissism* in art. The sculptor inhabits the image of his own body, is in love with himself; and naturally there is no room for another spirit.[15] There is then no question of "animism" in art, but one only of humanism, of that self-regarding, self-exalting humanism

15. The whole question of *Einfühlung* (empathy), which I have so often discussed before, is involved at this point. Describing Michelangelo's *Slaves*, Heinrich Wölfflin wrote (*Classic Art,* tr. Peter and Linda Murray [London and New York, 1952], pp. 71–72): "Here there is an unparalleled representation of the human body just beginning a movement; the sleeping man stretches himself, his head still lolling back and his hand mechanically running up his chest, his thighs rubbing together, he draws a deep breath as he awakens, just before he reaches full consciousness." Such an effect can only be produced by a total identification of artist with subject.

43

that finally subordinates art to sophisticated ideals of type or convention and thereby incurs its downfall. Goethe, addressing the Society of German Sculptors in 1817, told them that "The topmost aim of all plastic art is to render the dignity of man within the compass of the human form. To this aim every nonhuman element, in so far as it lends itself to treatment in this medium, must subordinate itself. Such elements must first be assimilated to the dignity of man in order that they may set it off, instead of calling attention to themselves or even departing from it. Draperies and all kinds of garments and attributes come under this head, also animals; and to these latter only sculpture knows how to impart that dignity which is theirs by virtue of the fact that they are in a measure akin to that embodiment of the divine which we meet in the human figure." [16]

The intention, we see, was metaphysical—to render the dignity of man—and to this intention everything had to be sacrificed. Speaking at the beginning of a century in which virtually no sculpture of any permanent value was to be created anywhere in the civilized world, Goethe did not realize that he was demanding too much of the art of sculpture. It is true that there is nothing inherently incompatible between dignity and vitality, and conceivably the human figure can embody a human conception of the divine. A human figure carved by Michelangelo is both vital and dignified. We may say that it is a *great* work of art because it is dignified, but it exists *as a work of art* only because it is vital.

Humanism is, no doubt, a prejudice; it is a prejudice to which we are naturally addicted. There are other possible values: the absolute values of transcendental religion; the totalitarian values of the state; the moral values of society. The values of art are the vital and formal values of the creative imagination itself, and these, as we shall see, are

16. *Goethe: Wisdom and Experience*, selected by Ludwig Curtius,
tr. and ed. Hermann J. Weigand (New York, 1949), p. 242.

not necessarily co-extensive with human values and do not necessarily find their highest expression, as Goethe and Hegel thought, in the image of man. We may, however, go so far as to say that the realization of this image in the art of sculpture was one of the decisive stages in the development of a specifically human consciousness.

CHAPTER THREE

The Discovery of Space

The peculiarity of sculpture as an art is that it creates a three-dimensional object *in space*. Painting may strive to give, on a two-dimensional plane, the illusion of space, but it is space itself as a perceived quantity that becomes the particular concern of the sculptor. We may say that for the painter space is a luxury; for the sculptor it is a necessity.

A solid object is situated in space; it occupies or displaces a definite amount of space. It becomes an object for us by being differentiated from other objects and by being delimited from the space surrounding it. We have a sensation of the amount of space occupied by the object, which is the *quality* of volume, or *bulk*. If we refer to the *quantity* of matter the object contains, we speak of its *mass*.

We are not born with a notion of the object as a distinct entity, existing and moving in a spatial field; such a notion is built up during the first two years of life by processes of discrimination, association, and selection.[1] Out of the original chaotic experience of vastness (to use William James's phrase) the infant constructs real space, and this

1. These processes have been observed in great detail by Jean Piaget. Cf. especially *La Construction du réel chez l'enfant* (Neuchâtel and Paris, 1937; tr. Margaret Cook as *The Construction of Reality in the Child*, New York, 1954; as *The Child's Construction of Reality*, London, 1955).

46

construction involves several subordinate processes that are gradually co-ordinated. As a beginning, separate objects have to be discriminated within the total field of vision. In itself this process involves several stages of development: the objects must be arranged in a definite order, and then their relative sizes must be perceived and assessed. At the same time, all the different sensations—of sight, touch, hearing, taste, and the rest—must "coalesce" in the same thing. In this process, one of the sensations usually will be "held to *be* the thing," while "the other sensations are taken for its more or less accidental *properties,* or modes of appearance."[2] We tend to see the bulk of a tree, for example, but to feel the bulk of a piece of furniture, a tool, or a book. The point to emphasize, for our present purposes, is that space perception is almost entirely acquired by education. We say "almost entirely" because the individual may be conditioned to his environment by certain hereditary biological processes; we are not born into a static or a mechanical world but are insinuated into a continuous process of organic evolution.[3]

When we consider the evolution of sculpture, it is important for us to realize that the kind of coherent space perception that man now possesses is a construction of the intelligence, and that even so, as William James pointed out, "touch-space is one world; sight-space is another world. The two worlds have no essential or intrinsic congruence, and only through the 'association of ideas' do we know what a seen object signifies in terms of touch." James mentions the case of a patient

2. William James, *Psychology* (London and New York, 1892), p. 339. In general I am relying on James's treatment of this subject.

3. Piaget (N.Y. edn.), p. 218. Cf. p. 217: "Hence, in the last analysis, it is the functioning of intelligence which explains the construction of space. Space is an organization of movements such as to impress upon the perceptions shapes that are increasingly coherent. The basis of these shapes derives from the very conditions of assimilation that entail the elaboration of groups. But it is the progressive equilibrium of this assimilation with the accommodation of the motor schemata to the diversity of objects which accounts for the formation of sequential structures. Space is therefore the product of an interaction between the organism and the environment in which it is impossible to dissociate the organization of the universe perceived from that of the activity itself."

cured of congenital cataracts by surgical aid who said, "It might very well be *a horse*," when a ten-liter bottle was held up a foot from his face. All this goes to show, as James says, that "it needs a subtler sense for analogy than most people have, to discern the *same* spatial aspects and relations" in optical sensations "which previously known tactile and motor experiences have yielded."[4]

I shall suggest in this chapter that sculpture is primarily an art of "touch-space"—is and always should have been—whereas painting is primarily an art of "sight-space"; and that in both arts most of the confusion between theory and practice is due to the neglect of this distinction. There may be some ambiguity in the word *primarily*, but though a complexity, or rather a complicity, of sensations is always involved in the creation and appreciation of a work of art, one and only one of these sensations "touches off" the process. This is the sensation I call primary. I think we must set out from the same point as Berkeley, who, in his *Essay towards a New Theory of Vision,* held that the tangible "feel" of a thing and the "look" of it to the eye are "specifically distinct."[5] It is not necessary to draw Berkeley's metaphysical conclusions from these primitive facts; however, we must remember that the peculiarity of the artist is that he deals with primitive facts, with sensations in their state of innocence. He works on the basis of a direct feeling and not on the basis of concepts, which are secondary intellectual constructions.

There is, perhaps, a mental process of this secondary kind that the phrase "tactile imagination" describes; and Bernard Berenson used the phrase to indicate the particular contribution that Giotto made to the development of the art of painting: ". . . it was of the power to stimulate the tactile consciousness . . . that Giotto was supreme master. This is his everlasting claim to greatness." Berenson dismissed all paintings before

4. James, p. 349.
5. (Dublin, 1709); reprinted with *Alciphron* (London, 1732), II; and in *Works,* ed. A. C. Fraser (rev. edn., Oxford, 1901), I, 93–210.

Giotto as negligible because "none of these masters had the power to stimulate the tactile imagination, and, consequently, they never painted a figure which has artistic existence. Their works have value, if at all, as highly elaborate, very intelligible symbols, capable, indeed, of communicating something, but losing all higher value the moment the message is delivered." [6]

I cannot so lightly dismiss the pictorial art of the Byzantine period —Mr. Berenson's strictures would apply to its mosaics as well as to its paintings—nor medieval painting in general as represented in wall paintings, stained-glass paintings, and illuminated manuscripts. It has always seemed to me that the evaluation of art according to the number of dimensions it includes is a curiously materialistic procedure. A *"keener* sense of reality," which the introduction of tactile values into painting is supposed to give, is not necessarily an artistic achievement. The intention of the artist might be to give a keener sense of irreality or superreality; and that, indeed, was the intention of the medieval artist. To lend "a higher coefficient of reality to the object represented," another of Mr. Berenson's phrases, is the aim that gradually corrupted the artistic consciousness and led the art of painting into the morasses of academicism and sentimentalism.[7]

For the sculptor, tactile values are not an illusion to be created on a two-dimensional plane: they constitute a reality to be conveyed directly, as existent mass. Sculpture is an art of *palpation*—an art that gives satisfaction in the touching and handling of objects. That, indeed, is the only way in which we can have direct sensation of the three-dimensional shape of an object. It is only as our hands move over an object and trace lines of direction that we get any physical sensation of the difference between a sphere and a square; touch is essential to

6. *The Italian Painters of the Renaissance* (London and New York, 1952), pp. 40–41.

7. Ibid., pp. 41, 42 respectively for the two phrases quoted.

the perception of subtler contrasts of shape and texture. A genuine sculptor is continually passing his hands over the work in progress, not to test its surface quality, though that may be one purpose, but simply to realize and to assess the shape and volume of the object. Unfortunately visitors to a museum "are requested not to touch the exhibits"—unfortunately, because that request deprives them of one of the essential modes of appreciating sculpture, which is palpation, handling. Admittedly, there is much sculpture in our public galleries that would not yield any pleasure as a result of this approach. If we merely "look at" sculpture, even with our sophisticated vision, which is capable of reading into the visual image the conceptual knowledge we possess from previous experience of three-dimensional objects, still we get merely a two-dimensional impression of a three-dimensional object. We are recommended, in manuals of art appreciation, to walk round a piece of sculpture and to allow all the various points of view to coalesce in our imagination. This difficult feat, if successful, might conceivably give us a ghostlike version of the solid object. Sculpture, again, is often mounted on turntables to save us the trouble of circumambulation. We see an object twisting and twirling in our line of vision, and from that impression of shifting planes and lights we are supposed to derive a sensation of solidity!

We observed in the first chapter that, in the early stages of the evolution of the art of sculpture, sculptural objects were small and palpable, or if they were on a scale too large to be handled they were not to be detached from a background, a matrix. Prehistoric sculpture takes the form either of small amulets or of relief sculpture such as the *Venus* [48] of Laussel. The two bison modeled out of clay at Tuc d'Audoubert, which are 24.4 and 25.2 inches long, are built up against a projecting rock and are hardly to be considered as detached monuments. A considerable number of prehistoric relief sculptures have been discovered

—the great majority representing animals—but sculpture in the round is extremely rare.

If we turn to the sculpture of Egypt we find a similar predominance of relief sculpture, and even when the statues are in the round they are often supported by a background. There are two possible but not contradictory explanations of this characteristic. In Egypt carved sculpture is historically later than clay modeling, and it was the practice to give support to the early clay figures, not in the modern way by inserting an armature of wire, but by leaning the figure against a vertical strip or sheaf of bamboo. This device, it is argued, was copied by the sculptor in stone. A much more plausible explanation is provided, however, by a consideration of the function of sculpture in Egypt. It was never regarded as a separate and distinct art. From the beginning it was subordinate to architecture, and the nature of the architecture determined the nature and even the technique of the sculpture. A statue of Ateta, from Sakkara,[8] shows the typical architectural setting of a piece of Egyptian sculpture of the Old Kingdom, in a rectangular niche surrounded by designs and inscriptions in low relief. Dr. Murray, in her book on Egyptian sculpture, suggests that in such a rectangular setting the figures could not be too naturalistic but had to follow the vertical and horizontal lines of the architecture as far as these could be echoed in the human figure. If one asks why Egyptian architecture was so rectangular, he is usually referred to the horizontal and vertical lines of the Nile Valley, a landscape unlike any other in the world. "The horizontal line of the top of the cliffs is repeated in the horizontal strata, and again in the flat plain which forms the habitable land of Egypt. In violent contrast to these levels stand the vertical lines of the cliffs, weathered by ages of wind and wind-blown sand into gigantic columns as straight and true as though set there by the hand of man. There are

[142, 143, 145–148, 150–155]

[150]

8. Margaret Alice Murray, *Egyptian Sculpture* (London, 1930), pp. 61–62 and pl. xi.

51

no curves in the Egyptian landscape, no rounded hills, no great peaks to break the level skyline of the cliffs. As Sir Flinders Petrie says: 'In the face of such an overwhelming rectangular framing, any architecture less massive and square than the Egyptian would be hopelessly defeated.'" [9]

One or two considerations, however, throw doubt on this materialistic argument. The Gothic style of architecture, for example, is quite independent of a particular type of landscape—it imposes itself on any landscape—and even in Egypt the theory would be contradicted at a later period by that country's ready assimilation of the Moslem style in architecture, so light and graceful in its general effect. We know that the artistic spirit works by contrast or counterpoint just as naturally as it works by harmony or imitation. Granted a style of architecture and the idea that sculpture should be functionally subordinate to it, then it is obvious that the style and technique of the glyptic art must be subordinate to the style and technique of the architectonic art, as we observed in the first chapter. The conscious will to art, the intention of the artist, and his consciousness of the intention of other artists are the primary determinants of style; style cannot be reduced to an automatic reaction to environment. Environment acts rather as a limiting factor, as a containment of forces that might otherwise be too dispersed. En-

9. Ibid., p. xvii. Worringer regards this explanation as only partly satisfactory. He points out that the stone used in Egyptian architecture was brought from neighboring mountain ranges, and that a tremendous will to work in stone must have been necessary to overcome all the technical obstacles that stood in the way of getting the huge blocks of stone and transporting them into the plains of the valley. "These gigantic blocks had to be brought to the place for which they were destined upon frail rafts and Nile boats. And when they were set up at their destination, they were great strangers upon the thin upper surface of this desert soil exploited by civilization, strangers from the mountains. We cannot admit that any unity grew up between the Egyptian soil and the gigantic stone monuments. Here it is rather the power of absolute contrast which determines the impression received. It was not a natural logic of geology that set these stone giants in their place, but a conscious will to art, following a definite abstract command without any feeling for the physical nature of the land. Egyptian stone architecture is just a deliberate and gigantic denial of the hazardousness and transience in the midst of which the artificial structure of Egyptian culture is placed."—*Egyptian Art*, tr. and ed. Bernard Rackham (London, 1928), p. 38.

vironment creates ethos, the prevailing spirit of a community, and in
the Greek conception of the word, ethos was always strictly localized.
Ethos does not explain style, only intensity. It explains, for example,
the fact that tragedy is a prevailing form, but it does not explain the
form of the tragedy or its poetic style.

The intention behind Egyptian art is functional. The architecture
is functional, and so is the subordinate sculpture. There is no room for
the play of fantasy, as Worringer has pointed out. This being the situa-
tion, the Egyptian sculptor had no desire to isolate the human figure
in space, to dissociate it from its niche or socket, for to do so would have
served no rational purpose. Space *as such* was not felt by the Egyptians,
who were complete strangers to what the Germans call *Raumgefühl*.
Their satisfaction with relief sculpture derived from this lack. Relief
sculpture is, in fact, the typical art of ancient Egypt, and as Worringer
has said, "No stranger, more consistent two-dimensional art has ever
existed, but it is just two-dimensional art and no more. We may think
of Greek art—how much artistic thinking had to be employed by it be-
fore it discovered its ideal relief style, that wonderfully delicate play of
balance between surface and depth which even in the most perfect
productions still always reflects the hesitations of a never-to-be-over-
come tension between surface and depth. The Egyptian relief is from
the very first complete in its pure surface character. No unrest born of
depth finds its way into it. It is entirely without tension and conflict.
The third dimension, the dimension by which we are actually aware of
depth, from which all that is more profound in the drama of artistic
creation draws its inspiration, is not present at all as a resistant in the
artistic consciousness of the Egyptian." [10]

From the point of view I am presenting, we can state that no com-
plete plastic consciousness was possible in Egyptian sculpture, because
the form was never isolated in space and was never handled as a three-

10. Ibid., p. 25.

[65] dimensional object. The technique was one of incision, essentially linear, essentially graphic. Egyptian sculpture was made to be read, like the Egyptian pictorial script. It kept this limited character for three millenniums, into the Ptolemaic period. Only the relatively small bronze or [57, 58, 142, 143] wooden servant statues, votive tomb figures, and folk art in general offer any exception to this rigid limitation of plastic feeling.

In this connection, the German art historian, Alois Riegl, invented the term "space shyness," and certainly the Egyptians were shy of space. It plays no part in their architecture nor in any of their subordinate arts, and all their arts, as I have previously pointed out, were subordinate to architecture. There are, however, two senses in which we can speak of space shyness: space as a practical necessity, to which we can react on a merely sensational level, and space as a concept, to which we react emotionally and spiritually. Worringer, who defines space as metaphysical consciousness, argues that the Egyptians were not aware of space in this second sense and that they were neutral and indifferent to the very idea. Their space shyness, therefore, was a form of inarticulateness. They were like children who have not yet discovered that space exists, except as a relationship between groups of objects. The same, with some qualifications, is true of the Greeks. "According to Aristotle," observes a modern physicist, C. F. von Weizsäcker, "the world is finite in extent. In its center is the ball-shaped earth, its outer boundary is the sphere of the fixed stars. Outside that sphere there is no thing and hence no place, since every place is the place of some thing. The idea of space as such, existing even if it is not filled by something, was unknown to the Greeks—with the exception of the atomistic school." [11]

In accordance with this essentially practical and limited concep-

11. C. F. von Weizsäcker, *The History of Nature*,
tr. Fred D. Wieck (Chicago and London, 1949), p. 65.

tion of space, we get the characteristic of Greek sculpture that has been called "the law of frontality," which is really no "law" at all but merely a limitation of sensibility. The development of Greek sculpture is often represented as an age-long struggle with this very problem. "The agile mind of the Greek," writes Dr. Richter, "determined to wrestle with these problems [of modeling and perspective]. Not content with what had been accomplished before him, he was eager to solve new problems, and so he started out on his adventure of representing a human body in all manner of postures, with bones and muscles correctly indicated, in proper relation and in right perspective, both in the round and in relief. To a pioneer in the field it was a formidable task. But with infinite patience the Greek artist accomplished it, and his solution of these problems was like the removal of shackles which had hampered the free development of art for generations. Thenceforward the road was clear. In a century or two we pass from the Apollo of Tenea to the Idolino, from the Nike of Delos to the Nike of Paionios, from the Spartan ancestor relief to the Hegeso stele." [12]

I have already admitted, in Chapter II, that for reasons that have little to do with any conception of space the Greek sculptor arrived at a completely realistic rendering of the human body image. Yet apart from this narcissistic form of projection, this re-creation of the self, Greek sculpture remained either bound to architecture, as in the Parthenon frieze, or anchored in some way to the earth. The Hegeso stele, mentioned by Dr. Richter, is a case in point. It represents the acme of the Greek sculptor's skill, but the figures, in all their grace and realism, remain prisoners within the architectural framework of the stele. This may be taken as a symbol of all Greek sculpture and indeed of all sculpture down to our own period. Even at the end of the nineteenth

12. Gisela M. A. Richter, *The Sculpture and Sculptors of the Greeks* (New Haven and London, 1930), p. 24.

century, in 1893, we find the German sculptor Adolf Hildebrand, in his famous treatise on sculpture, exercising all his ingenuity to establish the two-dimensional unity of the relief as a standard for all the plastic arts. He calls it an unchangeable law of art, and he says further that "The thousandfold judgments and movements of our observation find in this mode of presentation their stability and clearness. It is an essential to all artistic form, be it in a landscape or in the portrayal of a head. In this way the visual content is universally arranged, bound together, and put in repose. Through all figurative art this idea is the same, the one guiding thought. It acts always as a general condition and requirement to which all else is subordinate, in which everything finds a place and a unity." [13]

What we may call the visual prejudice cannot go farther. It is true that Hildebrand is prepared to free relief from its dependence on architecture; but his real object is to eliminate all sense impressions save those given in visual contemplation from a fixed point of view. Such a result can be achieved only by ignoring the palpability of the sculptured object and by confining the senses within a pictorial framework. This sense of imprisonment, of restraint, may become still clearer if we [21–25] turn abruptly to a consideration of Gothic sculpture. As sculpture it was gradually and profoundly influenced by the Greek ideal of humanism; it also remained, as sculpture, completely subordinated to architecture. Of course, the general architectonic conception had changed. Not only had the medieval architect become aware of space as a separate entity, but also he was fascinated by its metaphysical implications, by the problem of infinite extension. How he managed to suggest in the structure of his building this quality, this metaphysical sensibility, is another story that does not concern us now. When his feeling for space became

13. *The Problem of Form in Painting and Sculpture*, tr. and rev. with the author's co-operation by Max Meyer and Robert Morris Green (2nd edn., New York, 1945), p. 83.

coherent and conscious, he could no longer tolerate the imprisonment of sculpture in the architectural framework. The sculptured figures were freely accommodated within that framework, but they remain guests at their ease in such heavenly mansions. They are "at home" in their niches and seem free to leave if the spirit so moves them. In the mature Gothic style, they perch in the tracery like birds poised for [23] flight. Decoratively, however, they are still a unity with the architecture and contribute their share to its total lucid effect. Even at Chartres, where the earlier Portail Royal represents a complete subordina- [21] tion of the sculpture to an overriding architectonic purpose, there is no contradiction between the structural and the sculptural functions of the figures. One can hardly say the same of Greek caryatids; the caryatids of the Erechtheum, for example, seem to be imprisoned by the weight [20] they support.

There are other important distinctions to be made between Greek and Gothic sculpture, to which I hope to return in a later chapter, but none is so striking as this spatial element that was denied to Greek sculpture but in which Gothic sculpture began to stir restlessly. As a chief consequence, the Gothic sculptor was able to express the illusion of movement, a subject I must postpone discussing for the moment. What the Gothic sculptor did not achieve, any more than did the Egyptian or the Greek sculptor, was the complete emancipation of sculpture from architecture, and to this decisive achievement I shall devote the remainder of the present chapter.

We have already noted that for the Greeks there was no concept of "space" but only of "place." "Every body is at a place." Such was their theory of physics, and accordingly they believed, in a literal sense, that every body should have a place. Mental habits that would produce similar effects were characteristic of medieval scholasticism. One of these was the convention of *manifestatio* or clarification, which, according to Professor Panofsky, resulted in just such a subordination of

parts to the whole in Gothic architecture.[14] One cannot emphasize too strongly that the *objet d'art,* as a detached and independent *thing,* transportable or movable in space, is foreign to the Greek and Gothic civilizations; it is a peculiarly modern conception, the expression of a new change of human attitude.

The detachment and isolation of the *objet d'art* is a consequence of that growth of a sense and of a philosophy of individualism that has been studied by Burckhardt and others. Conformity to an ideal, to a canon of art, had been characteristic of all previous epochs of art. Even before Descartes based a philosophy on his affirmation *cogito ergo sum,* the artist had dared to say to himself: *creo ergo sum.* The medieval artist might have a particular genius, a unique quality of expressiveness, but his creative archievements did not relate to any idea of his own personality. Rather they were the results of a discovery of some new aspect of God's creation, a revelation of the divine in nature. Man had to situate the divinity within his own breast before he could claim that his originality was the expression of a unique self. Once the artist had reached that conviction, he no longer wished to sink his individual creation into some complex logical structure such as a cathedral, where his individuality was lost in the collective ideal. He began to set his work on its own isolated pedestal and to invite admiration for this work of art as an expression of his own skill, of his own personality or of his own ideal of beauty.

This parturition was not achieved without difficulty. It involved not merely a secularization of art and a declaration of the independence and separate entity of individual achievements but also an inner reorganization of the work of art thus rendered independent of a sup-

14. Erwin Panofsky, *Gothic Architecture and Scholasticism* (The Wimmer Lecture 1948; Latrobe, Penna., 1951). Cf. Robert Grinnell, "The Theoretical Attitude toward Space in the Middle Ages," *Speculum,* XXI (Apr., 1946), 141–57; "Franciscan Philosophy and Gothic Art," *Ideological Differences and World Order,* ed. F. S. C. Northrop (New Haven, 1949), pp. 117–36.

porting background. The first process has been considered in some detail by art historians; I refer in particular to Dr. Frederick Antal's study, *Florentine Painting and Its Social Background*. Antal shows how in the early fifteenth century the leading painters and sculptors gradually won a new social status for themselves so that they ceased to be artisans under the instruction of their patrons and became free artists with what Dr. Antal calls an "upper-middle-class mentality." This secularization of art and the emancipation of the artist were developments that enabled the artist to meet the snobbish requirements of the new burgher class. Artists were required to make not only portraits of the burghers or their wives, but also *cassoni,* bridal caskets, birthday platters, and other such commemorative objects that, though still treated as part of the furniture of the house and not as works of art giving independent aesthetic satisfaction, nevertheless did liberate artists from official and ecclesiastical patronage and allowed them to develop and to express their own personalities in their work. Antal also shows how the particular artists who thus began to separate themselves from the mass of craftsmen "were, characteristically enough, the same whose interests were mainly in scientific and technical questions. What was formerly technical skill was put more and more to the service of scientific innovation based on theoretical knowledge; for it was by establishing a theoretical and scientific foundation for itself that art could obtain greater social recognition, could free itself from the crafts, and so those who practised it could rise from the condition of artisans close to the upper middle class. In this context, pioneering importance attached to the technical and mathematical studies of Brunelleschi, particularly those on perspective. This architect and engineer, who was so deeply interested in technical and mathematical questions and also demonstrated the application of linear perspective to painting, already worked . . . with theoretical scientists. Masaccio, Donatello, Uccello, and Ghiberti directed their

[158, 160–163]

interests towards the same subjects: technics, optics, and perspective." [15]

How much they understood of these questions and how scientifically they applied their knowledge to their arts is another question, to which I shall return shortly. Let us first note, however, that the curiosity newly awakened in these artists, which was historical as well as scientific, led them to a study of the art of the ancient world and particularly to a study of Greek sculpture. Ghiberti in his *Commentarii* tells us that he began about this time—the mid-fifteenth century—to collect specimens of antique sculpture. The same is true of Donatello, and "Brunelleschi and Donatello were the first artists to go to Rome for the express purpose of studying antique art." [16]

What is significant about this development is that for the first time artists are found contemplating pieces of sculpture—monuments, not amulets—*as detached works of art,* are found collecting them and appreciating them irrespective of the architectural function for which they were originally conceived and executed. There was, however, a time lag between the conception of a free-standing statue and the discovery of an aesthetics appropriate to such sculpture. The fragments from antiquity were, after all, fragments of a sculpture whose aesthetics had already been determined by an architectural function. These sculptors of the early Renaissance did not yet dare to conceive of an emancipated art. Their first independent figures, works like Donatello's

[86] *David* of 1408-9, even if not actually executed for an architectural setting, a niche designed by some architect, were nevertheless inspired by antique works that had had such a function. The whole conception of such a figure as this, actually conceived for a setting in the Piazza della Signoria, or of the same sculptor's *Judith and Holofernes* [17] is, to borrow

15. (London, 1947), p. 376.
16. Ibid., p. 377.

[84-87]
17. Donatello made several *Davids.* The first, in marble, very early in his career,

was ordered for the Duomo at Florence in 1408 but was found to be too small. A second, the famous bronze, dates from about thirty years later. Sir Eric Maclagan, in his

an excellent term from John Summerson, *aedicular*.[18] The statue was thought of not merely as occupying a niche or an architectural frame; it was conceived as an object viewed standing in a niche and therefore always viewed frontally. That we unconsciously acquiesce in the Renaissance attitude toward its sculpture will be discovered by anyone who tries to obtain photographs of these statues taken from any but a frontal point of view.

How difficult escaping from this law of frontality proved to be is illustrated by the story of the commissioning of Michelangelo's *David* of 1501–4, which comes almost a full century later than Donatello's [96–98] first *David*. We know that Michelangelo carved this colossal statue without any site in mind, because a commission was appointed, after the work had been completed, to decide on a site in Florence; and the commission not being able to agree, the sculptor himself was left to select a site. Even in this case we must assume that all the time Michelangelo conceived his work as erected against an architectural background and as producing its optimal effect from a single point of view. Wölfflin points out that when the original statue was moved from its exposed position by the Palazzo Vecchio into the shelter of a museum, and a bronze cast was substituted for it, "a most unhappy position was chosen for this, illustrating the present-day lack of a sense of style. The

Norton Lectures for 1927–28 (*Italian Sculpture of the Renaissance*, Cambridge, Mass., 1935), described this bronze as "perhaps the first really free-standing nude since Classical times." The figure illustrated on pl. 84–85 is officially ascribed to Donatello, but on the basis of a convincing stylistic analysis John Pope-Hennessy has recently given it to Antonio Rossellino (*Burlington Magazine*, CI:673 (Apr., 1959), 134–39).

18. Cf. *Heavenly Mansions and Other Essays on Architecture* (London, 1949). I should like to quote the following paragraph from this book (p. 9) as support for my general thesis that the true aesthetic of sculpture was derived from *Klein-* *plastik:* "It has been satisfactorily shown, by Mâle, Lasteyrie and others, that the re-entry of figure–sculpture into architecture in the Romanesque churches of the 11th century was conditioned by the sculptors' familiarity with metal–work, manuscripts and other objects of art: the technique of architectural sculpture, up to the Gothic revolution in the middle of the 12th century, shows clear evidence of such a derivation. But so far as I know, nobody has developed the corollary of this— namely, that the aedicular architecture of Romanesque churches may have been reinforced or given renewed vitality from the same source."

bronze was set up in the middle of a large open space, so that one gets the most monstrous views of the figure before one sees him properly. In its own day, immediately after it was finished, the question of a site for the statue was referred to a committee of artists, whose memorandum still exists: they were unanimous that it must be related to a wall-surface, either in the Loggia dei Lanzi or near the door of the Palazzo della Signoria. The figure requires this, for it is entirely worked in planes to be seen from the front and not from all sides: a central position is most calculated to emphasize its ugly qualities." [19]

Michelangelo was well aware of the unique problems that beset the sculptor in any attempt to realize a three-dimensional object in space. There is, however, little in his recorded statements on the art of sculpture that is theoretical in nature. In answering Benedetto Varchi's famous questionnaire about the relative merits of painting and sculpture, he welcomed Varchi's own view that any superiority was not due to the nature of the art but rather to the judgment and ability of the artist, whatever the medium. He does express the view that "painting should be considered excellent in proportion as it approaches the effect of relief, while relief should be considered bad in proportion as it approaches the effect of painting." [20] From this we may deduce that Michelangelo's ideal in sculpture was to get away from a pictorial or painterly effect, a deduction that is supported by his further distinction, made in the same letter to Varchi, between the sort of sculpture executed by cutting away from the block and the sort executed by building up or modeling, which, Michelangelo says, resembles painting.

The general view of the period is best expressed by Benvenuto Cellini in his answer to Varchi's questionnaire. Sculpture, says Cellini, is seven times as great as any other art based on design, because a

19. *Classic Art*, tr. Peter and Linda Murray (London and New York, 1952), p. 48.

20. *Literary Sources of Art History*, ed. Elizabeth G. Holt (Princeton, 1947), p. 193.

statue has eight show-sides and they should be equally good.[21] "A painting is nothing more than one of the eight principal views required of a statue. And this is so because when a worthy artist wants to model a figure—either nude, or draped, or otherwise . . . he will take some clay or wax and begin to fashion his graceful figure. I say 'graceful' because beginning from the front view, before making up his mind, he often raises, lowers, pulls forwards and backwards, bends and straightens every limb of the said figure. And once he is satisfied with the front view, he will turn his figure sideways—which is another of the four principal views—and more often than not he will find that his figure looks far less graceful, so that he will be forced to undo that first fine aspect he had decided upon, in order to make it agree with this new aspect. . . .

"These views are not only eight, but more than forty, because even if the figure be rotated no more than an inch, there will be some muscle showing too much or not enough, so that each single piece of sculpture presents the greatest variety of aspects imaginable. And thus the artist finds himself compelled to do away with the gracefulness that he had achieved in the first view in order to harmonize it with all the others. This difficulty is so great that no figure has ever been known to look right from every direction." [22]

This statement of Cellini's illustrates perfectly the visual prejudice of Renaissance sculpture. In a later chapter we shall see that this prejudice is associated with the desire to give an illusion of movement to the statue; for the present I want to emphasize that it inevitably leads to a painterly conception of sculpture, to a conception of sculpture as a coherence of surfaces rather than as a realization of mass. Michelangelo did, I believe, instinctively reject this illusionist approach to the object

21. Ibid., pp. 205–206.
22. From "Sopra l'arte del disegno," included in *I trattati dell' oreficeria e* *della scultura* (Florence, 1857), pp. 217–18; tr. Marco Treves, *Artists on Art*, ed. Robert Goldwater and Marco Treves, 2nd rev. edn. (New York, 1947), pp. 89–90.

in space. We are told that he delighted not only in looking at antique sculptures but also in running his fingers over their subtle surfaces. Still, "over the surface" is not the full palpable grasp of the mass in space, and Michelangelo's sculpture never became in this sense "free." Rodin pointed out that nearly all Michelangelo's figures are conceived not as a self-subsisting harmony or equilibrium of parts balanced against each other in graceful unity but rather as a variant of the console, that is to say, as a projecting bracket that seems to imply the support of the wall behind it. The legs are bent outwards, the thorax curved inwards to give a tense and even tortured attitude that seemed to Rodin to have much in common with the art of the Middle Ages and to reflect a medieval anxiety or torment of the spirit.[23] Whatever the expressive significance of such forms, and I see no reason to question Rodin's interpretation, this technical observation confirms the hypothesis that the free placing of sculpture in space had not been achieved by the end of the sixteenth century, not even by Michelangelo. Again, as in Greece and Egypt, it was only in and through *Kleinplastik*, small objects that can actually be handled, that sculpture became emancipated from all architectonic and utilitarian purposes and conceived as an independent plastic art.

[94, 95]

Before developing this thesis that the art of sculpture in its complete aesthetic integrity had to grow from sculpture in miniature, let us glance at the path of decadence that set in after Michelangelo's death. The seeds of that decadence had already been sown by Leonardo. That Leonardo despised the art of sculpture is evident from the terms in which he speaks of it. He cannot hide his disdain of an art that demanded physical strength, that caused, as he said, "much perspiration which mingling with the grit turns into mud." The sculptor's face "is pasted and smeared all over with marble powder, making him look like

23. Auguste Rodin, *Art,* tr. from the French of Paul Gsell by Mrs. Romilly Feden (Boston, 1912), pp. 192–93, 202.

64

a baker, and he is covered with minute chips as if emerging from a snowstorm, and his dwelling is dirty and filled with dust and chips of stone. . . . How different is the painter's lot. . . . He is well dressed and handles a light brush dipped in delightful color. He is arrayed in the garments he fancies, and his home is clean and filled with delightful pictures, and he often enjoys the accompaniment of music or the company of men of letters who read to him from various beautiful works to which he can listen without the interference of hammering and other noises." [24]

Leonardo's snobbish prejudice is matched by an intellectual one: "In the first place, sculpture is dependent on certain lights, namely those from above, while a picture carries everywhere with it its own light and shade; light and shade therefore are essential to sculpture. In this respect, the sculptor is aided by the nature of the relief, which produces these of its own accord, but the painter artificially creates them by his art in places where nature would normally do the like. The sculptor cannot render the difference in the varying natures of the colors of objects; painting does not fail to do so in any particular. The lines of perspective of sculptors do not seem in any way true; those of painters may appear to extend a hundred miles beyond the work itself. The effects of aerial perspective are outside the scope of sculptors' work; they can neither represent transparent bodies nor luminous bodies nor angles of reflection nor shining bodies such as mirrors and like things of glittering surface, nor mists, nor dull weather, nor an infinite number of things which I forbear to mention lest they should prove wearisome." [25]

Such an argument is a typical example of the logical fallacy known as *petitio principii*.[26] It assumes that the aims of painting and sculpture

24. Leonardo da Vinci, *The Literary Works*, ed. and tr. J. P. Richter and Irma A. Richter, 2nd rev. edn. (New York and London, 1939), I, 91.

25. *The Notebooks of Leonardo da Vinci,* ed. Edward MacCurdy (London, 1938), II, 229. Cf. American edn. in 1 vol. (Garden City, N. Y., 1941–42), pp. 854f.

26. "Begging the question."

are the same and that they are but different means of achieving the same end, which Leonardo gave as the imitation of all the visible works of nature, Berenson's "higher coefficient of reality." Throughout all Leonardo's writings on art, there is the supposition that art is a mirror held up to nature and that the work of art is most praiseworthy that is most like the thing represented. Even when Leonardo admits that the painter may have the duty to represent states of mind, then he must translate these too into observable actions. "A good painter," he says, "is to paint two main things, namely, man and the working of man's mind. The first is easy, the second difficult, for it is to be represented through the gestures and movements of the limbs. And these may best be learned from the dumb, who make them more clearly than any other sort of men." [27] This recommendation, to resort to the dumb for an adequate expression of states of mind, we may compare with our resort to the blind for an adequate expression of haptic sensations.

The real prejudice underlying Leonardo's approach to art is the visual one, which in itself is closely related to an intellectual prejudice —the desire not just to realize or represent but to understand and to explain the works of nature. It led, in one direction, to the anatomy of the human figure, and I need not remind the reader how much time and industry Leonardo devoted to this scientific study. In the other direction his intellectual prejudice led to the study of perspective, and in that blind alley all sense of the palpable and ponderable qualities of the object were lost.

The theories of perspective developed by Brunelleschi and others in the fifteenth century had an immense effect on all the arts. However beneficial these influences may have been on architecture and painting —and I have my doubts about the effects of their influence on the latter art—in sculpture their effects were disastrous. We do not always

27. *Das Buch der Malerei,* ed. Heinrich Ludwig (Vienna, 1882), p. 216; quoted in *Artists on Art,* p. 52.

realize that the theory of perspective developed in the fifteenth century is a scientific convention; it is merely one way of describing space and has no absolute validity. G. R. Kernodle has shown how the theory was applied to the box-frame of the Renaissance theater, and the painter's frame is just such an arbitrary rectangle through which one sees an imaginary scene disposed in depth.[28] Such was the perspective imposed on the sculptor. Instead of situating his objects in a space to be directly realized by the senses, he was required to imitate the painter to the extent of situating his objects in an illusory frame of reference, perspectival space. This perversion of the primary haptic sensibility is very obvious in the stucco and bronze reliefs of the period. A molded frame serves as a proscenium, the scenery is disposed within architectural "wings," and the "space" is then cut off and contained by an architectural "backcloth." Within this box the figures perform as on an actual stage but frozen in some particular attitude. The sculptor imagined that he had created the illusion of space, but what is "space" in this sense but *a* space, a "place" in the Greek sense, and essentially a pictorial artifice? The same illusion was aimed at in reliefs less theatrical in their conception, as in Desiderio's *The Young Christ with St. John the Baptist*.

[71]

[70]

What should be equally evident is that any sculptor who starts out with painterly prejudices tends to approach his three-dimensional task from the same theatrical point of view. He is situating his object in an artificial box, the front of which may be "read off" with purely visual faculties just as we "read off" a painted picture. The object faces an audience, and as in a piece of scenery on the stage what is *not* seen need not correspond with what *is* seen. It is difficult to illustrate this divergence in sculptural quality in a book, but several of our plates give more than one view of a piece of Renaissance sculpture, and a

28. *From Art to Theater: Form and Convention in the Renaissance* (Chicago, 1944).

striking difference in tactile values as between the front and the back is obvious. The Greek law of frontality—Hildebrand's "unchangeable law of nature"—persisted throughout the entire Renaissance period.

If the artist has succeeded by these means in giving us aesthetic satisfaction, what harm, we may ask, is done? For centuries the Western world has admired this kind of sculpture. Must we now be robbed of our simple pleasures? Of course not; as one kind of sculpture, giving a specific though a limited pleasure, the typical reliefs of the Renaissance are justified. The aesthetics of relief sculpture cannot be wholly identified with those of painting. There are problems of texture, of the conveyance of three-dimensional qualities by means of actual light and shade rather than by color and chiaroscuro, that distinguish a carved or modeled relief from a panel painting of the same period. Into his [102–106] reliefs, such as the *Lamentation* in the Victoria and Albert Museum, and the later panels on the pulpit in San Lorenzo, Donatello put all the expressive power of which a "painterly" art is capable, but the reliefs remain essentially painterly (*malerisch*). As I hope to show in subsequent chapters of this book, there are other qualities that can be conveyed *only* by the art of sculpture, but by an art of sculpture completely emancipated from painterly prejudices.

68

CHAPTER FOUR

The Realization of Mass

The distinction between sight-space and touch-space, to which I referred at the beginning of the last chapter, had the effect of disengaging, from the purely visual apprehension of reality, the quantity known as *volume* or bulk. If, in addition to touching an object, we lift it or try to lift it, we get a sensation of its *ponderability* or mass. We may have an intuition of ponderability without actually lifting the object, merely from our generalized knowledge of the relative weight of such materials as marble, clay, bronze, and lead.

Our knowledge of an object is complete only when we have exhausted all our sensational reactions to it. Taste and smell are normally excluded from the aesthetic field. Sound is so distinctive as a sensation that the aesthetics of music has its separate vocabulary, and we can only trace analogies between this art and other arts. But the other two sensations, sight and touch, are both actively engaged in our aesthetic experiences, and it is often very difficult in any given case to dissociate entirely our visual reactions from our tactile reactions. Even when one organ is not directly involved, as when we look at a surface,

a whole series of associations based on the tactile knowledge of surfaces may be aroused. It is a false simplification to base the various arts on any one sensation, for what actually takes place, in any given experience, is a chain reaction or *Gestaltkreis* in which one sensation touches off and involves other sensations, either by memory association or by actual sensory motor connections. An art owes its particularity to the emphasis or preference given to any one organ of sensation. If sculpture has any such particularity, it is to be distinguished from painting as the plastic art that gives preference to tactile sensations as against visual sensations, and it is precisely when this preference is clearly stated that sculpture attains its highest and its unique aesthetic values. This peculiarity does not mean, of course, that we can discount our visual reactions to sculpture; nor does it mean that we refuse any aesthetic value to sculpture that is visually conceived. We are seeking the basic principles of this art, and these, I contend, involve tactile sensations.

Jean Piaget has shown, in one of his fascinating studies of the mental development of the child, how the child arrives at a quantification of qualities—how he passes from the conception of number and numerical relations such as the relation of parts to the whole (quantities that may be called "intensive" or logical), to a conception of "extensive" quantities such as weight and physical volume. The conscious awareness of these sensations, like the awareness of space that we dealt with in the last chapter, is not given at birth: it has to be acquired by a patient process of learning.[1] A child does not take long to learn that an object is solid or heavy or that it emits light or heat. Not merely the measurement of these quantities, however, but a comparative estimate of them is only slowly evolved. Our knowledge of the external world is due to a gradual sorting out and comparison of such quantitative estimates.

1. Jean Piaget and Bärbel Inhelder, *Le Développement des quantités chez l'enfant* (Neuchâtel and Paris, 1941).

70

Consciousness is selective, and people can be divided into psychological types according to the predominance of any one sensation in the imagination. Thus there are visual types, tactile types, and audile types. There is perhaps a normal type in whose mind the imagery due to the various sensations is evenly or appropriately mixed, but there can be no doubt that the acuteness of some one type of imagery determines whether an artist becomes a poet,[2] a musician, a painter, or a sculptor. Similarly, the strength of our reactions to one or another of these arts, our particular preference among the arts, is due to the relative acuteness in ourselves of one type of imagination. We may expect, therefore, to find visual types who have no appreciation of the tactile values of sculpture; and as I suggested at the end of the preceding chapter, we may even find visual artists like Leonardo who conceive and execute sculpture with a predominantly visual equipment. It was Hildebrand's contention, in his treatise *The Problem of Form in Painting and Sculpture,* that the unity essential to a work of art can be achieved only in vision and that the sculptor strives to accommodate his three-dimensional forms to the visual ease of a two-dimensional surface. That is the heresy I wish to contest in this chapter. My intention is to show that sculpture owes its individuality as an art to unique plastic qualities, to the possession and exploitation of a special kind of sensibility. Its uniqueness consists in its realization of an integral mass in actual space. The sensibility required for this effort of realization has nothing in common with visual perception, i.e., with the visual impression of a three-dimensional form on a two-dimensional plane.

The specifically plastic sensibility is, I believe, more complex than the specifically visual sensibility. It involves three factors: a sensation of the tactile quality of surfaces; a sensation of volume as denoted by plane surfaces; and a synthetic realization of the mass and ponderability of the object.

2. The poet is a special case, perhaps, because there are "visual" as well as "musical" (audile) poets, and no doubt a good poet is fairly acute in all his senses.

It is very difficult to convey the nature of these sensations by descriptive words or even by photographic illustrations. Ideally each reader of this volume should be provided, at this stage, with a piece of sculpture to hug, cuddle, fondle—primitive verbs that indicate a desire to treat an object with plastic sensibility.

A sensibility to surface quality is involved in other arts. Even the surface quality of a painting has considerable aesthetic significance, as we may realize if we compare the surface of a painting by Rembrandt with the surface of a painting by Vermeer. Surface is one of the elements of a painting's "facture." Even the surface quality of a sheet of paper used for a drawing or an engraving or even for writing, is of considerable aesthetic importance. Surface plays its part in all metalwork and ironwork, in jewelry and textiles, and is of supreme importance in the art of pottery. It would not be necessary to insist on the aesthetic significance of surface impressions in sculpture had there not [119] grown up during and since the Renaissance a convention based on the ideals of the Hellenistic decadence. This convention systematically tended toward the denaturing of all materials and toward the choice of certain materials, like pure white marble, devoid of any surface irregularities and therefore not emphasizing the materiality of the sculptural mass. The problem is not one of smoothness: smoothness, polish, and a [120, 121, scintillating surface can be used for aesthetic effect, as in certain Ren-
125–127] aissance bronzes. Pieces such as these exploit the smooth surface as a reflector of light, producing an effect I shall discuss at greater length in a later chapter. In the typical academic statue of white marble, however, the surface is monotonous and dead. The object seems to be to produce the visual impression of a plane surface shaded like white paper. To secure the opposite effect—to call attention to mass—the mod-
[205] ern sculptor tends either to use stones that are mottled or striated or to leave a rougher surface, even one showing the marks of his chisel or hammer. He has to a large extent abandoned the immaculate marbles

72

of the pseudoclassical tradition and uses instead a wide variety of stone, wood, metal, or indeed any material that offers a surface aesthetically stimulating, especially to the tactile sensibility.

Still, important as they are, there is nothing specifically sculptural about such surface aesthetics, so let us pass to the more difficult problem of volume.

Rodin related, in his conversations with Paul Gsell, how he came to realize the importance of relief in sculpture. This subject was taught to him by a sculptor called Constant, and one day Constant was watching Rodin as he modeled in clay a capital decorated with foliage.

"Rodin," he said to the young student, "you are going about that in the wrong way. All your leaves seem flat. That is why they do not look real. Make some with the tips pointed at you, so that, in seeing them, one has the sensation of depth."

Rodin followed his advice and was amazed at the results he obtained.

"Always remember what I am about to tell you," Constant went on to say. "Henceforth, when you carve, never see the form in length, but always in thickness. Never consider a surface except as the extremity of a volume, as the point, more or less large, which it directs toward you. In that way will you acquire the *science* of modeling."

This principle, said Rodin, had quite astonishing results: "I applied it to the execution of figures. Instead of imagining the different parts of a body as surfaces more or less flat, I represented them as projectures of interior volumes. I forced myself to express in each swelling of the torso or of the limbs the efflorescence of a muscle or of a bone which lay deep beneath the skin. And so the truth of my figures, instead of being merely superficial, seems to blossom from within to the outside, like life itself." [3]

Rodin's observation may seem simple, even naïve to those who are

3. *Art,* tr. Mrs. Romilly Feden (Boston, 1912), pp. 63–65.

73

accustomed to the art of sculpture either as sculptors or as amateurs. Nevertheless for the average person brought up to approach every work of art with binocular vision, this kind of vision, from depth to surface or from surface to depth, requires a new effort, a re-education of the senses.

Even more difficult is the third aesthetic effort of apprehension involved in the art of sculpture, what I have called a synthetic realization of the mass and ponderability of the object. This sensation is comparatively easy to convey in the case of small objects. We feel the hard roundness of the pingpong ball and may even get an aesthetic satisfaction from that sensation. We react aesthetically to the feel of the handle of a stick and to many other solid objects that we habitually use. The [40] Chinese and Japanese have developed a class of small objects carved out of such materials as jade, amber, and ivory, some of which are carried in the pocket and fondled from time to time. Some people treasure pebbles in this way, and a few pieces of modern sculpture have been produced with the intention that they be fondled.

This sensation of palpability, so evident in the small object, is felt by the sculptor toward his carving, *whatever its size*. It is one of the essential faculties engaged in the appreciation of sculpture. In his description of the mental process here involved which I quoted in the Introduction, Henry Moore has emphasized this sense of physical possession. The sculptor "gets the solid shape, as it were, inside his head—he thinks of it, whatever its size, as if he were holding it completely enclosed in the hollow of his hand. He mentally visualizes a complex form *from all round itself;* he knows while he looks at one side what the other side is like; he identifies himself with its center of gravity, its mass, its weight; he realizes its volume, as the space that the shape displaces in the air." [4]

4. Henry Moore, "Notes on Sculpture," *and Drawings* (2nd edn., New York, in Herbert Read, *Henry Moore: Sculpture* 1946), p. xl.

74

On the same occasion, Henry Moore made a generalization that will serve as our point of departure for a consideration of the historical development of these qualities in the art of sculpture. "Since the Gothic," he said, "European sculpture had become overgrown with moss, weeds—all sorts of surface excrescences which completely concealed shape. It has been Brancusi's special mission to get rid of this overgrowth, and to make us once more shape-conscious. To do this he has had to concentrate on very simple direct shapes, to keep his sculpture, as it were, one-cylindered, to refine and polish a single shape to a degree almost too precious." Moore then went on to claim that it was no longer necessary thus to restrict "sculpture to the single (static) form unit." Several forms of varied sizes, sections, and directions could be related and combined into one organic whole.[5]

Obviously the need to grasp the sculptured object in its palpable unity will impose certain limits on the art of sculpture. It cannot become too complex, too articulated, or even too large without sacrificing this aesthetic quality. Perhaps for this reason the greatest sculpture always has a certain compactness. Michelangelo, whose work has this [99–101] compactness, said that only those works were good that could be rolled from the top to the bottom of a mountain without breaking. Such irrefragability not many Greek masterpieces possess; when we think of Greek sculpture, we tend to visualize a torso that accidentally has lost its head and at least a couple of limbs. Our own bias merely confirms the visual bias of Greek sculpture, its conformity to that law of frontality that evaded the difficulties inherent in any realization of integral mass. For the sake of compactness and superficial integrity, [193] limbs may be deliberately omitted.

In order to achieve this integral feeling for volume and mass, two steps were necessary: the emancipation of sculpture from its architectural background or function, and reduction to a scale that enables

5. Ibid., p. xli.

75

the sculptor to grasp the material in his hands. I have already dealt with the first step; in general, sculpture had to wait for economic developments that created a demand for small portable pieces. Even in Egypt and Greece, however, and farther afield in China and Mexico, a demand had always existed for small cult objects, tomb figurines, clay dolls, ornaments, and jewelry, which gave rise to a class of objects of miniature size. Sometimes these are merely symbolic icons of no aesthetic interest, mass-produced and slurred in execution, but the best of the Chinese tomb figures (T'ang Dynasty, 618–906), the Greek Tanagra figurines, the Egyptian so-called servant statues, and the Mexican cult objects have a complete plastic integrity and must be considered as works of sculpture that fully satisfy our aesthetic criteria. Once one is rid of the prejudice of monumentality, whole groups of objects not normally classified as sculpture take on sculptural significance. The ancient Chinese bronze vessels, for example, were made by a process that is essentially sculptural: a model of the vessel was first modeled in wax over a core of clay, and the decoration was applied in relief. The final decorative details were carved or incised on this wax model. The model was then covered with several coatings of liquid clay, each in its turn being allowed to dry. The coated wax model was then fired, the wax melting and escaping through prepared vents but leaving its impress inside the hollow coat of clay. Liquid bronze was poured in, filling the space formerly occupied by the wax. The resulting vessel, cast in bronze, is therefore a replica of a sculptured object. With minor variations, this is the process by means of which bronze sculpture in general has been made.

At this point I shall deal briefly with the controversy that has raged in recent years over the respective methods of modeling and direct carving. Michelangelo, it will be remembered, said that when he spoke of sculpture, he meant the sort that is executed by cutting away from the block; the sort that is executed by building up, he said, resembles

[32, 33, 57–60]
[140, 141, 149]

[44, 45]

[47, 49, 50, 52, 53, 55, 180, 210]

painting.[6] There is, of course, a profound difference between these two techniques, but there can be no absolute difference of aesthetic worth: the essential sculptural values of significant form can be achieved by either method: the sculptural mass is there, and what difference there is is a difference of surface treatment. This difference, as we shall see later, can be deliberately exploited, but its anti-tactile effect can be mitigated either by carving the surface of the model before it is cast or by finishing off the bronze with hammer and chisel or file. Each method has its dangers. Modeling tends not only to looseness and imprecision of form but also to a preoccupation with surface effects to the detriment of mass. Cutting tends to monolithic rigidity, to a fear of freedom. A good sculptor will choose the method that best fits the particular form-conception from which he starts, and he will realize, as Ruskin said, that "what is true of chalk and charcoal, for painters, is equally true of clay, for sculptors; they are all most precious materials for true masters, but tempt the false ones into fatal license."[7]

[135–139, 144]

[134]
[6]

I think there is little doubt that the emancipation of sculpture came about through an increasing concentration on the model or maquette. The Greek sculptor did not use a model: he cut into his marble block free-hand.[8] "The first mention by ancient writers of clay models for statues is that of Arkesilaos and Pasiteles, both sculptors of the first century B.C."[9] But modeling was used extensively for bronze, and bronze was "probably the commonest material of Greek sculpture and certain distinguished sculptors, like Polykleitos and Lysippos, worked almost exclusively in that material. It is largely due to this circumstance that so few original works by the greatest Greek artists

6. See p. 62, above.
7. *Aratra Pentelici* (London, 1870), vi, 156 (*Works*, XX, 311).
8. For a detailed account of the technical methods of the Greek sculptor see Stanley Casson, *The Technique of Early Greek Sculpture* (Oxford, 1933).
9. Gisela M. A. Richter, *The Sculpture and Sculptors of the Greeks* (New Haven and London, 1930), p. 141.

have survived; for the intrinsic value of bronze caused it to be melted down in later times; and this brought about the destruction of a large output of Greek art." [10]

[61] An essential distinction exists between Greek bronze sculpture and Greek carved sculpture, and it is not merely a difference due respectively to a "plastic" and a "glyptic" technique. The bronze figure, though stylistically related to the major development of Greek sculpture, is always integral: it is complete in itself. The carved figure is always conceived and executed for its architectural setting, and out of sight is generally out of mind. There was no need for an integral form, and the Greek sculptor did not hesitate to take advantage of this facility. To quote Dr. Richter again: "It is interesting to observe the treatment by the Greek sculptor of the backs and other parts of his marble figures when they did not show. As a general rule he seems to have carefully finished only those portions which were visible. When a marble statue was exposed to view where it could be seen from all sides it was equally finished all around. But when a statue was seen only from the front or the side, not from behind, as in the pediment figures, the back did not generally receive the same attention. The tool marks were often not removed and even the modeling is sometimes only cursory; but the composition of each figure as a whole was carried out. On the other hand there are instances when the backs are beautifully worked even when they did not show, as in the Aigina and the Parthenon pediments. Single statues when intended to be placed against the wall or where the back was not seen are likewise often unfinished behind. We may mention as examples the Hermes of Praxiteles, the Zeus of Mylasa, and the standing youth in Boston. . . . In other words the attitude of the Greek sculptor was the same as that of the Greek potter—he did not waste labor where it profited nobody." [11]

This whole idea of "wasted labor" shows how far the Greek sculp-

10. Richter, pp. 135–36. 11. Ibid., p. 145.

tor was from the integral conception of the work of art that we now regard as essential to any complete aesthetic achievement. The Greek sculptor, and the Greek citizen who looked at sculpture, remained the spectator *ab extra;* but plasticity, as Hugo von Hofmannsthal once said in a pregnant phrase, "develops not through observation, but through identification." Commenting on this aphorism, Hermann Broch went straight to the heart of the problem I am dealing with—a problem of orientation, of reorientation. Hofmannsthal's aphorism, he remarks, "is a word of advice to the artist, and it implies: As long as objects are to you merely an antithesis to your 'I,' you will never grasp their real essence, and no amount of intensive observation, description or copying will help you to do so. You may succeed, however, if you are able to divest yourself of your 'I' by projecting it into the object so that the object can begin to speak in your stead. For you yourself, a single individual facing a single object, have only your subjective impressions, have thus like the animal-soul hardly a language, at best mere sounds of terror and delight, of warning and enticement, at most exclamations such as *Oh!* and *Ah!*; whereas real language perpetuates not only the momentary impression of objects but their essence, hence requiring a far more intimate, richer, more subtle relationship with them than animals have. And this second immediacy (as we may call it, since insight springs therefrom) is achieved exclusively by the surrender of the 'I' to the object. He, however, who is satisfied with subjective exclamations is no artist, no poet: confession is nothing, insight is everything." [12]

There was no surrender of the "I" in classical Greek sculpture: it remained coldly observed, in conception, in execution, in contemplation. Insight was not possible because immediacy was not present: the immediacy that enabled the artist to identify himself with the object,

12. Hermann Broch, introduction to (New York [Bollingen Series XXXIII] and Hugo von Hofmannsthal, *Selected Prose* London, 1952), p. xi.

79

[90] to project himself into the work of art so that the work of art "begins to speak" in place of the artist. Only in rare bronzes, usually of the Hellenistic period, has this process of identification taken place.

We may assume that the rarity of identification in Greek sculpture is due to the accidental reason already given, the destruction of much of the small sculpture of the period. Otherwise the prerequisites of the process—the emancipation of sculpture from an architectonic function and the presence of a prevailing humanistic spirit—were achieved in the classical period. They were not to recur until the Renaissance, and again the necessary emancipation and integration of sculpture were to be effected through *Kleinplastik* or miniature sculpture, more particularly through the growing practice of working from the wax model, and through the growing demand for secular bronzes.

Before dealing with this development, we must account for the intervening phase of sculptural evolution that occupied the Gothic period. I shall deal with this development mainly in the next chapter, under the heading of "The Illusion of Movement." Until the end of the thirteenth century, the evolution of Gothic sculpture was determined by principles distinct from both classical sculpture and modern sculpture. The basis, which in itself was distinct from any previous aesthetic conception, was an organic conception of building itself, not merely the building as an architectonic unit, which could always be a geometrical and intellectual conception, but the building as a dynamic organism intimately related to and reflecting the social organism of the Christian community. If one can imagine an independent sculpture within such a unified conception, it would be a sculpture that detached itself from an architecture merely to make more obvious its obeisance to the overruling spirit, its formal orthodoxy. Granted such ideals, what I have called an integral conception of sculpture was scarcely possible. Nevertheless, at the end of the thirteenth century and during the fourteenth century, we do see the emergence of such an ideal, notably in

the work of Arnolfo di Cambio and Giovanni Pisano and still more [72–74, 76]
clearly in the work of Tino di Camaino, to which only Dr. Valentiner [75, 78, 79]
has done full justice.[13] It is significant that all these artists had a bias
toward commissions that implied sculptures standing free from the
actual fabric of the buildings in which they worked—pulpits, fonts,
fountains, and tombs. We also know that Giovanni expressed a desire
to concentrate on the carving of ivory figures—on *Kleinplastik*, that is
to say—an example of which survives in the Sacristy of Pisa Cathedral.
In his work on a larger scale there is a feeling for the compactness
of mass and for the ponderability of the figure that is quite new in the
sculpture of the period. His last recorded work, the *Virgin and Child*
at the Cathedral of Prato, is usually compared with the ivory *Virgin*
from Pisa, and with good reason, for the form of the stone sculpture
has been influenced by the form of the smaller work in ivory.[14]

This new tendency, it seems to me, achieved complete plastic in-
tegrity in Tino di Camaino's work. A contemporary of Giotto, Tino
brings to sculpture not only the same austere humanism but also the
same sensibility for the formal integrity of the human figure. For the
first time in European monumental sculpture, the human figure is real-
ized *in the round* and not as a relief more or less subordinate to an
architectural background.

Another possible way to freedom lay through the development of
city planning and through the consequent use, for decorative purposes,
of free-standing statues. The sculpture of the Italian Renaissance of
the period before Michelangelo attains its greatest dignity in two
equestrian statues—the Gattamelata statue (*c.* 1450) at Padua by Dona-
tello and the Colleoni statue (1481–96) at Venice by Andrea del Ver- [5]
rocchio and Alessandro Leopardi. Such statues still have an architec-

13. Cf. W. R. Valentiner, *Tino di* *His Life and Work* (Paris, 1928), p. 36
Camaino, tr. Josephine Walther and rev. and pl. 90 (the ivory *Virgin*), pp. 47– [76;
R. H. Boothroyd (Paris, 1935). 49 and pl. 120 (*Virgin and Child*, cf. 179]
 14. Adolfo Venturi, *Giovanni Pisano*, Prato).

tural function, and their architectural pedestals unite them, or were intended to unite them, with the surrounding buildings. They are still spectacles to be viewed in a perspective of buildings and not to be realized in themselves and as distinct palpable presences. Presumably Leonardo's projected equestrian statue, which never got beyond the stage of the clay model, would have taken its place alongside the Gattamelata and Colleoni statues as one of the highest achievements of Renaissance sculpture; but all these statues, inasmuch as they were conceived and designed within a picturesque conception of architectural unity, remained, as we observed in Michelangelo's *David*, limited to a visual conception of the function of sculpture.

[122–124]
[116–118]

[132, 133]

All through the Renaissance, in fact, the development of sculpture may be interpreted as a struggle between the plastic and the painterly, between the palpable and the visible, between integral mass and the perspectival complex. The painterly conception of sculpture won the day: mass was dissolved in fluid atmosphere, and Michelangelo was followed by Giovanni da Bologna, by Benvenuto Cellini, and, eventually, by Bernini and Canova. I do not suggest that no great works of art were produced by sculptors in Italy after Michelangelo. I do maintain that the painterly conception of sculpture that triumphed during the Renaissance was based on a false aesthetic and that it inevitably led to the progressive degeneration of the art throughout the seventeenth, eighteenth, and nineteenth centuries. This may be an accepted truth, but it is perhaps still necessary to expose the weaknesses that, present in the painterly conception at its best, lead with logical inevitability to the horrors of academic sculpture at its worst.

The painterly conception may be best appreciated in such a modest sketch as the terra-cotta maquette by Giovanni da Bologna that is a study for a fountain figure modeled probably about 1575. It is built up by what Michelangelo called the painter's technique—the sensitive application of little dabs of clay, laid on with an instinctive flick

of the spatula or finger that gives a liveliness to every part of the sur-face. The general composition has a flowing rhythm very appropriate to the subject, and this rhythm turns in on itself and completes its movement, giving the figure a plastic unity. It can be viewed satis-factorily from any point of view, and for sculptural integrity all it lacks is any sense of outward thrusting mass and inwardly held tension. In other words, the plastic clay moves gracefully within a confined space and creates a surface unity of great charm. It is the beauty of a turban swathed round a head with perfect skill and taste: we admire the turban but have no idea of the shape of the head underneath.

One may look at a more elaborate example, Bernini's *Ecstasy of* [118] *St. Teresa* in Sta. Maria della Vittoria, Rome. The illustrations of this group do not usually give any idea of its architectural setting. It deco-rates the family chapel of the Venetian Cardinal Cornaro and is en-closed within gilded Corinthian capitals and twisted pediments that form a proportionate architectural frame; it is lit artificially from above, and the whole conception is so theatrical and is "produced" with such effect that an extraordinary illusion of dramatic actuality is created. Yet an illusion it remains: an impression created by light and shade, by visual perspective within a two-dimensional frame, for the creation of which effects sculpture is used as the most difficult rather than as the most appropriate medium. We may gasp in admiration; never did a sculptor so transform marble into such plastic rhythms. A painting might have achieved the same effect equally well, but by now a paint-ing would have faded, would have perished or would have been re-stored by other hands. Bernini's group has defied time. We should not despise such a technical feat. We need not despise it, but in its pres-ence we are denying ourselves the specific sensations that sculpture, and sculpture alone, can provide.

For the impact of this sensation in all its purity we return to Donatello—to Donatello who, as Adrian Stokes has said, "was in revolt

from the statuesque." I am not quite sure that this term "the statuesque" is the right one. I understand Mr. Stokes's meaning, however, for he goes on to say, in *The Quattro Cento*, a book rich in sensitive appreciation of the art of sculpture, that Donatello "felt the need for simplification, for a supreme, purely aesthetic *relevance* pervading every atom of humanistic ardor," and that he achieved this aesthetic relevance through a concentration on the *putto,* the *amorino,* the little [91] naked male child that escapes into freedom from the confines of the statuesque. "In the symbol of the putto," he writes, "the new ambitions of the body found a wide expression. The animal functions of infants are in themselves symbols to adults of the most profound release. They should have been permitted us: they are symbols of the freedom we cannot win. . . . The putto is a pagan emblem to those overburdened by a sense of guilt, an emblem that corresponds to so universal a desire for freedom that indecency of putti was indecency to no one." [15]

But the putto was more than *symbolic* of freedom: he was freedom in the sense that he embodied the sculptor's escape from the linear, from the painterly, from the two-dimensional world of the draftsman. He is the rounded, the caressed and palpable mass, and it was from his small frame that the whole concept of integral sculpture had to grow. But it took centuries. The eye is so quick, so immediately "on the spot," and the appeal of color is so potent, the rhythmic movement of line is so easily picked up by the eye, that the relatively slow, groping approach to mass and volume was ignored as a controlling principle. Naturally any piece of sculpture has volume: it is a crude mass of some sort. But the aim of a sculptor like Bernini and indeed of the whole tradition of sculpture—until late in the nineteenth century Rodin began to reconsider the aesthetics of sculpture—was to create a pictorial illusion in which the ponderability of the material was etherealized, an effect that the sculptor's favorite material, white marble, usually made

15. (London, 1932), pp. 130–31.

all too easy. The sculptor worked with and for the eye and never conceived his work as possessing any other unity than that of a visual image.

The mind, said Rodin, only with difficulty familiarizes itself with the notion of depth. It always tends to play over surfaces. Nevertheless, the sculptor's task is to see surfaces as thicknesses, to conceive form as volume. It may be asked, "Why be so dogmatic about the aims of the sculptor?" The aims of the artist in any material are the same: to produce a certain emotional reaction in the spectator. It is the unique privilege of art to convey a reaction that we may define variously as wonder, pleasure, enhanced vitality, and so on. This particular experience cannot be obtained by any other means than art. As between the various arts, however, one art may be more appropriate or more efficient than another for a desired effect: there are degrees of consciousness that can be expressed only by music, others only by poetry. No real confusion of means has ever existed between poetry and music or even between poetry and painting, though the relationship between these arts has been endlessly discussed. A very real confusion has always existed between the arts of sculpture and painting, however, a confusion due to the psychological fact that no clear separation is made in experience between the faculties of sight and touch. No clear separation *can* be made by people possessing both faculties in normal strength. Nevertheless, distinct reactions are experienced according to whether we give priority to sight and are satisfied with the visual image, or whether we give priority to touch (or imagined touch and haptic sensations generally) and prefer the palpable image. I know that we can get on quite well with a life of visual sensations, with perhaps a merely subcutaneous or subconscious life of tactile sensations. Still, that is not the point. Art is the sensuous apprehension or plastic cognition of the world: its purpose is to increase our sense of the wholeness of being, to develop our consciousness of reality. In that

sense it becomes part of our conception of evolutionary purpose, and there is a spiritual as well as a physical joy in the experience of such a conquest. To confine sculpture to the field of visual sensation is to neglect the possibilities of the field of palpable sensation. It is a restriction of the range or scope of art, and it deprives the sculptor of a challenge that in the past has given rise to the greatest achievements. Michelangelo is not superior to Bernini in technical accomplishment or in any of those tricks that create what we call "the living image." He is greater because his work is informed by a generative power that we can identify with natural forces. Great works of art, said Rodin, "express, indeed, all that genius feels in the presence of Nature; they represent Nature with all the clearness, with all the magnificence which a human being can discover in her; but they also fling themselves against that immense Unknown which everywhere envelops our little world of the known. For, after all, we only feel and conceive those things which are patent to us and which impress our minds and our senses. But all the rest is plunged in infinite obscurity. Even a thousand things which should be clear to us are hidden because we are not organized to seize them." [16] The function of art, Rodin went on to say, is not only to tell us all that can be known but to make us aware that there is a limit to what is known. Great works of art bring us to the edge of this abyss, and they make us feel a little dizzy.

It is a question of gamut, of the possible range of sensational apprehension and expressive power. There is, in the full scale of plastic sensibility, a power attaching to ponderability and mass, to the gestated and palpable volume of a solid creation, that cannot be experienced in any other manner, by any other means. Sculpture declined as and when it lost the feeling for these qualities; it has revived in our time precisely because certain of our sculptors have recovered that feeling. The sculptor who was responsible for the recovery of the true tradition of the

16. *Art*, p. 181.

art was, as I have already said, Rodin; yet even Rodin was still seduced by dramatic effects that are predominantly visual in their appeal, by a surface play of light and shade that has no relevance to the mass beneath. He was, after all, a contemporary of the Impressionists. Hildebrand, who was a contemporary of Rodin and whose treatise on sculpture is so representative of the whole Renaissance tradition, had a clear conception of the process of artistic creation, but he was willing to sacrifice the palpable values of mass to the visual unity of a plane surface and was therefore logically driven to the absurd proposition that the ideal sculpture is relief sculpture. It was left to their successor, Aristide Maillol, to represent plastic form in its essential massiveness, [130, 131] to allow it to stand resolutely and assertively in space. A torso by Maillol is a palpable reality: we may apprehend it visually, but the eye is not pandered to, is not flattered. The forms are expressed from a vital depth, and our sensations, if we become aware of them, are sensations of thrust, of weight, of solid existence. The same sensations, as organic forces embodied in a nonfigurative or "abstract" form, are [Frontispiece, 202] aroused by the sculpture of Jean Arp.

The Illusion of Movement

At first it would seem that there is an essential contradiction between sculpture and movement: a statue is something that stands, and the word itself comes from the same Latin root as the word "static." Nevertheless, underlying the whole development of sculpture from classical times, and very insistent in our own times, is the desire of the artist to represent movement. I say "artist" because the same desire has always excited the painter, and the methods adopted by the painter and the sculptor have often been quite similar. It is only recently that the sculptor has adopted what might have been an obvious means at any time: he has made his sculptured object actually move, like a windmill. That method, to a classical sculptor, might have seemed like cheating!

Apart from such actual movement, which I will consider later, the artist can give merely the *illusion* of movement. He can create this illusion in two ways only. One, which is common to painting and sculpture, is to compose in rhythmical and usually linear sequences so that the eye, following the sequential forms, so stimulates the mind that an hallucinatory sensation of movement is set up. This is most clearly illustrated in certain modern paintings, where the actual forms of the

objects depicted are duplicated and reduplicated in serial repetition, as if several separate shots of a cinecamera were printed over one another. The technique may actually have been suggested to the modern painter by the cinematograph, and was first fully exploited by the Italian futurists. Giacomo Balla's *Abstract Study of Velocity* (1913) [38*a*, 39] and Marcel Duchamp's *Nude Descending the Staircase* (1912) and *Sad Young Man in a Train* (1912) are examples of this experimental technique.

I shall try to show that the desire to "substitute the dynamic principle of the universality of life for the static principle of classic art," [1] a formulation of the aims of modern art that we owe to Moholy-Nagy, is one of the essential features of contemporary sculpture distinguishing it from the sculpture of the past. It would be a mistake, however, to assume that the same desire, perhaps in a less conscious and less "scientific" degree, did not exist in previous ages. The best example I can give comes from the ancient glyptic art of western Asia, the art of [38*b*, *c*] the Sumerians and Akkadians of the fourth and third millenniums B.C. Among the most characteristic products of this period are the so-called cylinder seals, small rollers made of various kinds of stone, only one and a half to two and a half inches long, but exquisitely engraved with religious and mythological subjects and frequently with processions of animals, these last no doubt connected with fertility cults. These cylinders were used as personal seals or signatures. They were rolled across the clay envelopes containing the tablets on which the cuneiform writing of the period was inscribed, and the tablets and envelopes were baked once the seals had been impressed. We must imagine the cylinder moving rapidly across the soft clay and leaving a trail of animals. The animals would actually seem to move as the cylinder left its trace. An

1. L. Moholy-Nagy and A. Kémèny in P. Morton Shand (Zurich, 1937), p. *Sturm* (Berlin, 1922), as quoted by C. 14. Further reference is given here to Giedion-Welcker, *Modern Plastic Art*, tr. László Moholy-Nagy, *Von Material zu Architectur* (Munich, 1928).

extraordinary dynamic rhythm is produced by the repetitive pattern of the animals' action, their backward sweeping horns and the zigzag pistons of their legs shown against the background of flickering lattice-work.

Comparable effects on a bigger scale were produced in the contemporary relief sculpture that was used to decorate the walls of Egyptian tombs. I am thinking in particular of the magnificent scenes from the mastaba of Akhuthotep in the Louvre (V dynasty, 2750–2625 B.C.), where long processions of servants, dancers, fishers, and animals of various kinds produce by rhythmical repetition an effect of movement. Much later, in the eighth and seventh centuries B.C., but in [64] the same tradition, are the Assyrian reliefs of which there are such fine examples in the British Museum. In all the reliefs of this period, however, the movement has to be read into a sequence of discrete units; there is no attempt to indicate movement in the individual figure. A technique for achieving the latter effect was, I think, first invented by Greek sculptors of the classical period and is best illustrated in certain [182] figures in the Parthenon frieze, carved to indicate the sequential rhythm of a slow procession.

The diaphanous tunics and skirts of the maidens were used by the sculptor to give an over all rippling effect, and this, combined with the disposition of the limbs in the action of walking, seems to give activity to the whole composition. The suggestion of movement is mainly due to the repetition of parallel folds of drapery, here gently kicked forward by the movement of the feet, the projection of the knees, and the swaying of the fringe of the upper garment. The movement is an illusion induced as the eye picks up the successive folds: a spatial vibration is translated into a kinetic sensation. The effect of movement is then intensified by the reversal of two of the figures, who create a kind of counterpoint and thus emphasize the main movement.

Apart from sequential rhythm, the sculptor can only rely on

rhythms self-contained within the statue itself, and again he will rely mainly on drapery and other external aids. The best example is possibly the *Winged Victory* of Samothrace, where an invisible wind, against [181] which the figure is poised for flight, whips the drapery into ripples and fluttering folds that induce in the spectator an acute consciousness of movement. Movement in this case is symbolic: we do not abstract it from the representation, to enjoy it as a distinct dynamic principle; we accept it as part of the theme, winged victory, exuberance, exaltation. The sculptor could not have conveyed his theme so effectively by any other means. It is movement for a purpose, movement as an expressive function, gesture.

Movement can be represented, that is to say, either as an expressive function of the human body or, for its own sake, as kinetic stimulus or enjoyment. It is not always easy to separate the two functions, and in a certain sense movement is implicit in all naturalistic representations of the human body or of animals. Nevertheless it poses a problem of enormous difficulty to the sculptor who dispenses with the extraneous aids of drapery. The usual method is to depict figures engaged in some more or less violent action, especially at some moment of tension or strain—hurling a spear, throwing the discus, brandishing a sword, or taking a leap into space. The best example of this kind of simulated movement is probably Bernini's *Apollo and Daphne*. It is true, there is [116] still a certain amount of external aid—a drapery fluttering round Apollo's loins and a skillfully up-sprouting laurel bush into which the upward straining figure of Daphne is merging. The eye is thus inevitably caught into the movement of the composition; we identify ourselves with the dynamic action of the group.

There is much sculpture of this kind, not only in the baroque period, but throughout the decadence that succeeded it. Indeed, one [107–115, sees that the effort to represent movement in this realistic manner was 178] one of the causes of the decline of the art of sculpture: the agitation,

91

[207–210]

the *de-composition* of the material, destroys all sense of ponderability, all possible appeal to a tactile sensibility. Sculpture became a prickly thicket into which a hand would scarcely venture. Only in certain works of modern sculpture has movement once again been embodied expressively in the formal conception, embodied as instinctive gesture.

A way to represent the movement of the body without recourse to such rhetorical violence was practiced by Rodin. Movement, he pointed out—in the conversations with Gsell from which I have already quoted —is a transition from one attitude to another.[2] An instantaneous photograph does not express movement, because it arrests movement and immobilizes or paralyzes the subject without any indication of the dynamic line of the movement. The sculptor should therefore indicate both the movement that has been completed and the movement that is just beginning. The gestures should stretch, as it were, between two points of equilibrium. Rodin and Gsell looked at a cast of the sculptor's

[188]

St. John the Baptist and observed how the left foot, which seems to press on the ground with all its strength, seems to be balanced by the glance of the figure toward the right. The whole body inclines in this direction, and the right foot advances to grasp the ground. At the same time the left shoulder, which is raised, seems to want to restore the weight of the body to that side in order to help the leg still trailing behind to come forward. The sequence of movements or strains, if "read" by the spectator in this order, gives a powerful impression of actual movement. It is an illusion: it is not even anatomically correct, as a photograph of the same movement would show. Yet the sculptor has achieved his purpose, which was to give us the feeling of an advancing figure.

The sculptor who, apart from Rodin, gave most thought to this problem of expressing movement in three-dimensional form was primarily a painter, Edgar Degas. He confined his modeling—he worked

2. *Art*, tr. Mrs. Romilly Feden (Boston, 1912), pp. 65–89.

almost exclusively in cast bronze—to two subjects of which movement was the essence: race horses and ballet dancers. Once again an impression of movement is conveyed by a disposition of the limbs that carries the eye from one point of equilibrium to the next, but in this example the difficulty of giving a static stance to the figure is avoided by lifting it bodily on a bracket. The desire to represent human beings or animals in movement inevitably leads to a purely visual conception of form, and for that reason Degas's sculpture and, later, Matisse's remain materializations of the painter's vision rather than palpable masses. Matisse's *Slave* (in the Art Institute, Chicago) has the same stance as Rodin's *St. John the Baptist,* but it has no movement, and the slave still seems to wear his chains.

[55, 192]

[188]

All the skill that has been devoted to the suggestion of movement, which in any particular case is not so rationally conceived as our analysis would suggest, has as its object to increase the naturalism, or in the case of a human figure, the humanism of the representation. That has not always been the function of movement in sculpture. At certain periods, notably in the Romanesque and Gothic periods, and now in our own period, the sculptor has become enamored of movement *itself,* and instead of using movement as an expressive element in a total effort to create an illusion of the living body image of which I wrote in the second chapter, he uses the sculptural medium in the second of the manners already indicated, exploitation of movement for its own sake. The means becomes the end: the end is the means.

To object to this as an illegitimate use of an art is to ignore a fundamental distinction that runs through all history—a distinction that arises according to whether the predominant feeling of a society is oriented toward abstract notions, toward things of the spirit, toward any escape from the visible world; or whether a society on the contrary accepts the visible world with confidence and joy, finding its spiritual satisfaction in a unity with nature and in its own fellowship. This

historical distinction, which has always been clear enough to the philosopher, was first applied to the history of art by Wilhelm Worringer, whose little treatise *Abstraction and Empathy* has been the basis for a new understanding of the historical evolution of art.[3]

This is not the place to deal with the distinction either in its philosophical or its broad historical aspects. If we assume that the humanism of classical Greece and of the Renaissance was determined by one kind of volition—a *joie de vivre*—and that the abstract or geometric art of the Celtic North and the art of the Romanesque and early Gothic periods, in so far as the latter was stylistically related to this northern style, was determined by another and opposed kind of volition—a desire to escape from the actuality of life, a desire to create a parallel order of life—then it is obvious that each kind of volition will give rise to a distinct type of art. The kind of consideration that we have just seen preoccupying Rodin in his representation of St. John the Baptist never [175] entered the head of the sculptor of the figure of Isaiah at Souillac. One cannot call such a figure lifeless; on the contrary it expresses far more vitality of a kind than does Rodin's figure. Still, it is vitality for the sake of vitality; it is a kinetic energy driven into the stone without any re- [174] spect for realism. Limbs are elongated to give haptic expression to a downward thrust, a thrust that has as its object not to bear the weight of a figure but to produce a countermovement in the drapery, a wave of parabolic curves. The hem of the prophet's robe is agitated into a geometrical zigzag, and every detail of hair, beard, and drapery is lineated, contoured with lines that create a rhythmic movement within the space occupied by the figure.

This figure dates from the twelfth century. An even better example [172] of such linear play is the tenth- or eleventh-century *Virgin and Child* in York Minster. The unfortunate destruction of the features in this magnificent work of art enables us to concentrate on the purely geo-

3. See p. 10, n. 6.

94

metrical elements of the drapery. There are, of course, bodies to support this drapery, but we get no sense, as we do from the draped procession in the Parthenon frieze, of a vital human being beneath. In the [183–185] Parthenon frieze the women's breasts in all their sensuous beauty were revealed as they would be revealed in any Renaissance representation of the Virgin and Child. Here they are rigorously suppressed; there is no human charm or grace left. There is, instead, an abstract design of extraordinary beauty, a rhythmical pattern as stimulating to the visual and tactile senses as a Gregorian chant is to the aural senses. Perfect examples of this rhythmical etherealization of the human body are found in early medieval representations of the Virgin: a beautiful example from the Auvergne, in wood, originally painted in polychrome, is in the [173] Metropolitan Museum.

These linear rhythms in early Gothic sculpture are just as varied as musical rhythms: one may apply to them conventional musical terms such as *staccato* and *legato*. Contrast, for example, the *scherzando* of the linear rhythm of the tympanum at Vézelay with the *andante maes-* [16] *toso* of the contemporaneous tympanum at St. Peter's, Moissac. Still [17] amusing ourselves with our musical analogy, we may describe these tympanums as linear symphonies, for the general formal conception of concentric arches, tympanum, and lintel represents so many separate movements with their variations and repetitions, their developments of a particular theme—such as that of the enthroned Elders of the Apocalypse or that of the seated Apostles—all bound together by the dominant [17, 18] theme of the Christ in glory.

It was partly this predominating desire for linear rhythm that kept the Gothic statue for so long clamped to the wall, a more or less low relief rather than a free-standing statue. The same movement could also be expressed in a detached figure, as we see in the ivory carvings of the period. Although in its original state this material suggests a treatment [77] in the round, it was frequently sawed and squared into flat panels and [66–69]

95

then was carved as a relief. Sometimes one can see a certain relationship between the shape determined by the original material and the elongation and compression of the design, as in the well-known eleventh- or twelfth-century relief in whalebone of the *Adoration of the Magi* in the Victoria and Albert Museum. One feels a certain tension here between the design and the confined space within which the sculptor had to work. If we compare this relief with a free-standing ivory of the same period, it is possible to suggest that the softer rhythms are related to the freedom of the surface and to the fact that the sculptor was not cutting into a flat surface but was working round a palpable mass, around which he could actually move as he worked. The linear motif is still predominant: we are held to the surface of the object. We are nevertheless at the beginning of an evolution where the line gradually becomes not a dynamic energy playing over a two-dimensional plane but a contour tracing the volume underneath, very much like the contours on a map. Such a technique is not, of course, confined to Europe, as in early Oriental sculpture we find exactly the same development: the lines of the drapery still have a powerful rhythmic function, but at the same time they serve to indicate the outward thrust of the body beneath the drapery. A modern sculptor like Henry Moore in his preparatory drawings will often trace the contours of the forms he intends to mold or to carve.

[67–69]

[170, 171, 176, 177]

To return to Gothic sculpture: the evolution of Gothic art reveals a gradual penetration of these abstract or geometric rhythms by the organic rhythms of nature. The change corresponds to that profound change in religion and philosophy that led from scholasticism to Franciscanism and Humanism. In sculpture it led via Nicola and Giovanni Pisano to Nino Pisano and Donatello. The conception of movement for its own sake, distinct from that of movement as an organic phenomenon, was lost. It was recovered to some extent in the baroque period but once

[80, 81]

more in subordination to architectural motifs. Apart from portrait sculp- [117]
ture, which is a distinct species, the sculpture of the baroque and the
rococo periods—from Bernini to Falconet, Houdon, and the innumerable
artists who contributed their works to the great palaces, churches, and
gardens of the seventeenth and eighteenth centuries—was an art of chi-
aroscuro, involving the dematerialization of the plastic volume of sculp-
ture as such. As such it was superb, and it plays an essential part in the
complete unity of Versailles or the Augustusburg at Brühl. "It plays a
part," however; as we shall see in the next chapter, it does not exist as
sculpture with sculpture's distinct aesthetic. Again, only in *Kleinplastik*,
the bronzes and porcelain figures of the period, do we get a separate
and integral conception of the sculptural object. I should like to give as
an example of such a conception one of Franz Anton Bustelli's por-
celain figures. Bustelli worked in the second half of the eighteenth cen- [35]
tury at Nymphenburg and at other porcelain factories, and his rare
works are masterpieces of sculptural form in which movement is con-
veyed by means of a certain formalization and interplay of plane sur-
faces. Nevertheless these means, which work well enough when the
object can be handled, lead in monumental sculpture, as we shall see
in the next chapter, to a disintegration of mass.

Modern sculpture was to make a distinct contribution to the his-
tory of the art by the creation of a dynamic interplay of plane surfaces.
I have already shown how Rodin introduced the notion of movement
into his sculpture by an impressionistic trick. The arrangement of the
limbs of his *St. John the Baptist* anticipates the apprehension of the [188]
eye: the muscles and pose of the joints telescope two consecutive move-
ments. When he had no limbs to help him out, Rodin produced a lively
effect by a certain rugosity. By using bronze with a reflective surface, [190]
this combination of roughness and smoothness produces a play of light
that, as one moves around the object or moves the object around, gives

animation to it; it seems to move itself. If for this arbitrary roughness of surface one substitutes in the manner of Bustelli plane surfaces of a geometrical outline, one gets a much more accentuated effect. The planes with their arrowlike points strike in all directions and create a machinelike kinetic rhythm. This development is parallel to the early phases of cubism and futurism in painting, and its stylistic origins are to

[164–169] be traced, in the same manner as the painting, to Cézanne and to African Negro sculpture. The final stages of this development in sculpture were divergent: in one direction it led to an exploration of light that gradually eviscerated the solid forms of sculpture and left a sculpture of volume in outline; in the other direction it led to a mechanization of

[211] sculpture, and to the invention of the "mobile"—sculpture in perpetual motion. The first direction will be considered in the next chapter; for the present let us continue with the desire to create first an illusion and then an actuality of movement.

I have already referred to the dynamic principles of the Italian futurist movement. These were expressed in certain attempts to mechanize the human body, to approximate limbs to pistons, and by repetition to give the effect of sequential positions. These experiments are now only of historic interest, because it was soon realized that only a caricature of the human body had been produced and that if movement was the ideal, a machine could express it more adequately than a body with its humanistic associations. The first necessity, therefore, was to dehumanize the elements of sculpture.

This result was first effectively achieved by a group of artists, some with training as engineers or architects, that was formed in Moscow in 1913. In 1920 two members of this group, Naum Gabo and Noton Pevsner, issued a "realistic" manifesto whose aims might be summarized:

1. To communicate the reality of life, art should be based on the two fundamental elements: space and time.

2. Volume is not the only spatial concept.

3. Kinetic and dynamic elements must be used to express the real nature of time: static rhythms are not sufficient.

4. Art should stop being imitative and try instead to discover new forms.[4]

Movement, of course, takes place in time, is only observable as a temporal displacement of matter. That sculpture or painting should attempt to represent this element, apart from motion pictures or objects actually moving in space by virtue of applied energy, would seem to be a contradiction of possibilities. In the early days of this "constructivist" movement, several sculptural machines were made. At its simplest, the sculptural machine is an object like Naum Gabo's *Kinetic Sculpture* of 1922, which was a metal spring that vibrated and that within the area of its vibration produced a "virtual volume." Similar constructions were made by all the members of the group, constructions that, if they did not actually move, suggested movement in purely mechanical terms, as does, for example, Antoine Pevsner's *Dancer* (1927–29). A little later [215] in Berlin, Moholy-Nagy began to construct objects that were also called "kinetic sculptures," and that were moved like machines by dynamos. One of these was a "light display machine," which the artist himself described: "This kinetic sculpture was designed for automatic projection of changing chiaroscuro and luminous effects. It produces a great range of shadow interpenetrations and simultaneously intercepting patterns in a sequence of slow flickering rhythm. The reflecting surfaces of the apparatus are discs made of polished metal slotted with regularly spaced perforations, and sheets of glass, celluloid, and screens of different media."[5]

4. Herbert Read, "Constructivism: the Art of Naum Gabo and Antoine Pevsner," *The Philosophy of Modern Art* (London, 1952), p. 231. This manifesto was printed as a handbill: for a translation see *Gabo: Constructions, Sculpture, Paintings, Drawings, Engravings* (London and Cambridge, 1957); for an extract, *Artists on Art*, ed. R. Goldwater and M. Treves (2nd edn., New York; 1947), pp. 454–55. See also the *Catalogue of the Gabo-Pevsner Exhibition* (Museum of Modern Art, New York, 1948).

5. László Moholy-Nagy, *The New Vision: Fundamentals of Design Painting Sculpture Architecture* (London, 1939), p. 141.

"It seems easy to prophesy," concluded Moholy-Nagy in 1939, "that such types of construction in many cases will take the place of static works of art." [6] And it is true that ever since the 1920's there has been a continuous development of kinetic sculpture, or "mobiles."

[211] "Mobiles" is a term that was invented by an American artist, Alexander Calder, to describe the delicately balanced shapes of sheetmetal or any other suitable material, suspended from wires in more or less complicated combinations, which in movement form an ever changing pattern of color and shadow. The use of a new word to describe these works of art is perhaps an admission that the art of sculpture is no longer in question, and certainly, if we return to our original definition of the art, the appeal of these objects is almost entirely visual. Still, they move in space, and as they move, they define volumes of space. They exist in three-dimensional space just as trees exist in such a space, and they make us conscious of space in much the same way, by waving like branches or trembling like leaves.

Calder's mobiles move in the slightest currents of air, but most of these mobiles, like gramophone records and cinema projectors, require the constant intervention of the spectator. They have to be "pushed around," or some mechanism has to be released to make them "work." This requirement, it seems to me, contradicts one of the unwritten laws of plastic art. For its profoundest effects, art always requires a different kind of effort, the effort of attention or contemplation. Simone Weil said with great acuity:

"The beautiful is that which we can contemplate. A statue, a picture which we can gaze at for hours.

"The beautiful is something on which we can fix our attention.

"Gregorian music. When the same things are sung for hours each day and every day, whatever falls even slightly short of supreme excellence becomes unendurable and is eliminated.

6. Ibid.

100

"The Greeks looked at their temples. We can endure the statues in the Luxembourg because we do not look at them." [7]

We can, in my experience, look at the gentler mobiles of Calder in this way; they are like Gregorian chant and repeat their graceful movements endlessly. We contemplate the movement as such—movement with a defined configuration of space.

There is one other possibility, that the work of sculpture should be conceived for a moving spectator. This is not quite the same as conceiving a piece of sculpture from eight or even eighty points of view, as recommended by Cellini. That conception is merely the addition of eight or eighty static conceptions. In 1950 Gabo was commissioned to [220–223] provide a piece of mobile sculpture for the well of a staircase in a new wing of the Baltimore Museum of Art. He pointed out to the Museum authorities that if a mobile were to be suspended in the middle of the well of the staircase, visitors to the museum would stop on the stairs to watch its movements, and the movement of the people would be obstructed. Let me devise, therefore, he said, a piece of sculpture that requires people to move continuously around it in a spiral direction, and by the time they have finished looking at it, they will be at the top or the bottom of the stairs—they will have been kept moving. The work he created cannot be appreciated fully in an illustration; one must go to Baltimore and climb the stairs.

Apart from these mobile experiments, the constructivists have virtually returned to the principle inherent in Gothic and the pre-Gothic sculpture of the North: the expression of movement by abstract linear means. Again, it is Gabo and Pevsner who have created the prototypes. To a spheric construction in plastic (1937) Gabo gives the title *Fountain*, thereby indicating his desire to represent the movement of water. A *Developable Column of Victory* by Pevsner (1946), a construction

7. Simone Weil, *Gravity and Grace*, tr. Emma Craufurd (London, 1952), pp. 185–86.

in brass and oxidized tin forty-one inches high, may be claimed as a modern equivalent of the *Victory of Samothrace*. It certainly expresses, by formal means, the same humanistic conception of "winged victory."

The relation between these constructions and the objects suggested by the titles given them by the artists is symbolic rather than representational. More often, the sculptor dispenses with such "pointers"; he calls his work simply a construction, and it is a self-contained expression of mass and movement completely unrelated to any specific object in nature. It is, as Gabo has said, "a new reality," as abstract as a mathematical or geometrical model, its beauty created by its intrinsic rhythms and proportions. I know of no better examples of such purely abstract kinetic sculpture than certain carvings by Barbara Hepworth, in which a counterpoint is created between the organic rhythms of the wood and the geometric intervals of the strings stretched across the hollows.

[213]

It will be seen that sculpture of this kind depends for its kinetic effect not only on its general formal conception but on the use of actual lines, in this case strings. In Pevsner's *Column of Victory* the lines are brass wires braised on to a ground of tin sheet. Gabo's *Fountain* also depends for its effect largely on the use of linear strips of plastic, and it is of course obvious that movement is best conveyed by line, as a line is symbolic of the movement of a point. Accordingly, one of the most striking developments in our time has been in the direction of linear sculpture, another apparent contradiction of terms that can be justified in so far as the lines are used tridimensionally to indicate volume. Once more Picasso probably conceived what might be called the operative prototype, in certain wire sculptures that he made in 1928. Some of the earlier works of the constructivists, however, such as Tatlin's *Project for a Monument to the Third International*, which was made in Moscow in 1920, are completely linear in their conception. Alberto Giacometti, who for the past twenty years has concentrated on the devel-

opment of a linear sculpture, uses plastic line both to express movement and to create a conception of space. His early works in this medium, about 1932–34, were often in the form of "projects" for a city square or [207] "place" and consisted of the outlines only of buildings with one or two symbols for human beings or birds suspended within the scaffolding. More lately Giacometti dispenses with the buildings and creates an impression of space simply by the disposition, on a platform, of linear symbols for human figures, instinct with movement. They seem to weave a concept of space by their indicated directions, which are opposed, away from each other. They do not seem to have a common center, and by this ambiguity they create an impression not of perceptual space but of metaphysical space.[8]

I shall have more to say about this linear sculpture, so characteristic of recent developments of the art, in the final chapter. Without doubt a crisis now exists; it will have to be resolved by a return to the tactile compactness that by definition is the distinctive attribute of sculpture or by recognition of a new type of art that transfers the line from a two-dimensional plane, where it has been recognized as the exponent of a *graphic* art, to three-dimensional space, where its function would seem to be to indicate stresses, forces, tensions normally invisible. Just as lightning speaks from the sky in vivid lines of fire when opposed fields of magnetism come into proximity, so these lines of forged steel stretch across space to express the spiritual conflicts of the modern age:

The memory throws up high and dry
A crowd of twisted things;
A twisted branch upon the beach
Eaten smooth, and polished

8. For a distinction between the *sense* of space and the *idea* of space, see Jean Piaget and Bärbel Inhelder, *La Représentation de l'espace chez l'enfant* (Paris, 1948).

As if the world gave up
The secret of its skeleton,
Stiff and white.
A broken spring in a factory yard,
Rust that clings to the form that the strength has left
Hard and curled and ready to snap.[9]

9. T. S. Eliot, "Rhapsody on a Windy Night," *The
Complete Poems and Plays* (New York, 1952), p. 14.

CHAPTER SIX

The Impact of Light

————————

"Light," wrote Cézanne in one of his letters, "does not exist for the painter." [1] By this paradoxical statement he meant to imply that light can and usually does distort the actual form of an object. Its general effect is to fall with obliterating force on those prominent points that it meets and from which it is reflected, and to throw into insignificant shade all parts of an object that lie outside the immediate area of impact. The resulting chiaroscuro can, of course, be exploited as an end in itself, and it was the chief delight of the mannerist painters of the seventeenth and eighteenth centuries. Cézanne, striving to realize the cubic volume and tactile surfaces of the objects he painted, was rightly horrified by such rhetorical devices. He did his best to render colors in their purity, that is to say, with the precise tone values they possess in an evenly distributed light, and he believed that the real form of the object then emerged. "When color has attained richness, form has reached its plenitude." [2]

If this evasion of arbitrary light effects is essential for the painter

1. *Letters*, ed. John Rewald, tr. Marguerite Kay (2nd edn., Oxford, 1941), p. 243 (letter of Dec. 23, 1904, to Émile Bernard).

2. Émile Bernard, *Souvenirs sur Paul Cézanne* (Paris, 1912), p. 37, as quoted in Erle Loran, *Cézanne's Composition* (Berkeley and Los Angeles, 1943), p. 14.

105

in his rendering of three-dimensional form on the two-dimensional surface of his canvas, it is obviously still more important for the sculptor who is striving to create three-dimensional forms of direct sensational appeal. With whatever intention it is created, sculpture is always at the mercy of the light in which it is placed, and since it will often be placed arbitrarily, without any reference to or even knowledge of the artist's original intention, the wise sculptor will take his precautions. He will endeavor to anticipate the impact of light and to modify his forms to receive it.

If sculpture is designed for an architectural setting, the problem is relatively simple. The statue has a niche or pedestal assigned to it, and a single aspect of the statue is presented to the light, which then varies only with the time of year and position of the sun. Even for that relatively simple problem there is no satisfactory solution. The statues that decorate many a west front of a Gothic cathedral may be thrown into almost impenetrable shade in the early hours of the day and will have a maximum effectiveness only for an hour or two of the afternoon or evening. Even then, shadows of a very different effect will be cast in summer and in winter.

The best of such architectural sculpture exhibits what may be called a various life: it is designed for a chiaroscuro effect by the very fact that it is part of an architectural complex with its recessions and projections, its fenestration and crenellation. In our first chapter we found that such architectural sculpture, by its very *raison d'être*, cannot acquire independent sculptural values; it is an applied art, sacrificing its integrity to a superior unity.

The total effect of such architectural sculpture, or sculptured architecture, is best considered as a surface effect, the kind of effect that Monet delighted to render in his paintings of the façades of Gothic cathedrals. The building presents a fretted surface of greater or lesser complexity, and we apprehend it aesthetically as a patterned surface,

an apprehension not essentially different from the aesthetic pleasure derived from viewing lace or filigree or weathered rock. By sacrificing its [224a] formal integrity and distinct ponderability, sculpture can contribute greatly to the effect of intricate tracery. Its purpose is then to break down the impact of light by substituting for the even surface of the wall a complex and varied relief pattern. The same purpose can be achieved by tracery and fenestration and by architectural detailing generally, and it is doubtful whether sculpture would ever have been employed for this purpose had it not been required at the same time to serve the illustrational or didactic purposes of religion. Only in the baroque and rococo periods is sculpture deliberately used in a free rhetorical fashion to produce a surface effect, an abstract play of light and shade. Its tendency then is to become abstract; natural forms approximate to fantastic or ornamental motives. Forms disintegrate under the impact of light in the interests of allover pattern.

Baroque architecture, in its origins and characteristic development, is essentially an architecture of sunlight. That is to say, baroque architecture requires for its maximum effect a strong light, the stronger the better. The distinctive quality of baroque, as many art historians have observed, is dynamic. "The elementary phenomenon is this," wrote Heinrich Wölfflin, "that two totally different architectural effects are produced according to whether we are obliged to perceive the architectural form as something definite, solid, enduring, or as something over which, for all its stability, there plays an apparent, constant movement, that is, change." This effect is partly achieved by purely formal values, by the sculptural techniques analyzed in the preceding chapter; however, the forms are given a further dynamic effect by light. When Wölfflin says that "the impression of movement is only attained when visual appearance supplants concrete reality," he is really thinking of our perception of light effects: "A [purely visual] movement is set going over the sum of the forms, independently of the particular

viewpoint. The wall vibrates, the space quivers in every corner." He even speaks of "the gentle flicker of a façade." Vibration, quivering, flickering—these are metaphorical terms as applied to the static forms of a building. What really happens is that the flicker and vibration of the sun's rays create an apparent movement among these forms. Wölfflin of course realized that his expressions were metaphorical, and in the same context he admitted that the painterly element in baroque architecture is due to light and shade. "Light and shade, which cling to every form, become a painterly element at the moment at which they seem to have an independent import apart from the form. In classic style, they are bound to the form; in the painterly style, they appear unbound and quicken to free life. It is no longer the shadows of the separate pilaster or window-pediment of which we become aware, or, at any rate, not of these only. The shadows link up among themselves, and the plastic form can at times be quite submerged in the total movement which plays over the surfaces. . . . The deadly enemy of the painterly is the isolation of the single form. In order that the illusion of movement may be brought about, the forms must approach, entwine, fuse." [3]

This dissolution of the concrete reality of the building as a whole infects, as it were, every visible element in the building, and, above all, the sculptures that are included in the building's plastic unity. The form of each sculptural detail disintegrates under the impact of light unless that form is deliberately conceived to receive that impact. The sculptor assumes, of course, that his sculpture will have a constant po-[159] sition in the architectural complex dictated to him by the architect. Beyond this freedom, his control can be exercised only through a choice of material or through a modification of form. His material will probably be dictated to him by the architect, but, theoretically speaking, he is in a position to consider the varying effect of the impact of light on

3. *Principles of Art History*, tr. M. D. Hottinger (New York, 1949), pp. 65–66.

different materials. Marble, for example, if not too highly polished, limestone, granite, and many other stones, have a mat surface; they do not reflect the rays of light that impinge on them. A few metals such as lead, wrought iron, and patinated bronze have a similar property. Also, most metals and many stones can be polished, and then the source of light is reflected on the surface of the object and produces areas of high light and of deep shade that profoundly modify our perception of the form. [193]

Rodin, who is to be considered as an impressionist, deliberately exploited light. The result is that the lighting of his statues, particularly in museums, presents a difficult problem, for the lighting of one statue may be disastrous to its neighbors. By one mode of lighting a shimmering effect may be produced, in which the solid mass of the figure is entirely dissolved. The effect is impressive, but we may doubt whether the sculptor himself would have wished for such a pictorial or painterly effect. If we place one of Rodin's bronze portraits in strong direct light, then an animation of the features is produced that is undoubtedly the desired effect. Light is life to such a portrait, but what is life for one piece of sculpture is meaningless disintegration for another. Matisse's *Slave*,[3a] for example, was meant to stand solidly, not to be seen as the more or less meaningless smudge that it will appear if flooded with light. Admittedly, in an illustration we are looking at a photographer's lighting and not at the object itself in a natural light. Still, however much we may vary our light or change our position as observers, the fact remains that light is a moving, fluctuating element, and as it plays over the smooth surface of a solid object, it modifies and even completely transforms the plastic impression of that object on our senses. [187, 189]

The most direct solution of the dilemma thus presented to the

3a. Illustrated in Alfred H. Barr, Jr., *Matisse: His Art and His Public* (New York, 1951), p. 305.

artist is to exploit it, to heighten the reflective power of the surfaces of his object until they act as mirrors and create a play of light that is the desired aesthetic effect. We then have an illusion of movement; it is not, however, the illusion of a moving object such as we considered in the previous chapter but the movement of the light reflected from a [197] static object. Brancusi's polished forms are the best illustration of this exploitation of reflected light. In some cases Brancusi has repeated the same theme in marble and in polished brass with interesting modifica- [194–196] tions determined by the different surfaces. His busts of Mlle. Pogany are an example. In the marble version the cheeks are rounded to take tender gradations of light; in the polished brass they are segmented, to produce an incisive curve. The marble is the more tactile, the brass the more visual form.

Light may also be exploited as a defining element, especially when the object is seen—as the sculptor intended it to be seen—against a dark background. Sometimes the light will seem to flow around the contours of the object, like a line of fire.

More often the effect of light falling on the modeled planes is fragmenting. In other words, that tension between the two spaces to which Focillon has drawn attention—the space occupied by the object, *espace-limite;* and the space surrounding the object, *espace-milieu*—disappears if the surface is full of peaks of light and pits of shade.[4] A detail from [186] Maillol's lead *River* figure illustrates my point. Actually, as the face looks up to the rift of sky between Fifty-third and Fifty-fourth Streets, it seems to be seeking for the light rather than shrinking from it, but any photograph illustrates the effect I am referring to, an effect in which the violent chiaroscuro perforates the drum-skin tension between inner and outer space. The sense of a containing surface is lost. Still waters, we say, lie deep; and it is the primary aim of sculpture to lie deep, to present a still surface.

On the other hand, this disintegrating effect of light may be seized

4. *L'Art des sculpteurs romans* (Paris, 1931), pp. 23–25.

as a motif and may be exploited. Throughout the history of art, certainly of the minor arts, there has always been a tendency to exploit defects, for example, to take a flaw in the glaze of a pot and to make it a justification for the decorative beauty of that particular glaze. Admired glazes like the so-called "peach bloom" of Chinese porcelain originated in this way; crazing or crackle, at first a technical defect, is then deliberately produced for its aesthetic effect. In the same way, it seems to me, the fragmented surface of a rugged bronze, such as Rodin's head of Balzac, may have suggested the deliberate exploitation of [190, 191] planes of light in Picasso's *Head of a Woman* (1909). This head belongs, of course, to the transitional stage of cubism, and it has an immediate parallel in Picasso's paintings of the period. Still, cubism in painting was due precisely to the fragmentation of visual impressions implicit in the whole development of painting from Impressionism onwards, and though Picasso and Braque may have taken their immediate inspiration from Cézanne or from Negro sculpture and not directly from Rodin, my point still holds good. What had been a defect in the haptic integrity of impressionistic sculpture was now exploited as an aesthetic value. The division into contrasted plane surfaces was organized systematically to create a cubic form, no longer appealing to specifically tactile sensations but creating a structural or architectonic unity, as in Brancusi's *Adam and Eve*. From that point onwards sculpture [216, 217] has evolved toward a self-consciously cubistic style typified by the early work of Lipchitz and Laurens. [198, 199]

Cubist sculpture has a close aesthetic affinity with baroque sculpture, inasmuch as in both cases the solidity and palpability of the object are sacrificed to a deliberate effect of chiaroscuro. As we see in the sculpture of Lipchitz and Laurens the play of light is again exploited [198, 199] for its own sake. It is significant that the later work of these two sculptors, far removed from their early cubist experiments, is distinctly baroque in character.

A far more deliberate use of light than any we have considered so

111

far has been made by certain modern sculptors. There are two distinct developments to consider. The first is due to the use by the sculptor of certain newly invented materials that reflect and even refract light with unparalleled effect. Transparent or translucent sculpture is not un-

[41] known in the past; there are the famous skulls of rock crystal from Mexico, not to mention various rock crystal carvings of the late classic, Gothic, and Islamic periods. There is also a whole class of miniature sculptures of molded and drawn glass made at Murano and Limoges in the seventeenth and eighteenth centuries; however, the recent in-

[214] vention of various types of translucent and transparent plastic materials that have the advantage of being easily cut or bent has given the sculptor a new opportunity to exploit light. The constructivists in particular

[219] have made good use of this opportunity. Naum Gabo, by using Perspex (or Lucite), a material of crystal purity, seems to create his forms in light itself. We are no longer aware of a gross material substance but only of space defined by light and given significant form. These images are nonfigurative, but the sculptor has claimed that they are "images of reality," images that express a new and specifically modern form of consciousness. "I cannot help rejecting all repetitions of images already done," the sculptor has said, "already worn out and ineffective. I cannot help searching for new images and this I do, not for the sake of their novelty but for the sake of finding an expression of the new outlook on the world around me and the new insight into the forces of life and nature in me." [5] Obviously such an art has a direct relationship, more than sympathetic, with those sciences like optics and physics that have revealed so much of the inner structure and organization of the material world. It would nonetheless be wrong to think of such sculptures as scientifically conceived. They are, rather, poetic images, but theirs is a poetry of light.

5. Naum Gabo, "A Retrospective View of Constructive Art," in J. J. Sweeney, Katherine Dreier, and Naum Gabo, *Three* *Lectures on Modern Art* (New York, 1949), p. 83.

The constructions of Richard Lippold are also images of light, but [218] light reflected from the bright surfaces of nickel-chromium wire, stainless-steel wire, and brass rods. They need a strong artificial light and a black background for their maximum effect, and then they glitter like magnified snow crystals.

The second development of modern sculpture that deliberately exploits light is of quite a different origin and has quite a different purpose. We have already seen that the impact of light on the surface of an intentionally solid mass is to create areas of high light that, if the material is at all smooth or polished, have a disintegrating effect on the static tension of the mass. It is as if a hole had been eaten into the mass by some acid. Everything is done, in museums and private galleries, to diffuse the light so that this disturbing effect is not produced, but again the modern sculptor has grasped a potential value from this defect. He has seen that if the light, instead of being reflected from the protuberant boss, were to be admitted through the mass at such a point of impact, a subtle counterpoint of volume and void would thus be brought about. For each convexity a corresponding concavity is created, and the result is an expressive rhythm of forms far superior to the rhythm of the form from which light is too crudely reflected. Henry Moore has [203, 205, been the supreme master of this device. A long series of recumbent 206] figures is conceived as rhythmical variations of boss and hollow, of mass and void, with the result that light is no longer in opposition to the solidity of the object but is an integral part of the total sculptural effect. Space invades the object, and the object invades space, with the one plastic rhythm.

If this device is taken far enough, we are once more left, as we are in the exploitation of devices to represent movement, with a *linear* sculpture. It almost seems that there exists a tendency for art to revert to the characteristics of the memory image, that there is an unconscious will to make the images of art correspond to the images in memory, which, as Emanuel Loewy long ago pointed out in connection with

[209]

[208, 212]

Greek sculpture, are without light and shade.[6] Some of Moore's works, such as the *Double Standing Figure* in bronze of 1950, are virtually linear, though a suggestion of modeling still lingers in some of the elements and the total effect is still one of an object situated in three-dimensional space. The temptation is to go further than this and to create, as we saw in the preceding chapter, objects with linear outlines that define space but do not occupy it. At this point, as I suggested, a new art is born: a negative sculpture, a sculpture that denies the basic elements of the art of sculpture as we have hitherto conceived it, a sculpture that rejects all the attributes of palpable mass. I do not deny that an art of great possibilities is conceivable in this direction, but technically it would be classified in any museum not as sculpture but as wrought ironwork. It is an art that in the past was not despised. Some of the masterpieces of Gothic and Renaissance art belong to this category.

These developments, made all the more possible by modern processes and materials, have culminated in a general cultural phenomenon for which we might borrow José Ortega y Gasset's phrase, the dehumanization of art.[7] It is a process that has taken place in all the arts, even in literature. To the majority of people this development of art is profoundly disturbing; it does not agree with their conception of art as a record of "lived reality." To the artist, however, the drift is instinctive and therefore inevitable. It is not with him a process of willful perversion. He creates the images he does create because he must create such images or be false to his consciousness of what is significant in his experience. This state of consciousness he absorbs from his environment, from a mechanistic civilization, from a general atmosphere of anxiety and mental anguish. He has every right to turn on those

6. *The Rendering of Nature in Early Greek Art,* tr. John Fothergill (London, 1907), pp. 67–68.
7. *La Deshumanización del arte,* tr.

Helene Weyl as "The Dehumanization of Art," *The Dehumanization of Art and Notes on the Novel* (Princeton, 1948).

who complain of his inhumanity and to say: "It is not I but you who have created the conditions that compel my imagination to create images of terror and despair. Your science, your politics, your way of life are responsible for a dehumanization of life itself." The kind of mind that conceives Buchenwald or the atomic bomb cannot expect the artist to create an illusory world of ideal human types. Art must correspond to the reality that conditions the spiritual outlook of each age: in that sense great art is always realistic. It is also realistic in another sense, because it still treats as real the universals of harmony and grace. Modern art is inhuman; but it is not inept. It can give to anguish itself the intensity of tragic art; and against nihilism and despair it will protest with constructive images that affirm the possible existence of a harmonious realm of essence.

"The poet," says José Ortega y Gasset, "aggrandizes the world by adding to reality, which is there by itself, the continents of his imagination. Author derives from *auctor,* he who augments. It was the title Rome bestowed upon her generals when they had conquered new territory for the City." [8] The modern artist is an *auctor* in this sense. The territory we live in is a waste land, inhabited by hollow men. That is the reality we experience, the truth as we perceive it. "But wait," says the artist: "What we endure, what we suffer, is not the whole of reality. The world of the imagination is also a reality, and in my imagination is a consciousness of an extension of the lived reality—the consciousness of a new reality. Perhaps I can create symbols that will express my consciousness of this other, this new-found reality." Such at any rate is the daring ambition of the modern artist: to live on the frontiers of existence and to work to extend them.

The experimental development of form in sculpture ends, for the moment, at this point. I am far from suggesting that linear sculpture represents a stable conquest of new plastic forms. On the contrary, I am

8. Ibid., p. 31.

inclined to see in linear sculpture a return to the visual prejudices of the Renaissance or perhaps to the surface dynamism of the Middle Ages. In any case this is decidedly not a *palpable* art; it is not an art that engages the full range of plastic sensibility. I do not wish to establish a hierarchy of the arts based on a quantitative sensational basis. One cannot say that the eye is superior to the ear and that *therefore* Michelangelo is superior to Beethoven, nor that Michelangelo is superior to Giotto because his sensibility for three-dimensional form was more acute or more clearly expressed. Indeed, I have always protested against comparative evaluations of artists or even of works of art, because every authentic aesthetic experience is *sui generis,* unique. We may like oranges better than apples, but we do not assert that therefore oranges *are* better than apples. Doctors may assure us that apples are better for us than oranges, but we do not therefore assert that apples are more beautiful than oranges. We may assert that the figures in the Portail Royal at Chartres are architecturally more appropriate for that particular location than would be the *Three Standing Figures* of Henry Moore, but three figures from Chartres, torn from their context, their architectural setting, would look fragmentary and frustrate in a London park. What we can say—and it has perhaps been the recurrent theme of this volume—is that to each particular co-ordination of the senses corresponds an appropriate art with its aesthetic laws. If we give prominence to vision and subordinate all other sensations to its law of maximum aesthetic effect, then we get one kind of art; if we give prominence to touch and subordinate all other sensations to *its* law of maximum aesthetic effect, then we get another kind of art. I have not assumed that sculpture is an art of tactile sensation only; I have pointed out that even within the concept of "tactile sensation" we must include those somatic or haptic sensations that take place inwardly. What I have asserted—and nothing in my aesthetic experience has ever weakened my conviction on this point—is that the art of sculpture achieves

its maximum and most distinctive effect when the sculptor proceeds almost blindly to the statement of tactile values, values of the palpable, the ponderable, the assessable mass. Integral volume, not apparent to the eye alone, but given by every direct or imaginable sensation of touch and pressure—such is the unique sculptural emotion.

This specific sensibility has been predominant, it seems to me, in all the great epochs of sculpture. To select these epochs is to make oneself an arbiter of taste, but I have declared my principles in the preceding pages, and abiding by them I believe my choice can be decisive. It will be remembered that Matthew Arnold once selected from the world's poetry eleven lines or verses that he gave as touchstones for the essential qualities of poetry. In the same spirit, Allen Tate revised these touchstones for our modern sensibility, and Huntington Cairns, in his anthology *The Limits of Art*, brought these touchstones together. I think I may claim to be acting less metaphorically if I make a similar selection of touchstones for the art of sculpture, for all except one, which is a bronze, will be literally touched stones.

I begin with the head of an Egyptian prince, which is now in the [142, 143] Boston Museum of Fine Arts. It is a limestone carving of the period of the Old Kingdom—the IV dynasty, say about 2840–2680 B.C.[9] It was intended as a reserve head to be placed beside the mummy of the prince in his tomb. The carving is of extreme delicacy and expressiveness, but no less expressive is the firm sense of bony structure and tense containment of volume. It is a piece that admirably illustrates all those qualities of integral mass and palpability that I have called the primary characteristics of sculpture.

A bronze head, made perhaps in the sixteenth century, from the [165]

9. Cf. William Stevenson Smith, *A History of Egyptian Sculpture and Painting* in the Old Kingdom (2nd edn., Oxford, 1949), p. 25 and pl. 7b.

117

Benin kingdom in Nigeria and now in the British Museum, is of equal plastic power. It is more elaborate than the Egyptian head, but no less expressive or less beautiful. In spite of the intervention of at least four thousand years, these two heads from the continent of Africa share the same universal qualities of great sculpture.

[62] My third touchstone is the Rampin horseman from the Louvre. Actually only the head belongs to the Louvre, as the torso is at the National Museum of Athens, but the late Humfry Payne discovered that the two fragments belonged together, and in our illustration they are shown reunited. This figure belongs to the so-called Archaic period of Greek sculpture and may be dated about 560 B.C.[10] It is a period that used to be regarded as preparatory to the mature style of the fifth century, but that we now dare to assert was never surpassed in essential sculptural values, for what the fifth century added were for the most part painterly values. At least, what the fifth century gained in ideal harmony, we may say, it lost in expressive vitality.[11]

[79] My fourth touchstone is a figure representing Charity by Tino di Camaino—a sculptor whom I have mentioned more than once. At present in the Museo Bardini in Florence, it originally belonged to the baptistry of the Cathedral and was perhaps one of the figures of the Virtues recorded as standing over one of the portals.[12] In the early sixteenth century this figure and its companions were evicted as being too clumsy (gòffo) for the refined taste of the period. Elegant groups by Sansovino and Rustici were substituted; the strength of simplicity, the power of compact mass were exchanged for some exercise in paint-

10. Cf. Humfry Payne and Gerald Mackworth-Young, *Archaic Marble Sculpture from the Acropolis: A Photographic Catalogue*, introduction by Humfry Payne (2nd edn., London, 1950), pp. 6–9.

11. Cf. my remarks on this subject in *Icon and Idea* (Charles Eliot Norton Lec-

tures, 1953–54; Cambridge, Mass., 1955), pp. 74–86 and pl. 46.

12. Cf. W. R. Valentiner, *Tino di Camaino*, tr. Josephine Walther and rev. R. H. Boothroyd (Paris, 1935), pp. 74–80.

erly rhetoric. Luckily this figure has been salvaged, and Tino is now honored far above the usurpers of the sixteenth century.

For my fifth touchstone I take a detail from Michelangelo's *Pietà* [92, 93] of 1498–1500 in St. Peter's. By comparison with my other touchstones, this is a relatively sophisticated work, but one could not find a more nearly perfect example of a sensitive counterpoint established between the palpable volumes of the human features and the linear dynamism of the enclosing garments. That is of course a poor way of describing a symbol of such ineffable dignity and tenderness; no plastic symbol was ever so self-sufficient, so far beyond the capacity of comparable linguistic symbols.

My sixth touchstone is a reclining figure representing the Mayan [204] deity Chac Mool. Here we find a simplification of forms dictated to some extent, perhaps, by the rectangle of stone from which the figure was carved but nevertheless achieving a concentration of numinous power appropriate to this deity of rain and fertility. The hands over the belly grasp a bowl ready to receive whatever sacrifices were due the god, and the whole attitude of the figure expresses a tense minatory power by means of the formal values given to it by the sculptor.

Finally I select a reclining figure by Henry Moore. It was carved in [205] brown Hornton stone in 1929. I might have selected a much more representative example of this sculptor's work, but doing so would have been to evade the essential difficulties of contemporary art as typified by this piece of sculpture. In formal values it is not unrelated to the Mayan figure of Chac Mool; Moore has admitted the influence of such sculpture on his own work. Indeed, if we dismiss the religious and historical associations of the Mayan figure, we are left with a formal composition that does not differ in any essentials from the formal composition of this figure of Moore's.

But, it will be said, the numinous and terrifying associations of the

[92, 93] Mayan piece make its power and greatness, just as the dignity and tenderness of Michelangelo's *Pietà* make its greatness. To acquiesce in such a statement is to be guilty of the fundamental error in art appreciation: it is on the contrary the power and greatness of the sculptor's forms that make possible, in the one case, an association with emotions of terror and propitiation, or, in the other case, with emotions of love and sorrow.

But what emotions then, it will be asked, are we supposed to associate with the forms of Moore's *Reclining Figure?* In our world without religious or social consciousness it is for each of us to become conscious of whatever new values are discoverable in the forms conceived by the artist. I myself believe that this piece does suggest, in its magical way, certain chthonic forces—forces of the earth and of organic growth—and that it is possible that these forces proceed from some deep level of the unconscious, the level that Jung calls collective because it is no longer personal. If this belief is true, then the modern artist is once again creating the symbols for our most profound spiritual experiences. He does not create these consciously: the faculties with which he advances beyond the frontiers of existence are exploratory, intuitive. The artist does not seek: he finds.[13]

Nearly two hundred years ago, during his residence at Breslau between 1760 and 1765, Lessing wrote his *Laokoon,* an essay designed to set limits to the arts of painting and poetry. He took for his point of departure a piece of sculpture, and he confessed in his Preface that under the term of painting he comprehended the plastic arts generally. He was able to be so comprehensive because, following Winckelmann, he judged the arts by their purposes, not by their procedures, and

13. So Picasso affirms. Cf. "Picasso Speaks," *The Arts,* III (May, 1923), 315–29; reprinted in Alfred H. Barr, Jr., *Picasso: Fifty Years of His Art* (New York, 1946), pp. 270–71.

held that the purpose of the plastic arts was distinct from that of the poetic arts. Poetic drama, for example, may express human emotion in all its expressive range, but the plastic arts are limited by an ideal of beauty that forbids not merely caricature and all expressionistic exaggeration but a whole range of human emotions. "There are passions, and degrees of passion, which are expressed by the ugliest possible contortions of countenance, and throw the body into such a forced position that all the beautiful lines which cover its surface in a quiet attitude are lost. From all such emotions the ancient masters either abstained entirely, or reduced them to that lower degree in which they are capable of a certain measure of beauty.

"Rage and despair disgraced none of their productions; I dare maintain that they never painted a Fury." [14]

I quote Lessing not to revive an almost forgotten controversy but to throw into relief our distinctively modern approach to the arts. Woe to the artist, cries Lessing, who sacrifices beauty to expression! Woe to the artist, we cry, who sacrifices expression to beauty! The very meaning of these words has changed. We demand from the artist not the expression of "a great and self-collected soul," which was Winckelmann's description of Greek art; not a literary or philosophical ideal of any kind. For good or ill we now demand from the artist an expression of *truth,* and in judging the success of the artist in this task our criterion is the subjective criterion of vitality rather than the objective criterion of harmony. We say of a work of art that it *moves* us, that it appeals to us, that it fascinates us, that it excites us—all expressions that indicate a psychological and not an intellectual reaction. We have revalued the art of the past in the same subjective way and have nothing but amusement or contempt for the aesthetic judgments of the

14. *Selected Prose Works,* ed. Edward Bell, tr. E. C. Beasley and Helen Zimmern (new edn., rev., London, 1890), p. 15.

eighteenth and nineteenth centuries. In this revaluation of aesthetic values—from beauty to truth, from idealism to realism, from serenity to vitality—the whole of the modern movement in art, beginning with Impressionism, is involved as a practical activity, and the whole of the modern criticism of art is involved as a philosophical activity.

Truth, as an aim, is just as ambiguous as beauty, and the distinctions that Lessing made between the arts as appropriate instruments for the representation of beauty must now be drawn between the arts as appropriate instruments for the expression of truth. That is what, in my tentative way, I have been trying to draw in these pages. The problem is to determine, as between the various plastic arts and their appropriate techniques, the range of aesthetic effectiveness. Crudely we say that silk purses cannot be made out of sows' ears. A little less crudely we say that tactile sensations are best conveyed by palpable objects. Our real aim is to treat the infinitely complex range and subtle intricacy of human sensibility as an instrument for the apprehension of reality—of reality in its widest sense—and to learn a little about the correct focusing of that instrument. Our objective is not pleasure, or it is pleasure only incidentally. We have discovered that art has a biological function, that the artist, like the photosynthetic cells that absorb creative energy from cosmic rays, is the sensitive organ of an evolving consciousness—of man's progressive apprehension and understanding of his universe. Giotto, Piero della Francesca, Rembrandt, Cézanne, Picasso; Giovanni Pisano, Michelangelo, Rodin, Moore: these are names that mark some of the many stages of this creative evolution. I have drawn these names from the present cycle of civilization. Other names could be quoted from other cycles, the Oriental, the Greek, the medieval. There is an impressive continuity in art's witness to man's evolving sense of reality. From time to time a civilization falls from grace, and art is destroyed by fanaticism, taxation, and war. But the monuments remain—monoliths along a path that for four hundred cen-

turies is otherwise unmarked. The illustrations to this volume mark out that path, a path that begins faintly with stray images of fertility from paleolithic caves, broadens out to become the measured highway of human culture, and now points to the future with icons that have not yet precipitated ideas. Without these milestones of his spiritual odyssey, man would be like a child lost in the night.

PLATES

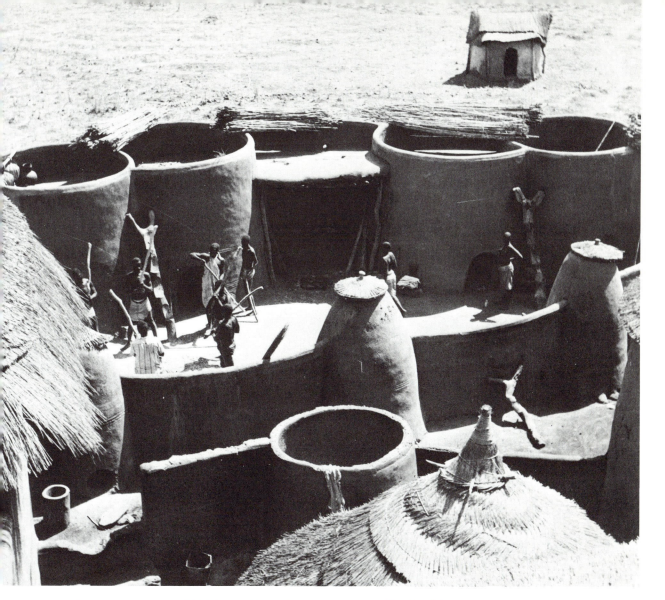

1. A native compound. Gold Coast, West Africa, xx century. Hand-molded from mud

2 (over). Rajrani Temple. Bhuvaneshvara, India, about A.D. 1100. Sandstone

3. Kailasanatha, from the northwest. Ellora, India, about A.D. 750–850. Rock-cut

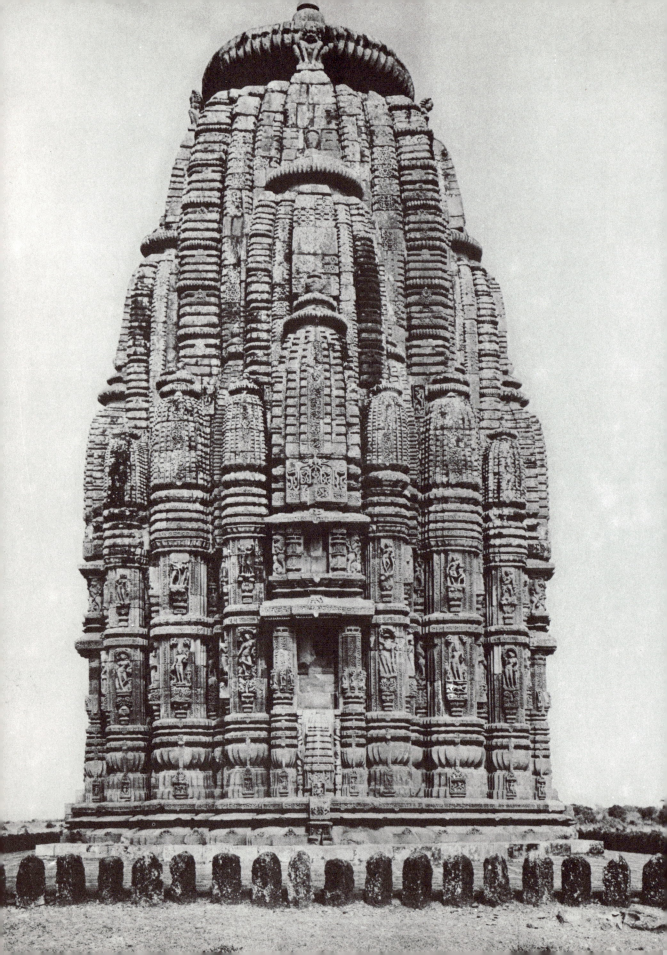

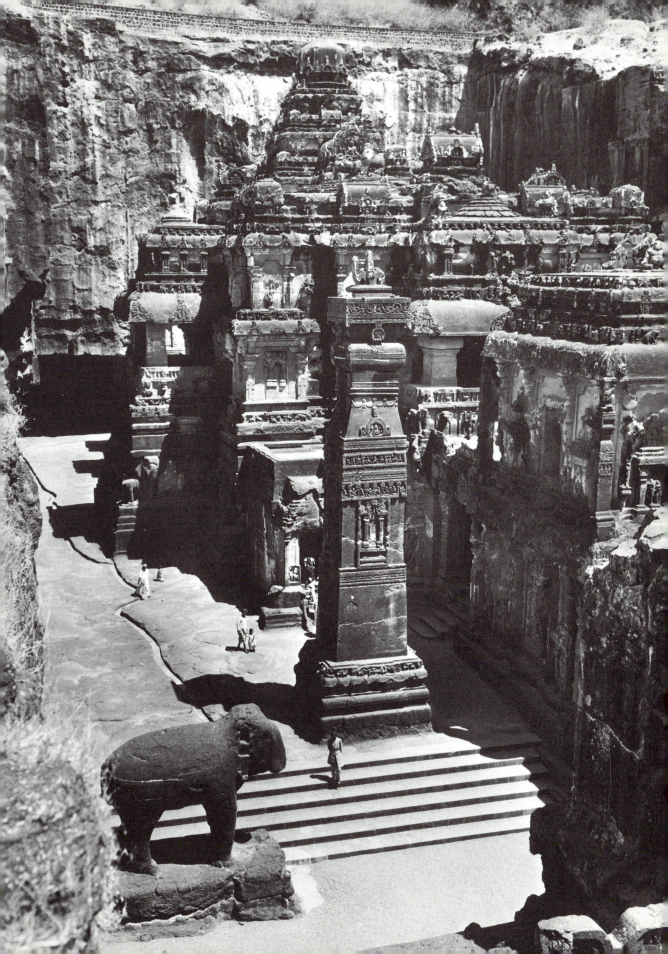

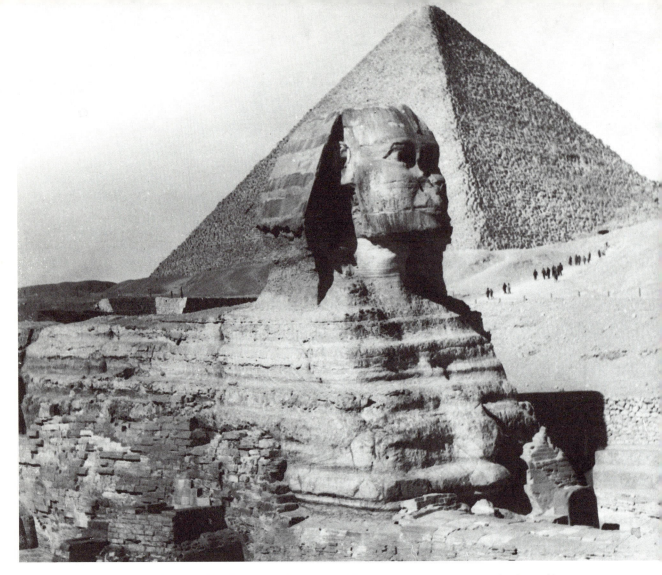

4. Sphinx and pyramid at Memphis. Egypt (IV Dynasty), about 2850 B.C. Rock-cut limestone and masonry

5 (right). ANDREA DEL VERROCCHIO (1436–88) and ALESSANDRO LEOPARDI (d. 1522?). The Colleoni Monument, Venice, modeled 1479–81, completed 1496. Bronze. Over life-size

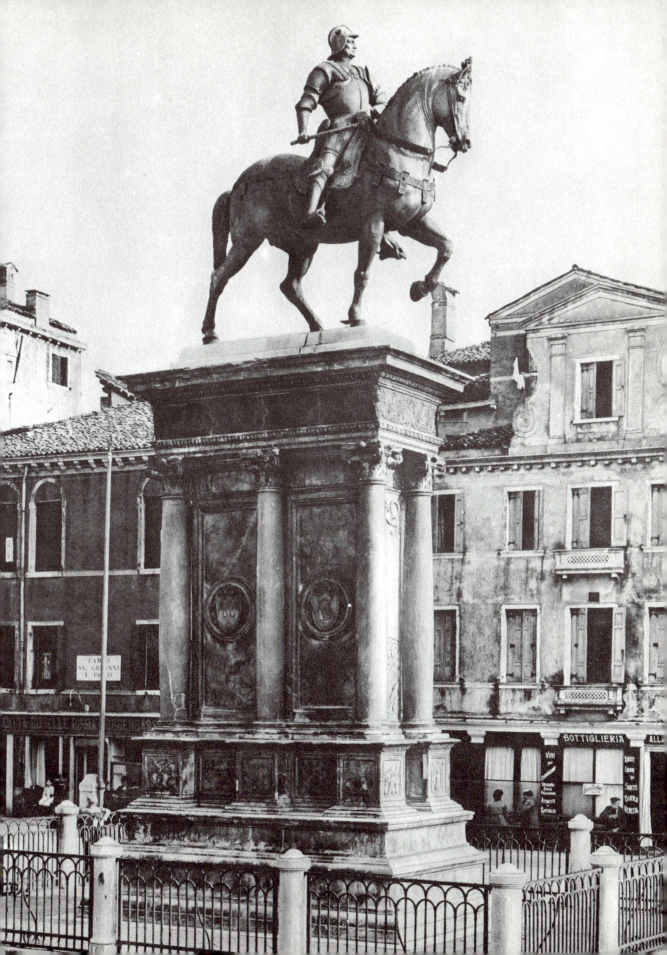

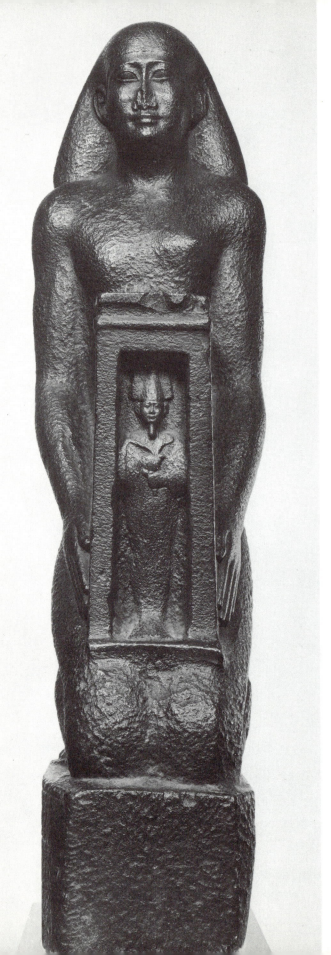

6. Kneeling figure of Jed-her(?), with shrine of Osiris. Egypt, 323–30 B.C. Hard black stone. H. 21⅛ in.

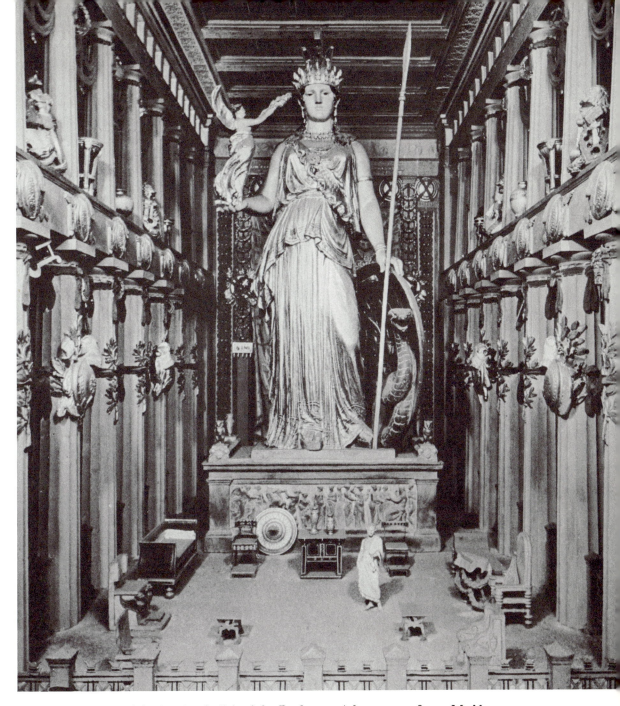

7. A reconstruction of the interior (cella) of the Parthenon. Athens, 447–38 B.C. Marble. W. 71 ft. L. 194 ft.

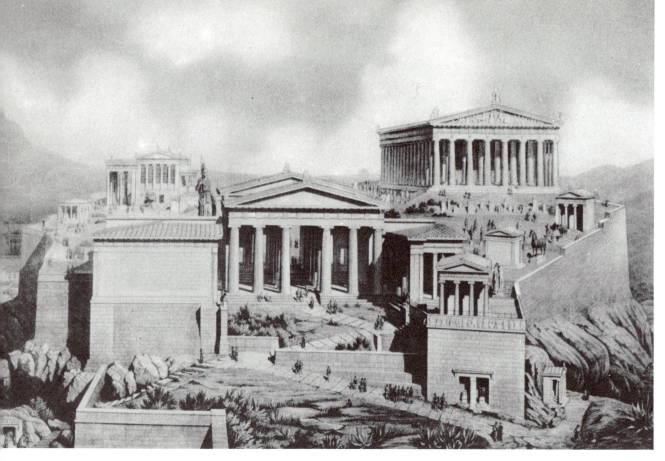

8. A reconstruction of the Acropolis. Athens, v century B.C.

9. The temple at Segesta. Sicily, about 430–20 B.C. L. 200 ft.

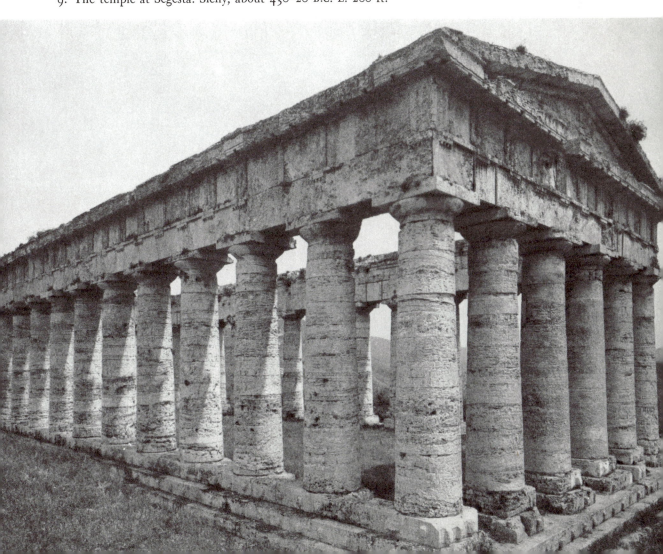

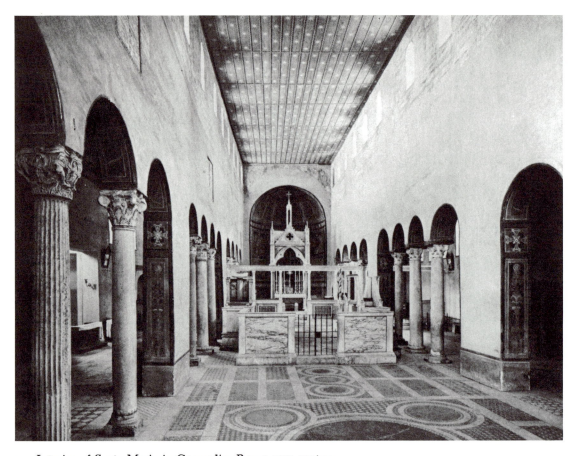

10. Interior of Santa Maria in Cosmedin. Rome, VIII century

11. Henry Moore. Details of screen on the Time-Life Building, London. 1952–53. Portland stone. 26½ ft. x 10 ft.

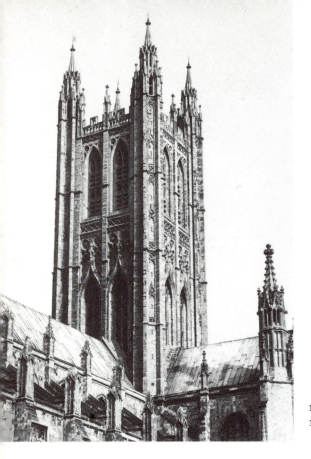

12*a*. Bell Harry Tower of Canterbury Cathedral. 1495–1503. H. 235 ft.

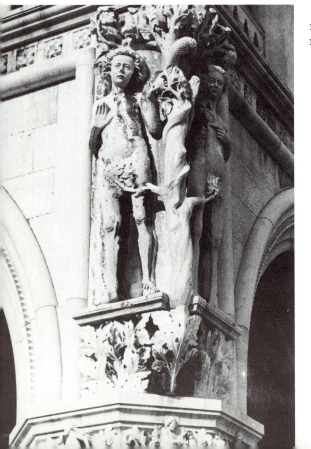

12*b*. The Fall of Man. Ducal Palace, Venice. About 1300–1350. Stone

13 (right). Carved naturalistic ornament of South-well Cathedral. English, about 1100–1150. Stone

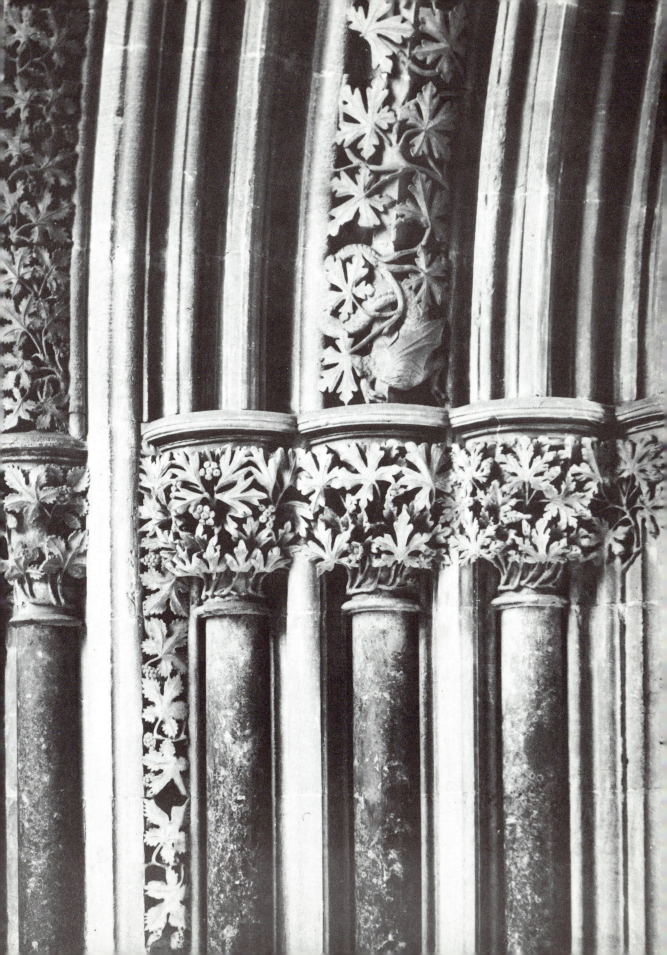

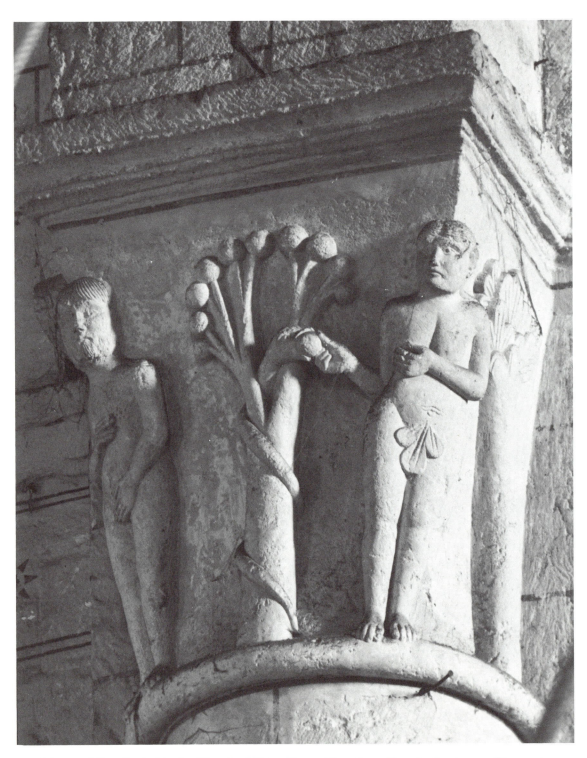

14. Adam and Eve. Capital in the Church of Notre-Dame, Chauvigny. French, about 1100. Stone

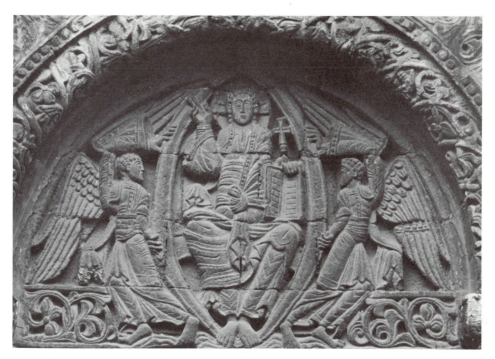

15a. Christ supported by angels. From the tympanum of the Prior's door, Ely Cathedral. English, about 1140. Stone

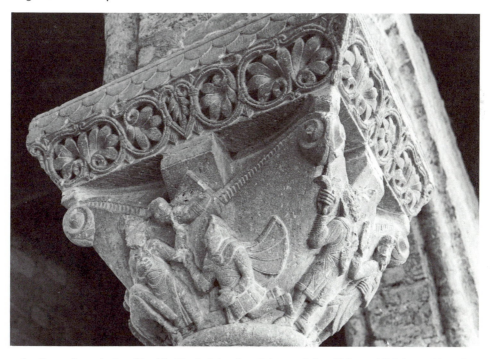

15b. Samuel anointing David. Capital in the cloister of the Abbey of Moissac. French, early XII century. Stone

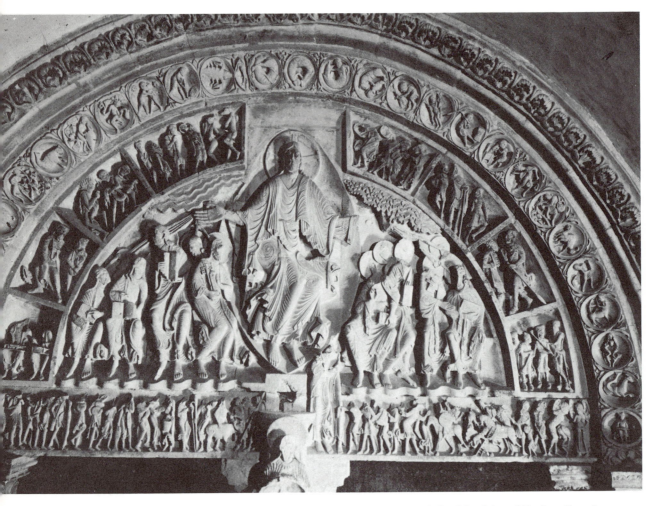

16. The Pentecost. Tympanum in the narthex of the Church of the Magdalen, Vézelay. French, about 1132. Stone. w. 31 ft. 4 in. H. 35½ ft. (The figures on the archivolt and lintel probably represent the distant peoples waiting for the Gospel)

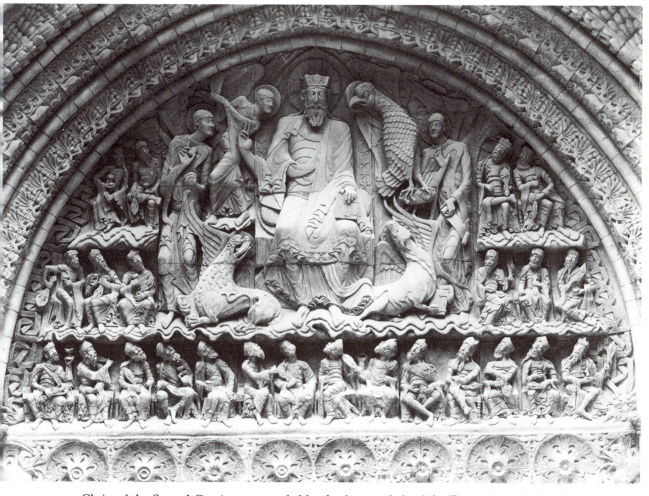

17. Christ of the Second Coming, surrounded by the four symbols of the Evangelists and adored by the four-and-twenty Elders of Revelation. Porch of the Church of St. Peter, Moissac. French, 1115–35. Stone. w. 18 ft. 8 in.

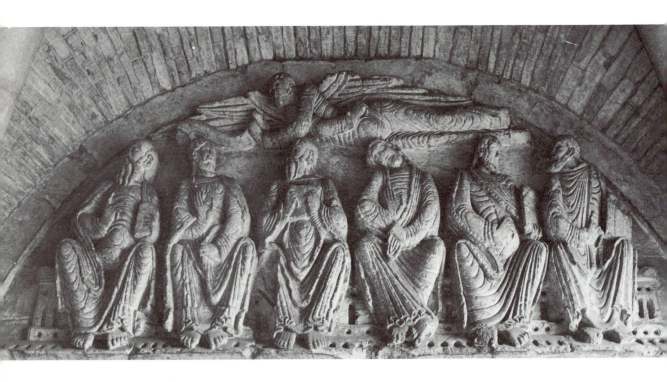

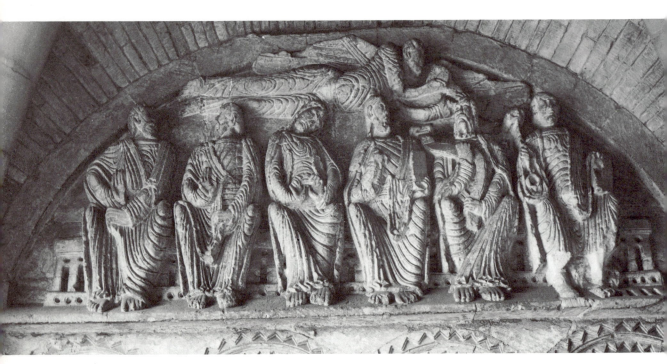

18. The Apostles. Spandrels, east (above) and west sides of the south porch, Malmesbury Abbey. English, about 1160. Approximately half life-size

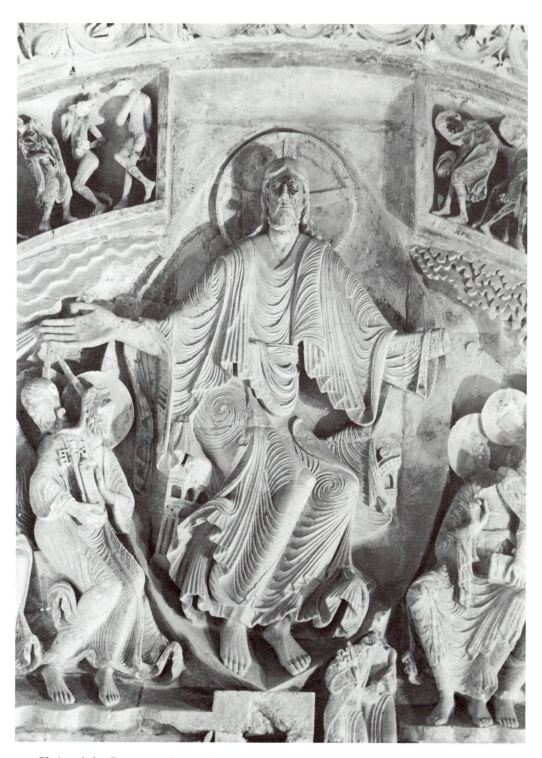

19. Christ of the Pentecost. Detail of plate 16

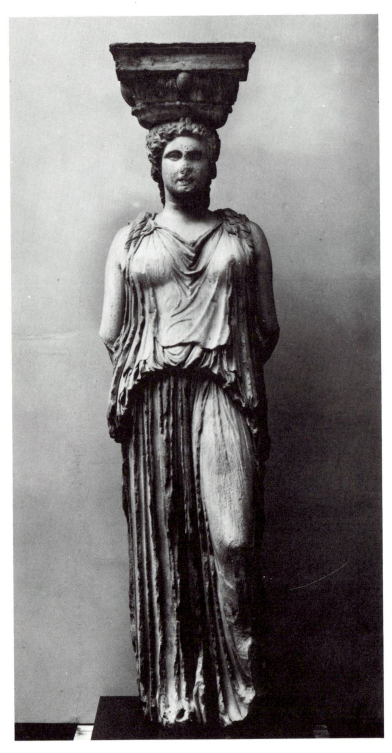

20. Caryatid from the Erechtheum. Athens, 421–409 B.C. Marble.
H. 7½ ft.

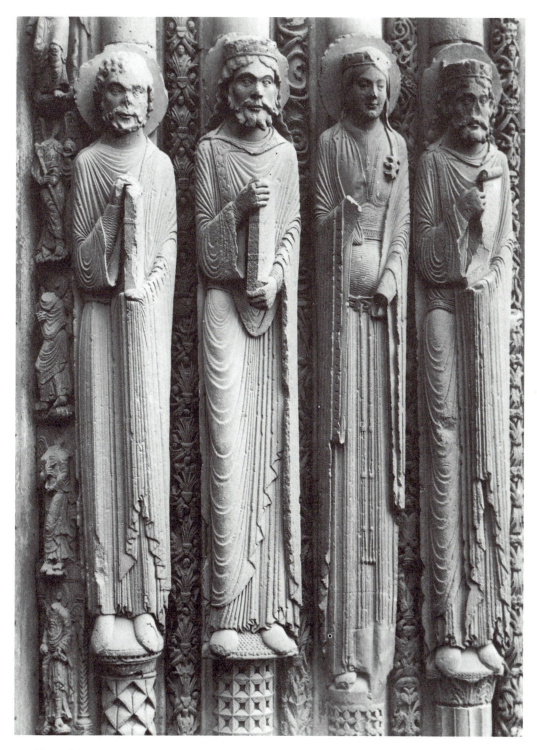

21. Four figures (the ancestors of Christ?) from the west front (Portail Royal) of Chartres Cathedral. French, about 1150. Stone. H. 20½ ft.

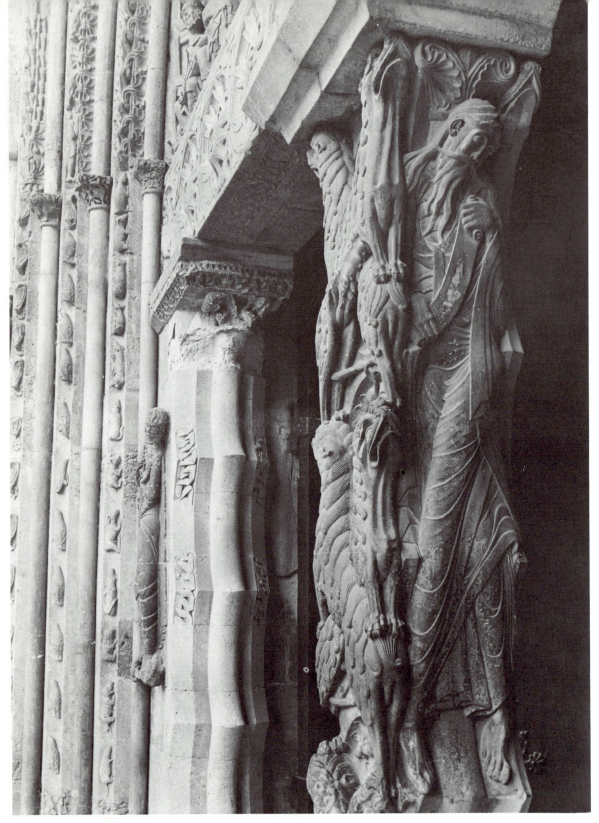

22. Pier, with crossed lions and a prophet. Church of St. Peter, Moissac. French, about 1100–1150. Stone

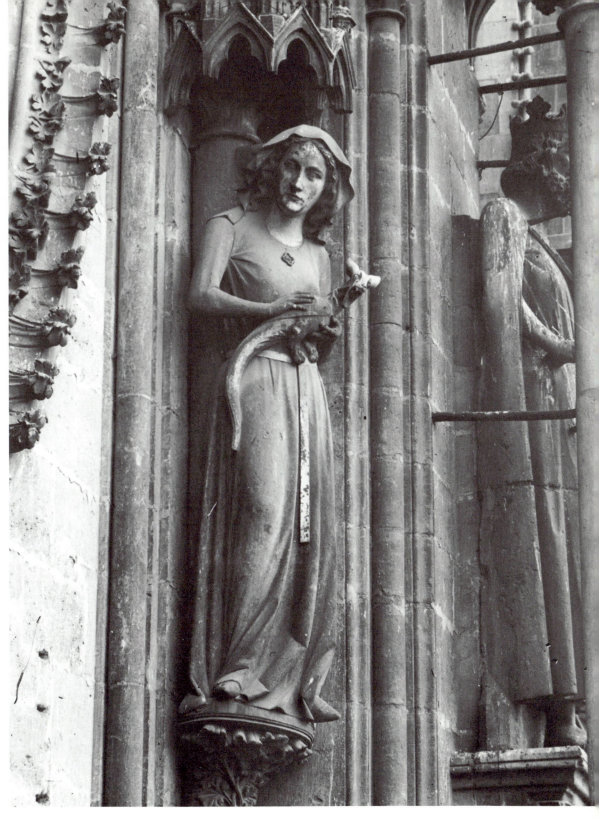

23. Eve. Exterior of the north end of the transept, Reims Cathedral. Late XIII century. Stone

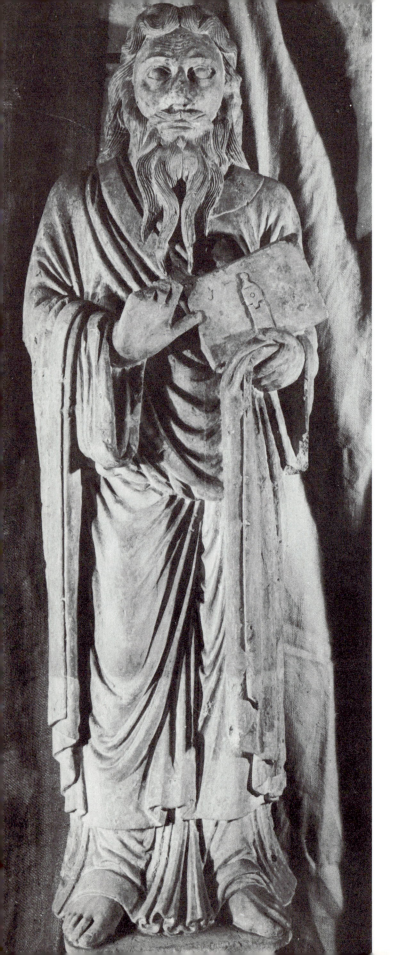

24. A prophet or evangelist. St. Mary's Abbey, York. About 1200. Stone. H. 5 ft. 8½ in.

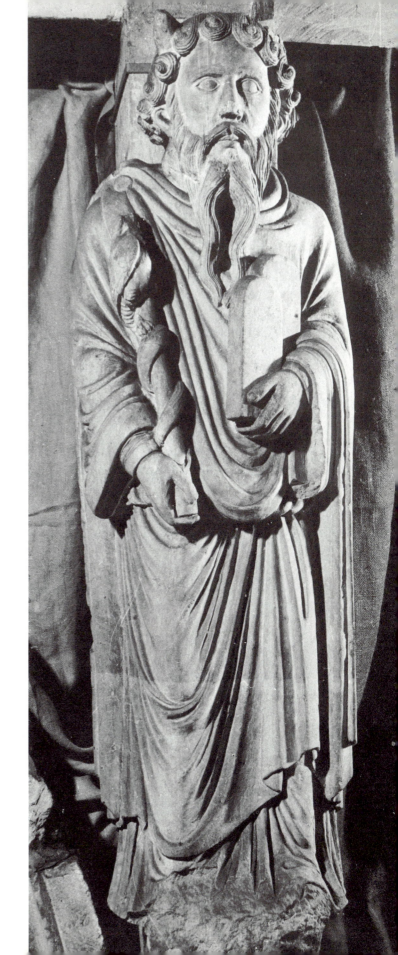

25. Moses. St. Mary's Abbey, York.
English. About 1200. Stone. H. 5 ft.
9½ in.

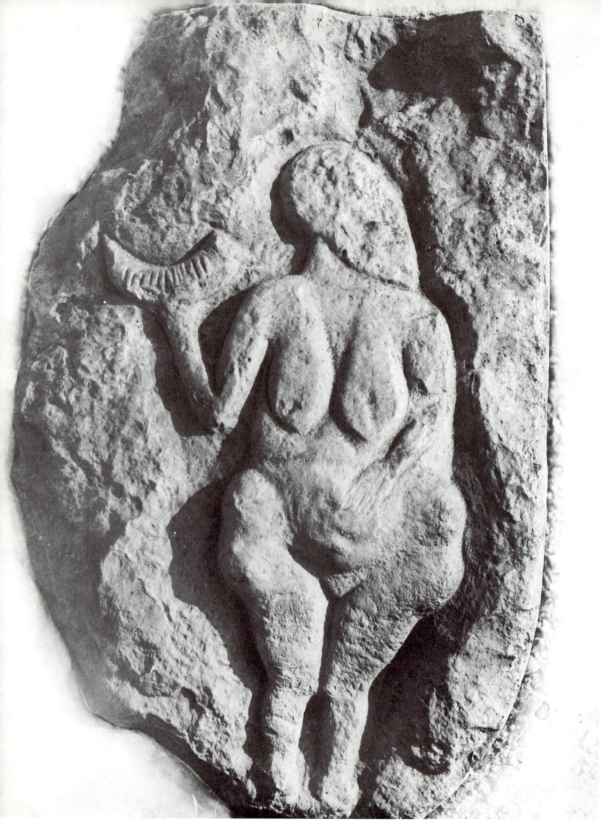

26. The "Venus" of Laussel (Dordogne), France. Carving from a rock shelter. Paleolithic period (Périgordian style). Limestone. H. 17 in.

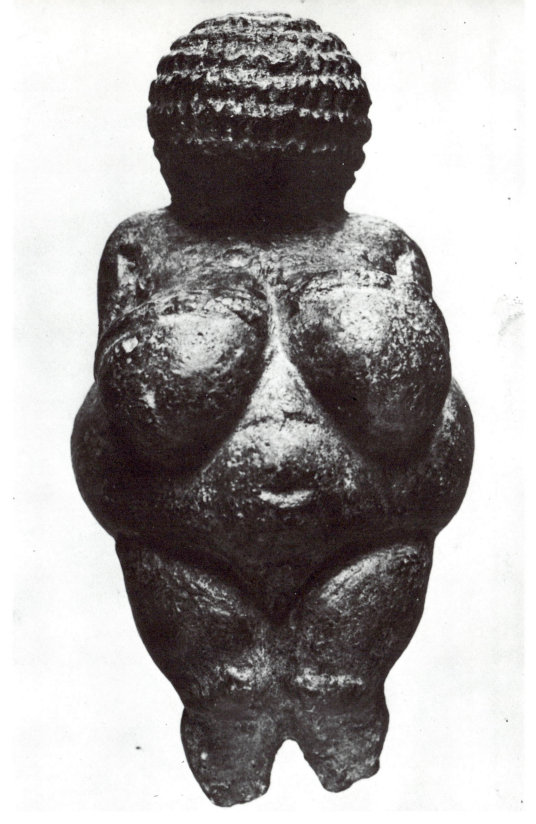

27. The "Venus" of Willendorf, Austria. Paleolithic period (Aurignacian style). Limestone. H. 4⅛ in.

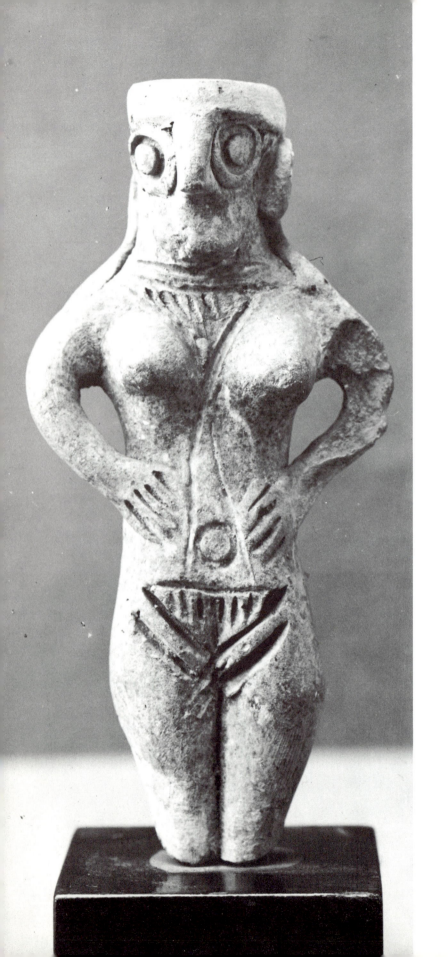

28. Statuette.　Mesopotamia (Sumer), XXIX century B.C. Terra cotta. H. about 5 in.

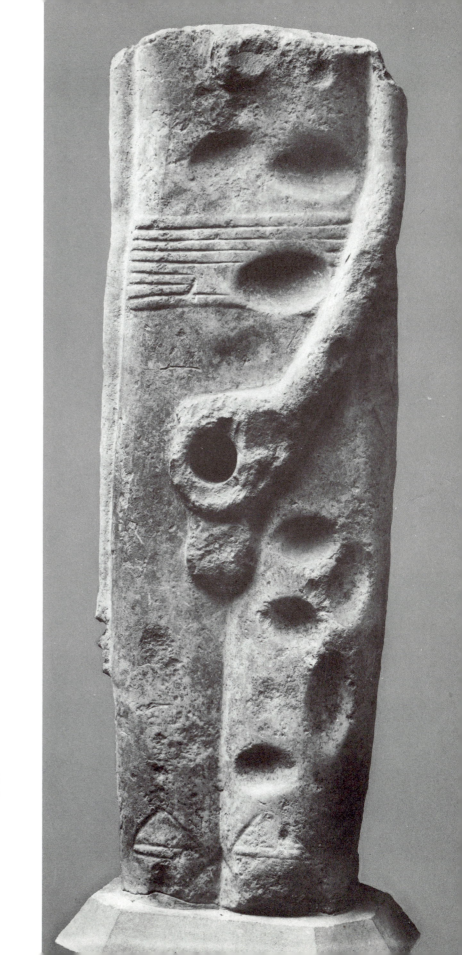

29. Min, God of Koptos, Egypt,
prehistoric period. Limestone. H.
77 in.

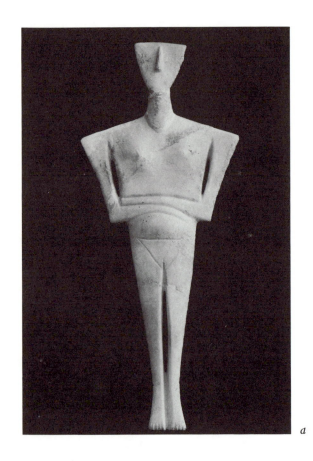

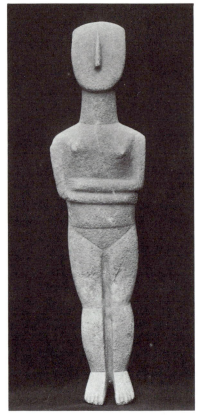

a

b

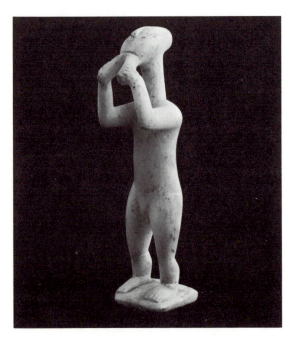

30. Statuettes. Cyclades, end of
3rd millennium B.C. Carved mar-
ble. H. about 20 in. *a*. From Skyros.
b. From Paros. *c*. From Amorgos

c

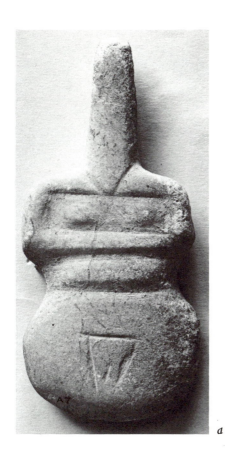

a

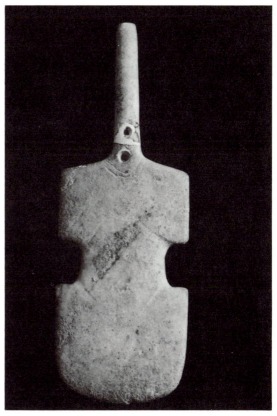

b

c

31. Amulets (fertility charms?).
Cyclades, end of 3rd millennium
B.C. Carved marble. H. about 5 in.
a. From Amorgos. *b*. From Kimo-
los. *c*. From Paros

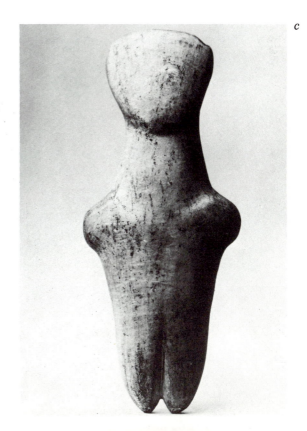

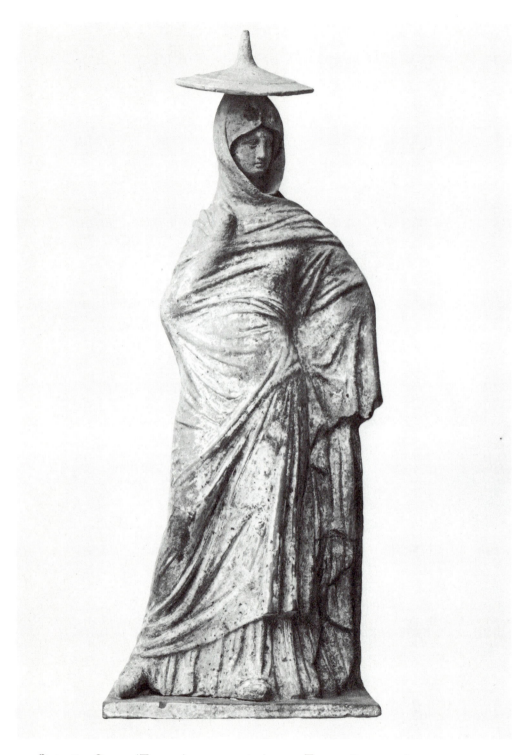

32. Statuette. Greece (Tanagra), IV–III centuries B.C. Terra cotta. H. 10 in.

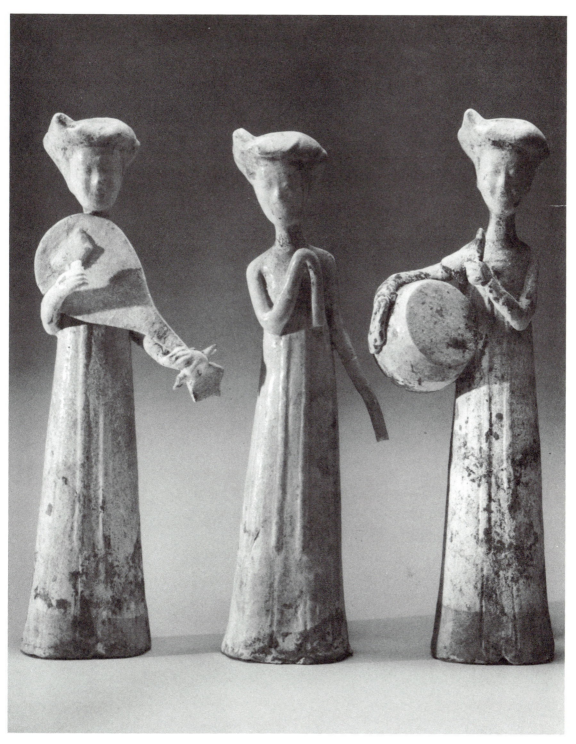

33. Musicians. China (T'ang Dynasty), A.D. 618–906. Terra cotta. H. about 10¾ in.

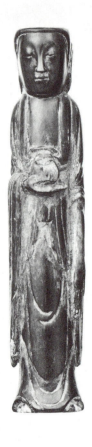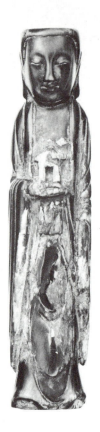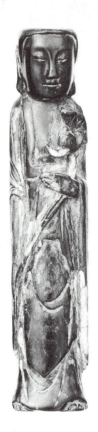

34. Statuettes of the Bodhisattva Avalokiteshvara. China (T'ang Dynasty), A.D. 618–906. Carved ivory. H. 3¾ in.

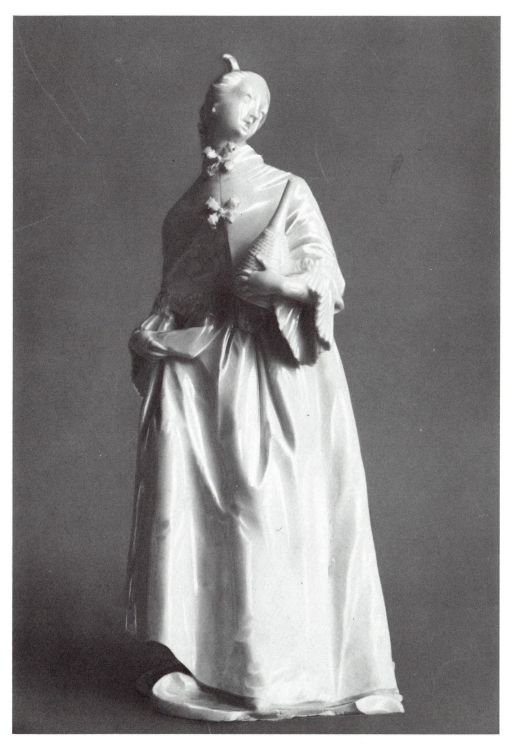

35. Franz Anton Bustelli (1723–63). Lady with flask. Bavaria (Nymphenburg), about 1760. Porcelain. H. 7¾ in.

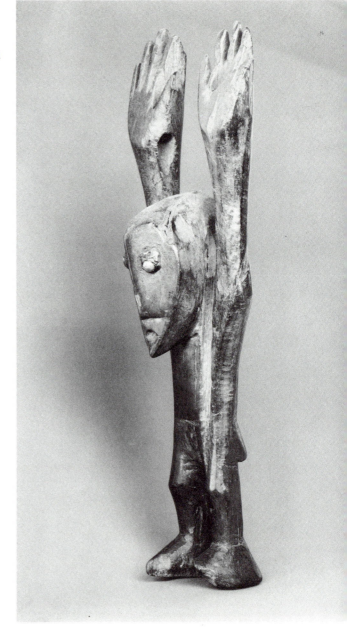

36*a*. Figure. Belgian Congo (Waregga tribe). Wood. h. 9¼ in.

36*b*. Youth Imploring. Modeled in clay by a congenitally blind youth of 17. xx century

37*a*. Mask. Ivory Coast (Dan tribe?). Wood. H. 10⅝ in.

37*b*. Pain. Modeled in clay by a congenitally blind youth of 18. xx century

38*a*. GIACOMO BALLA. Abstract Study of Velocity. 1913. Gouache on paper. 17 x 20 in.

38*b*. Impression from cylinder seal. Mesopotamia (Susa), before 3000 B.C. Steatite. H. 0.67 in.

38*c*. Impression from cylinder seal. Mesopotamia (Tello), before 3000 B.C. Marble. H. 0.86 in.

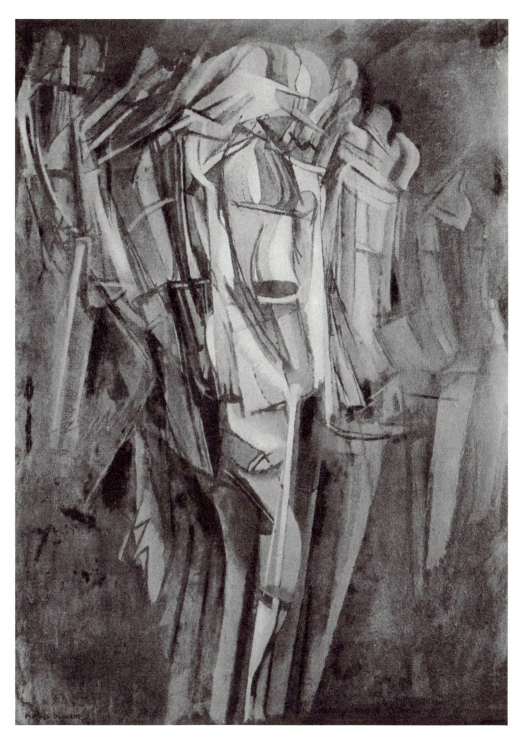

39. MARCEL DUCHAMP. Sad Young Man in a Train. 1911. Oil on cardboard. 28.6 x 39.4 in.

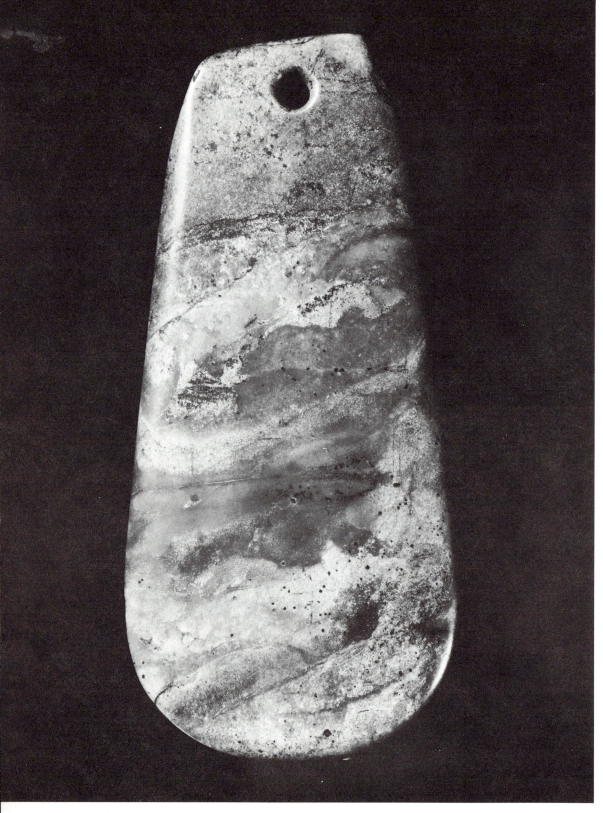

40. Ax-shaped tablet. China, before 220 B.C. Jade. H. 7¾ in.

41. Carved skull, probably representing the Death God. Aztec, about 1324–1521. Rock crystal. H. 8⅓ in.

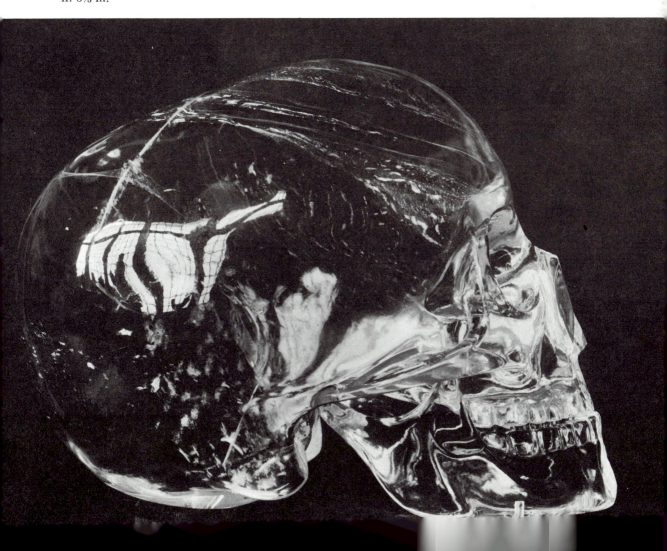

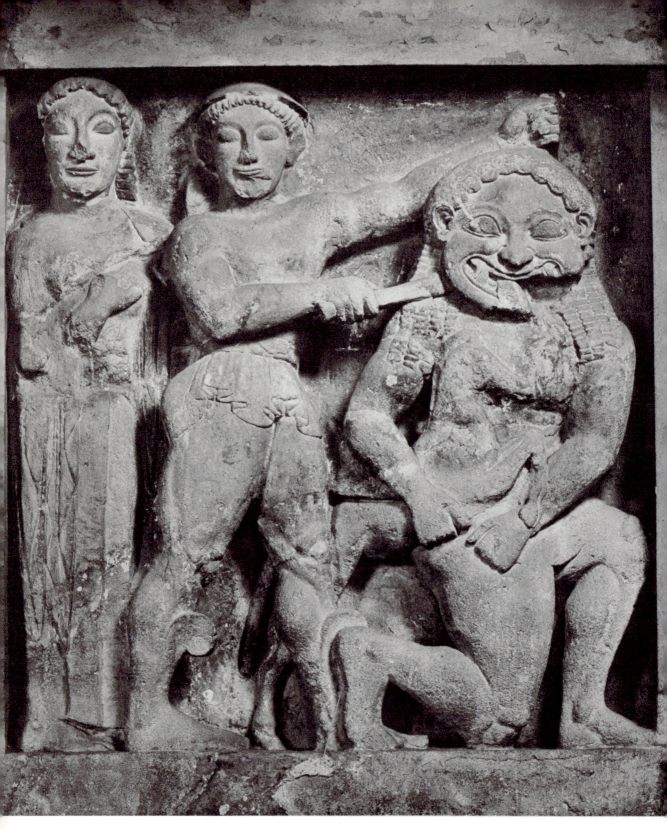

42. Perseus beheading Medusa, from a metope of Temple C at Selinus. Sicily, 550–530 B.C. Marble

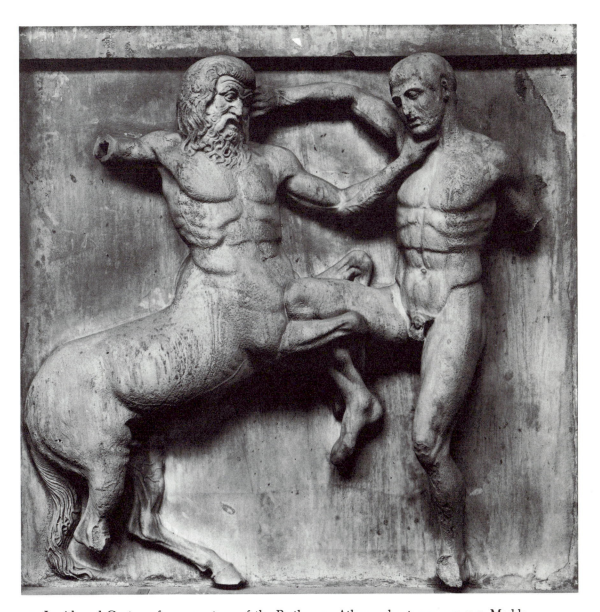

43. Lapith and Centaur, from a metope of the Parthenon. Athens, about 447–443 B.C. Marble. 47 x 50 in.

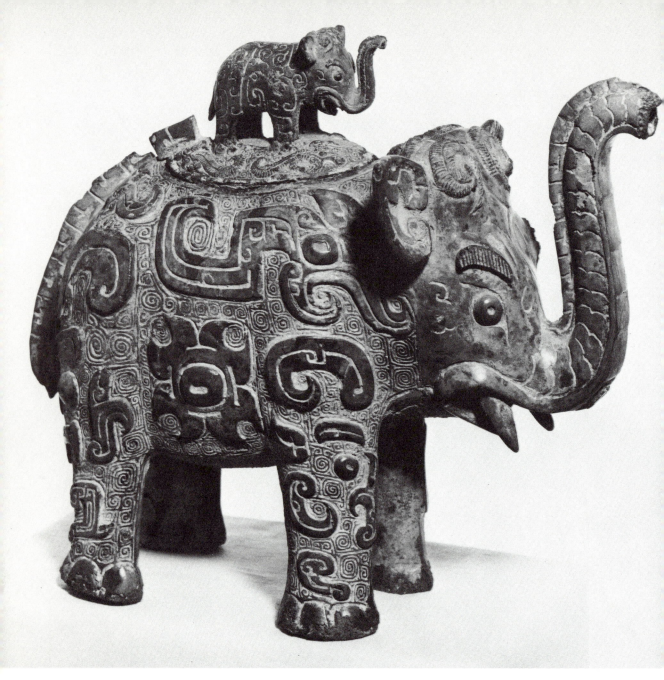

44. Elephant. China (early Chou Dynasty, or earlier), about 1122–249 B.C. Bronze ritual vessel. H. 8¼ in.

45. Monster. China. (Shang Dynasty), about 1766–1122 B.C. Bronze ritual vessel. H. 7⅛ in.

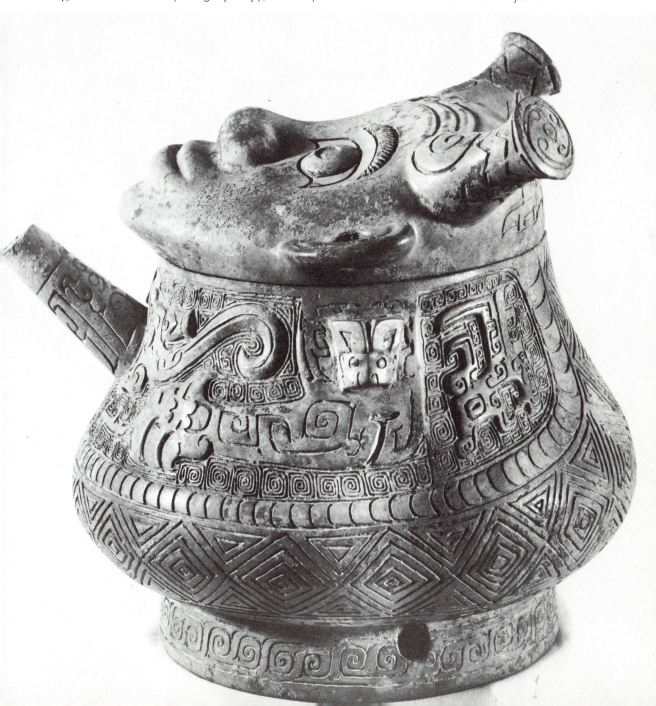

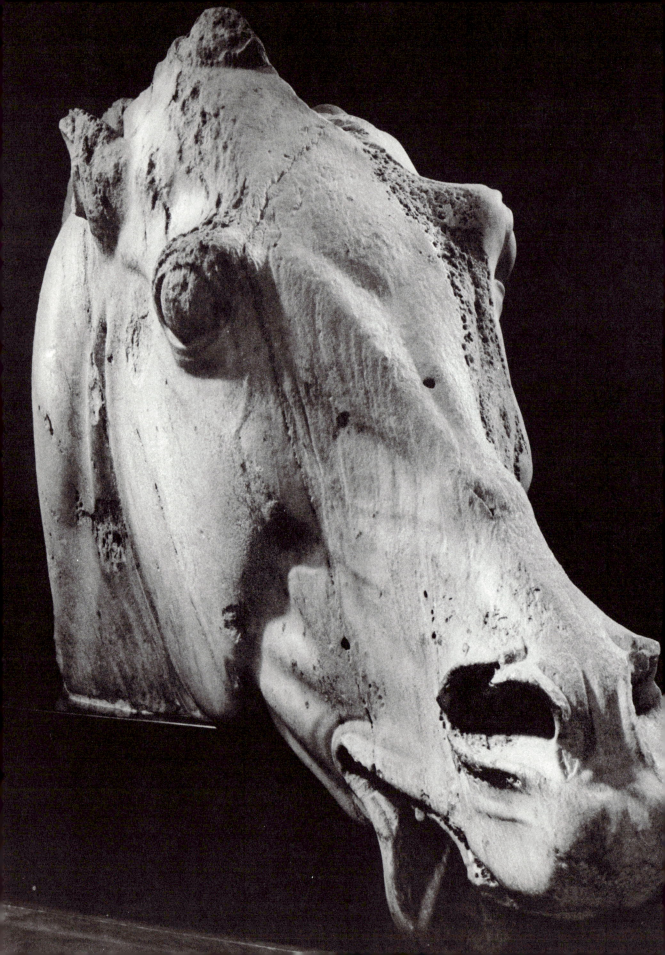

46 (left). Head of a horse, from the Parthenon frieze, east pediment. Athens, 442–38 B.C. Marble. H. 41 in.

47. Head of a cat, from a group of cat and kittens. Egypt (Saïte or Ptolemaic period), VII–I centuries B.C. Bronze. L. of group, 21²⁵⁄₃₂ in.

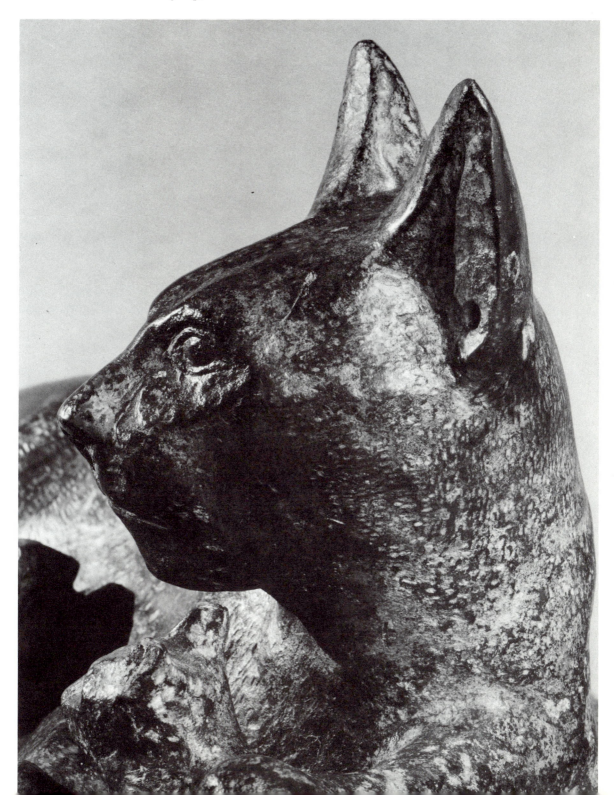

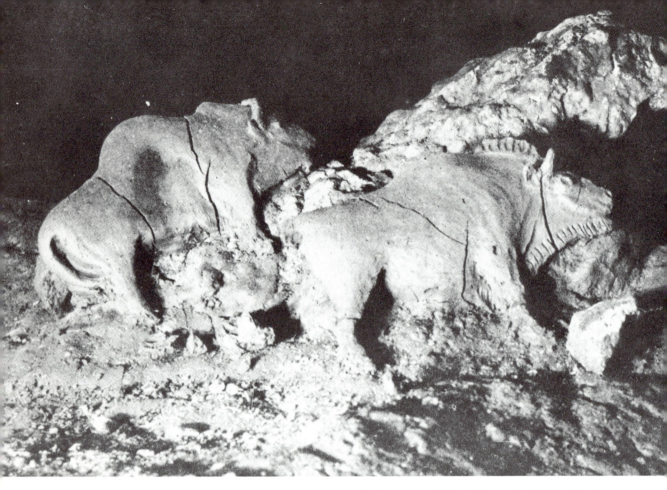

48. Bisons. Grotto of the Tuc d'Audoubert (Ariège), France. Paleolithic period (Magdalenian style). Modeled in clay. L. about 24 in.

49. The She-Wolf nourishing Romulus and Remus. Siena, xv century. Bronze. H. 14⁵⁄₁₆ in.
L. 25¼ in.

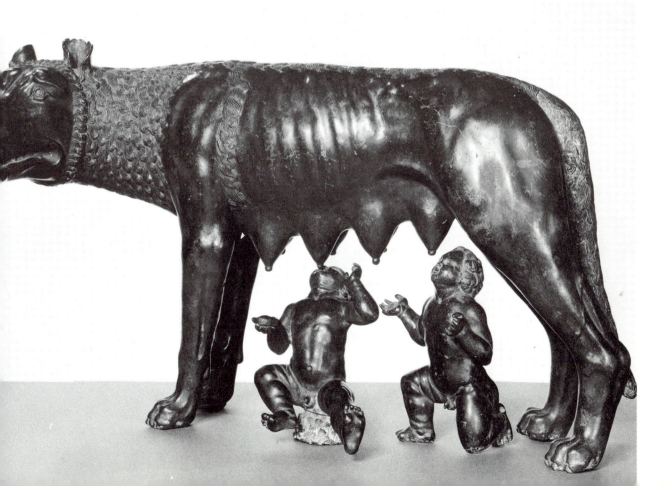

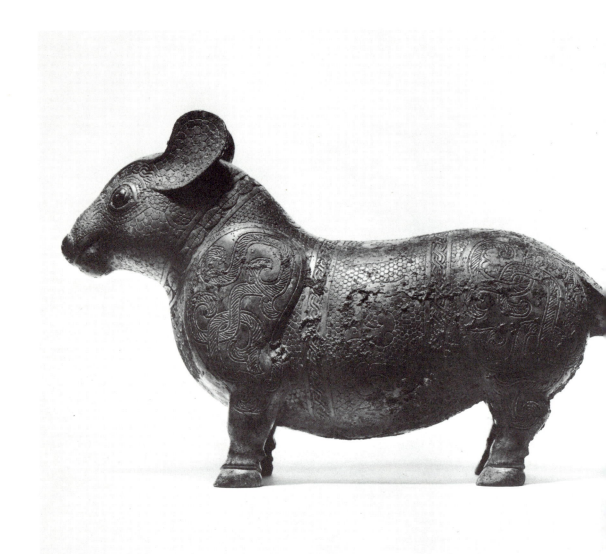

50. Quadruped. China (late Chou Dynasty), VI–III centuries B.C. Bronze. H. 4½ in.

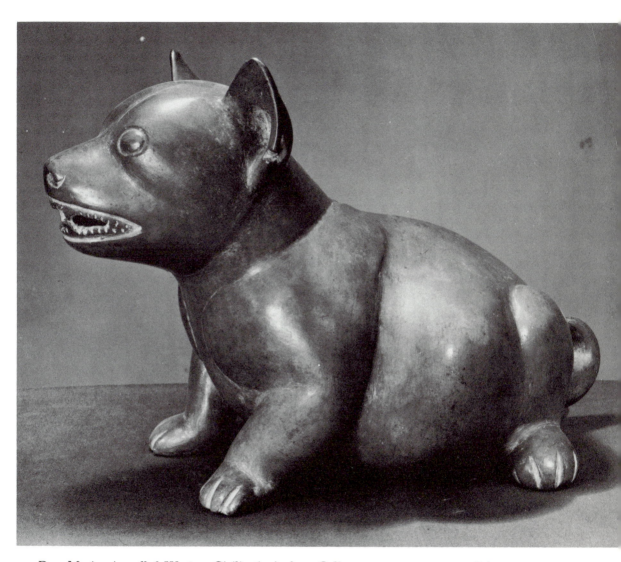

51. Dog. Mexico (so-called Western Civilization), from Colima, 500 B.C.–A.D. 1521. Ocherous clay, covered with a polished red slip. L. 16½ in.

52. Fabulous bird. Mosan, early XIII century. Gilt bronze ewer, cast and chased, enriched with niello and silver. H. 7⅜ in.

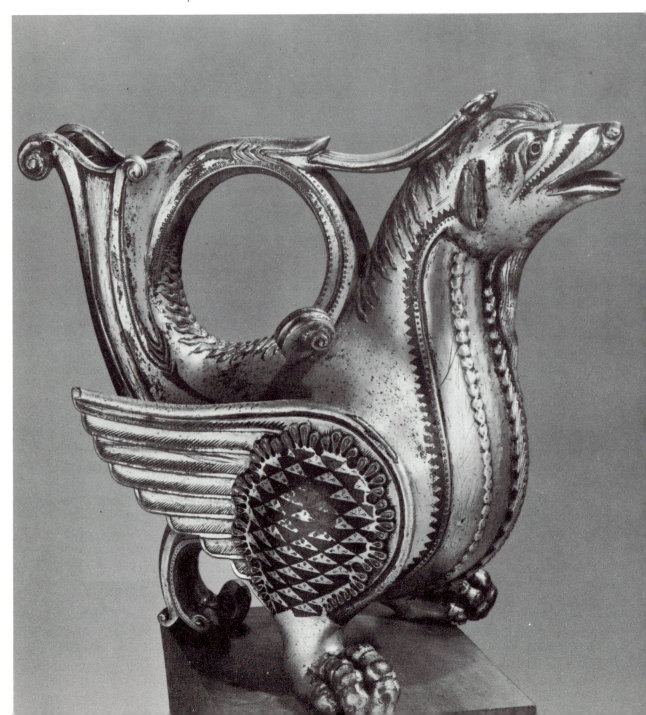

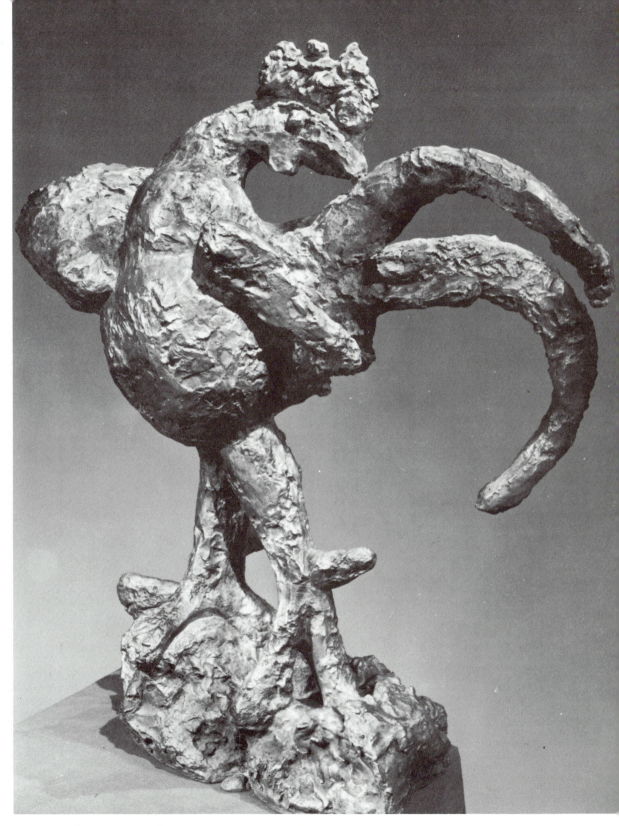

53. Pablo Picasso. Cock. About 1932. Bronze. h. 26½ in.

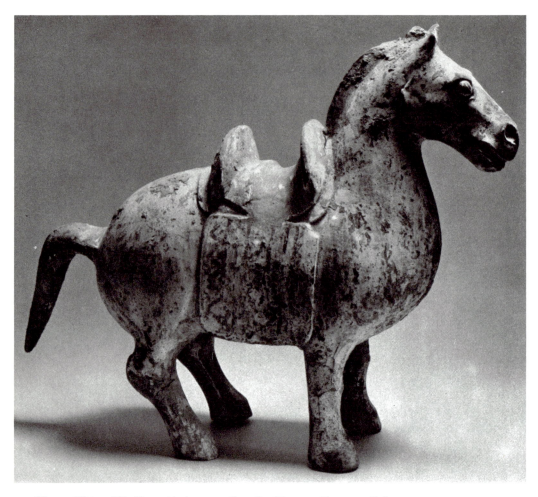

54. Horse. China (Six Dynasties), A.D. 265–589. Terra cotta. L. 11⅘ in.

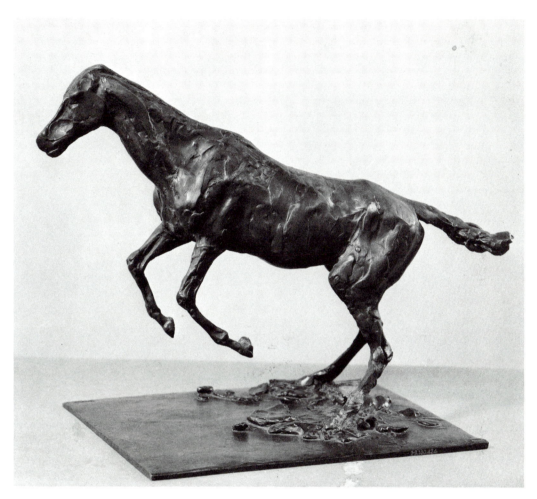

55. EDGAR DEGAS (1834–1917). Horse clearing an Obstacle. About 1865–81. Bronze. H. 11¼ in.

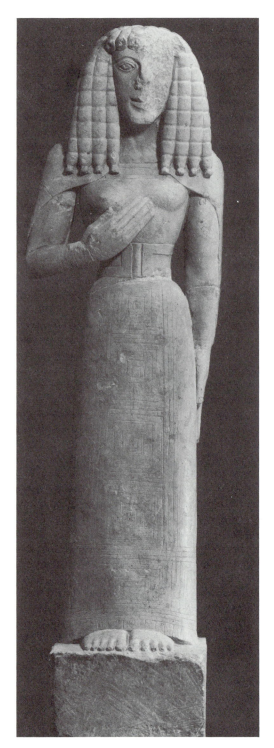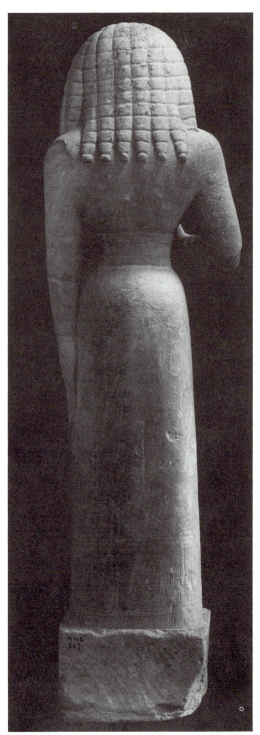

56. "The Lady of Auxerre." Greek (possibly Cretan), end of VII century B.C. Limestone. H. 29½ in.

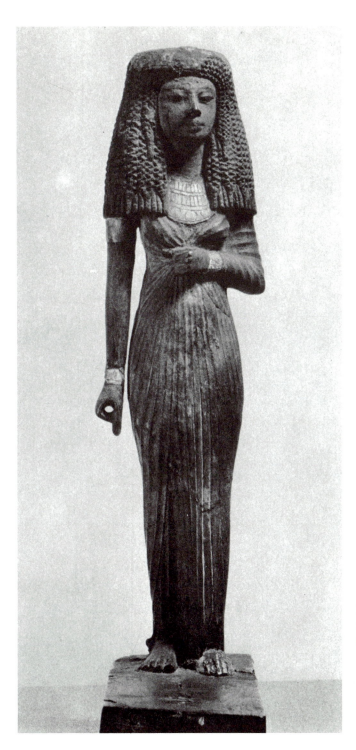

57. Funerary figure. Egypt (New Kingdom), about 1580–1090 B.C. Polychrome wood, traces of gilt. H. 9¾ in.

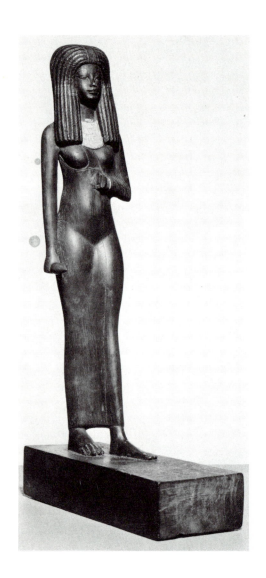

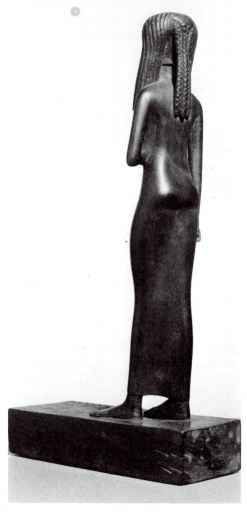

58. Funerary figure of a lady. Egypt (New King-
dom), about 1580–1090 B.C. Wood, with gold-
leaf applied to necklace. H. 11½ in.

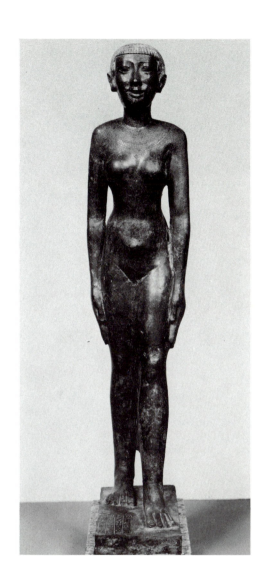

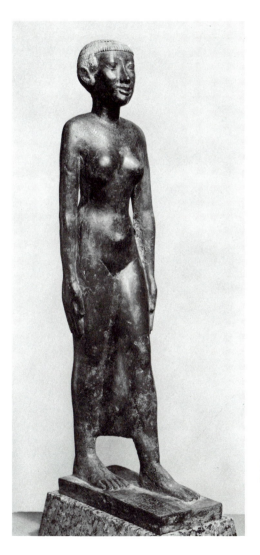

59. Votive statuette of a lady. Egypt (Saïte period), 663–525 B.C. Bronze. H. 26⅝ in.

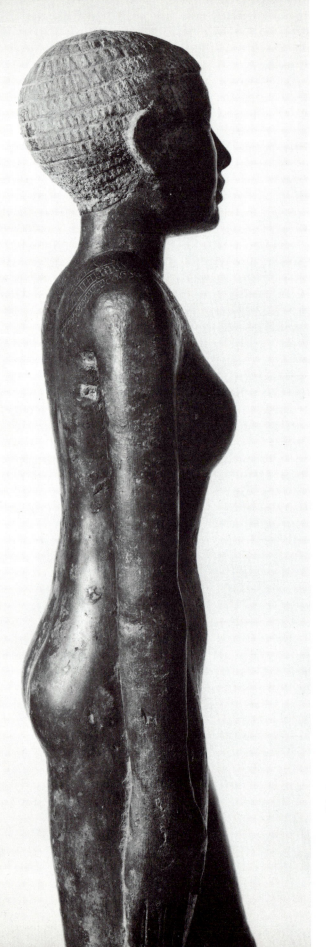

60. Votive statuette of a lady. Detail of
plate 59

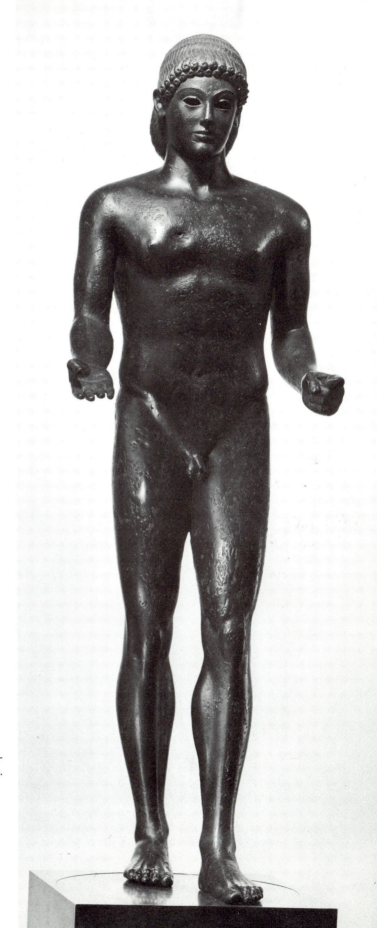

61. Apollo, found in the sea near Piom-
bino, Italy. Greek, early v century B.C.
Bronze. H. 45¼ in.

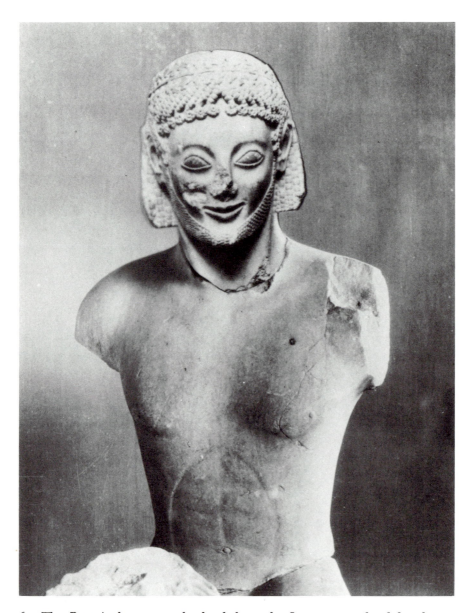

62. The Rampin horseman: the head from the Louvre, completed by the broken torso from the National Museum, Athens. About 560 B.C.

63. Stone fragment worshiped as Rukmini. India (Nokhas), probably X century A.D. Sandstone. H. 5 ft. 4½ in.

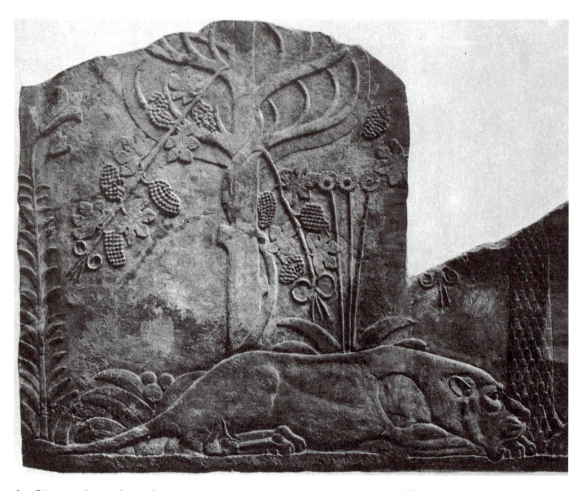

64. Lioness from the palace of Assur-bani-pal. Assyria (Nineveh), 668–26 B.C. Alabaster. H. 38½ in. w. 69 in.

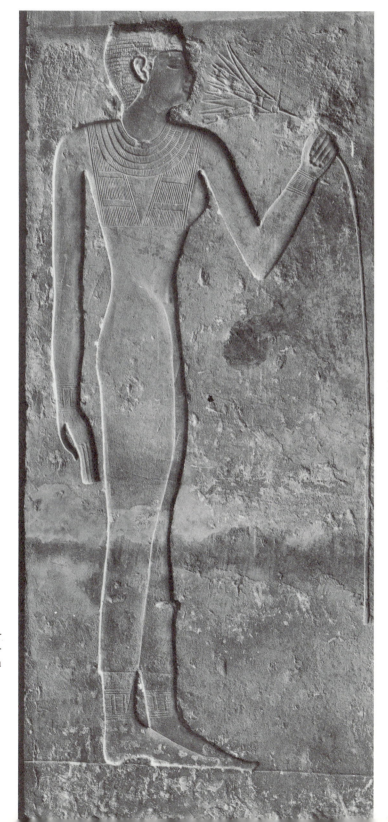

65. Young woman with a lotus blossom. Egypt (v Dynasty style), 2750–2625 B.C. Limestone block carved in sunken relief. H. 4 ft. 3 in.

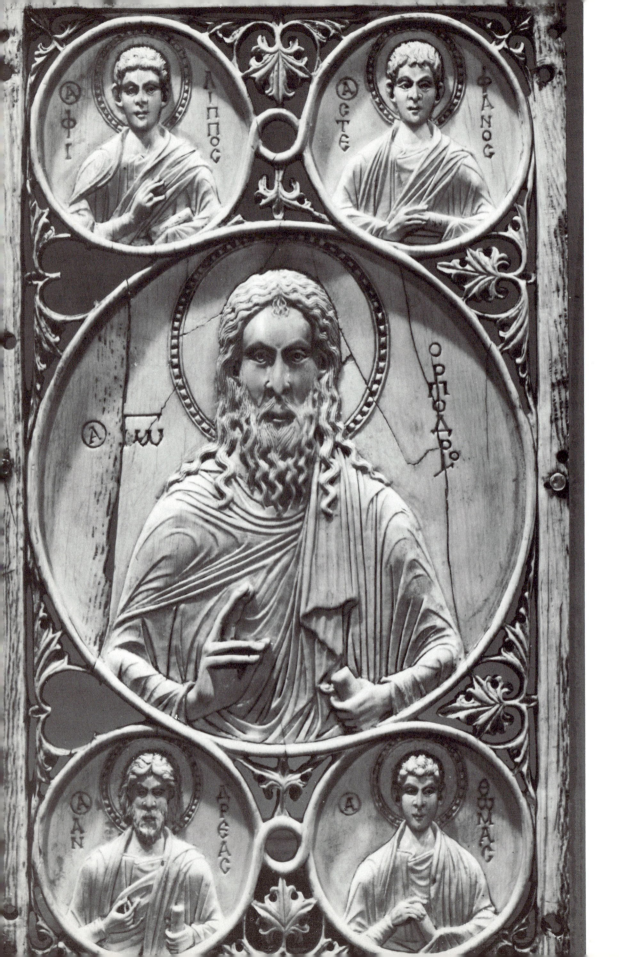

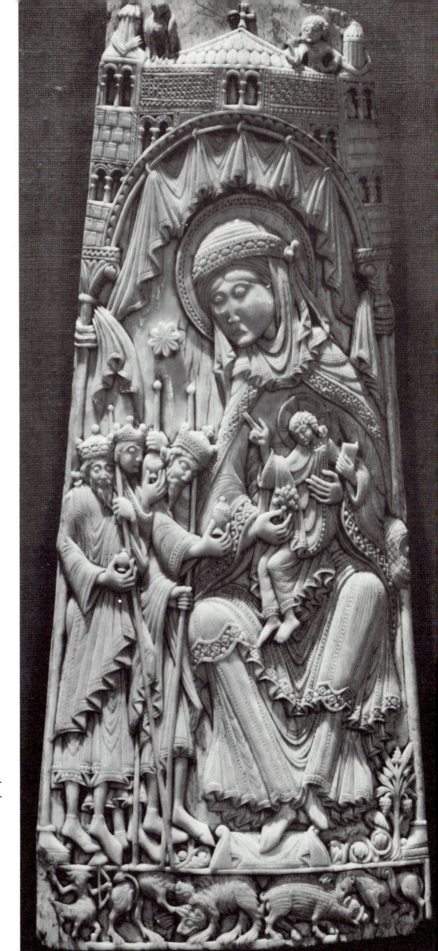

66 (left). St. John the Baptist and Saints. Byzantine, XI–XII centuries. Pierced panel of ivory. H. 9¼ in. W. 5¼ in.

67. The Adoration of the Magi. English, XI–XII centuries. Whalebone. H. 14¼ in.

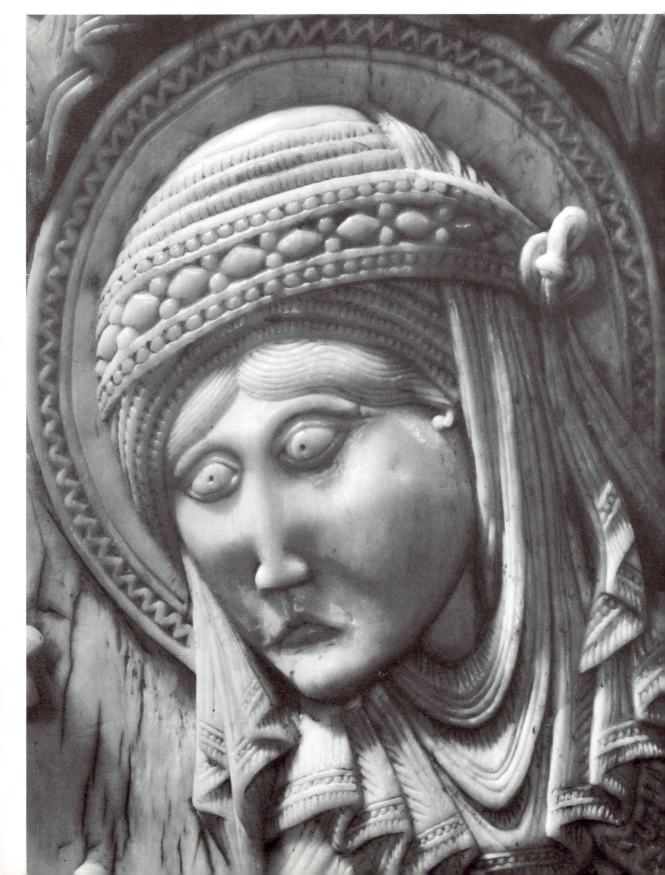

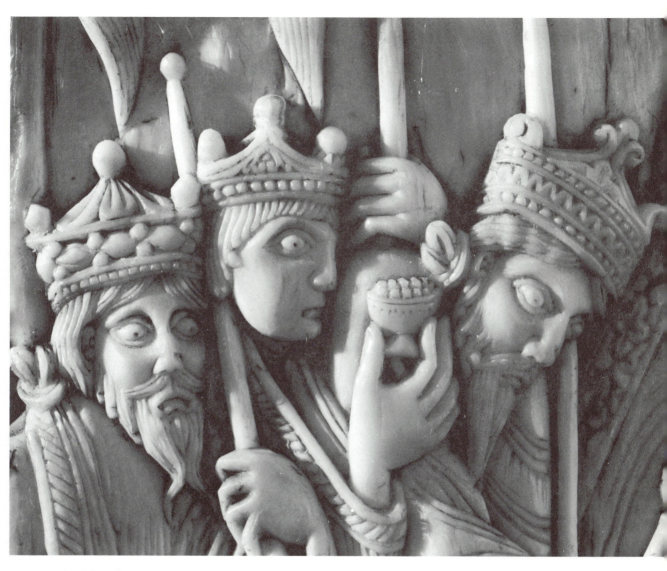

69. The Three Magi. Detail of plate 67

68 (left). Head of the Virgin. Detail of plate 67

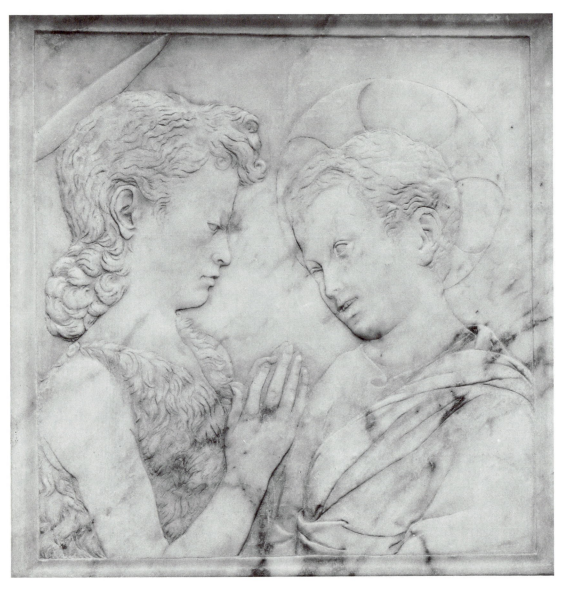

70. DESIDERIO DA SETTIGNANO (1428–64). The Young Christ with St. John the Baptist. Florence, mid-xv century. Marble. H. 15¾ in.

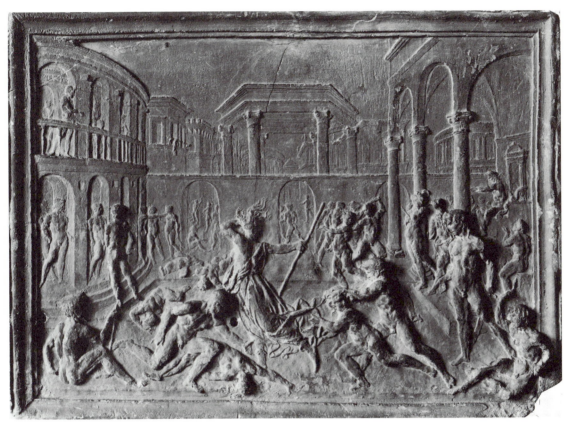

71. Francesco di Giorgio Martini (?) (1439–1502). An Allegory of Discord. Siena, about 1450–1500. Stucco. w. 26½ in.

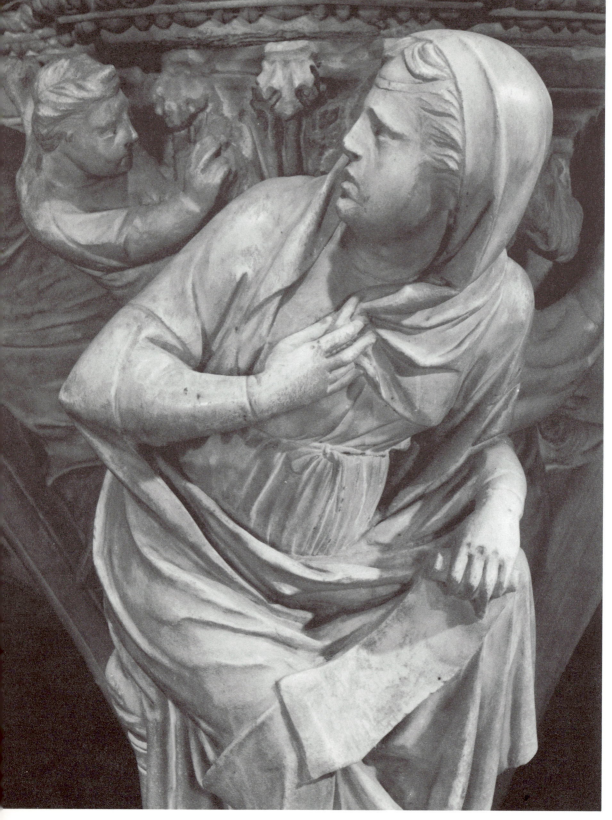

72. GIOVANNI PISANO (1240?–?1320). The Annunciation. Detail from a panel of the pulpit in Sant' Andrea, Pistoia. Commissioned 1298, completed 1301. Marble. Panel: 33 x 40¼ in.

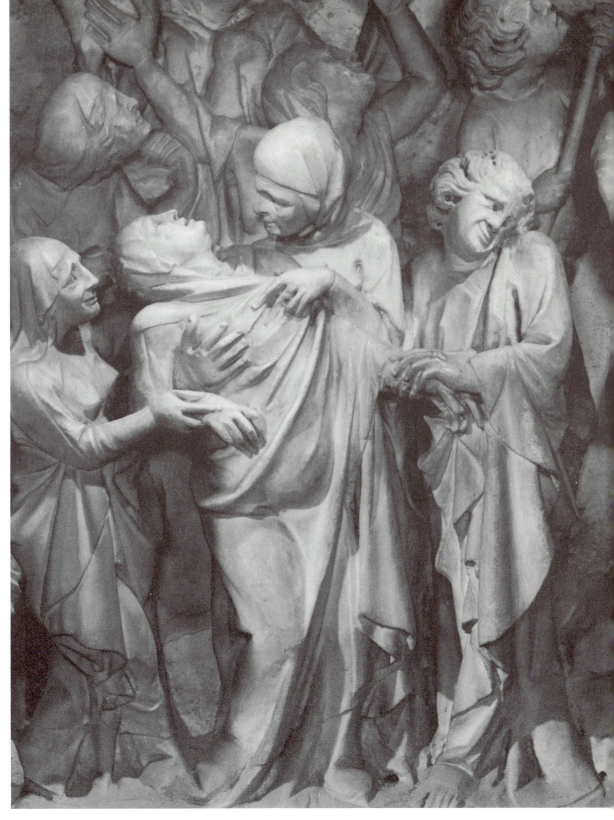

73. GIOVANNI PISANO. The Virgin Mary. Group from the Crucifixion Panel of the pulpit in
Sant' Andrea, Pistoia (see plate 72)

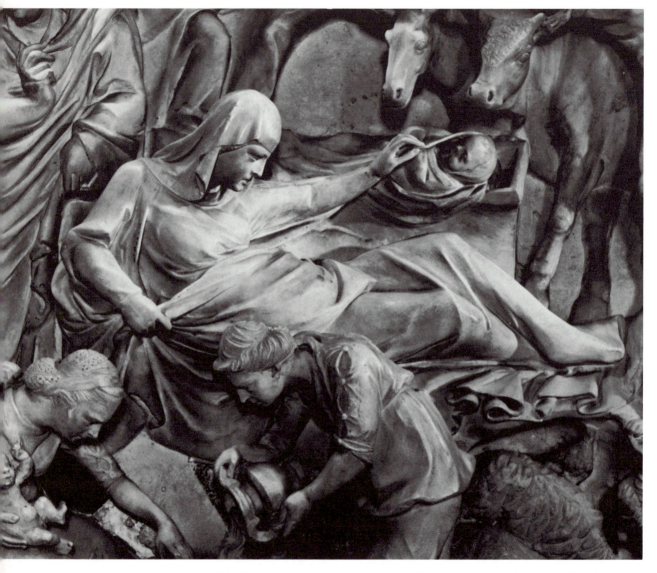

74. GIOVANNI PISANO. The Nativity. Detail from a panel of the pulpit in Sant' Andrea, Pistoia (see plate 72)

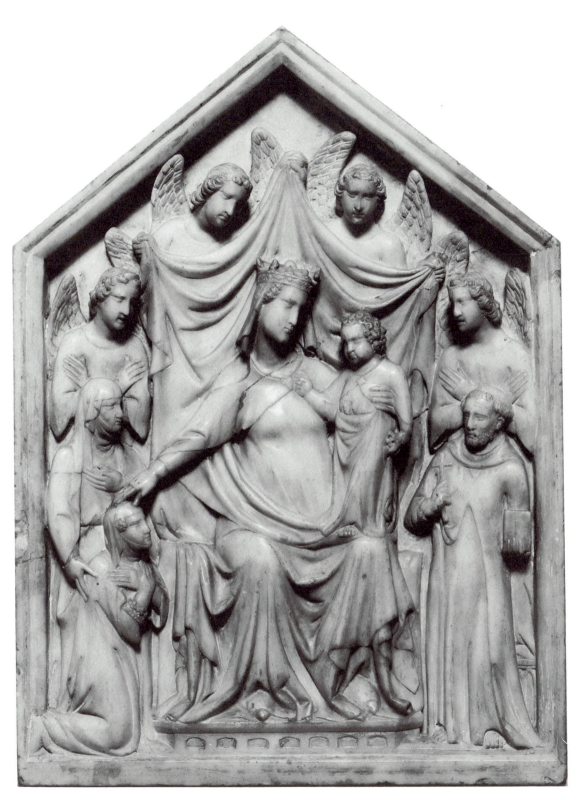

75. TINO DI CAMAINO (1285?–1337). Votive relief of Queen Sancia, with donor, Virgin and Child, Sts. Clara and Francis, and angels. Italian, about 1300–1337. Marble. H. 20¼ in.

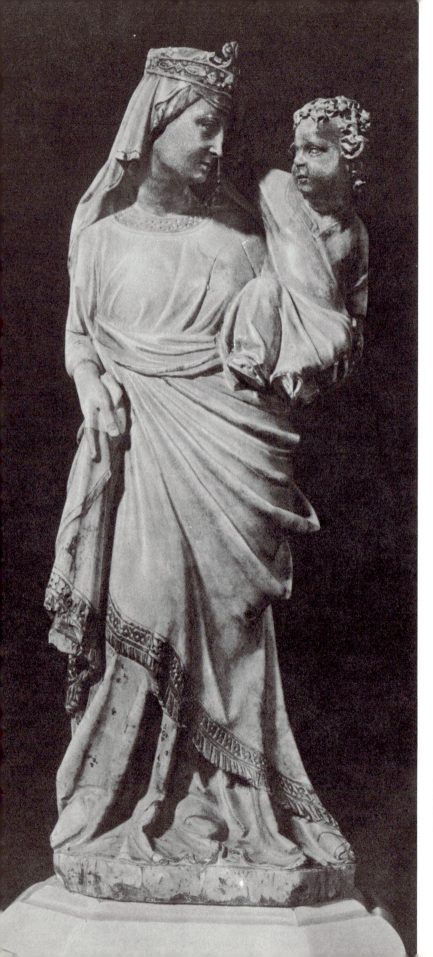

76. GIOVANNI PISANO. Virgin and Child, in the Cathedral at Prato. About 1317. Marble. H. 27½ in.

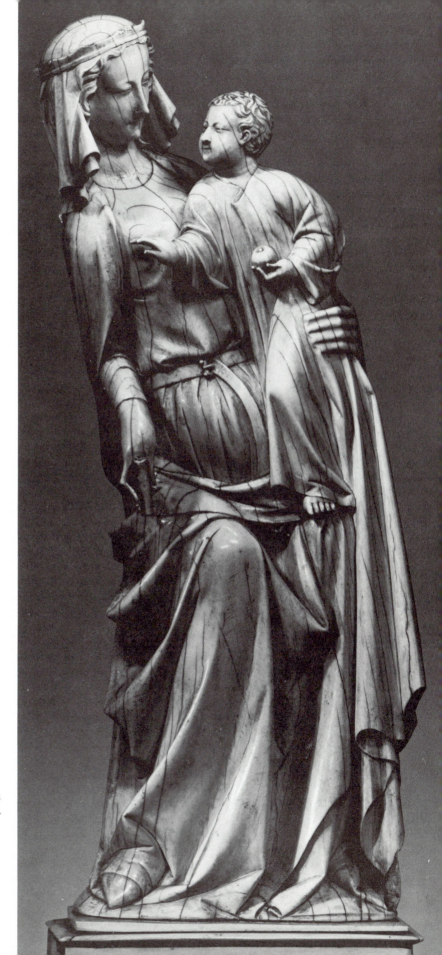

77. Virgin and Child. French
(School of Paris), XIV century.
Ivory. H. 14 in.

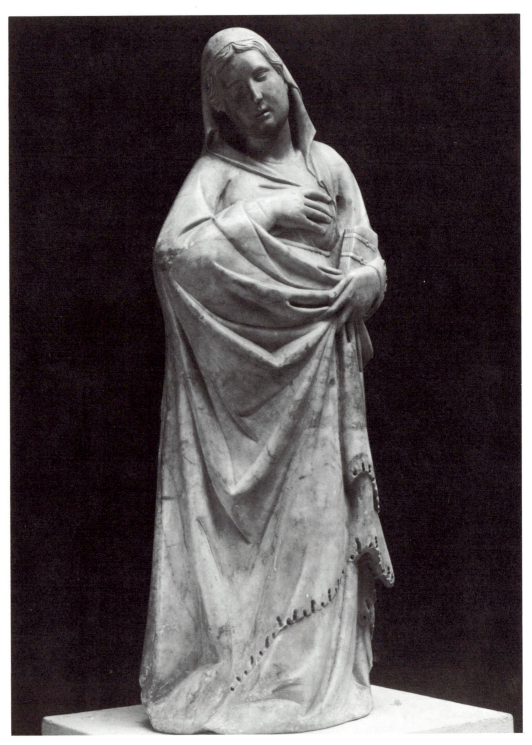

78. Tino di Camaino. Virgin of the Annunciation, in the Church of Santa Croce, Florence. About 1319. Marble. h. 28¾ in.

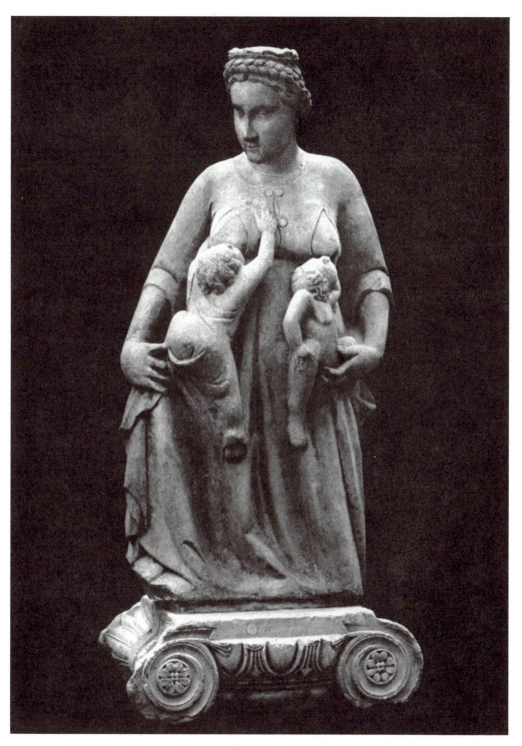

79. TINO DI CAMAINO. Charity. Florence, about 1321–24. Marble. H. 49¼ in.

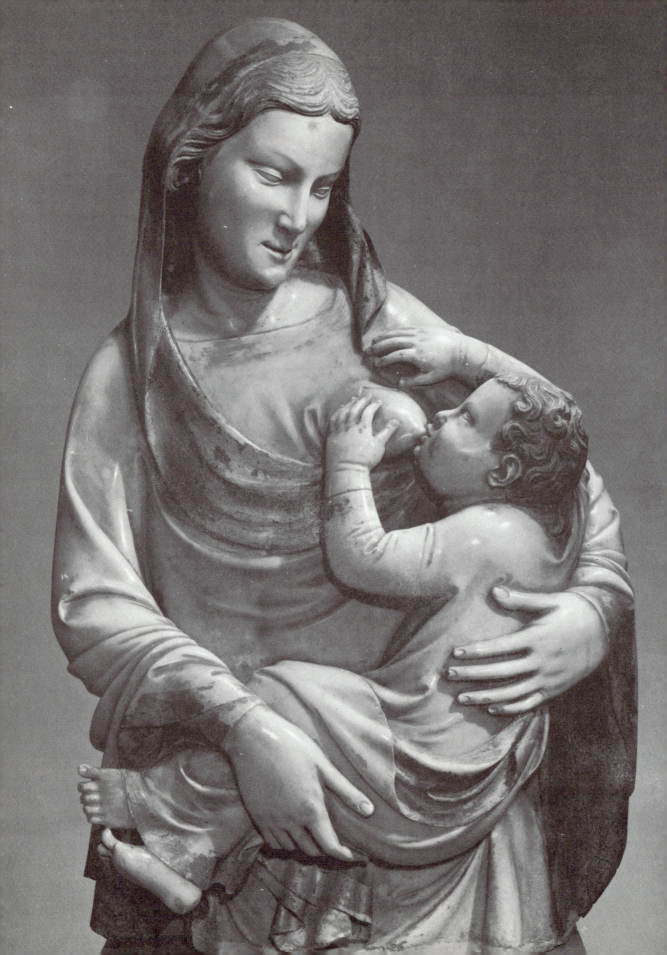

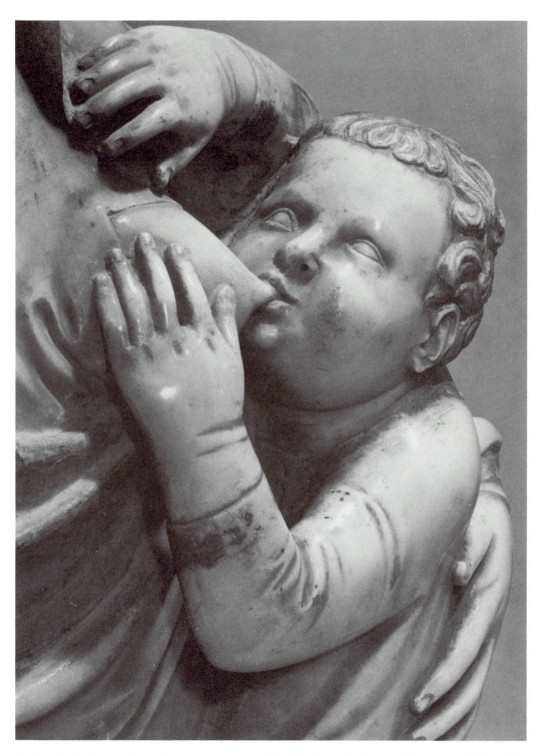

80–81. Probably by Nino Pisano (1313?–?1368). Virgin and Child ("Madonna del Latte"). Pisa, about 1365–68. Marble. H. 35⅝ in.

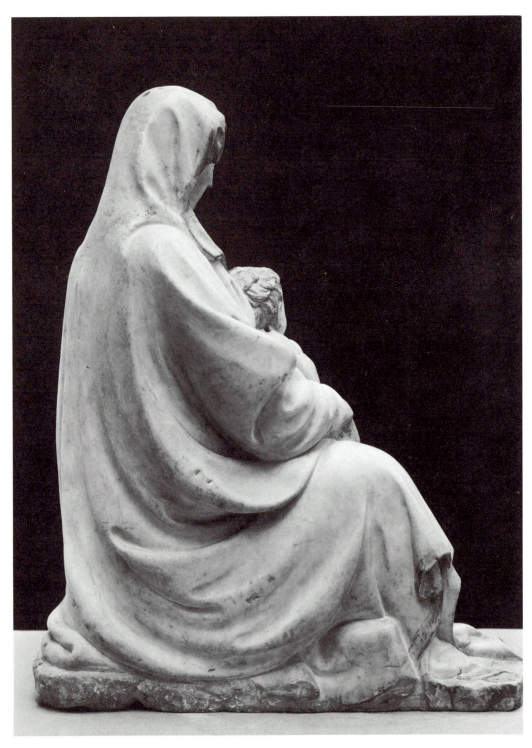

82. Jacopo della Quercia (1371–1438). The Madonna of Humility. Italian, about 1428–35. Marble. H. 23 in.

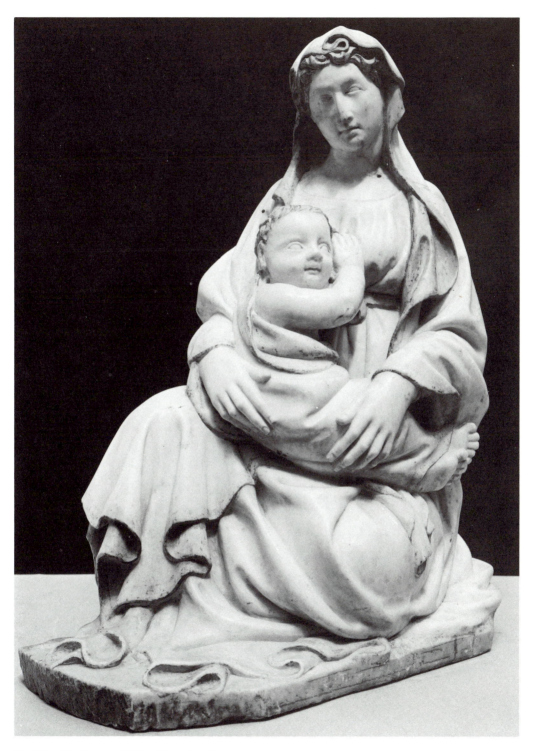

83. The Madonna of Humility. Another view.

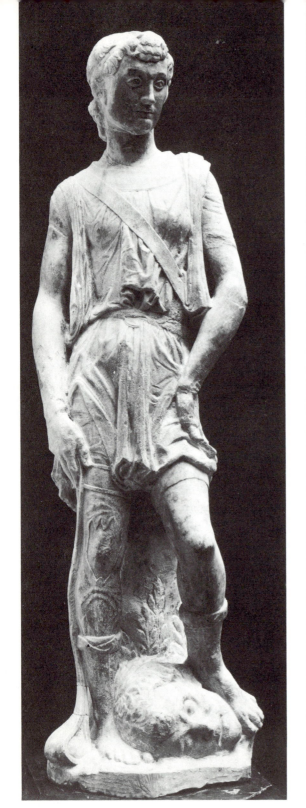
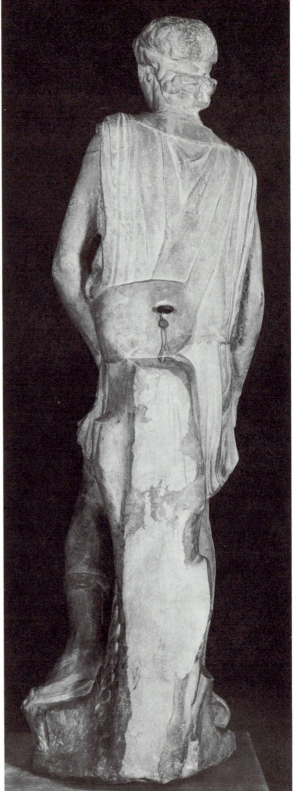

84. DONATELLO (about 1386–1466). The David of the Casa Martelli. Italian, 1434–38. Marble. H. 64 in.

85. The David of the Casa Martelli. Head of Goliath

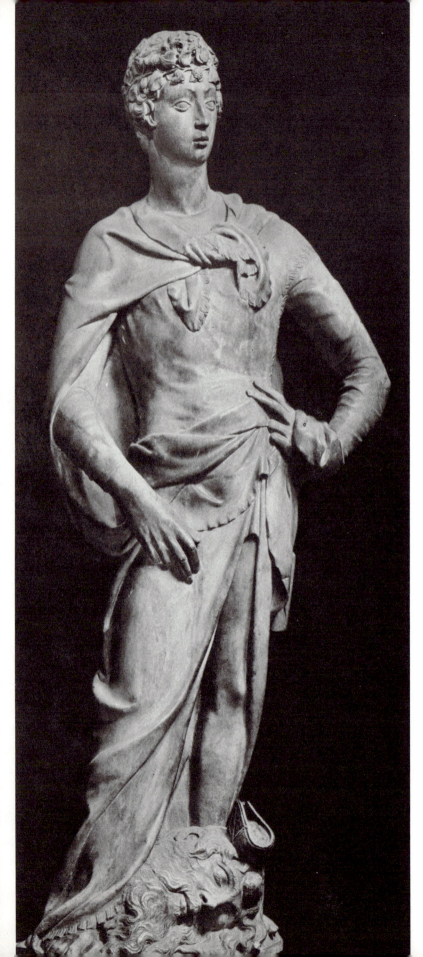

86. DONATELLO. David. Florence, 1408–9. Marble. H. 75½ in.

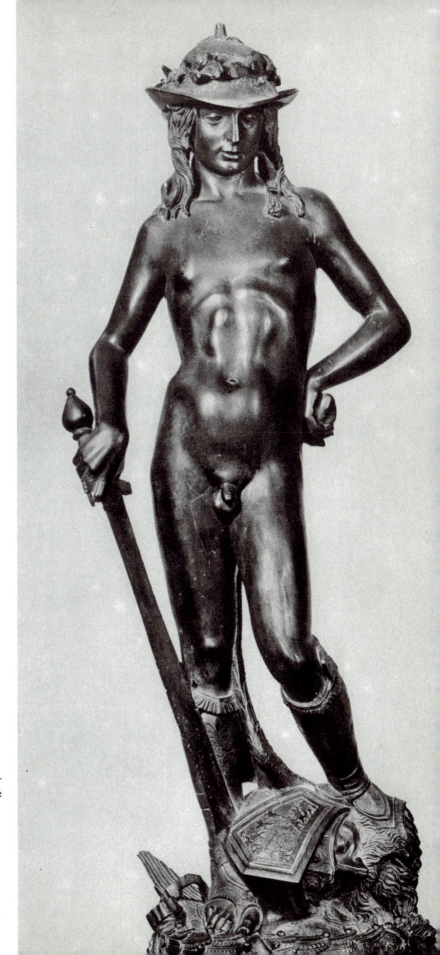

87. DONATELLO. David. Florence, 1438–43. Bronze. H. 60½ in.

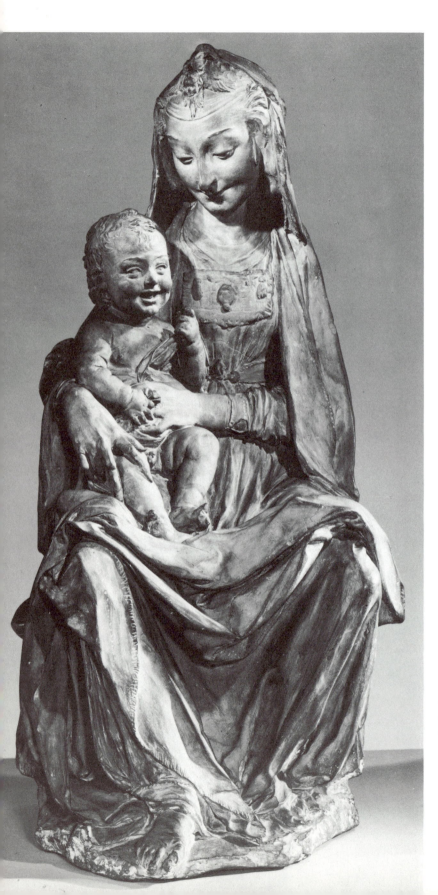

88–89. ANTONIO ROSSELLINO (1427–78), formerly attributed to Leonardo. The Virgin with the Laughing Child. Florence, mid-xv century. Terra cotta. H. 20 in. (Right: detail)

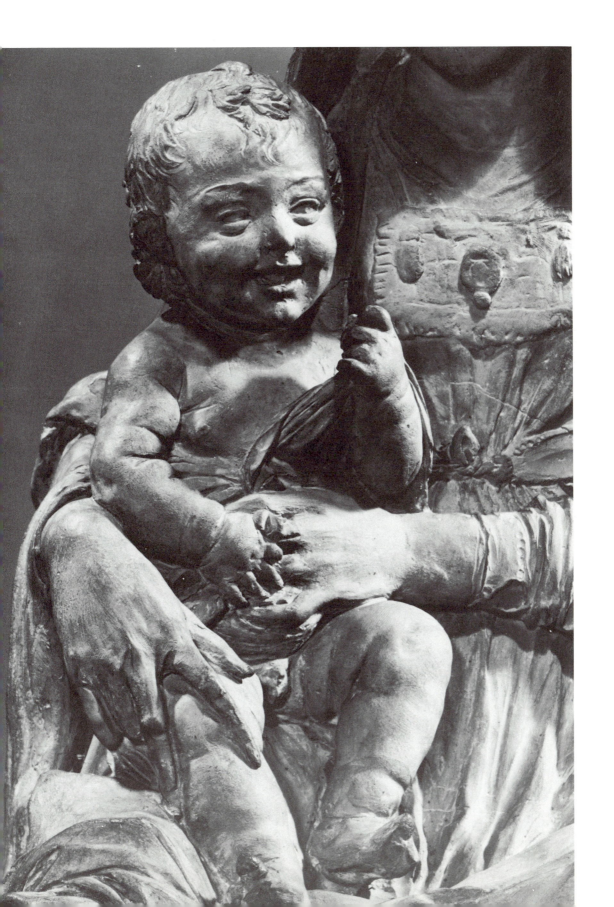

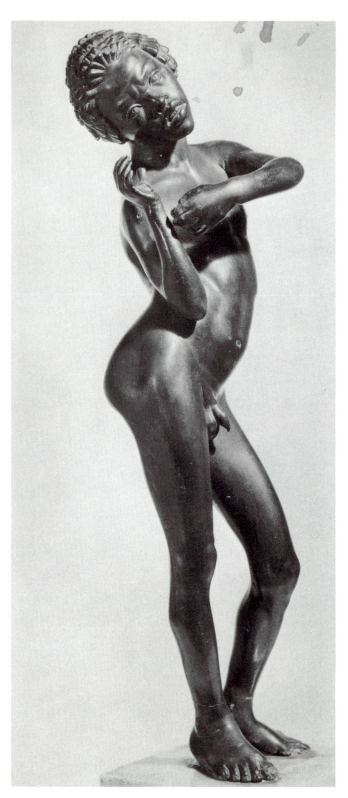

90. Statuette of a Negro musician, found at Châlon-sur-Saône in 1763. Hellenistic, late IV–I centuries B.C. Bronze. H. 8 in.

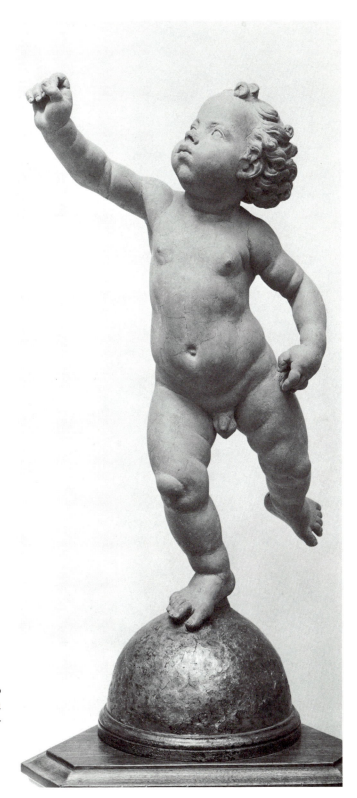

91. ANDREA DEL VERROCCHIO
(1436–88). Putto poised on a
globe. Florence, mid-xv cen-
tury. Terra cotta. H. 29½ in.

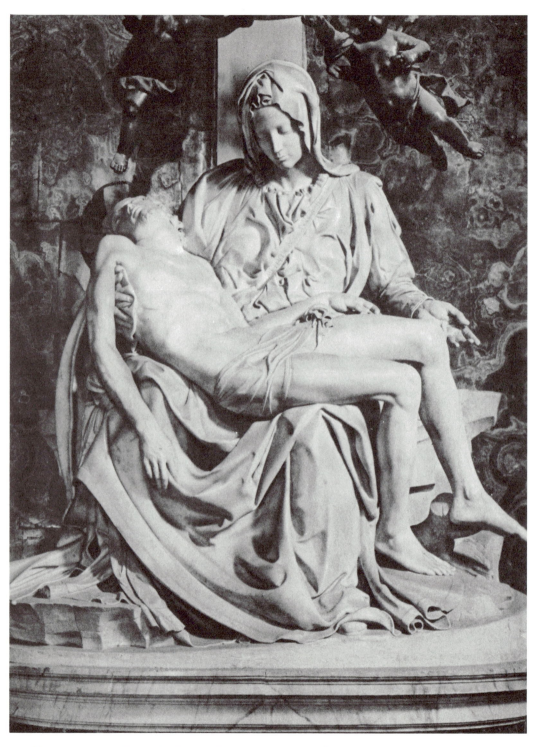

92. MICHELANGELO. Pietà, St. Peter's, Rome. 1498–1500. Marble. H. 69 in.

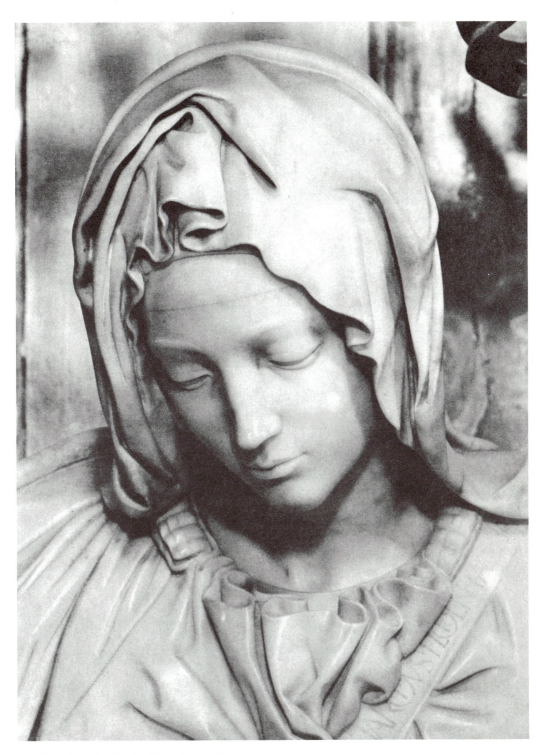

93. Detail of the Pietà. (See plate 92)

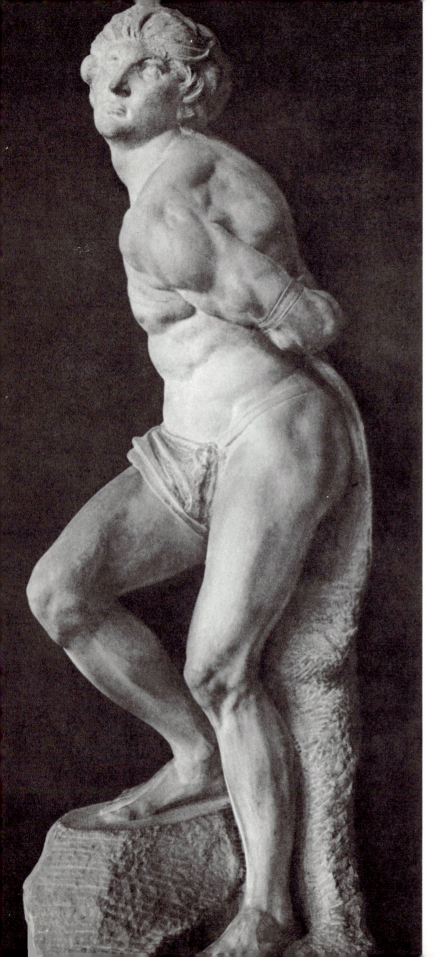

94. MICHELANGELO. Slave, intended for the tomb of Pope Julius II. Rome, 1513–16. Marble. H. 86½ in.

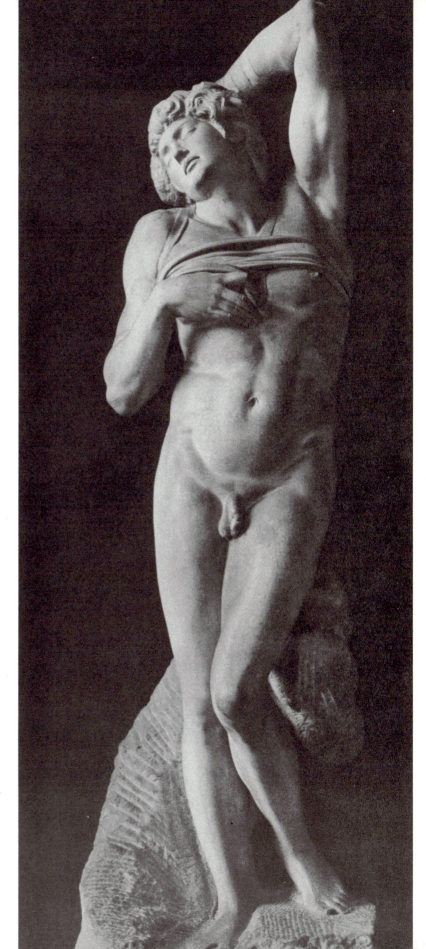

95. MICHELANGELO. Slave. H. 90½ in. (See plate 94)

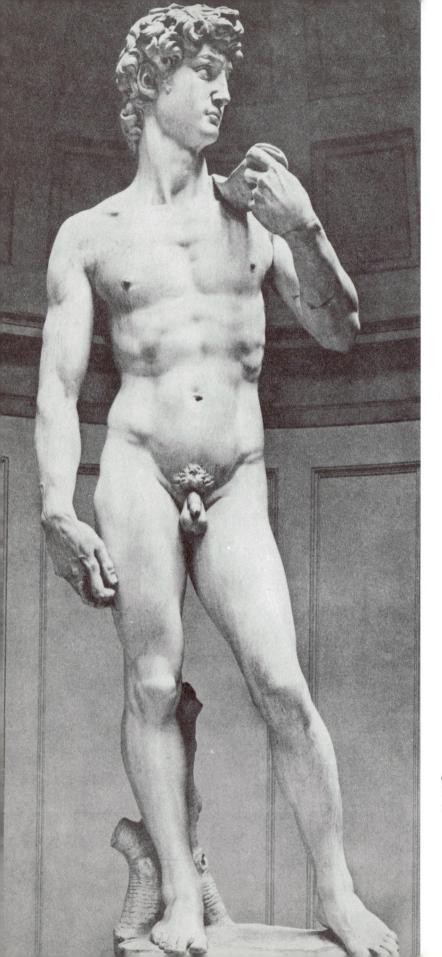

96–97. MICHELANGELO. David.
Florence, 1501–4. Marble. H. 18
ft. ½ in.

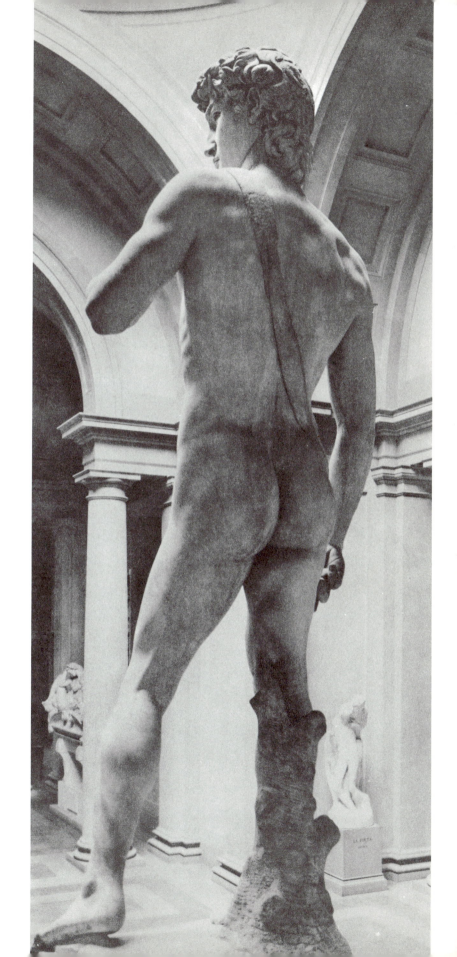

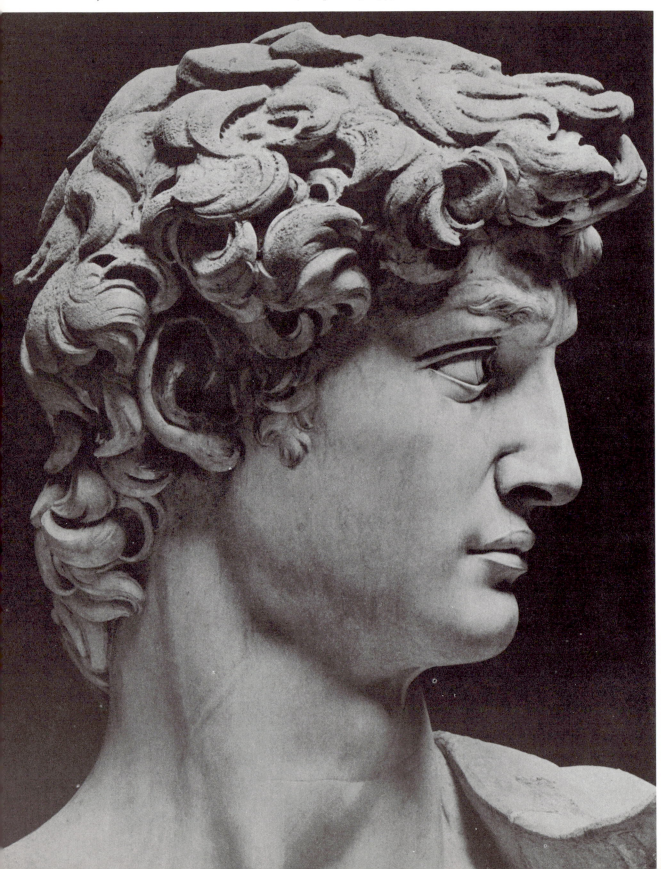

98. MICHELANGELO. Head of David. (See plates 96–97)

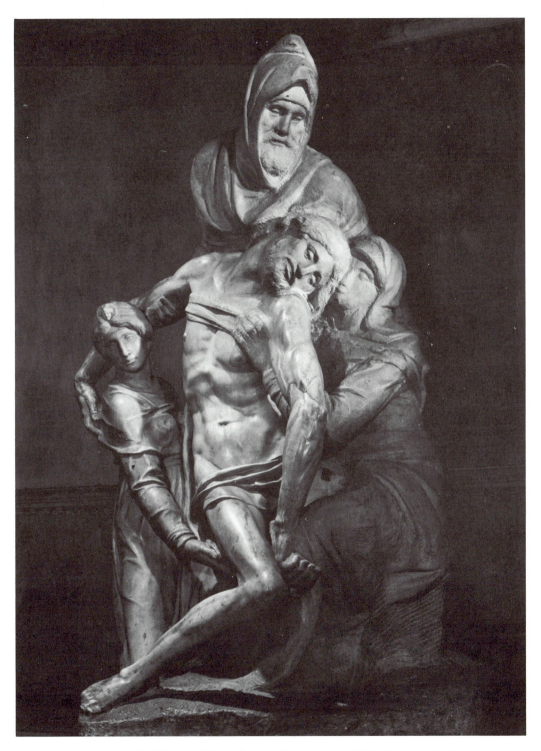

99. MICHELANGELO. The Florence Pietà. Rome, about 1550–56. Marble. H. 7 ft. 8 in.

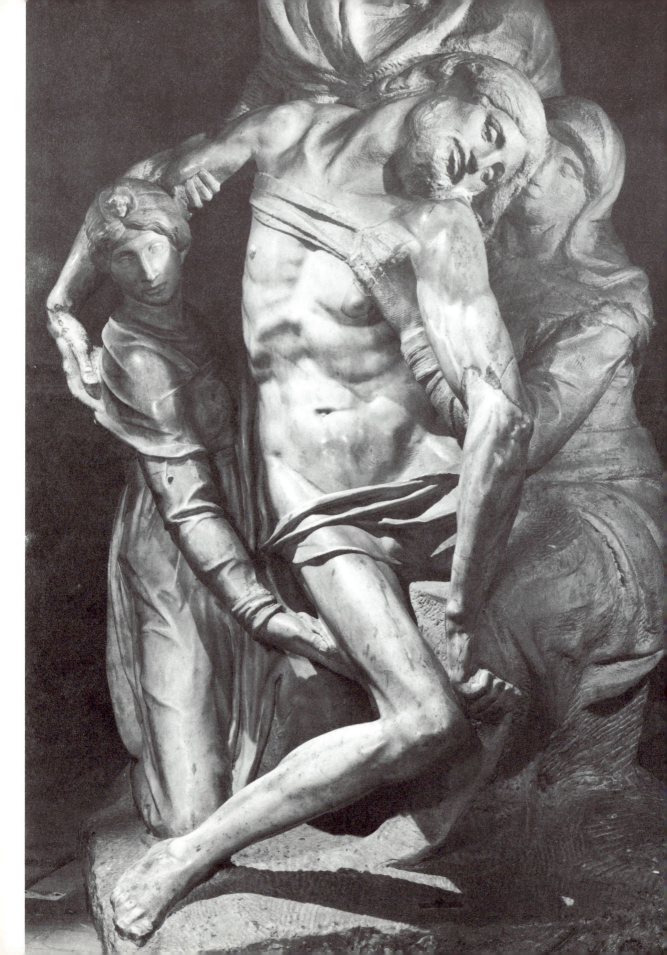

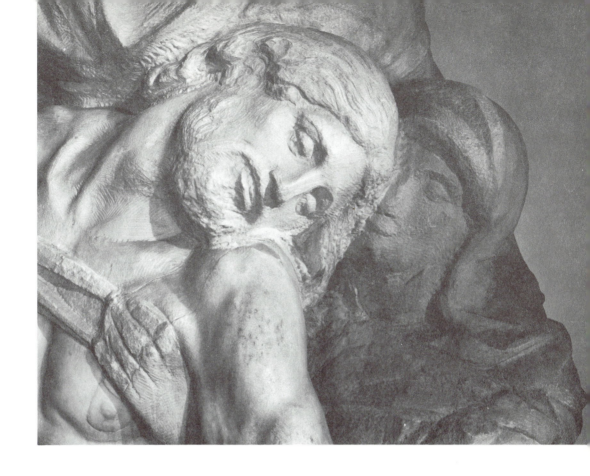

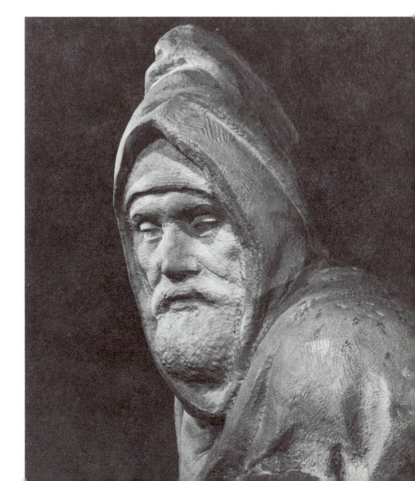

100–101. Michelangelo. The Florence Pietà. Details. (See plate 99)

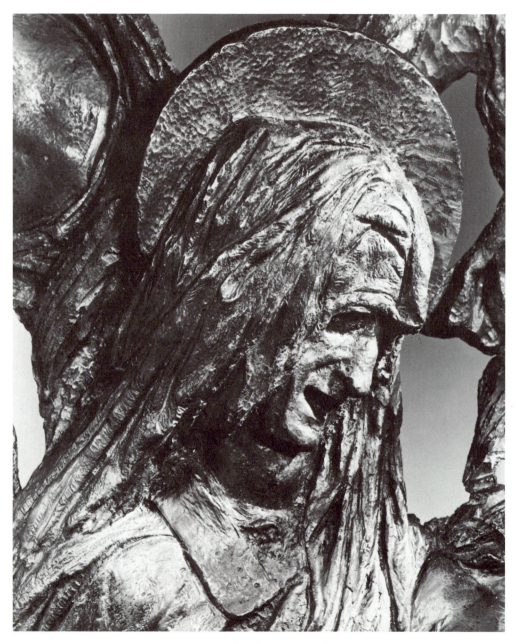

102. DONATELLO. The Lamentation over the Dead Christ. Detail from the Pietà. 1450–60. Relief in bronze. Group, 13 x 16½ in.

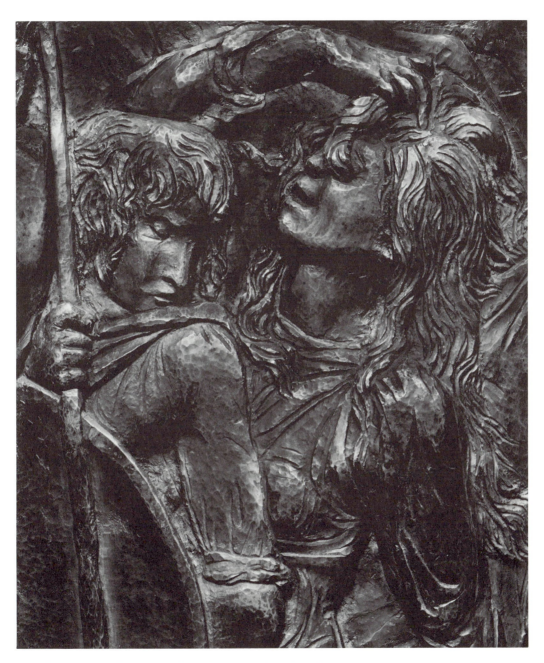

103. DONATELLO. Deposition from the Cross. Detail. (See plate 104)

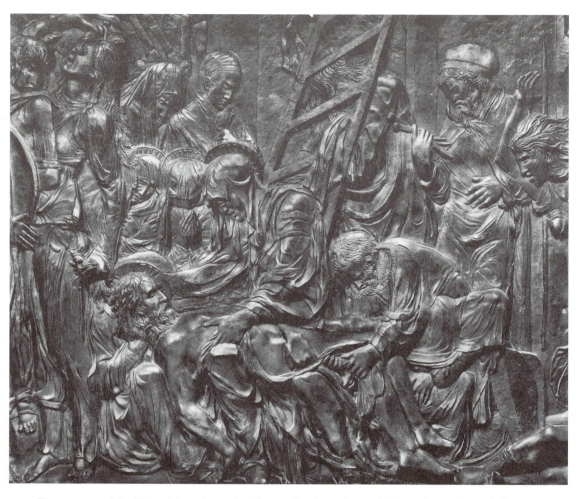

104. DONATELLO. The Deposition from the Cross. Section of panel from the pulpit of San Lorenzo. Florence, about 1460–66. Relief in bronze

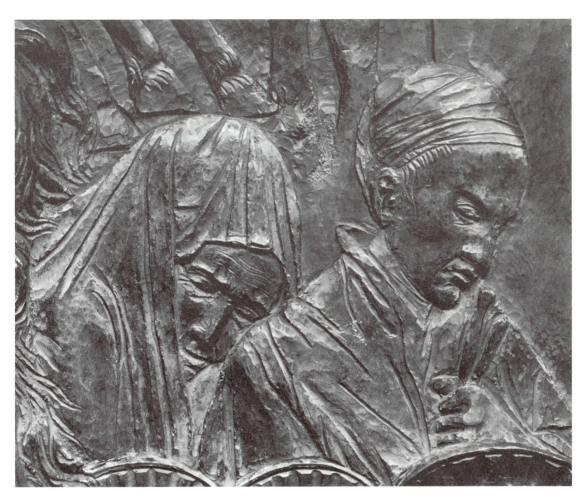

105. The Deposition from the Cross. Detail

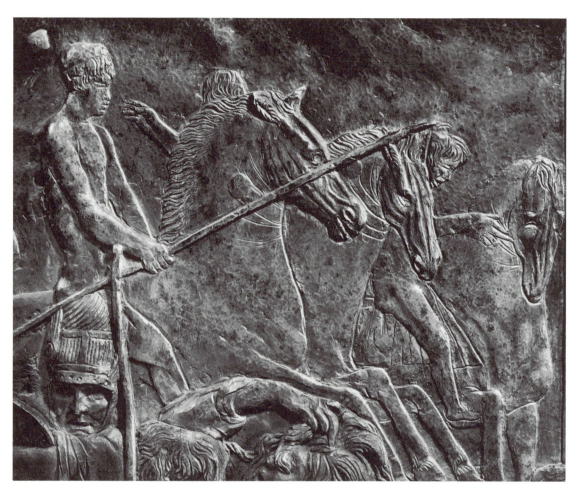

106. DONATELLO. The Deposition from the Cross. Detail. (See plate 104)

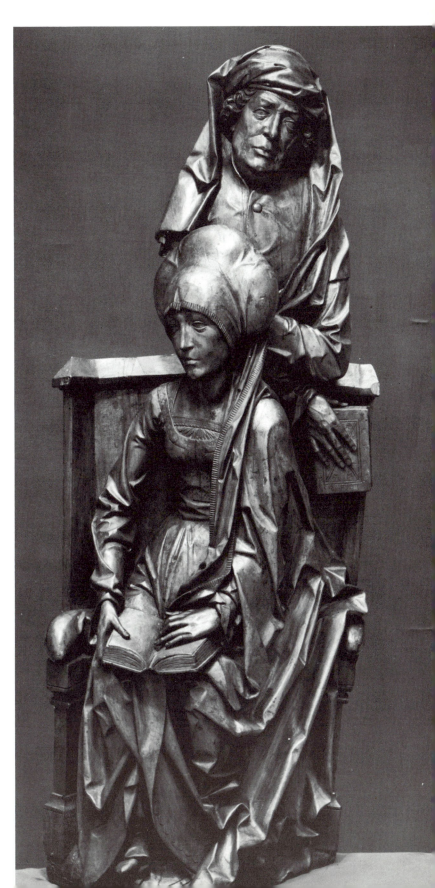

107. TILMAN RIEMENSCHNEI-
DER (1460?–1531). Mary Sa-
lome and Zebedee. German,
about 1500–1510. Limewood.
H. 47 in.

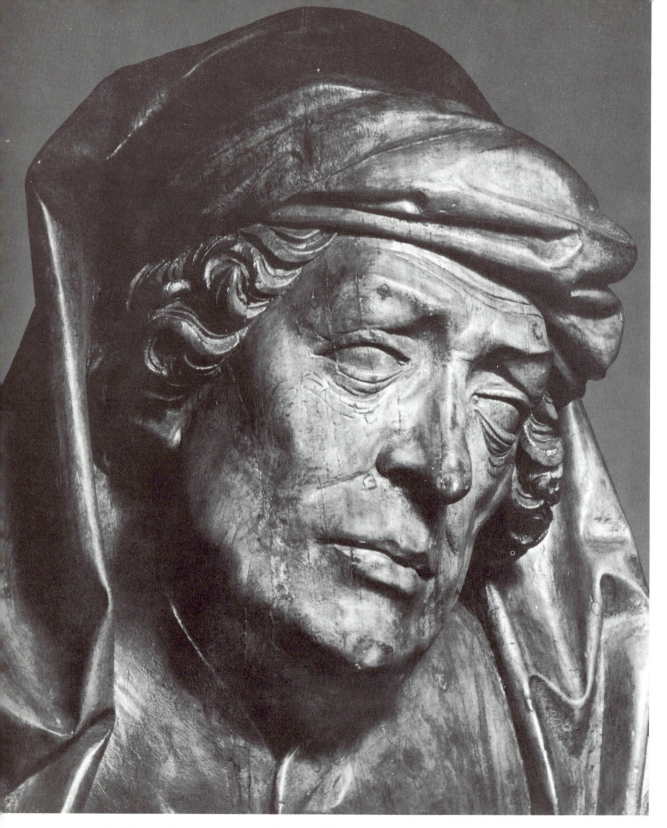

108. TILMAN RIEMENSCHNEIDER. Zebedee. (See plate 107)

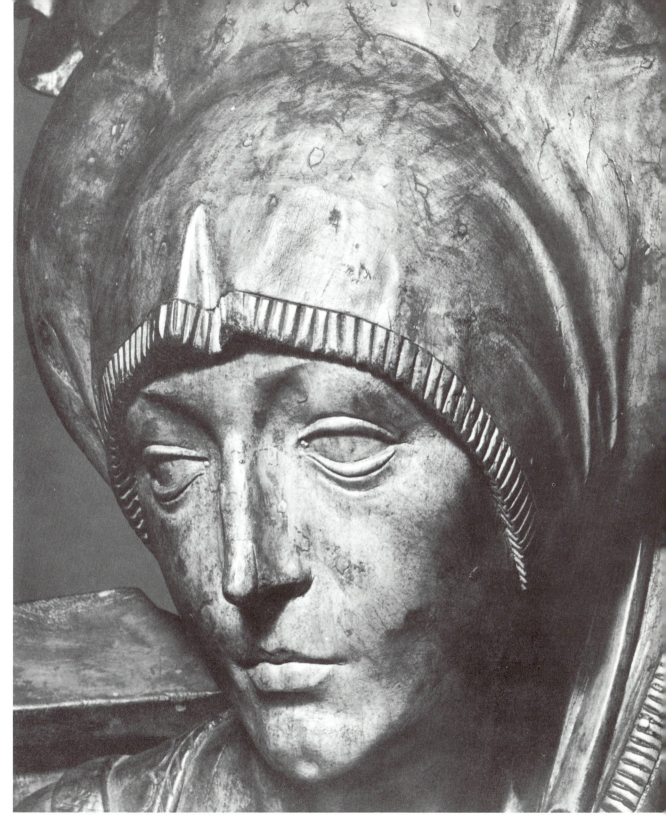

109. Mary Salome. (See plate 107)

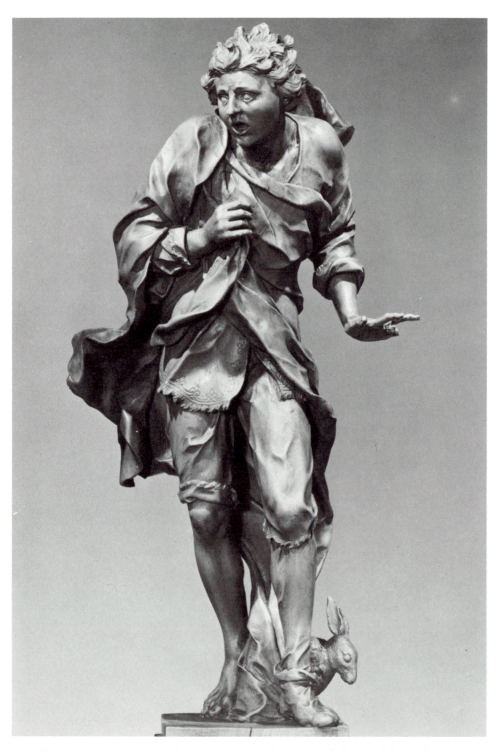

110. Sometimes attributed to JOSEF THADDÄUS STAMMEL (1695–1765). A figure symbolizing Fear. South German, about 1750–65. Boxwood. H. 14¼ in.

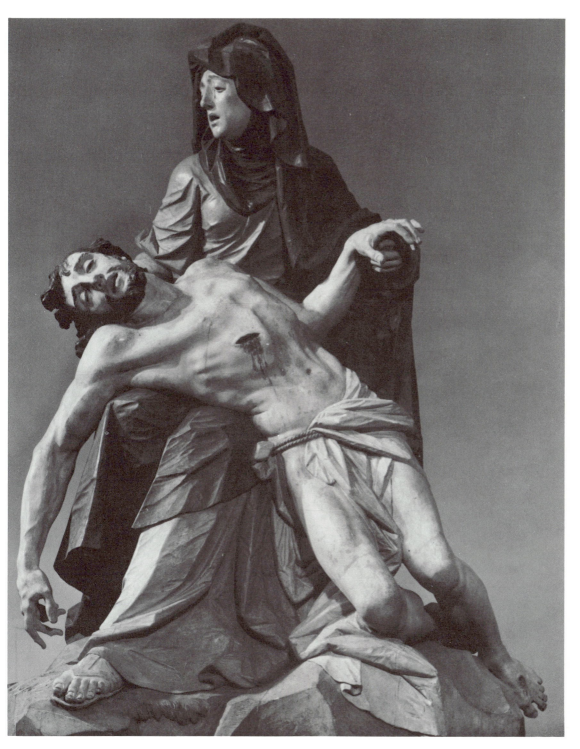

111. FRANZ IGNAZ GÜNTHER (1725–75). Pietà. Nenningen (Württemberg), Friedhofkapelle.
1774. Limewood. H. 64 in.

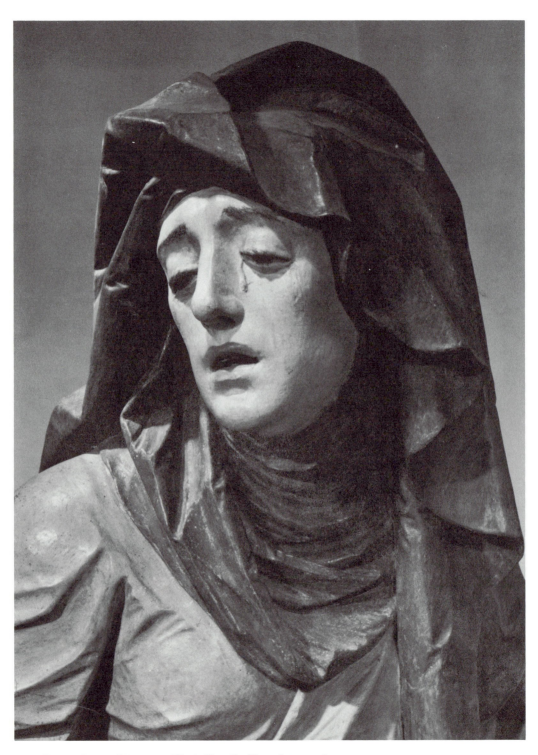

112. FRANZ IGNAZ GÜNTHER. Pietà. Detail. (See plate 111)

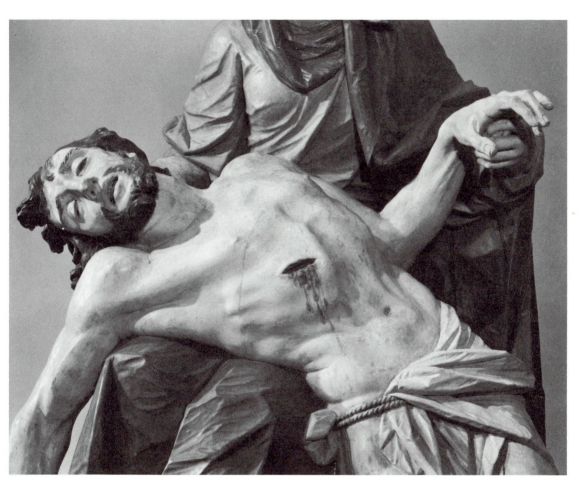

113. Pietà. Another detail

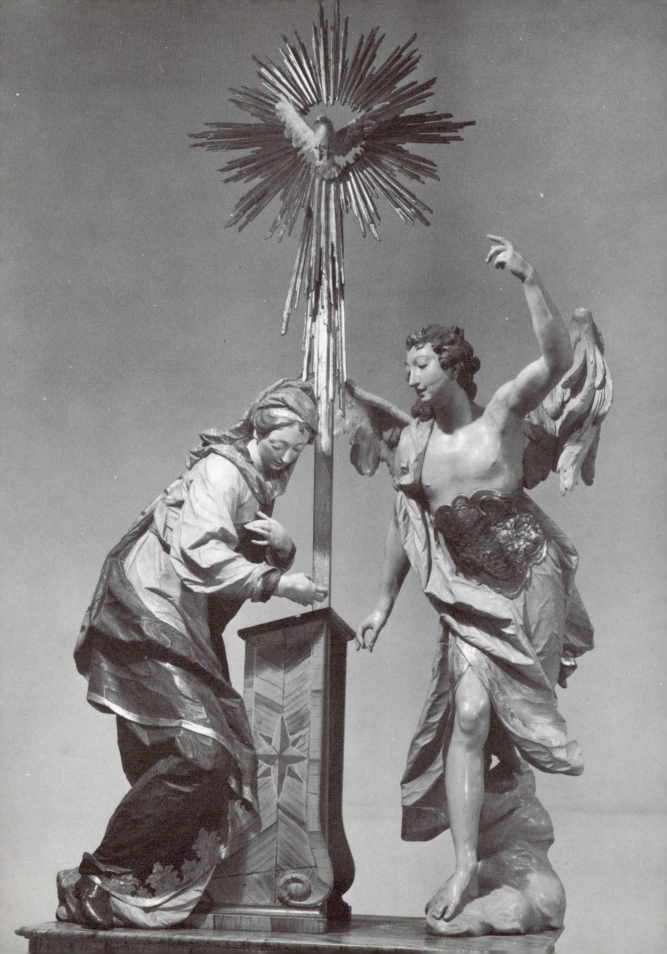

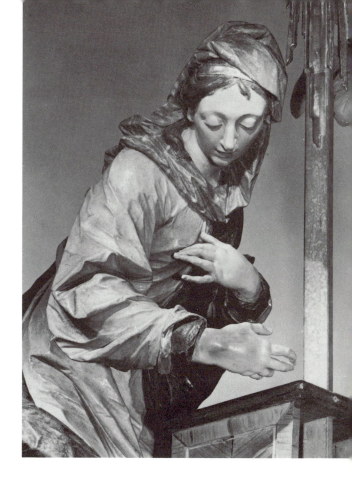

114–15. FRANZ IGNAZ GÜNTHER. The Annunciation. Executed in 1764 for the Rosenkranzbrüderschaft of Weyarn, Bavaria. Limewood. H. 63 in.

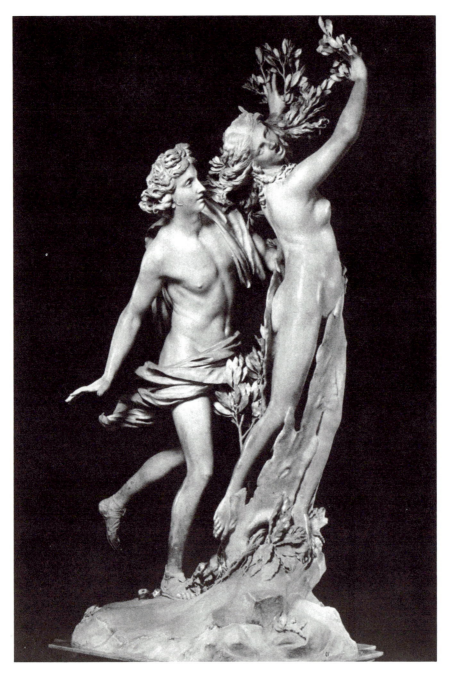

116. GIOVANNI LORENZO BERNINI (1598–1680). Apollo and Daphne. Rome, 1622–24. Marble. Life-size

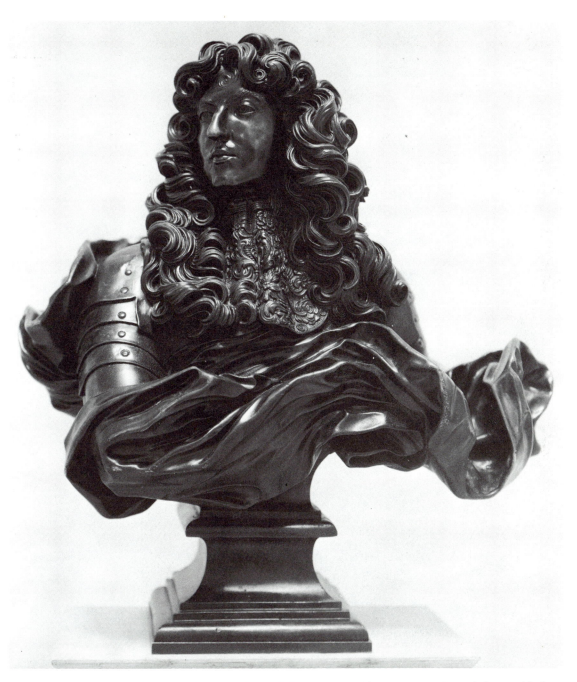

117. Giovanni Lorenzo Bernini. Louis XIV. Italian, 1665. Bronze replica of the marble bust at Versailles. H. 38¾ in.

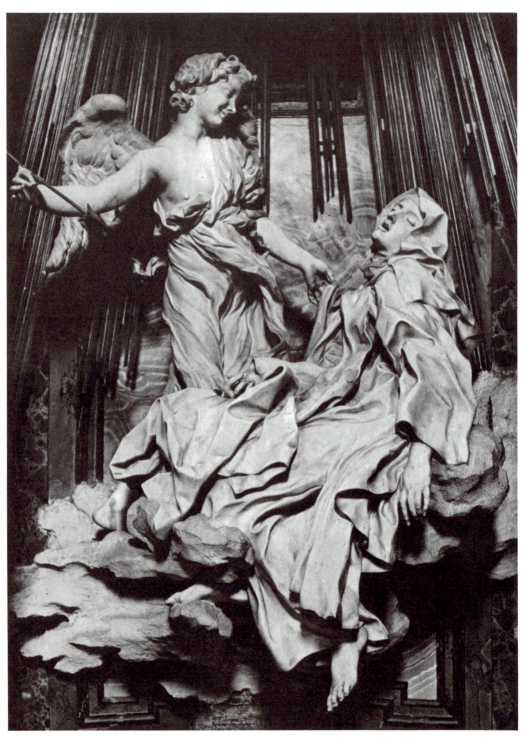

118. Giovanni Lorenzo Bernini. Ecstasy of Saint Teresa. In Santa Maria della Vittoria, Rome. 1645–52. Marble. Life-size

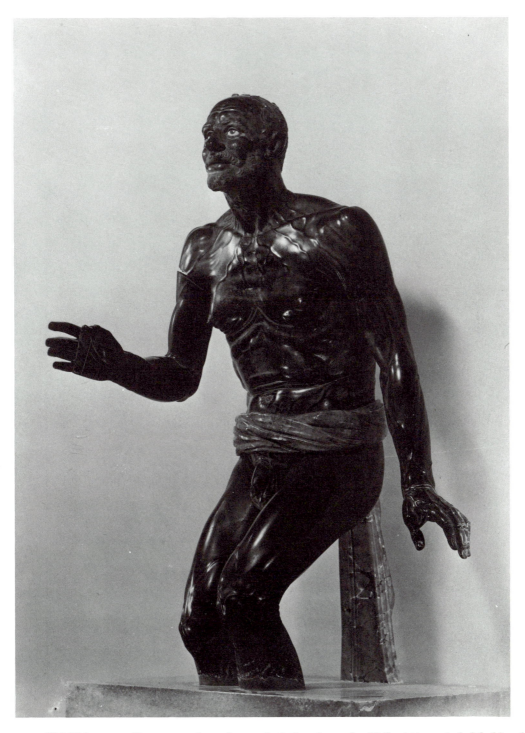

119. Old Fisherman. Roman version of a work dating from the Hellenistic period. Marble of different colors. H. 48 in.

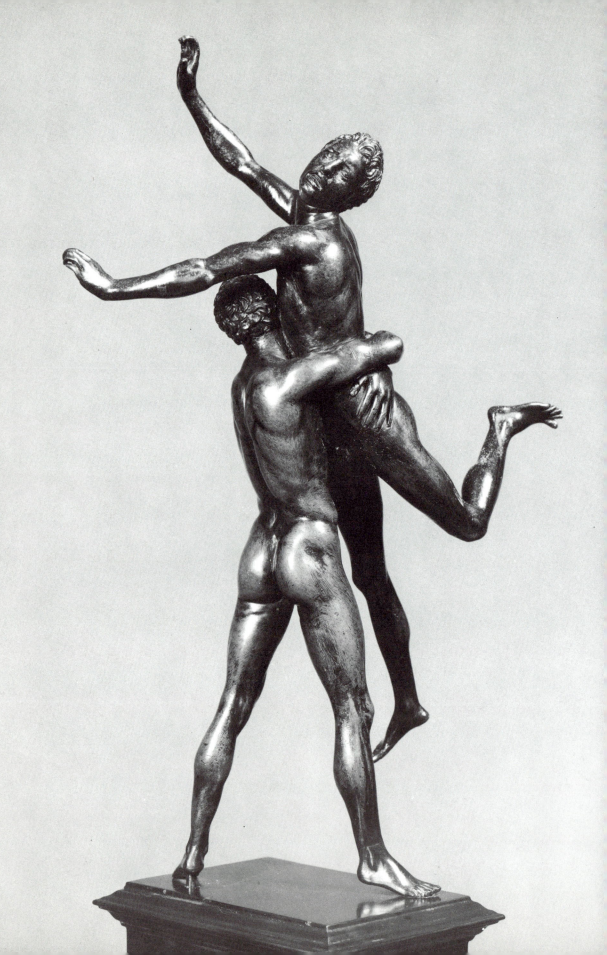

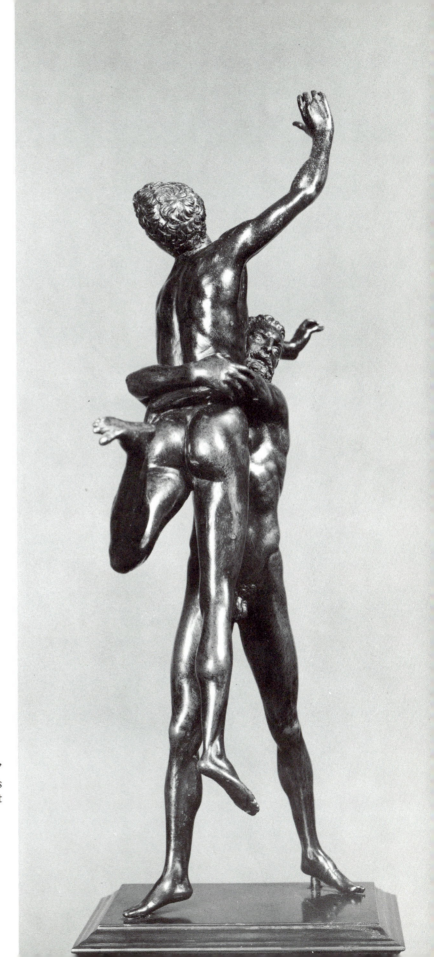

120–21. Francesco da Sant'
Agata (*fl.* 1520–30). Hercules
and Antaeus. Padua, about
1520. Bronze. H. 15¼₆ in.

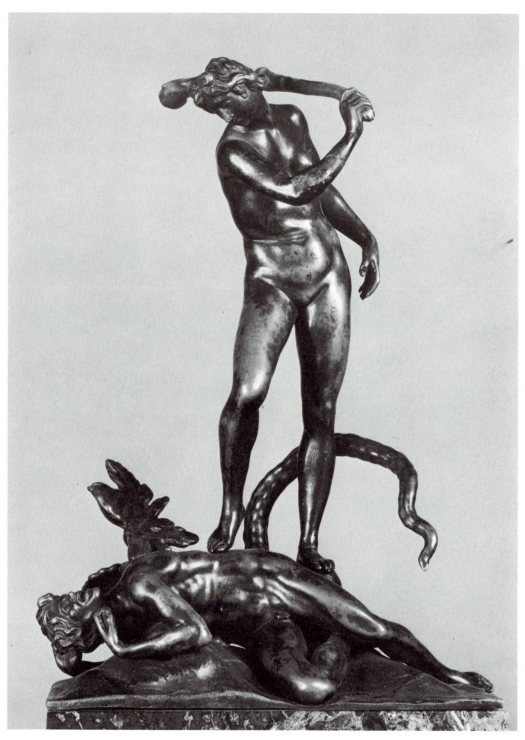

122. BENVENUTO CELLINI (1500–1571). Virtue Overcoming Vice. Florence, XVI century. Bronze. H. 9½ in.

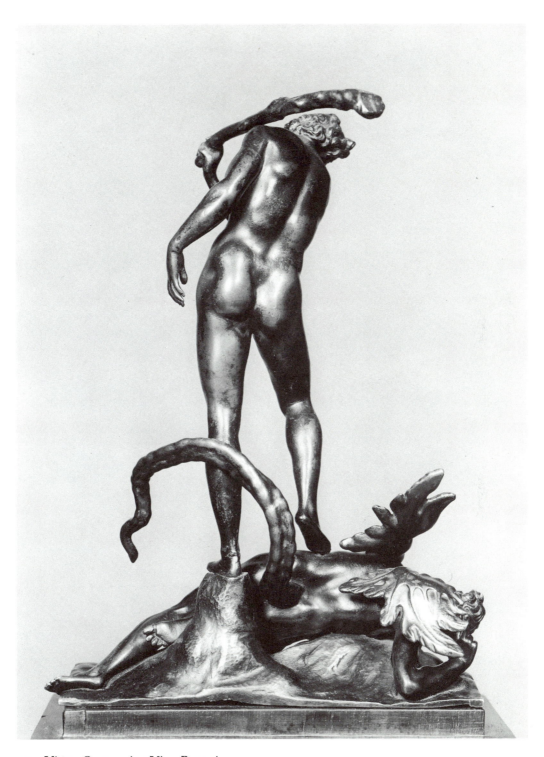

123. Virtue Overcoming Vice. Rear view.

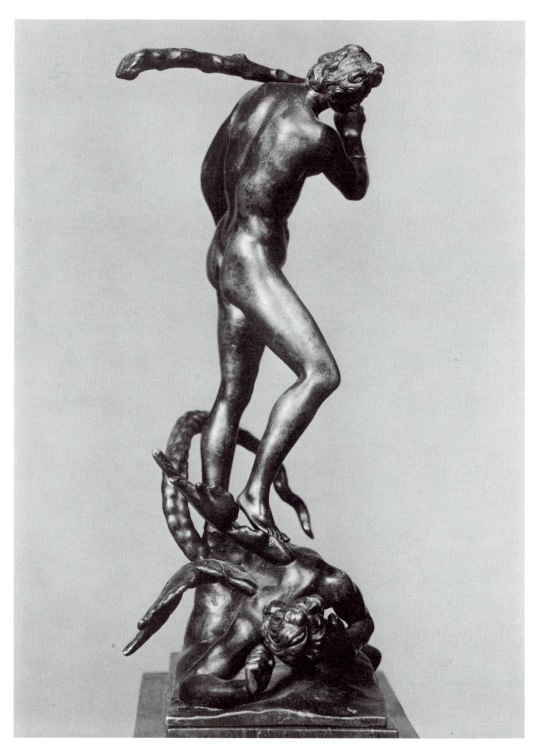

124. BENVENUTO CELLINI. Virtue Overcoming Vice. Profile. (See plate 122)

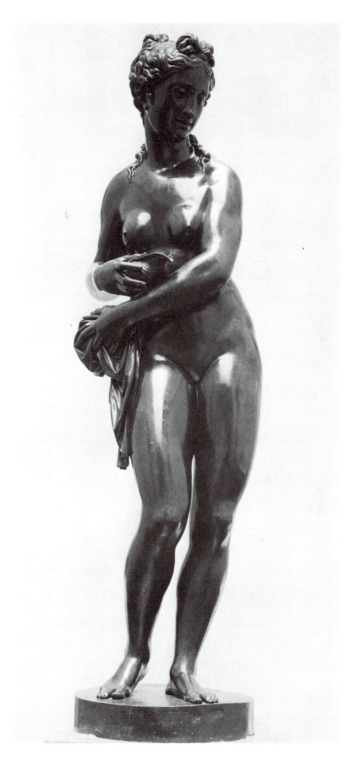

125. Jacopo Sansovino (1486–
1570). Venus Anadyomene.
Florentine-Venetian, XVI cen-
tury. Bronze. H. 65⅛ in.

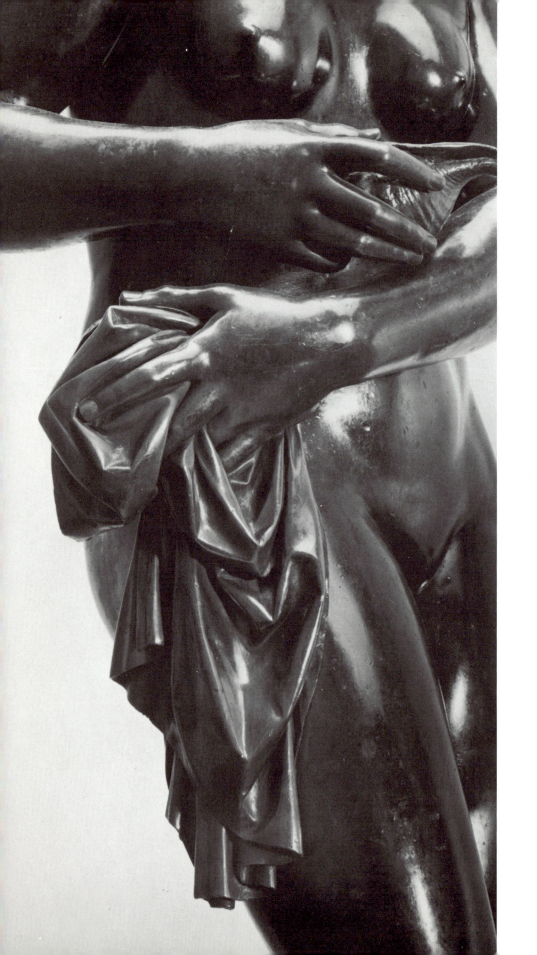

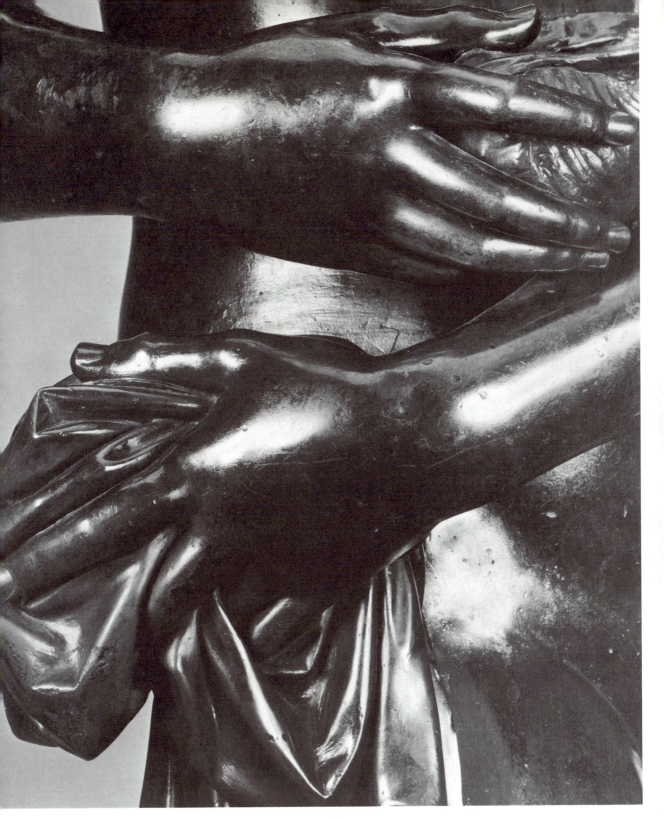

126–127. Jacopo Sansovino. Venus Anadyomene. Details. (See plate 125)

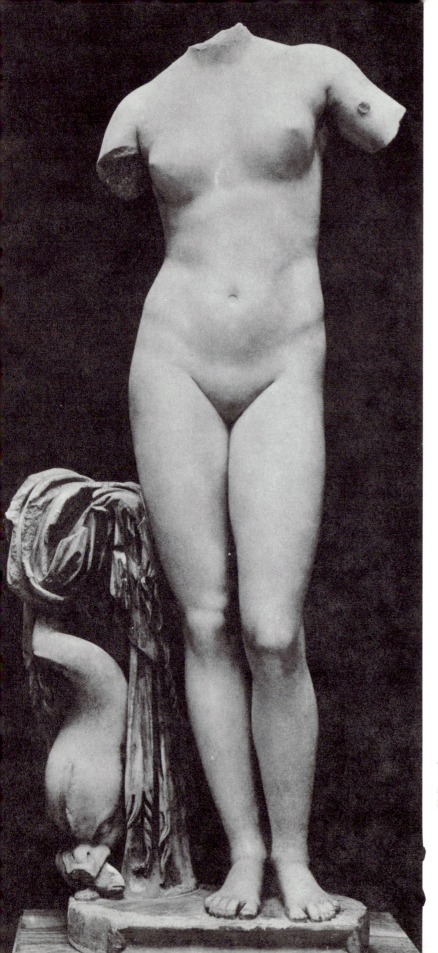

128–129. Aphrodite (Venus Anadyomene), found at Cyrene. Roman copy of a Greek original, about 1 century B.C. Marble. Slightly under life-size

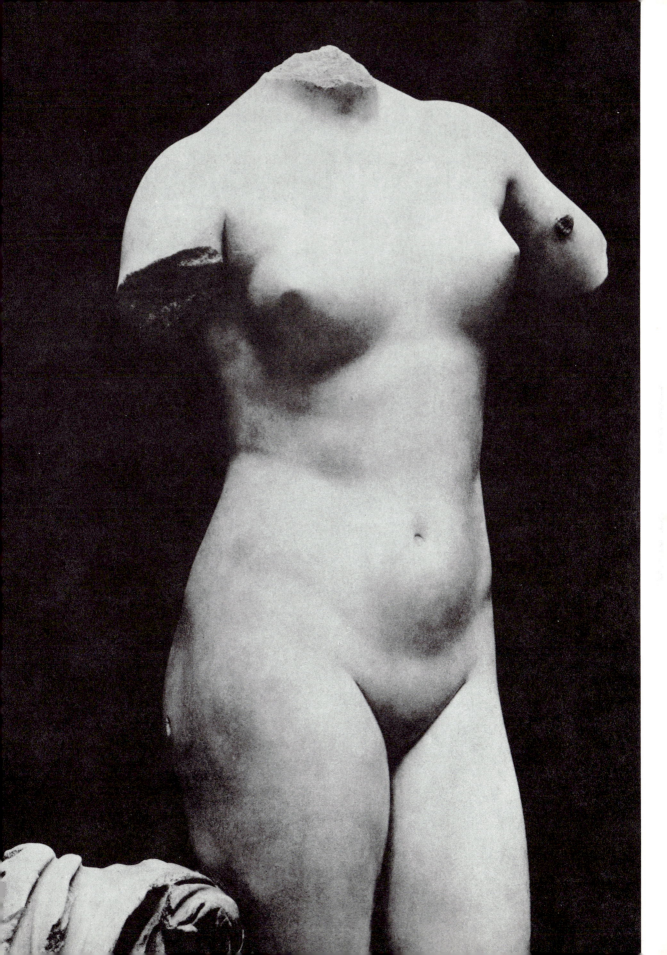

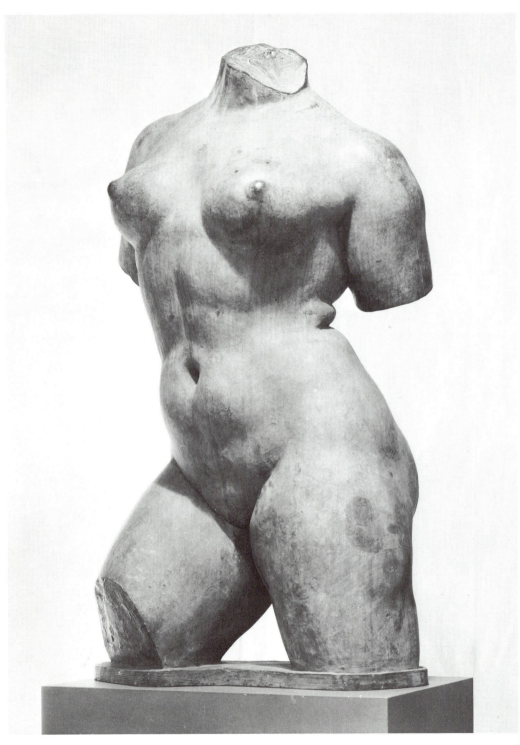

130. ARISTIDE MAILLOL (1861–1944). Chained Action (monument to Louis Blanquí). About 1906. Bronze replica (by sculptor) of lead original. H. 47 in.

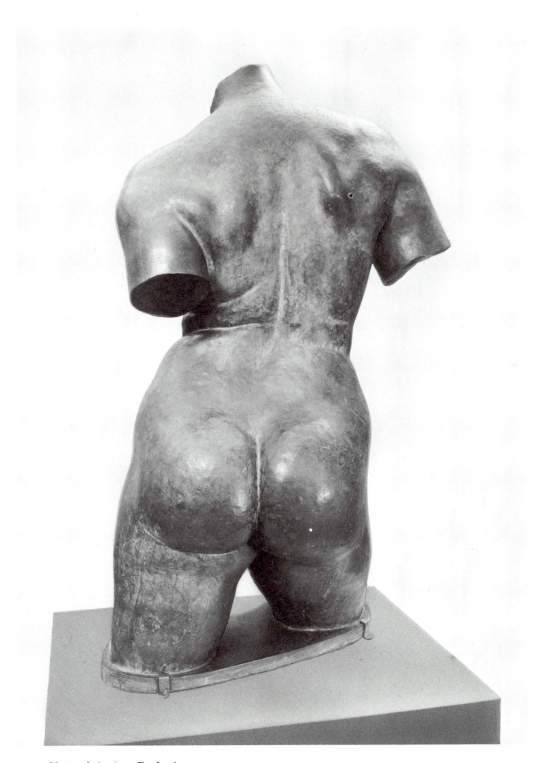

131. Chained Action. Back view

132. GIOVANNI DA BOLOGNA (1524–1608). Study for a fountain figure. Flemish-Florentine, XVI century. Terra cotta. L. 19 in.

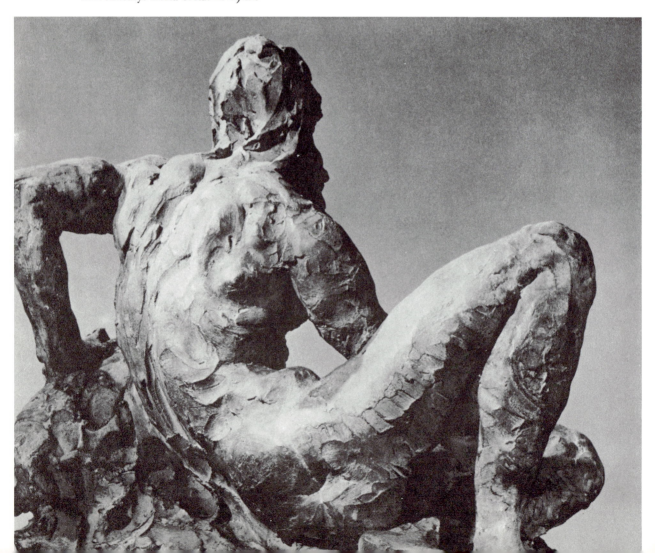

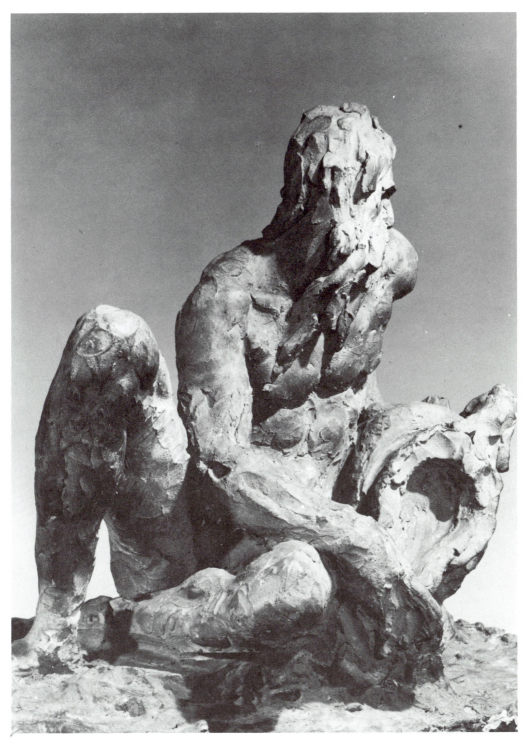

133. Study for a fountain figure. Another view

134. AIMÉ JULES DALOU (1838–1902). A woman reading. French, XIX century. Terra-cotta model. H. 9 in.

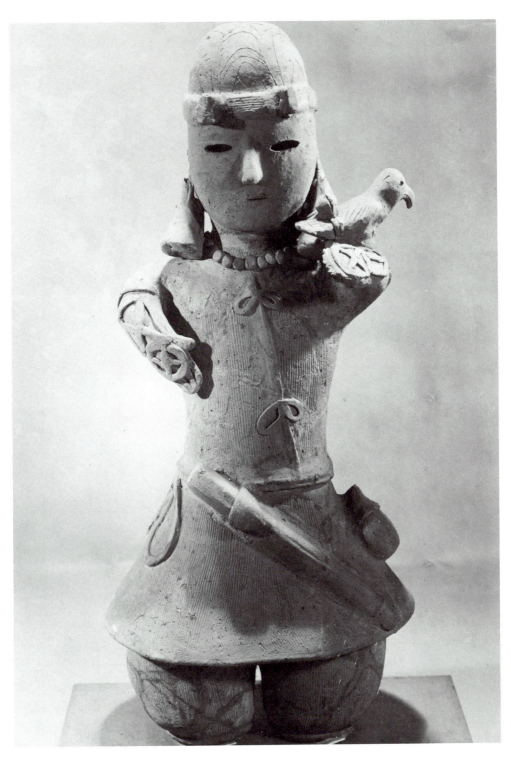

135. Soldier with a falcon. Japan, pre-Buddhist period. Clay. н. 29.6 in.

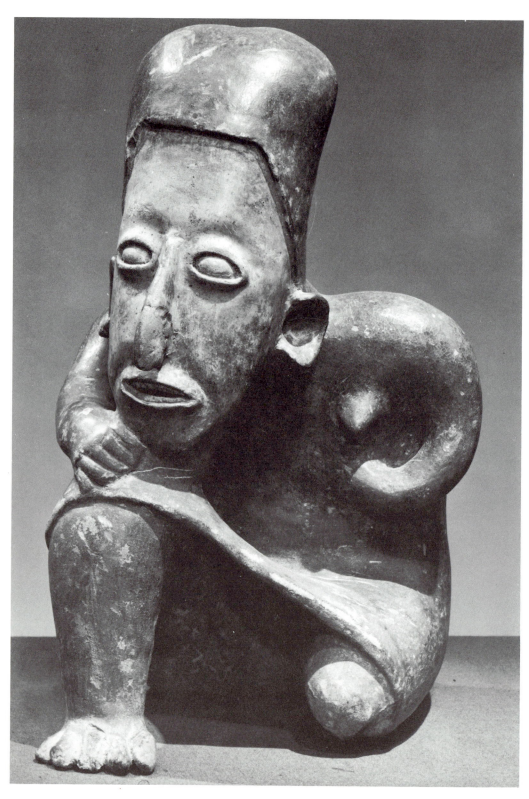

136. Seated female figure. Western Mexico (Nayarit), about 500 B.C.–A.D. 1521. Ocher terra cotta. H. 17 in.

137. The Wrestler. Mexico (Olmec culture), from Uxpanapan (Vera Cruz), about 500–100 B.C. Stone. H. 26 in.

138. Prince of Flowers, God of Joy, Music, and Dancing. Mexico (Zapotec culture, 3rd period), from San Lorenzo Albarradas (Oaxaca), about A.D. 500–1000. Deep buff terra cotta. H. 18½ in.

139. The Scribe of Cuilapan. Mexico (Zapotec culture), from Cuilapan (Oaxaca), about 400 B.C.–A.D. 1521. Ocher terra cotta. H. 13⅓ in.

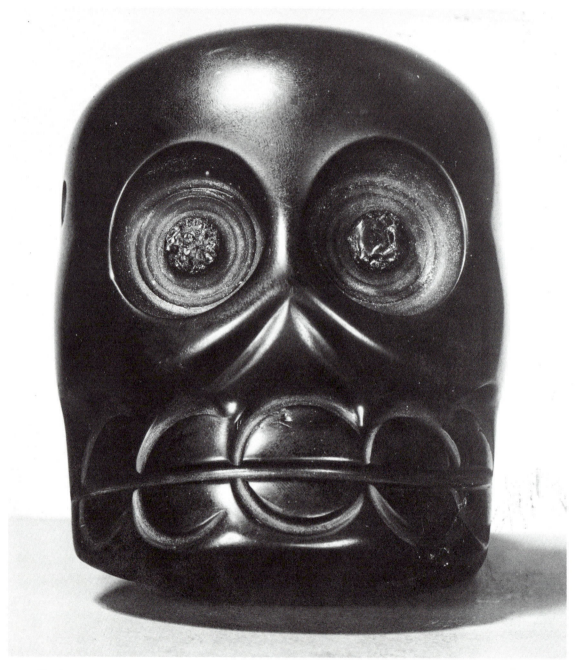

140. Head or skull. Aztec (Texcoco), about A.D. 1324–1521. Obsidian. H. 4¼ in.

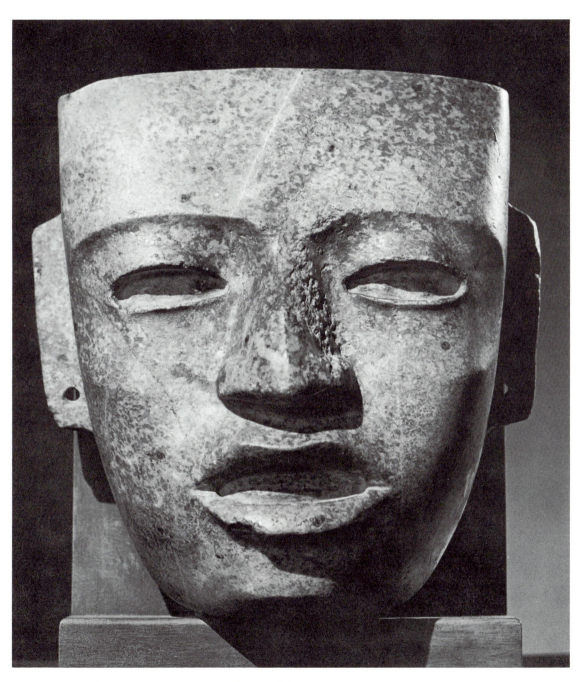

141. Mask of green serpentine. Mexico ("Toltec," style of Teotihuacan), about A.D. 800–1200. H. 8½ in.

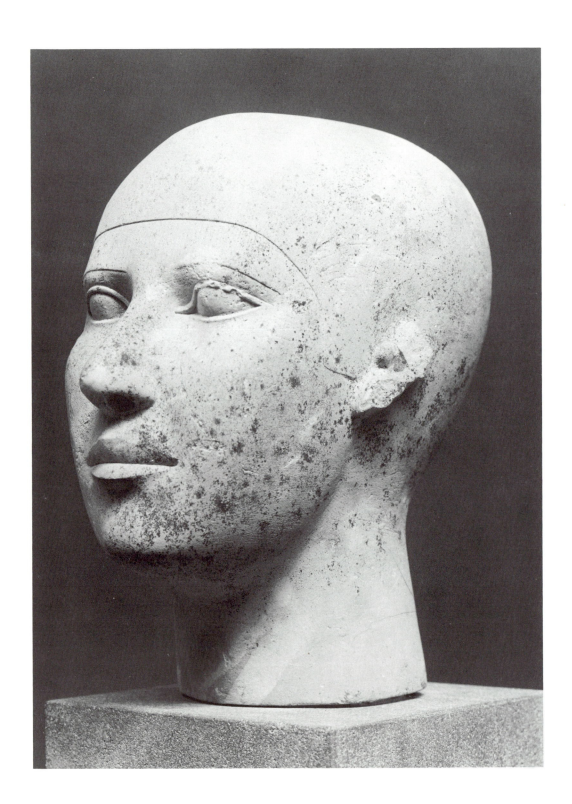

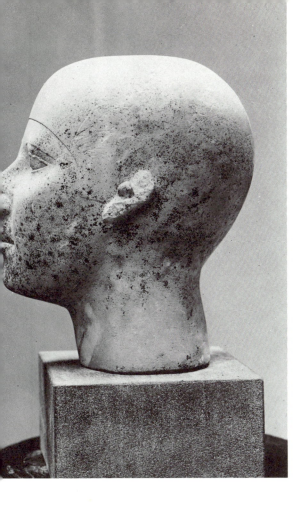

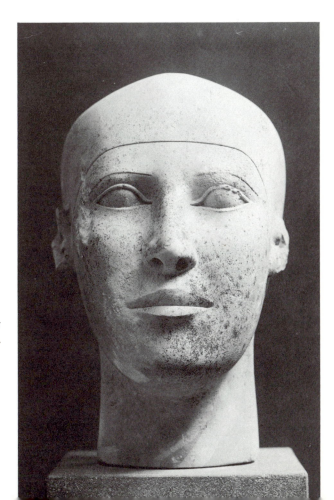

142–143. Head of a prince, from Giza. Egypt (IV Dynasty), about 2840–2680 B.C. Limestone. H. 10½ in.

144. Head of an old man, possibly a priest of Isis. Rome, mid-I century B.C. Marble. Approximately life-size

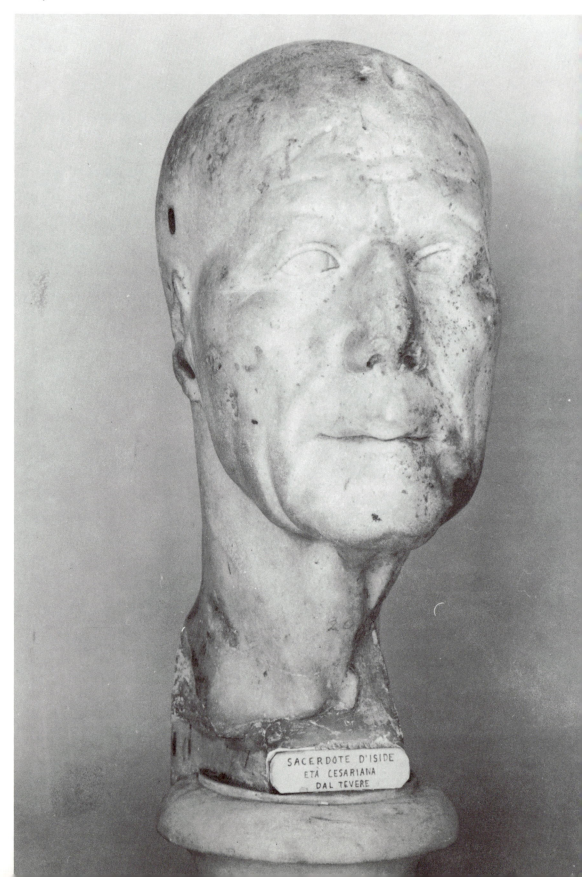

SACERDOTE D'ISIDE
ETÀ CESARIANA
DAL TEVERE

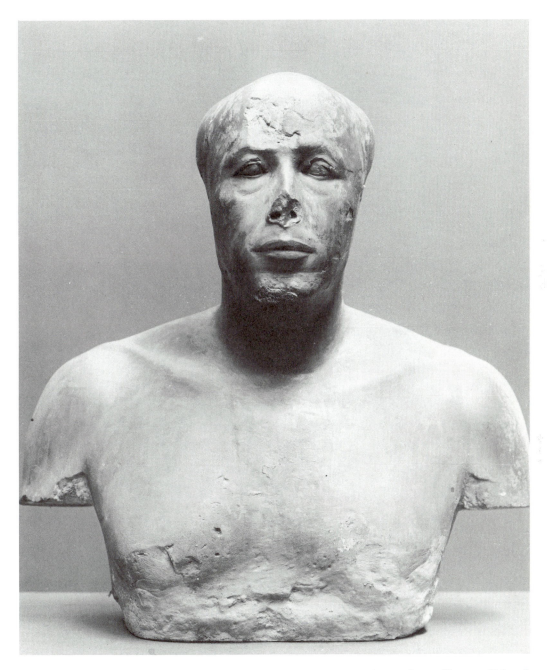

145. Bust of Prince Ankh-haf, from Giza. Egypt (IV Dynasty), about 2840–2680 B.C. Painted limestone. H. 20 in.

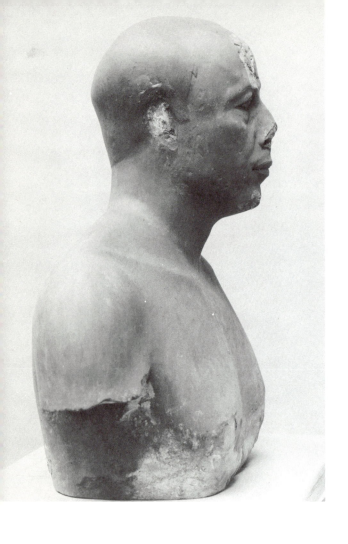

146. Bust of Prince Ankh-haf. Side and three-quarter views. (See plate 145)

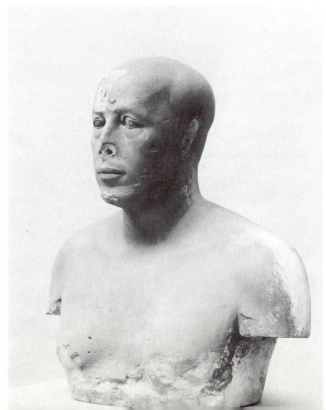

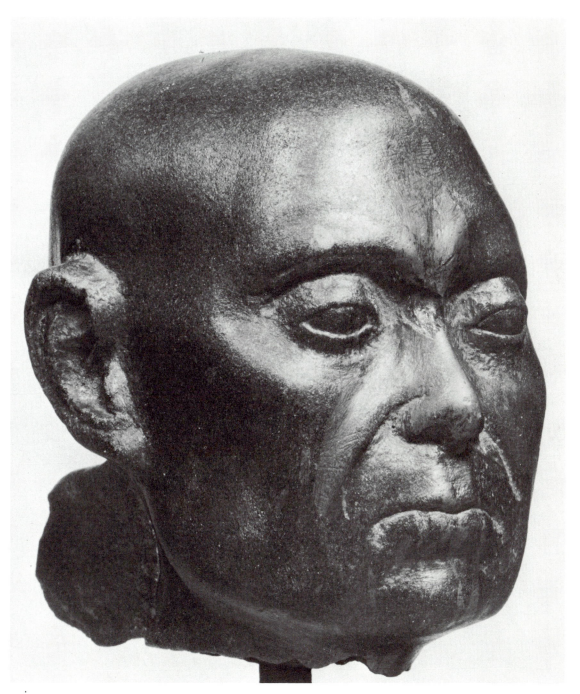

147. Head of a priest (Saïte period), 663–525 B.C. Green schist. H. 3¾ in.

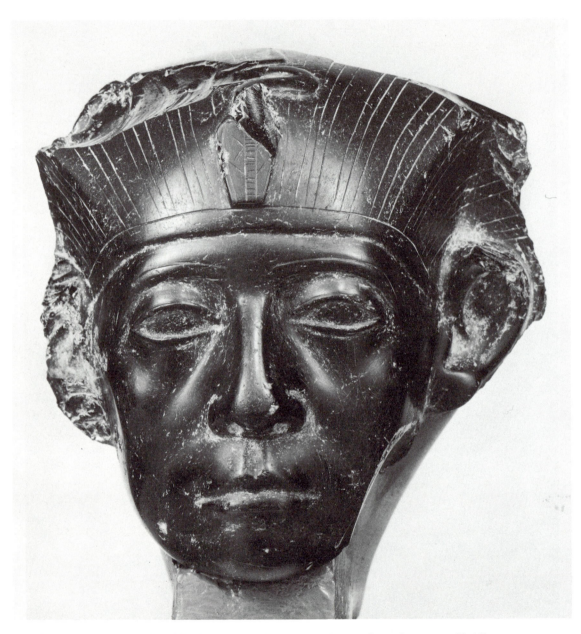

148. Portrait of Amenemhat III. Egypt (XII Dynasty), about 1850–1800 B.C. Obsidian. H. 4¹⁵⁄₃₂ in.

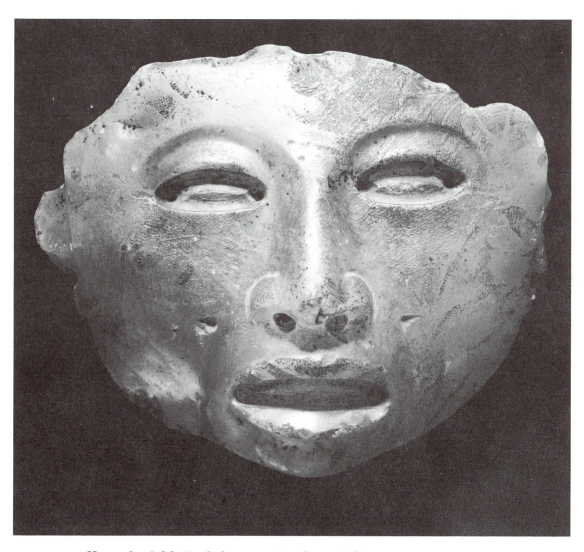

149. Human head. Mexico, before A.D. 1521. Onyx. H. 6 in.

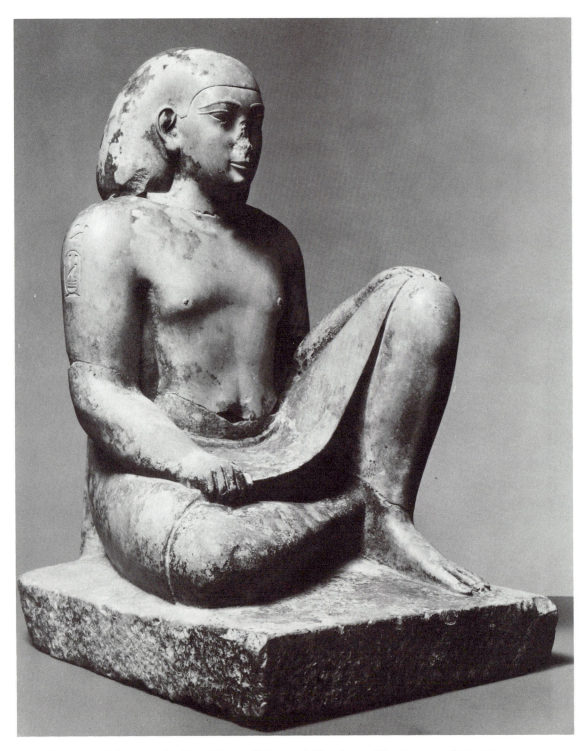

150. Statuette of the courtier Bes. Egypt (Saïte period), about 663–525 B.C. Limestone. H. 12²¹⁄₃₂ in.

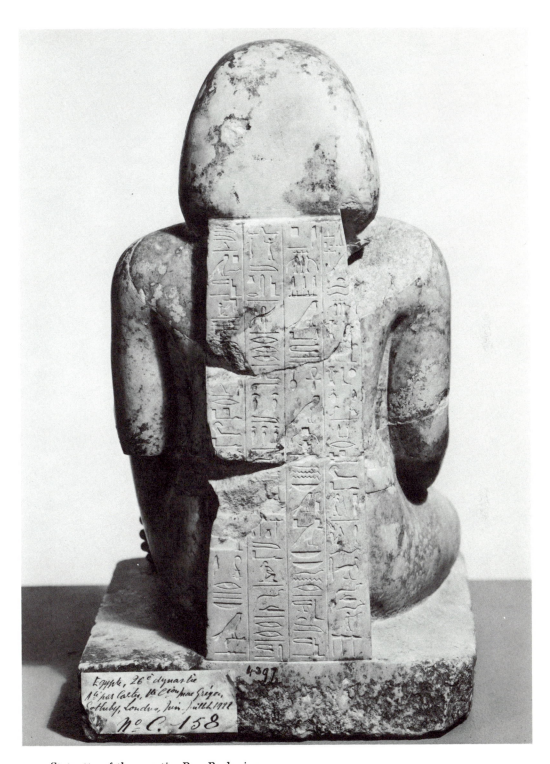

151. Statuette of the courtier Bes. Back view.

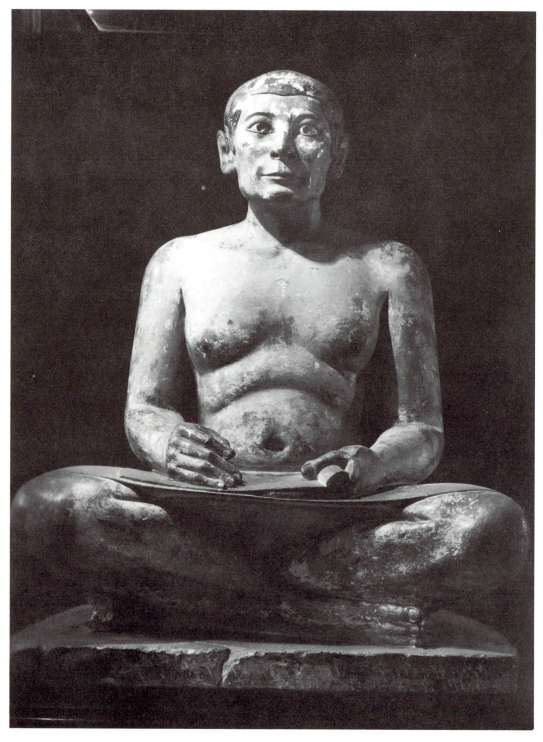

152. A seated scribe, found at Sakkara in a v Dynasty tomb. Egypt, about 2680–2540 B.C. Painted limestone. H. 29 in.

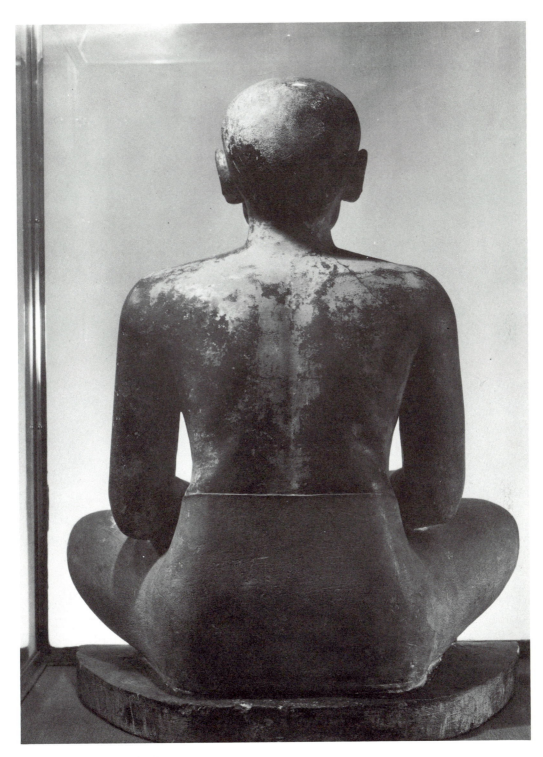

153. A seated scribe. Back view.

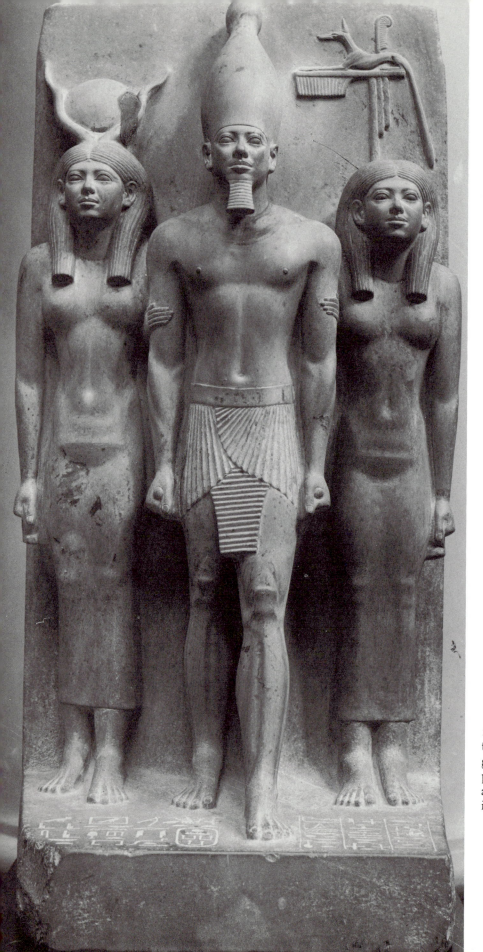

154. King Men-kau-Ra between
the goddess Hathor and the
goddess of the nome of Dios-
polis Parva. Egypt (IV Dynasty),
about 2800 B.C. Schist. H. 37¼
in.

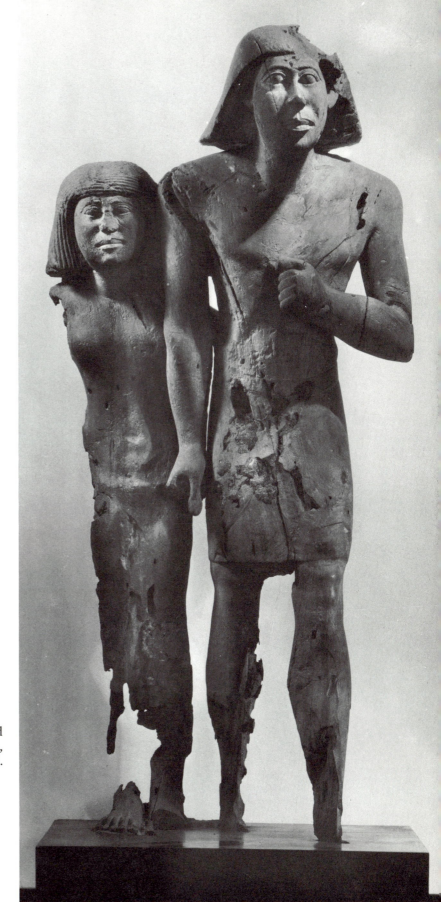

155. Memphite functionary and his wife. Egypt (IV Dynasty), about 2840–2680 B.C. Wood. H. 27 in.

156. Nicholas Broker and Godfrey Prest. Head of the effigy of Richard II, in the Confessor's Chapel, Westminster Abbey. About 1395. Bronze. Life-size

157. Head of the effigy of Edward III, in the Confessor's Chapel, Westminster Abbey. After 1377. Bronze. Life-size

158. DONATELLO. So-called portrait of Niccolò da Uzzano. Florence, about 1432. Painted terra
cotta. H. 18 in.

159. DESIDERIO DA SETTIGNANO. Detail from a fireplace. Florence, mid-XV century. Sandstone.
8½ x 12 ft.

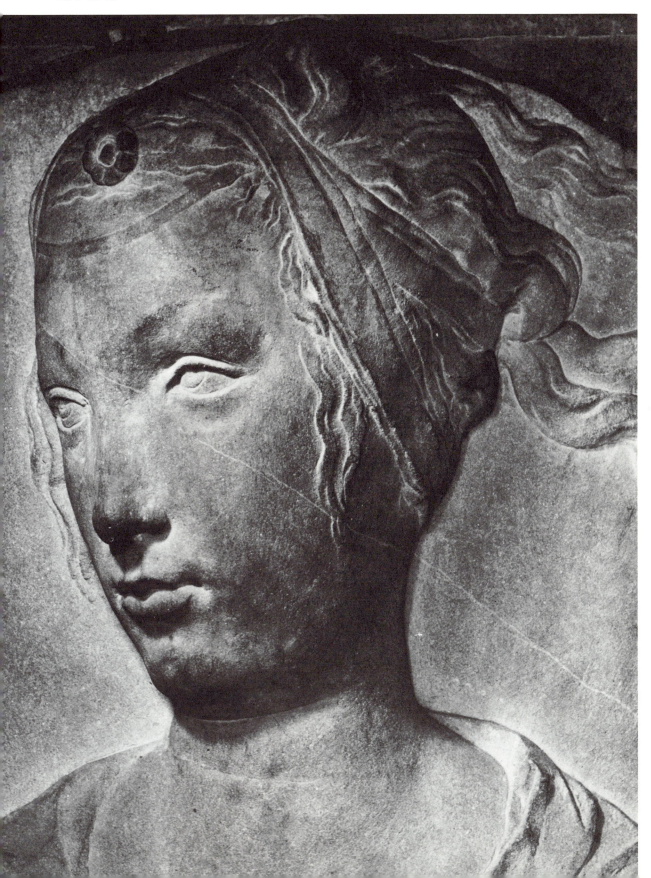

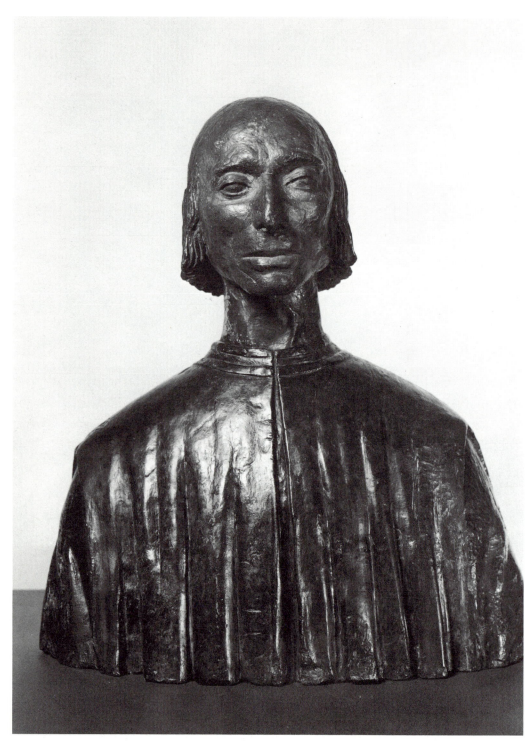

160. Portrait of an old man. Florence, about 1450–1500. Terra cotta. H. 23¼ in.

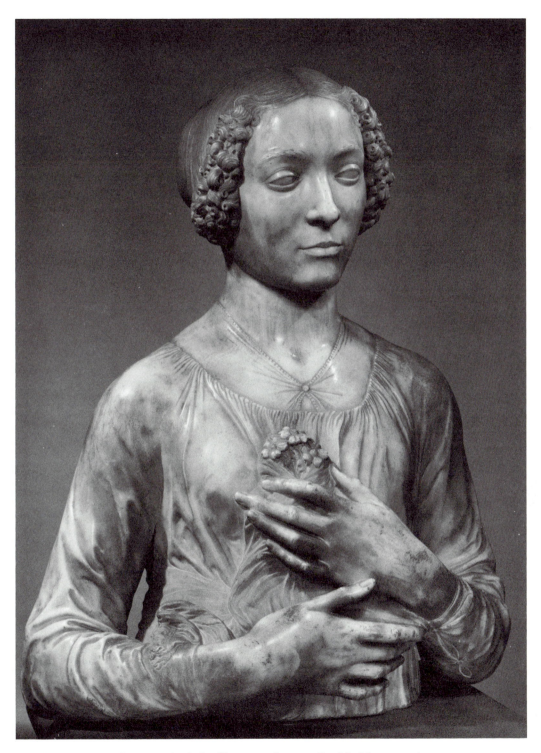

161. VERROCCHIO. Portrait of a lady. Florence, about 1480. Marble. H. 24 in.

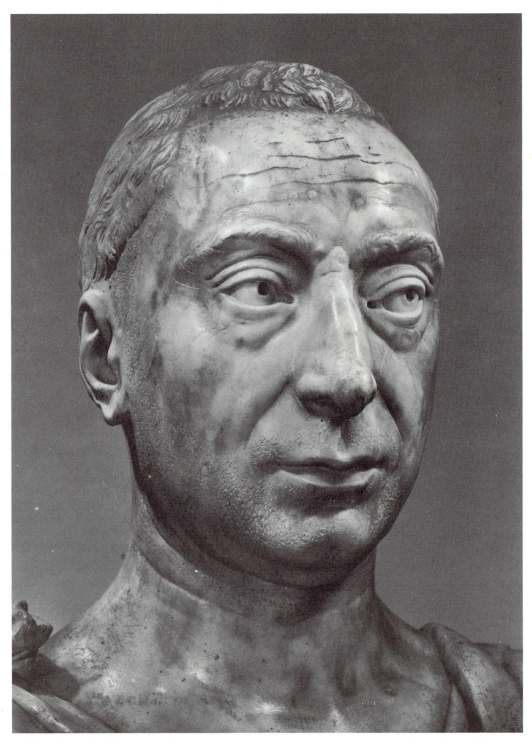

162. ANTONIO ROSSELLINO. Perhaps a portrait of Matteo Palmieri. Florence, about 1468. Marble. H. about 22 in.

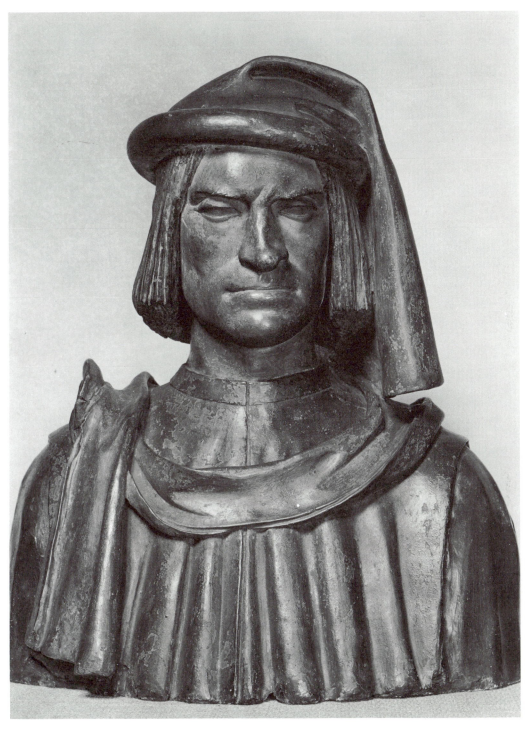

163. Verrocchio. Portrait of Lorenzo de' Medici. Florence, about 1470–88. Terra cotta. h. 25⅞ in.

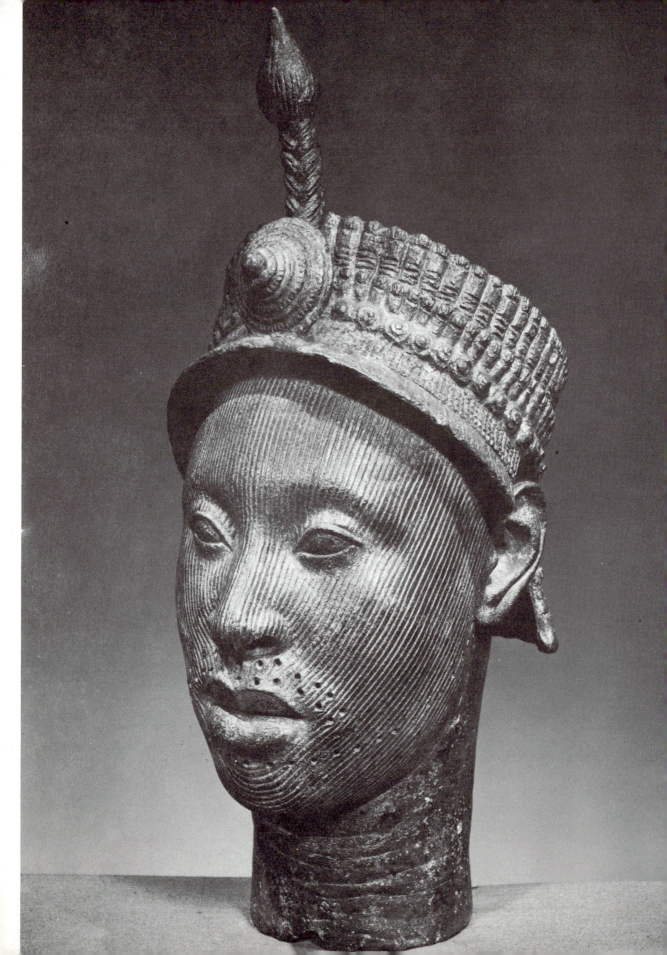

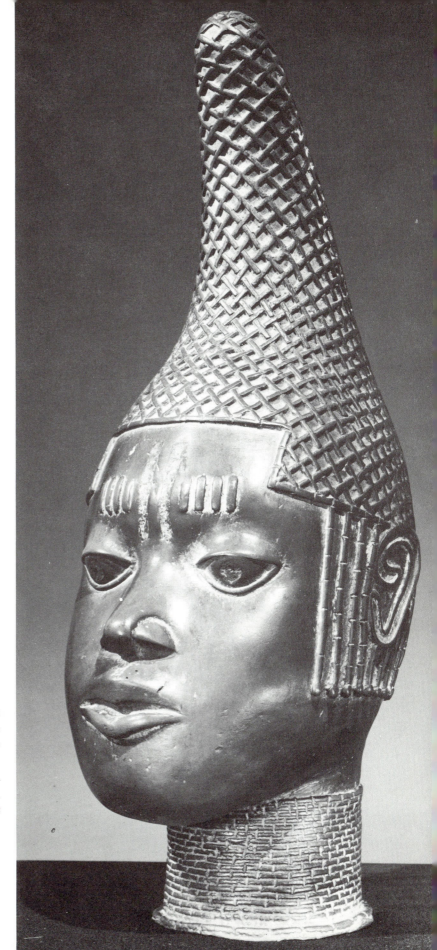

164 (left). Portrait of a Yoruba of ancient Ife. Southern Nigeria, xv century or earlier. Bronze. Approximately life-size

165. Head of a girl. Benin, Nigeria, probably xvi century. Bronze. Approximately life-size

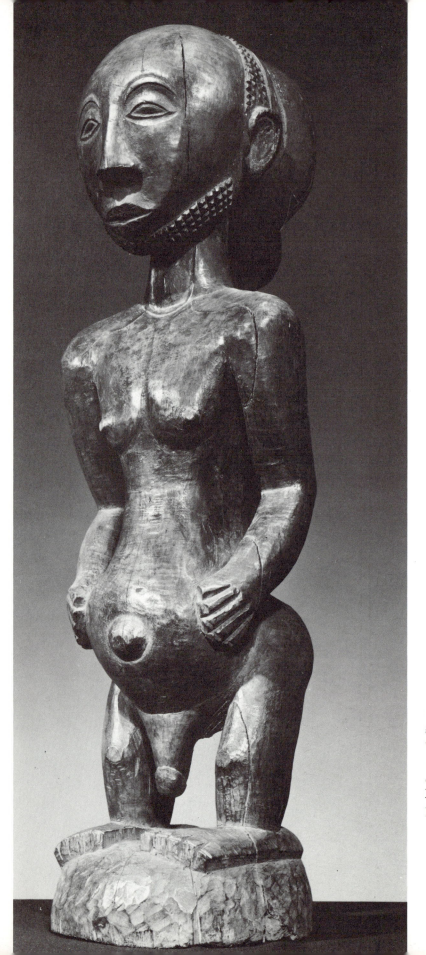

166. Male figure. Belgian Congo (Baluba tribe), probably xix century. Wood. H. 27 in.

167 (right). Carved wooden cup in the shape of a head. Belgian Congo (Bakongo tribe), probably xix century. H. 7½ in.

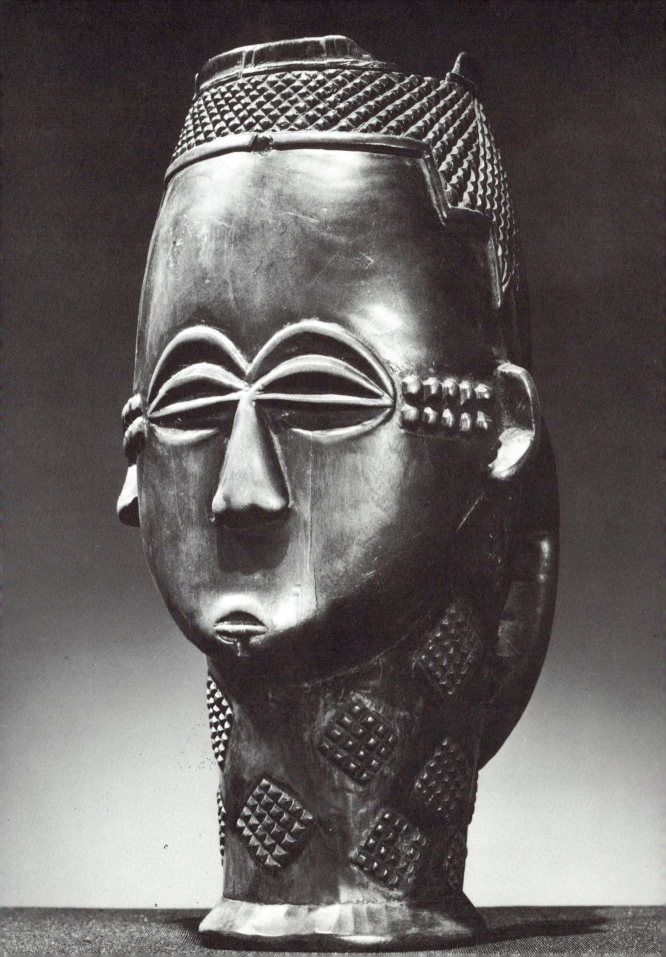

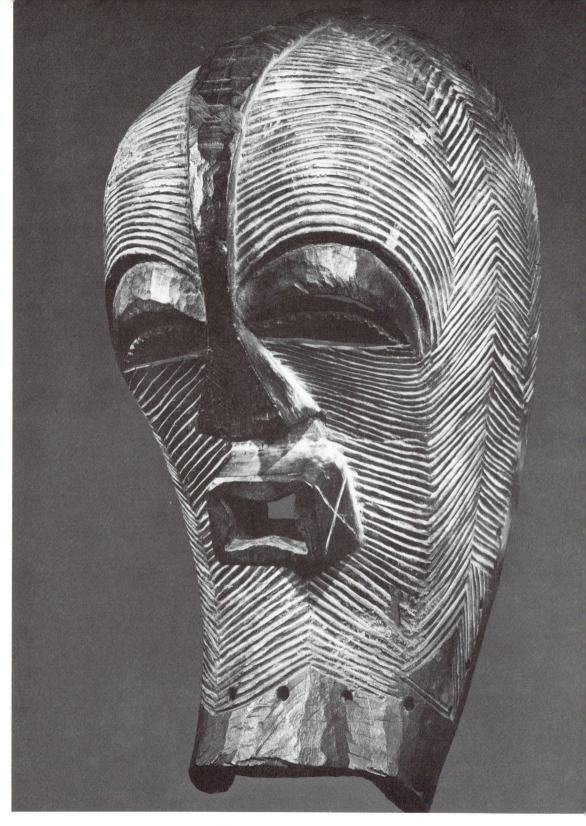

168. Ceremonial mask of carved wood. Belgian Congo (Bashonge tribe), perhaps XIX century. H. 14½ in.

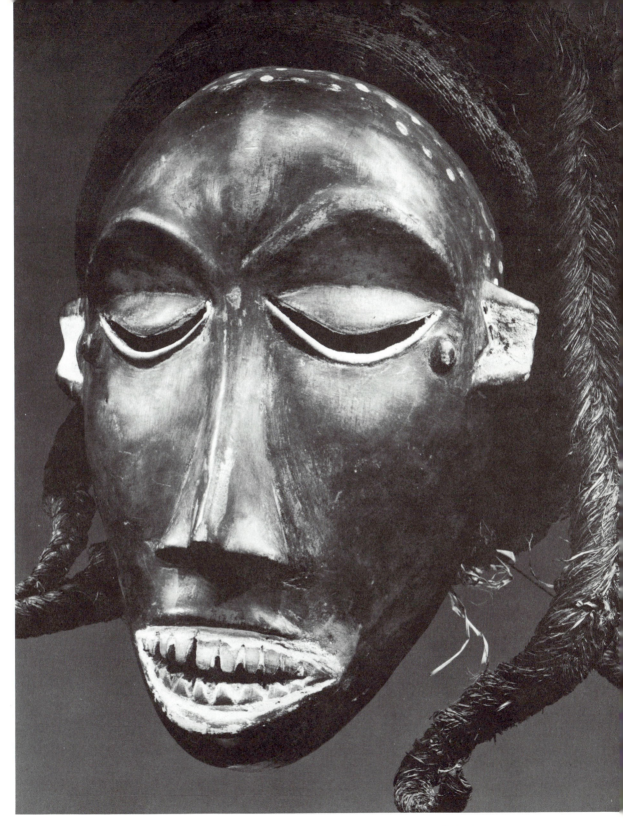

169. Mask with pigtails. Belgian Congo (Bapende tribe), perhaps XIX century. Wood. Approximately life-size

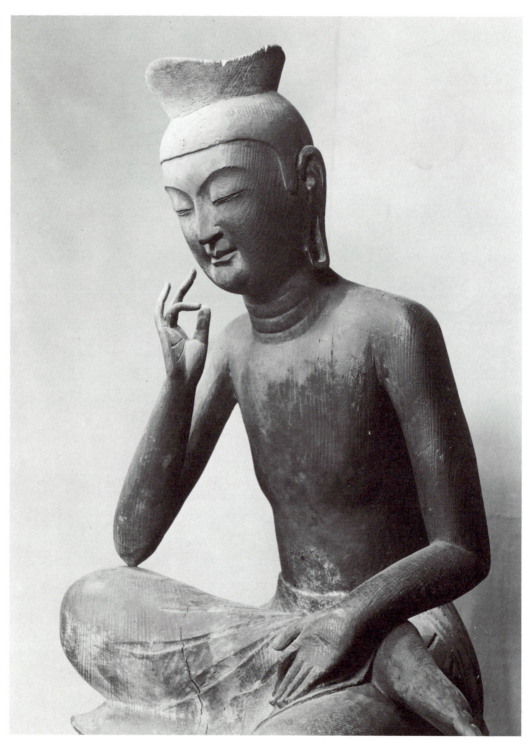

170. The Maitreya of the Koryuji Temple, Kyoto. Japan (Asuka period), VII century A.D. Wood, originally lacquered. H. 48.2 in.

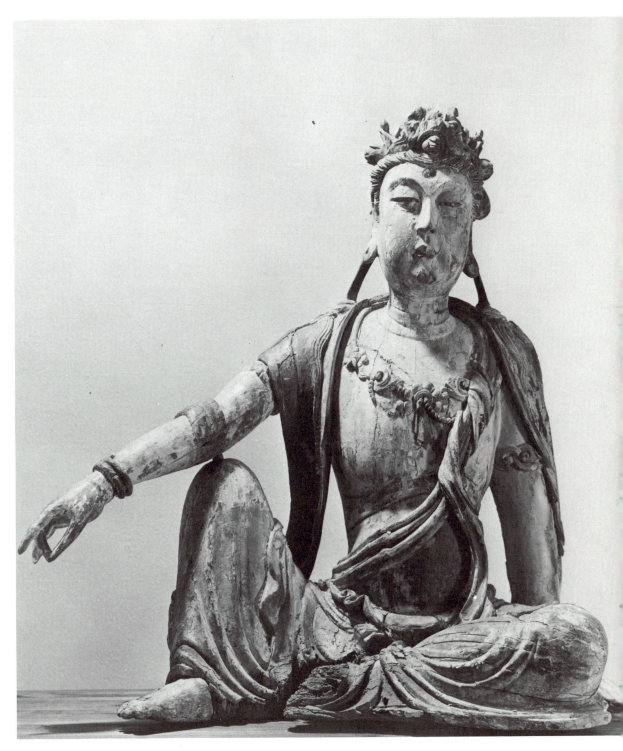

171. Kuanyin. China (Sung Dynasty), A.D. 960–1279. Painted wood. H. 35½ in.

172. Virgin and Child, in choir of York Minster. English, late XI century. Stone relief. H. 24 in.

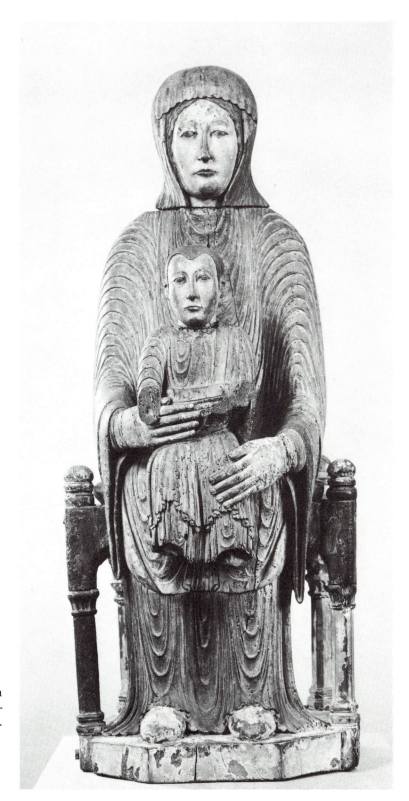

173. Virgin and Child. French
(School of Auvergne), 1150–
1200. Oak, painted in colors. H.
31 in.

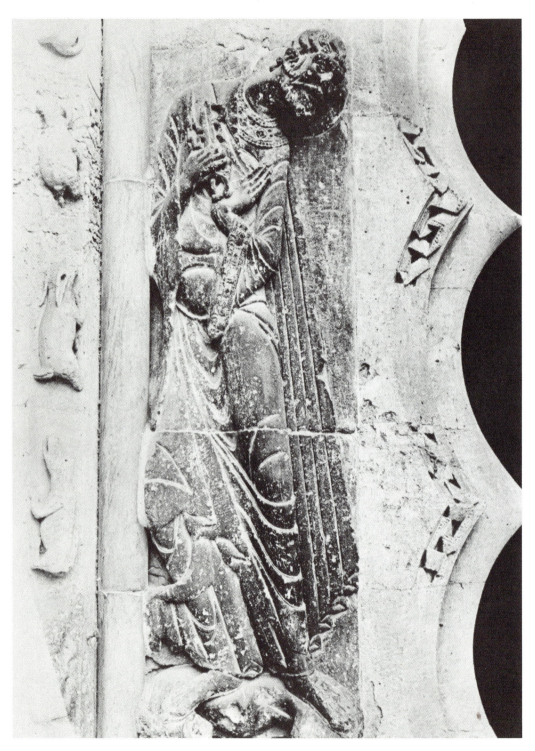

174. St. Peter, in the Church of St. Peter, Moissac. French, about 1100–1150. Stone. 59 x 19¼ in.

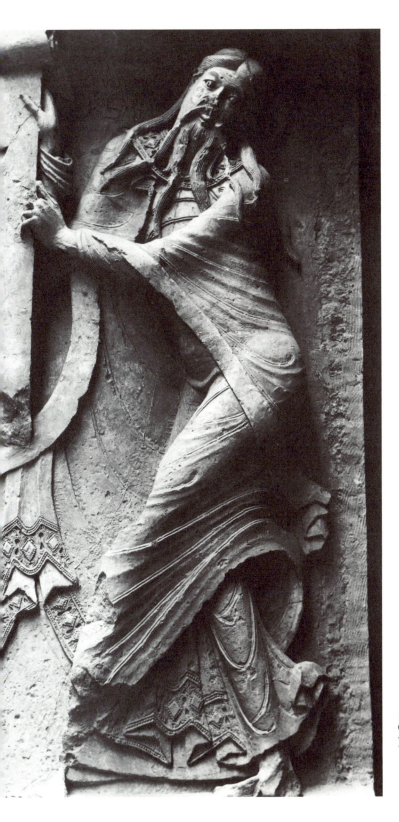

175. The prophet Isaiah, in the Church of St. Mary, Souillac. French, mid-XII century. Stone

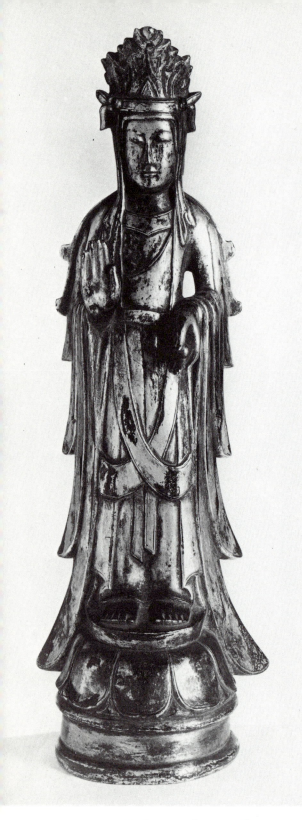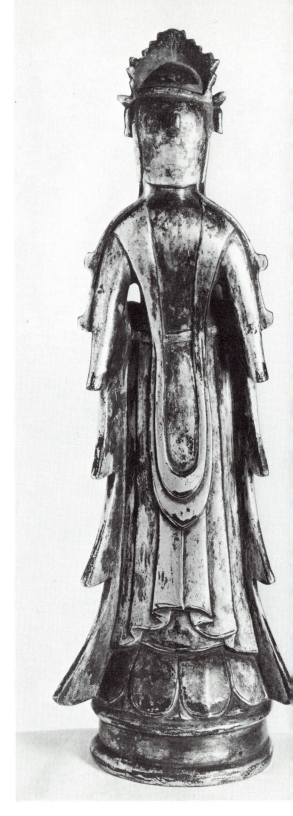

176. Bodhisattva. Japan, mid-vii century A.D. Gilt bronze. H. 13⅓ in.

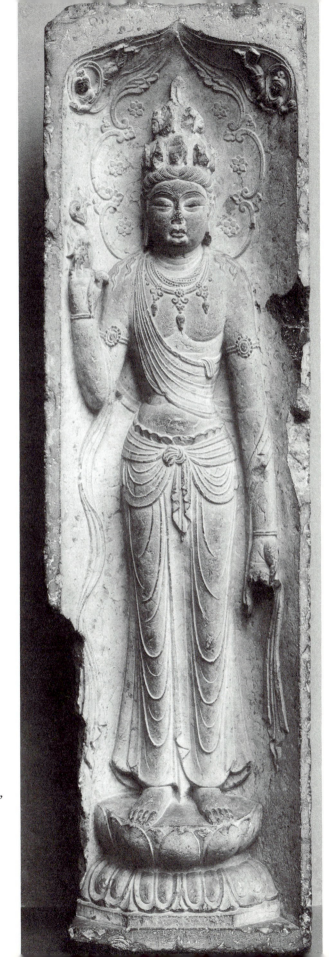

177. Buddhist figure. China (T'ang Dynasty), A.D. 618–906. Colored stone. H. 39 in.

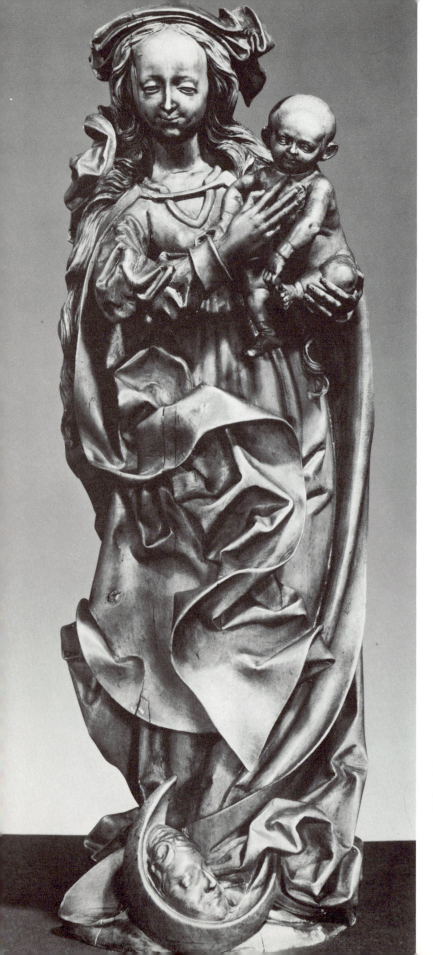

178. VEIT STOSS (1447–1452).
Virgin and Child. German,
about 1505. Boxwood. H. 8⁹⁄₁₆
in.

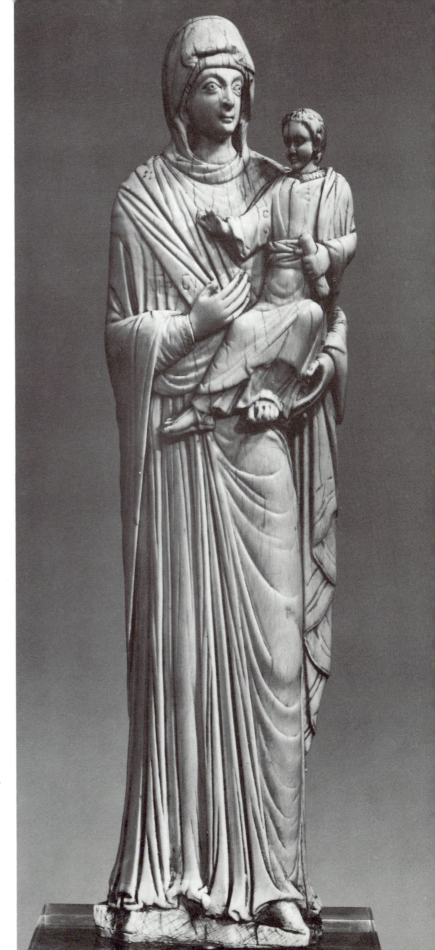

179. Virgin and Child. Byzantine, xi–xii centuries. Ivory. H.
12¾ in.

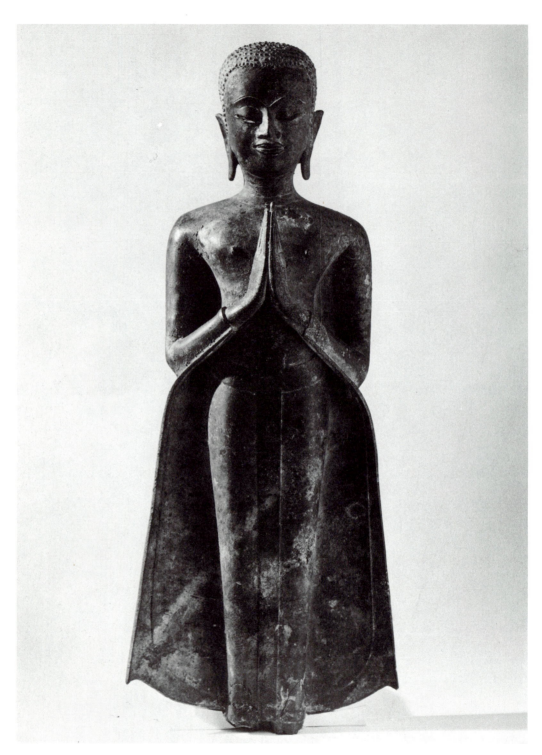

180. Praying figure. Siam, XVII–XVIII centuries A.D. Bronze. H. 12⅜ in.

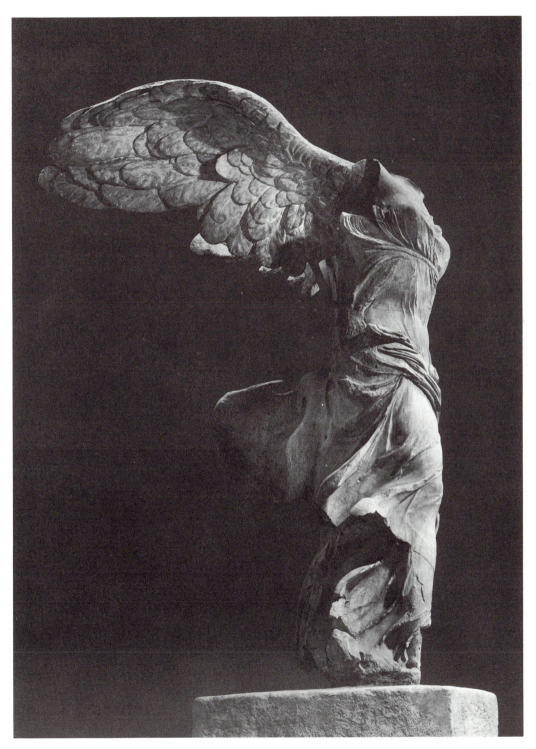

181. The Victory of Samothrace. Greek, end of IV century B.C. (or II century B.C.?). Marble. H. (of statue alone) 9 ft.

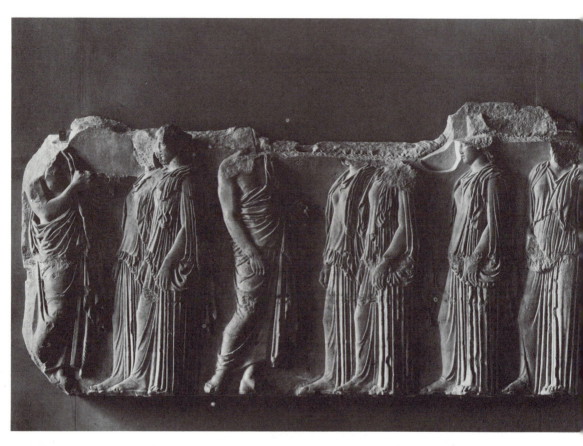

182. Fragment from the Parthenon frieze representing the Panathenaic procession. Athens, 442–438 B.C. Marble. H. 41 in.

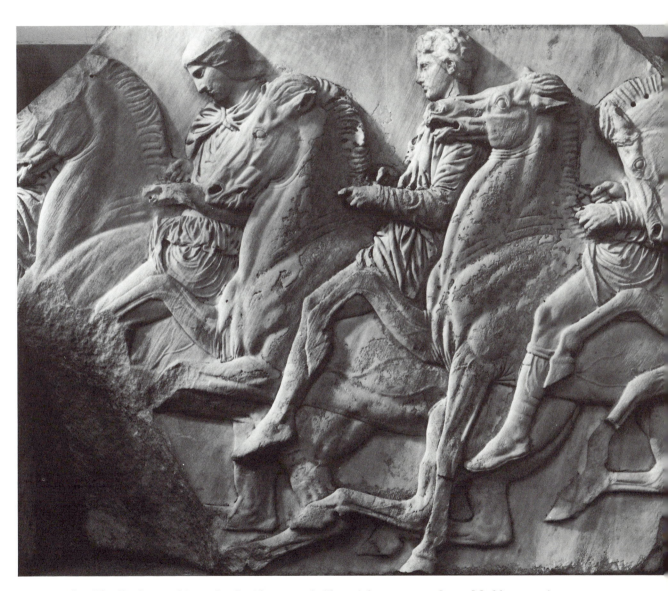

183. The Parthenon frieze, detail of horses and riders. Athens, 442–438 B.C. Marble. H. 41 in.

184. Dione and Aphrodite, from the Parthenon, east pediment. Athens, 442–438 B.C. Marble. H. 4 ft. 1 in.

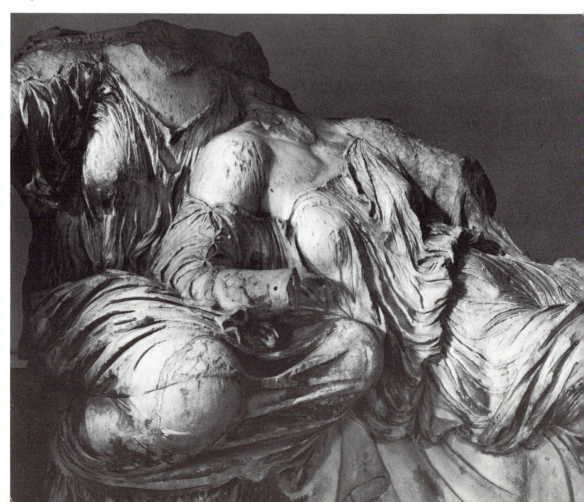

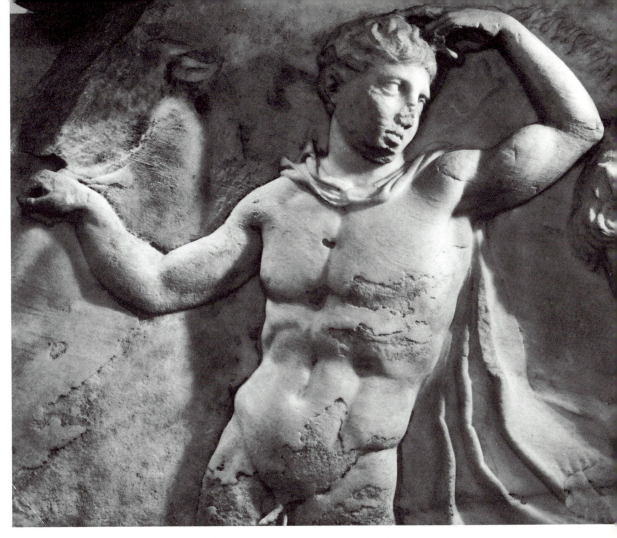

185. The Parthenon frieze, detail of figure. Athens, 442–438 B.C. Marble. H. 41 in.

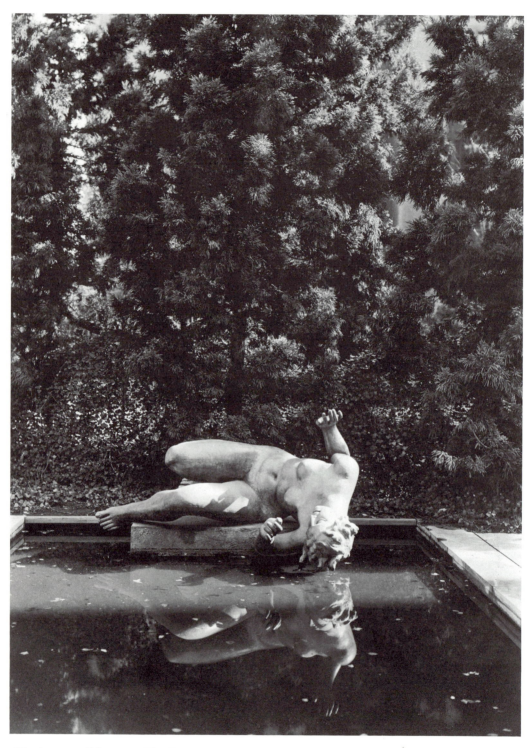

186. Aristide Maillol. The River. 1939–43. Lead. l. 7½ ft.

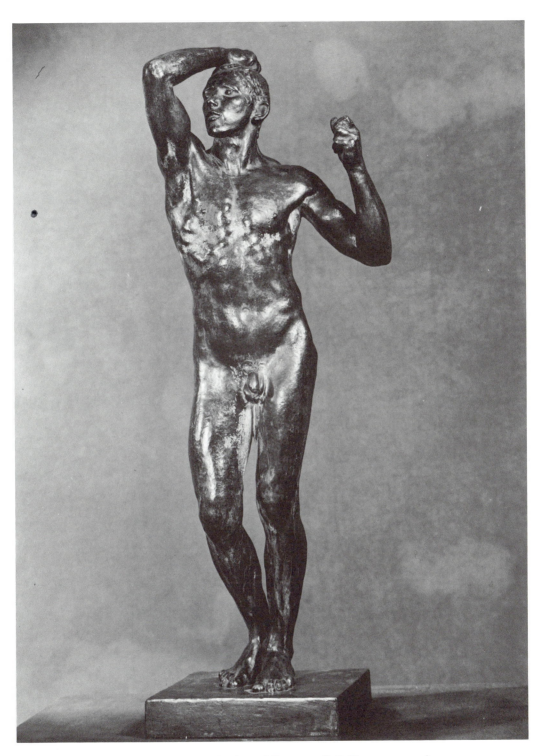

187. AUGUSTE RODIN (1840–1917). The Age of Bronze. 1876. Bronze. H. 72 in.

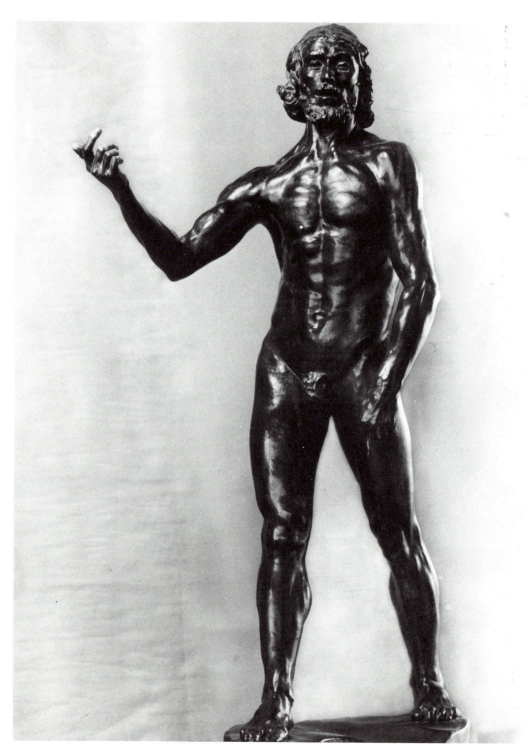

188. AUGUSTE RODIN. St. John the Baptist. 1879. Bronze. H. 80 in.

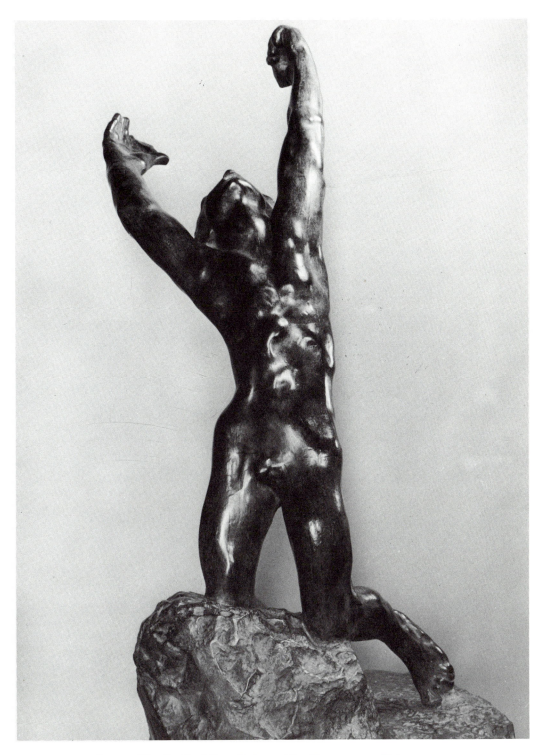

189. AUGUSTE RODIN. The Prodigal Son. Before 1889. Bronze. H. 54¾ in.

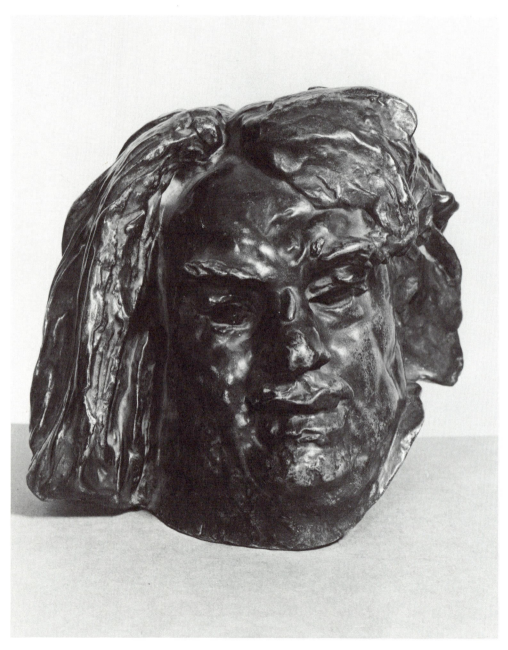

190. Auguste Rodin. Head of Balzac. 1893. Bronze. 6⁷⁄₁₆ x 7½ in.

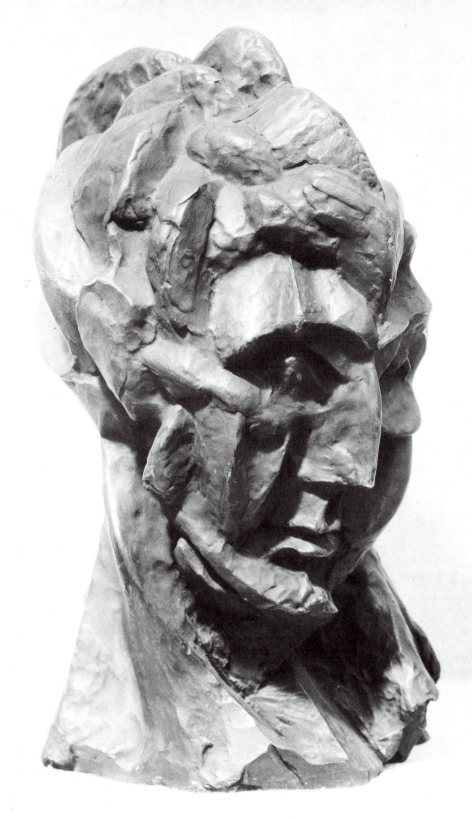

191. PABLO PICASSO. Woman's Head. 1909. Bronze. H. 16¼ in.

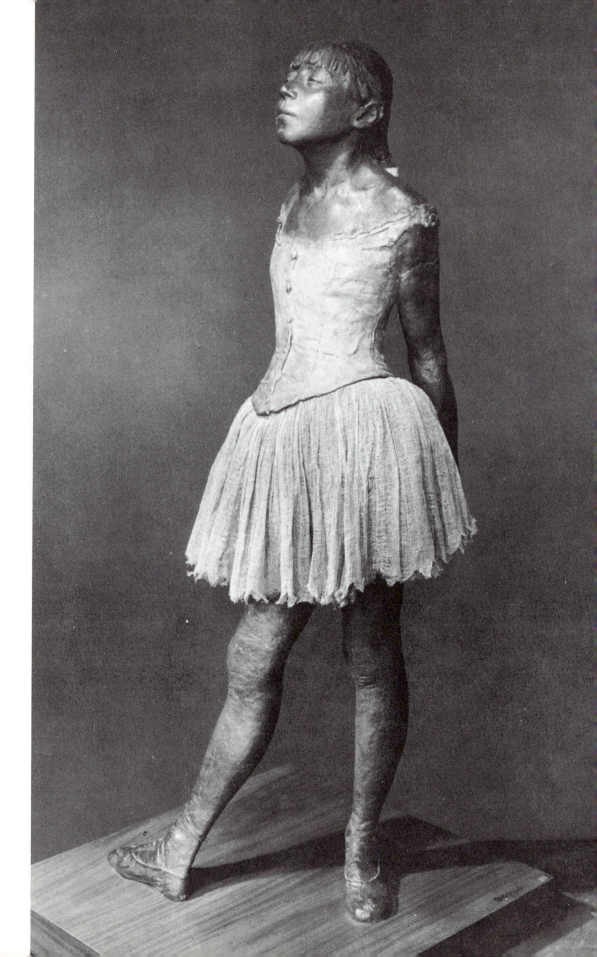

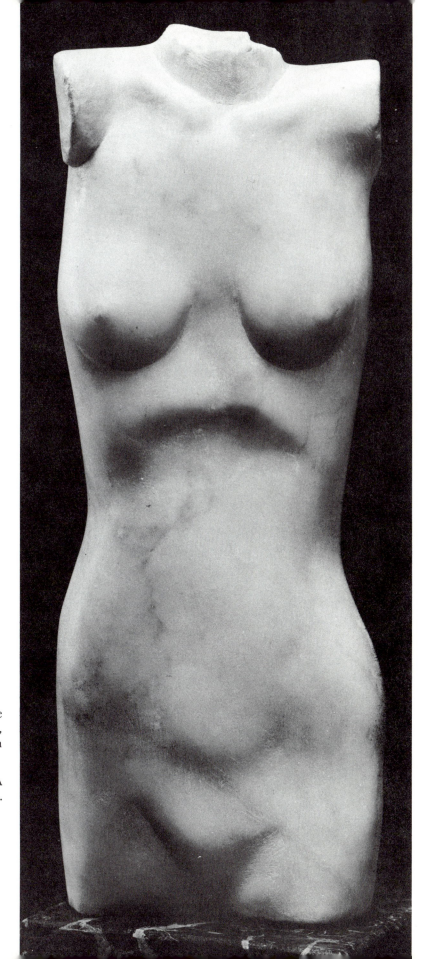

192 (left). EDGAR DEGAS. The
Little Dancer. 1880–81. Bronze,
with muslin dress and satin
hair ribbon. H. 39 in.

193. HENRI GAUDIER-BRZESKA
(1891–1915). Torso. Marble.
H. 10 in.

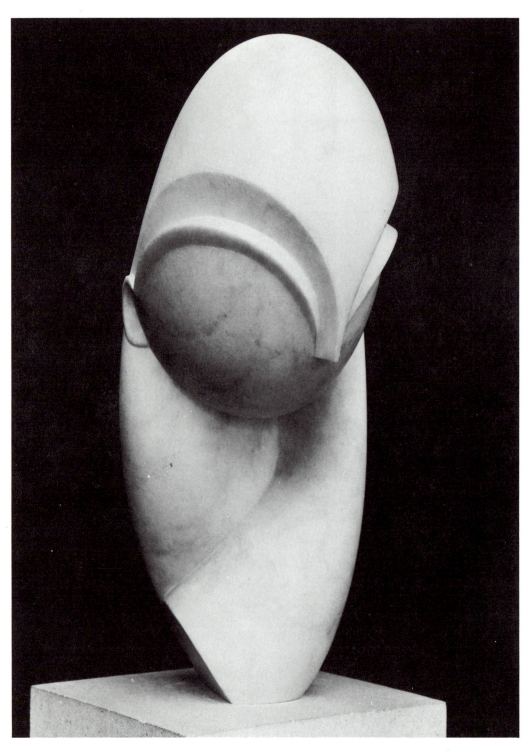

194. Constantin Brancusi. Mlle. Pogany. 1931. Marble. H. 27½ in. (with base)

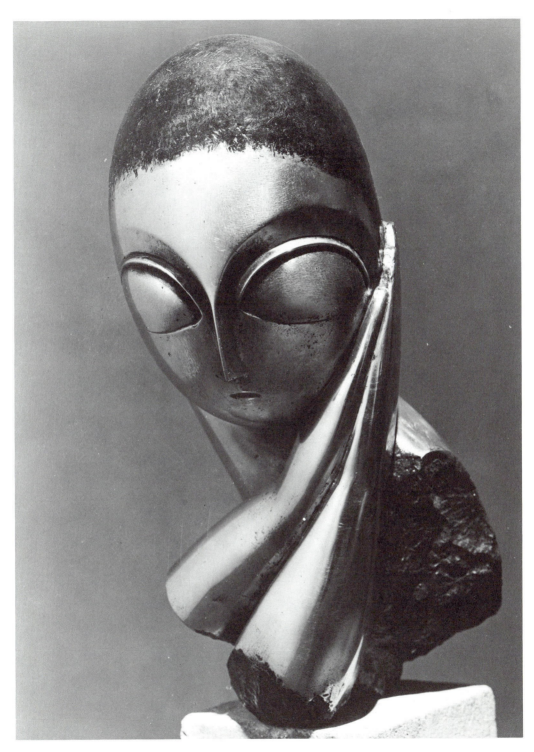

195. CONSTANTIN BRANCUSI. Mlle. Pogany. 1913. Bronze. H. 17¼ in.

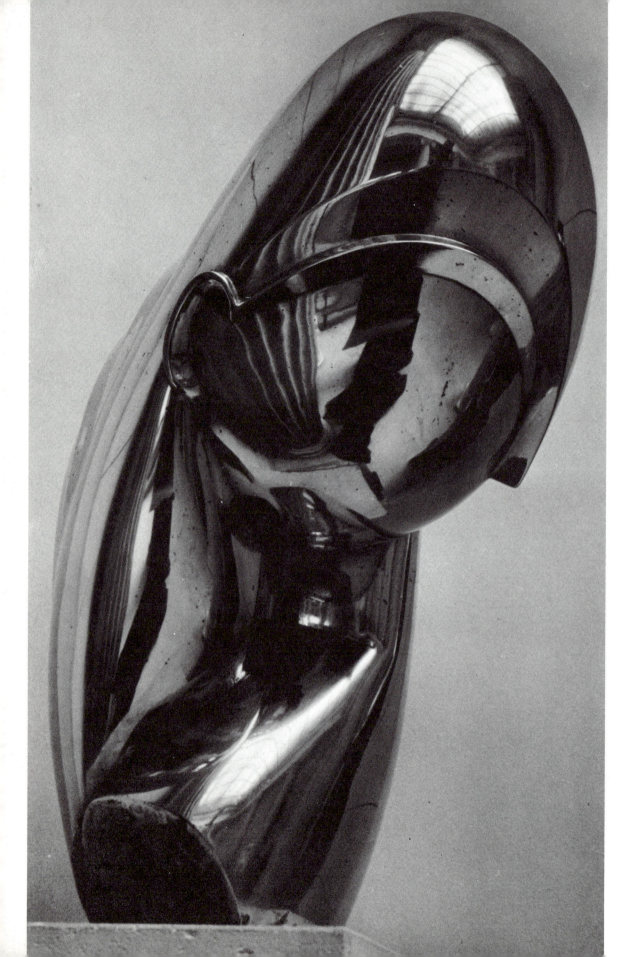

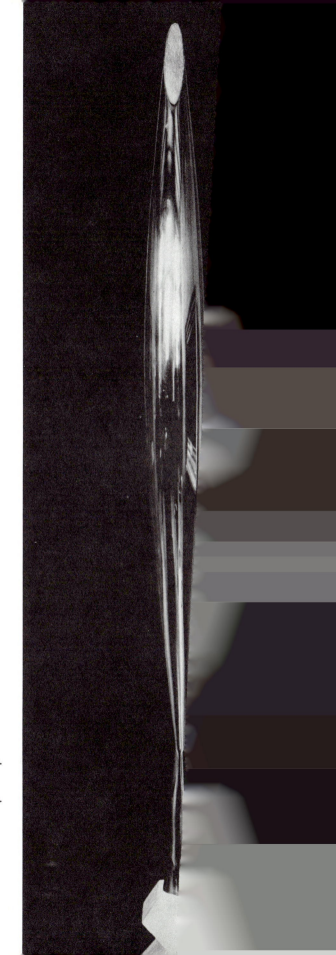

196 (left). CONSTANTIN BRANCUSI. Mlle. Pogany.
1920. Polished brass. H. 17 in.

197. CONSTANTIN BRANCUSI. Bird in Space. 1940.
Bronze. H. 52 in.

198. JACQUES LIPCHITZ. Man with a Guitar. 1915(?). Cast stone. H. 38¼ in.

199 (right). JACQUES LIPCHITZ. Mother and Child II. 1941–45. Bronze. H. 50 in.

200–201. HENRY MOORE. Madonna and Child. 1943–44. Hornton stone. H. 59 in.

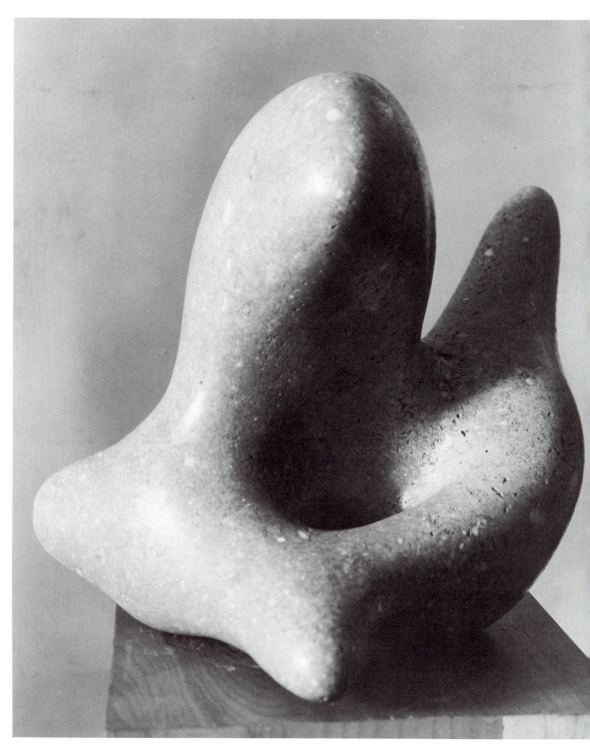

202. Jean Arp. Outrance d'une outre mythique ("Extremity of a mythical wineskin"). 1952. Stone. H. 17 in.

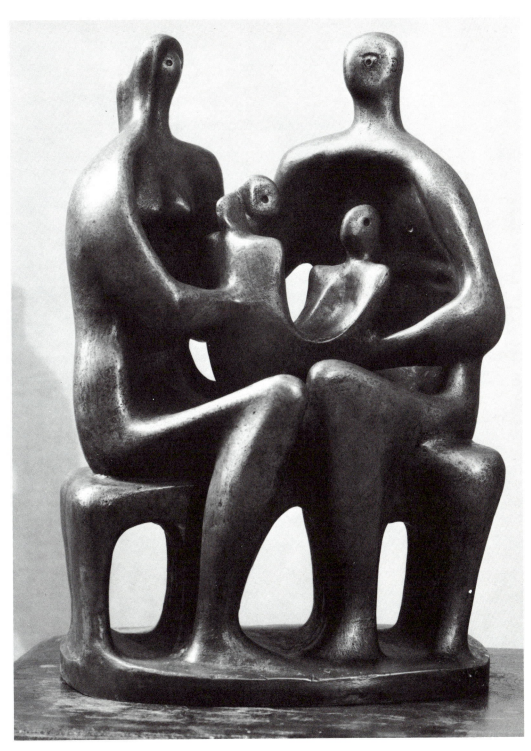

203. HENRY MOORE. Family group. 1947. Bronze. H. 16 in.

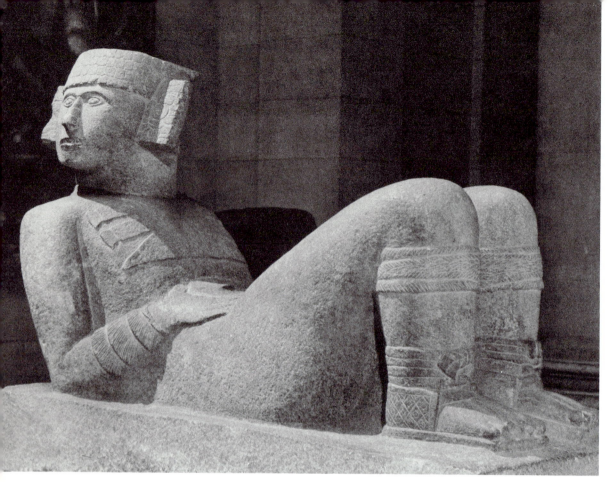

204. Chac Mool, the Rain Spirit. Mayan (New Empire), from Chichén Itzá, A.D. 948–1697. Limestone. L. 58½ in.

205. HENRY MOORE. Reclining figure. 1929. Brown Hornton stone. L. 32 in.

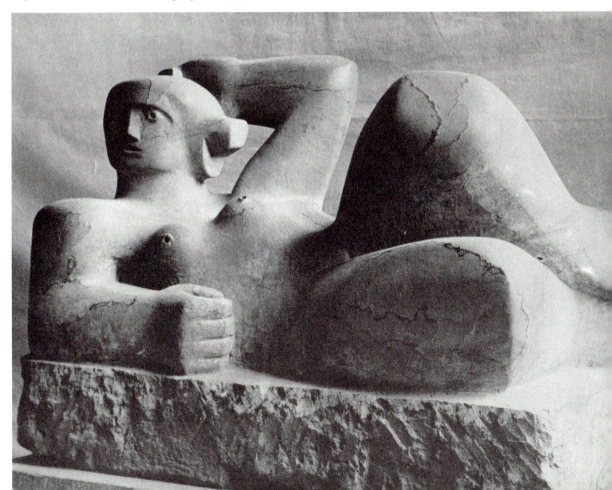

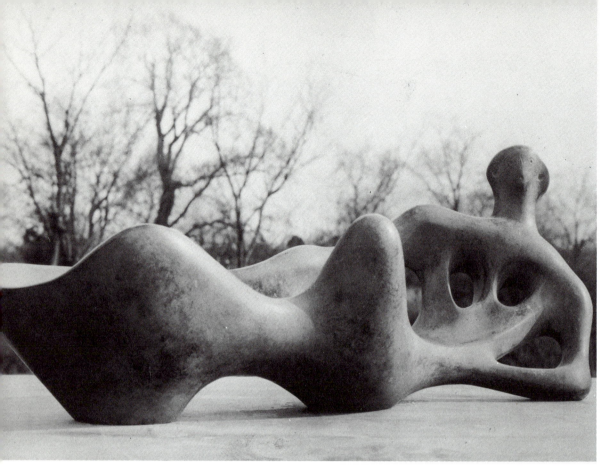

206. HENRY MOORE. Reclining figure. 1945. Bronze. L. 17½ in.

207. ALBERTO GIACOMETTI. A city square. 1948. Bronze. H. 8½ in.

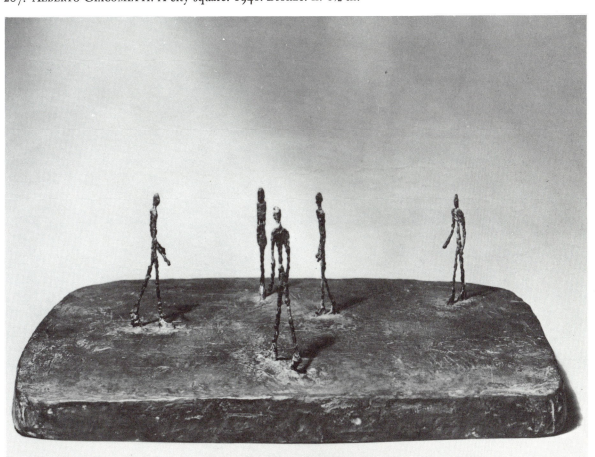

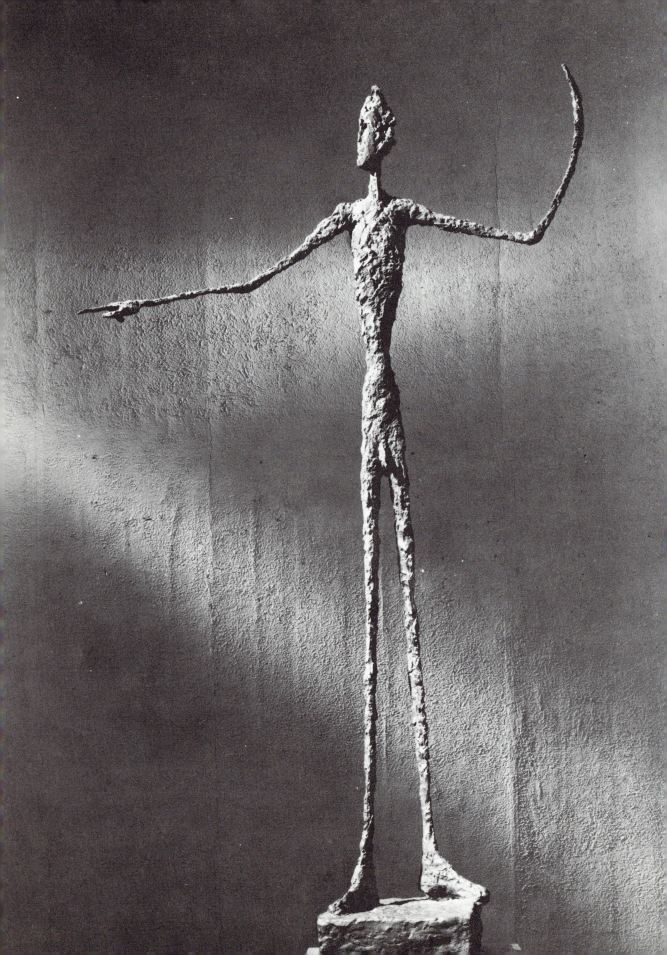

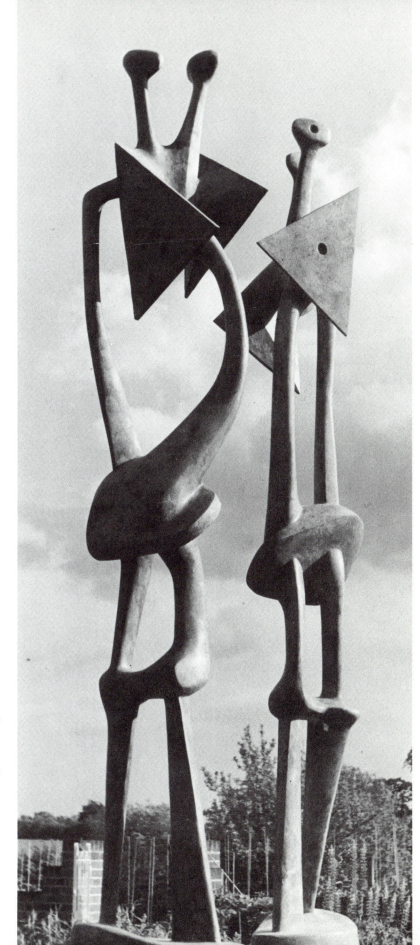

208 (left). ALBERTO GIACO-
METTI. Figure of a man. 1947.
Bronze. H. 70½ in.

209. HENRY MOORE. Double
standing figure. 1950. Bronze.
H. 7 ft. 3 in.

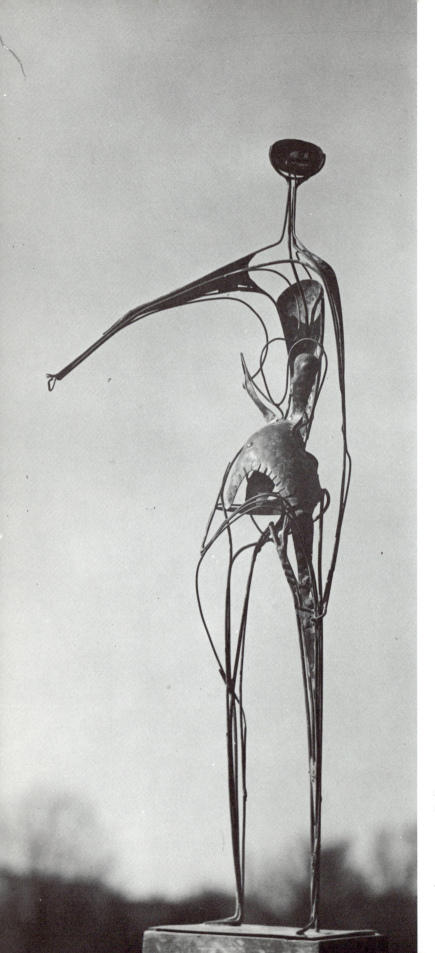

210. Reg Butler. Woman
standing. 1952. Bronze wire
and sheet metal. H. 18½ in.

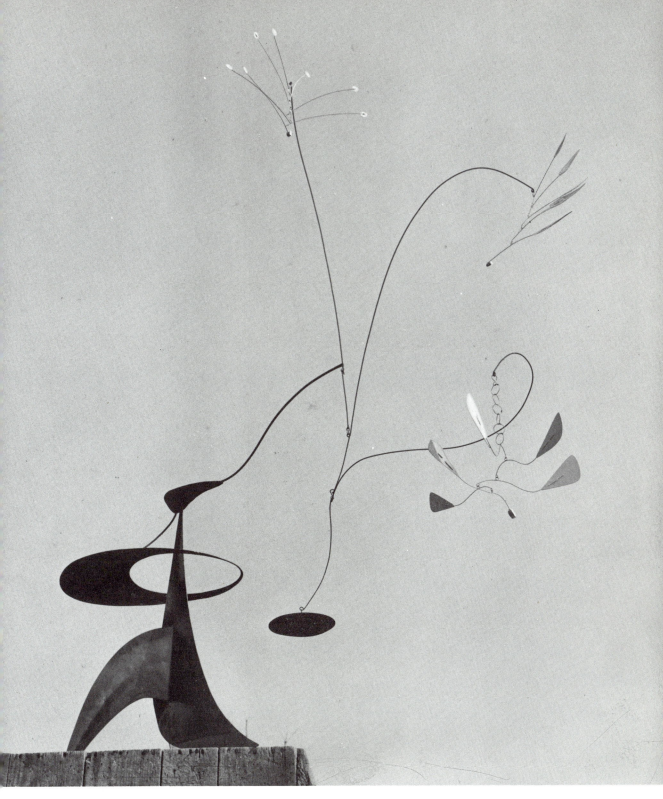

211. ALEXANDER CALDER. Bougainvillea. 1947. Mobile of wire and sheet metal. H. 76 in.

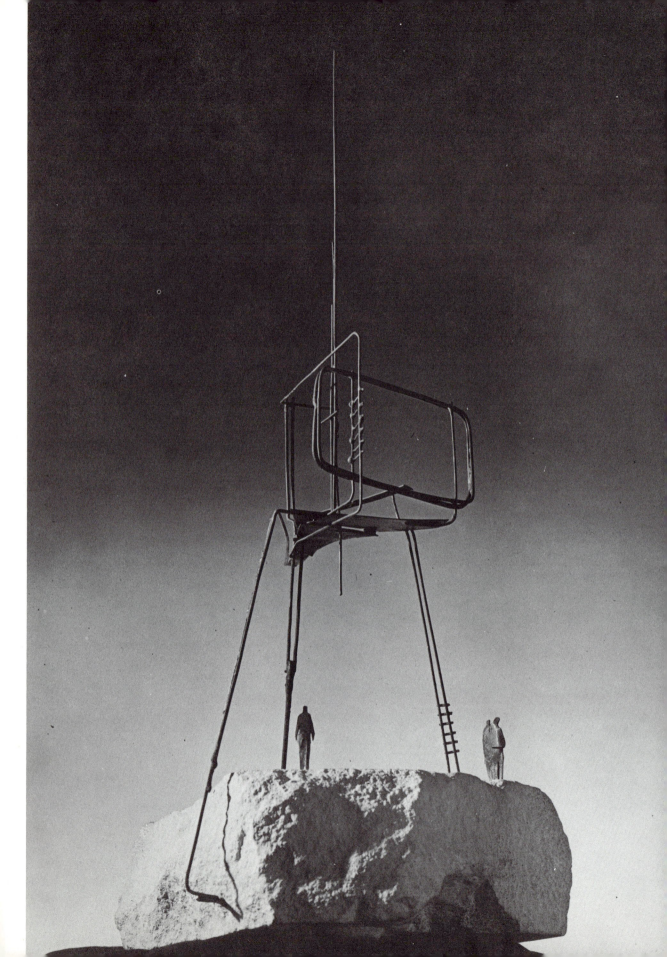

212. REG BUTLER. Project for a monument to the Unknown Political Prisoner. 1952. Bronze wire with stone base. Projected minimum H. 150 ft., with 3 figures 8 ft. high.

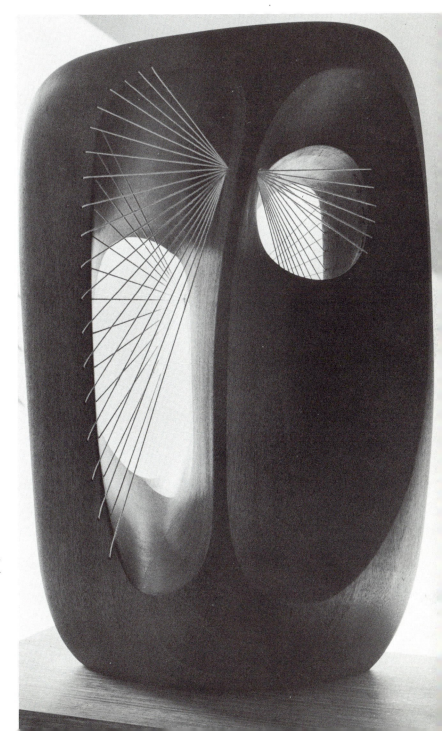

213. BARBARA HEPWORTH. Head ("Elegy"). 1952. Mahogany and strings. H. 17 in.

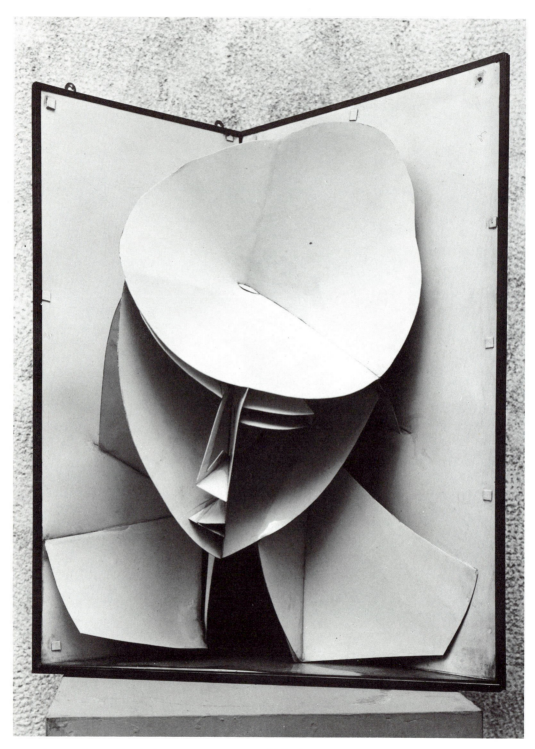

214. NAUM GABO. Head of a woman. 1917. Celluloid and metal. H. 24½ in.

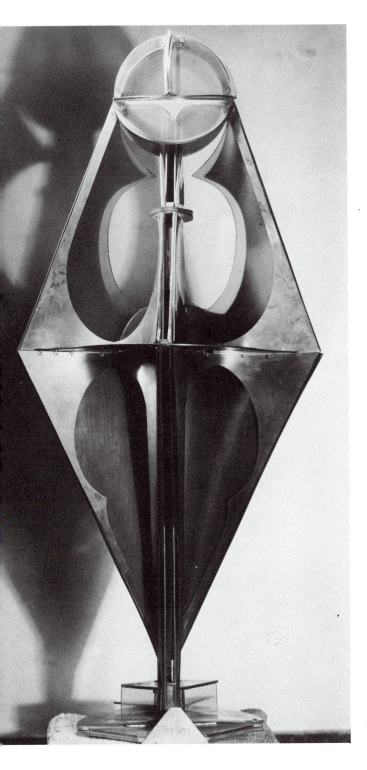

215. ANTOINE PEVSNER. The Dancer. 1927–29. Brass and celluloid. H. 31¼ in.

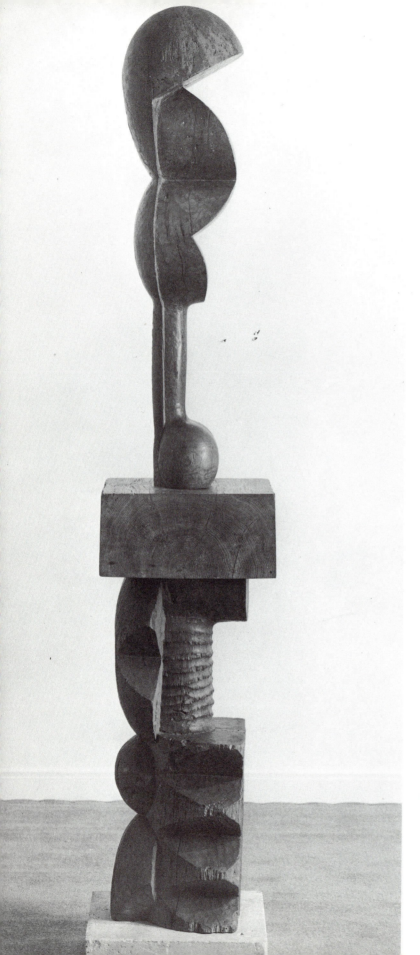

216. CONSTANTIN BRANCUSI.
Adam and Eve. 1921. Old oak,
chestnut, and limestone. H. 93
in.

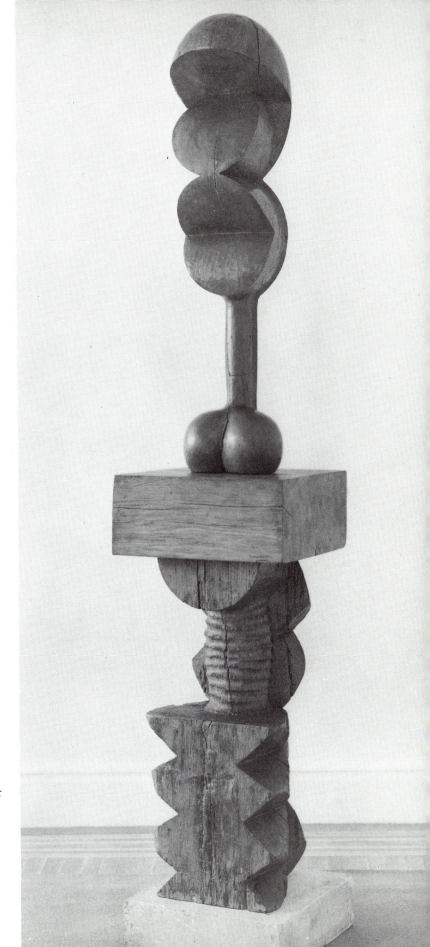

217. Adam and Eve. Another
view

218. RICHARD LIPPOLD. Variation No. 7: Full Moon. 1949–50. Nickel-chromium wire, stainless-steel wire, and brass rods. H. 10 in.

219. NAUM GABO. Spiral theme. 1941. Construction in plastic. H. 7½ in.

220. NAUM GABO. Construction suspended in space: view from first floor. 1952. Aluminum (baked black), plastic, gold wire, bronze mesh, steel wire. Suspended 15 ft. into the stairwell of the Baltimore Museum of Art

221. Construction suspended in space: view between first and second floors

223. Construction suspended in space: view between second and third floors

224*a*. Rock sculpture. Chinese, date uncertain. L. 24 in.

224*b*. HENRY MOORE. Detail from a reclining figure. 1951. Bronze.

INDEX

Index